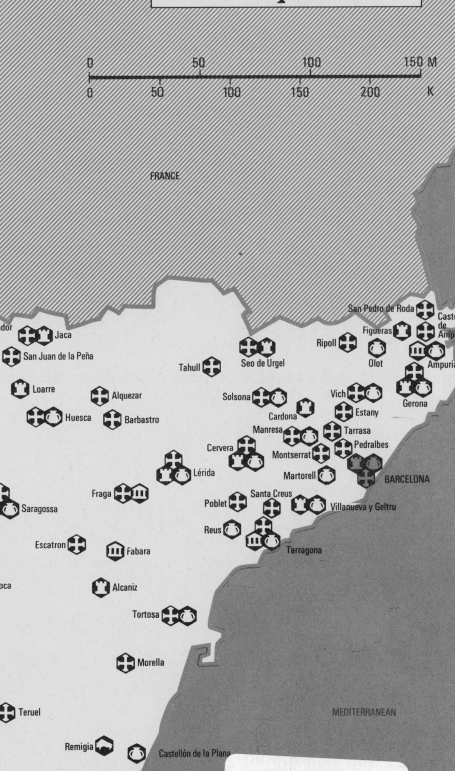

Art Treasures in northern Spain

0 50 100 150 M

0 50 100 150 200 K

Bay of Biscay

FRANCE

San Sebastian Fuenterrabia

Bilbao

Roncesvalles

San Pedro de Roda

Castello de Ampurias

Pamplona San Salvador de Leyre Jaca

Figueras

Ripoll

Estella Sanguesa San Juan de la Peña

Seo de Urgel

Olot

Ampurias

Olite Uncastillo

Tahull

Vich

Gerona

La Oliva Sádaba Loarre Alquezar

Solsona

Estany

Logroño

Huesca Barbastro

Cardona Tarrasa

San Millán de Cogolla

Manresa Pedralbes

Tudela

Cervera Montserrat

Martorell

BARCELONA

Domingo de Silos Agreda Lérida

Numantia Tarazona Fraga

Santa Creus Villanueva y Geltru

Soria Veruela Saragossa

Poblet

El Burgo de Osma Reus

Berlanga de Duero Escatron Fabara Tarragona

Medinacelli Calatuyud

Siguenza Nuevalos Daroca Alcaniz

Cogolludo Tortosa

Guadalajara Morella

Albarracin Teruel MEDITERRANEAN

calá de Henares Remigia Castellón de la Plana

Cuenca Segorbe

Sagunto

Valencia

Belmonte

Art Treasures in Spain

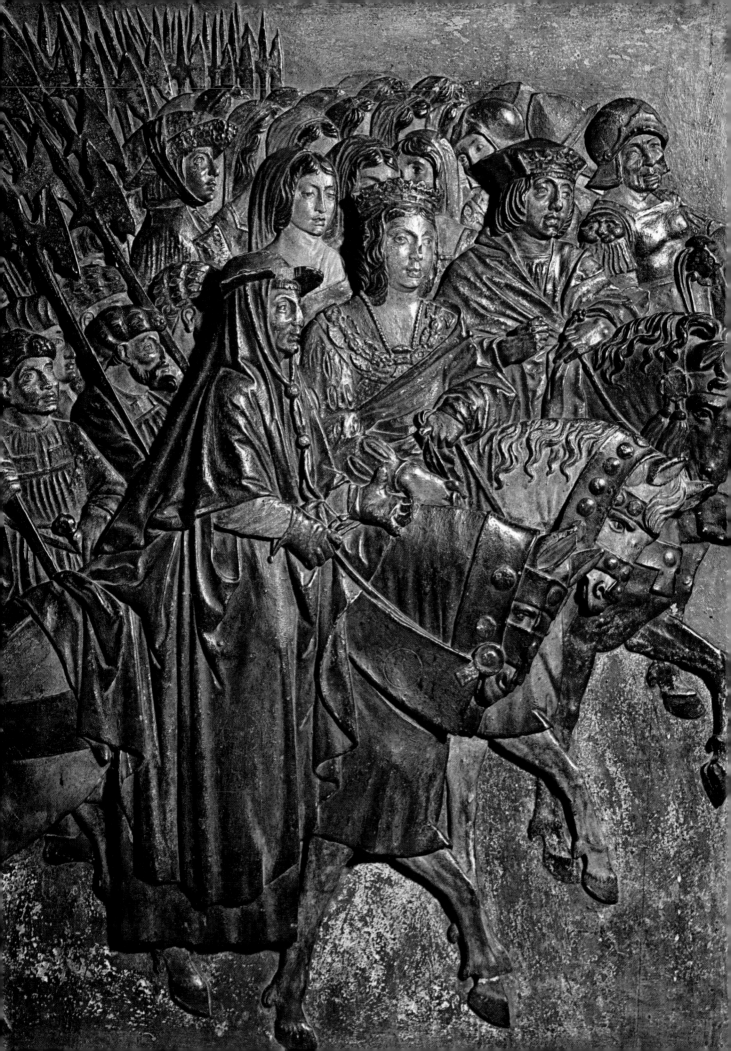

Art Treasures in Spain

Monuments, Masterpieces, Commissions and Collections

Introduction by Juan Ainaud de Lasarte

Director General of the Art Museums of Barcelona

McGraw-Hill Book Company

New York Toronto

General Editors
Bernard S. Myers
New York
Trewin Copplestone
London

half title illustration:
Detail of altar frontal from Santo
Domingo de Silos; gilt copper inlaid
with enamels; early 12th century;
Museo Provincial, Burgos

frontispiece:
The Catholic Kings entering Granada
detail from the polychrome wood
retable; 1520–22; Felipe Vigarny;
Granada Cathedral

opposite:
Apostles; column in the Cámara Santa,
Oviedo Cathedral; 12th century

Library of Congress Catalog Card Number 70–76758
44228
Published jointly by
McGraw-Hill Book Company, New York and Toronto
and the Hamlyn Publishing Group Limited, London and Sydney
Hamlyn House, The Centre, Feltham, Middlesex, England
© The Hamlyn Publishing Group Limited, 1969. All rights reserved.
Printed in Italy by Officine Grafiche Arnoldo Mondadori, Verona
Phototypeset by BAS Printers Limited, Wallop, Hampshire, England

Contents

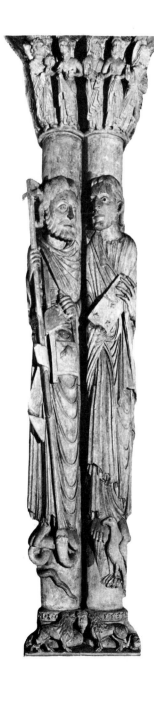

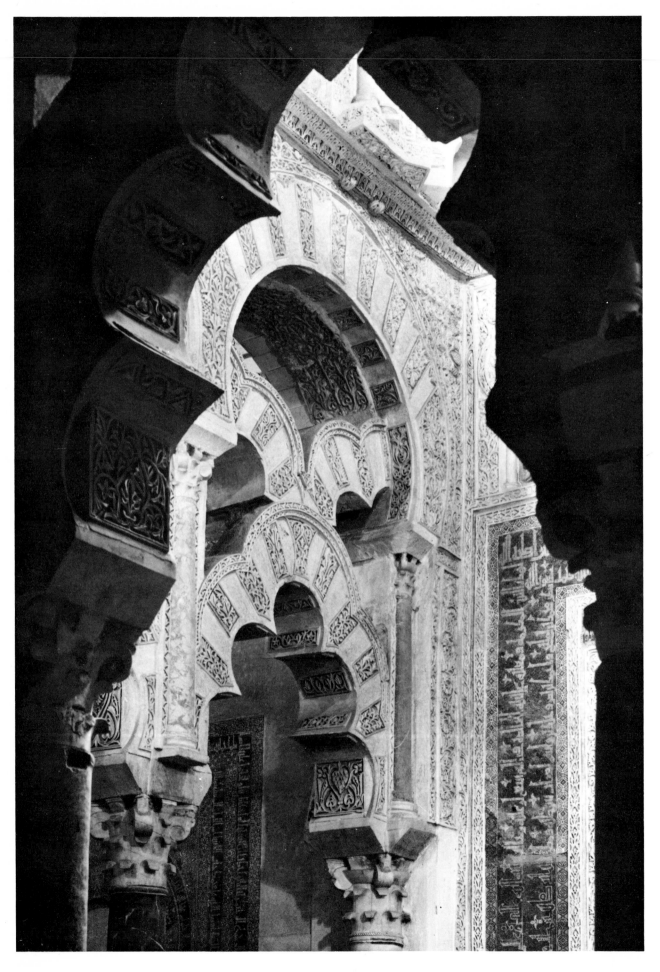

6

In 1845 Richard Ford's work *A Handbook for Travellers in Spain and Readers at Home* came out in London. This, unquestionably one of the finest books written on Spain during the Romantic period, perfectly summarises in its title – not without a certain fine sense of humour – its dual function; a companion and guide for those on the road and an invaluable source of information for the armchair traveller. I am convinced that the present volume, which brings together the interests and knowledge of a group of specialists, will achieve a similar purpose for this century.

The word 'treasures' can be applied simply to precious objects such as jewellery, but it can be extended – as occurs here – to all those works of art whose value rests solely on the skill or genius of their creator or, in some cases, on their own intrinsic value. This last aspect justifies beginning the volume with the splendid paintings in the caves of Altamira, produced by primitive man to whom the concept of art in our sense meant nothing. Before long, treasures in the more traditional sense begin to appear: the combs and torques of the treasure of Caldas belong to the Celtic world of sea voyages which carried tin from Britain to the great markets of the Guadalquivir valley, where the Phoenicians founded the colony of Cádiz, and other peoples from the eastern Mediterranean gathered to share the great mineral wealth of the peninsula.

Many objects of ancient Carthaginian, Egyptian or Greek tradition from other burial-grounds or settlements in the south illustrate the richness and variety of this world, later to be submerged under the invasions of Romans, Visigoths and Moors. Each one of these three consecutive periods was marked by innovations from outside, but also, sadly, by the final disappearance of much that had gone before. However, many Roman buildings have been preserved because of their very solidity, while some fine examples of Visigothic art, such as the Guarrazar treasure, have survived simply because they were buried for safety.

A new situation arose with the Reconquest, the great and complex movement of the Christians from the north towards the south. Throughout this period Moorish art flourished in successive stages at the same time as, and often closely linked with, the varied pre-Romanesque forms, the great development of Romanesque art, and later, the rich Gothic style.

To the 16th and 17th centuries belong the greatest glory of the Spanish monarchy. Close political and cultural ties with Italy and Flanders had been established in the preceding era, and now the royal family and aristocratic collectors brought foreign works of art and artists into the country, giving an added impetus to the native painting schools.

Nevertheless, despite the large number of 18th-century travellers and collectors, Spain's rich artistic heritage did not achieve international fame until the first half of the last century, when various factors helped to bring it all to the notice of the rest of Europe. During the troubled times after the Peninsular War works from Spanish collections were avidly bought and disseminated throughout Europe, and further works of art were dispersed as a result of the suppression of Spanish convents and monasteries in 1809, 1820, and particularly in 1835. Another decisive factor was the foundation in 1819 of the Prado Museum, which has become one of the greatest international collections.

By then the isolated figure of Goya had heralded a new freedom of artistic expression in Spain, although it was not fully explored until the present century. Now such names as Gaudí, Juan Gris, Dali, Miró and of course Picasso are known throughout the world as founders of some of the modern movements that are an established part of European art history.

Juan Ainaud de Lasarte

Introduction

VESTIBULE
OF THE MIHRAB
c. 965
Great Mosque, Córdoba

The Great Mosque was begun by Abd-al-Rahman in 785, and enlarged in the 10th century by al-Hakam II, who added some fourteen cross aisles, nearly doubling the area of the building, and built the splendid *mihrab*. After the capture of Córdoba by St Ferdinand in 1236 the mosque was reconsecrated as a Christian church, and in 1523 the Cathedral Chapter, with the authority of the Emperor Charles V, began the cruciform church that now occupies the centre of the mosque. When Charles actually went to Córdoba, in 1526, he was horrified at the disastrous effects of his religious zeal and he rebuked the Chapter thus: 'You have built here what you or anyone might have built anywhere else, but you have destroyed what is unique in the world.' Fortunately restorations are being carried out and it is still possible to perceive something of the splendour the building must once have possessed.

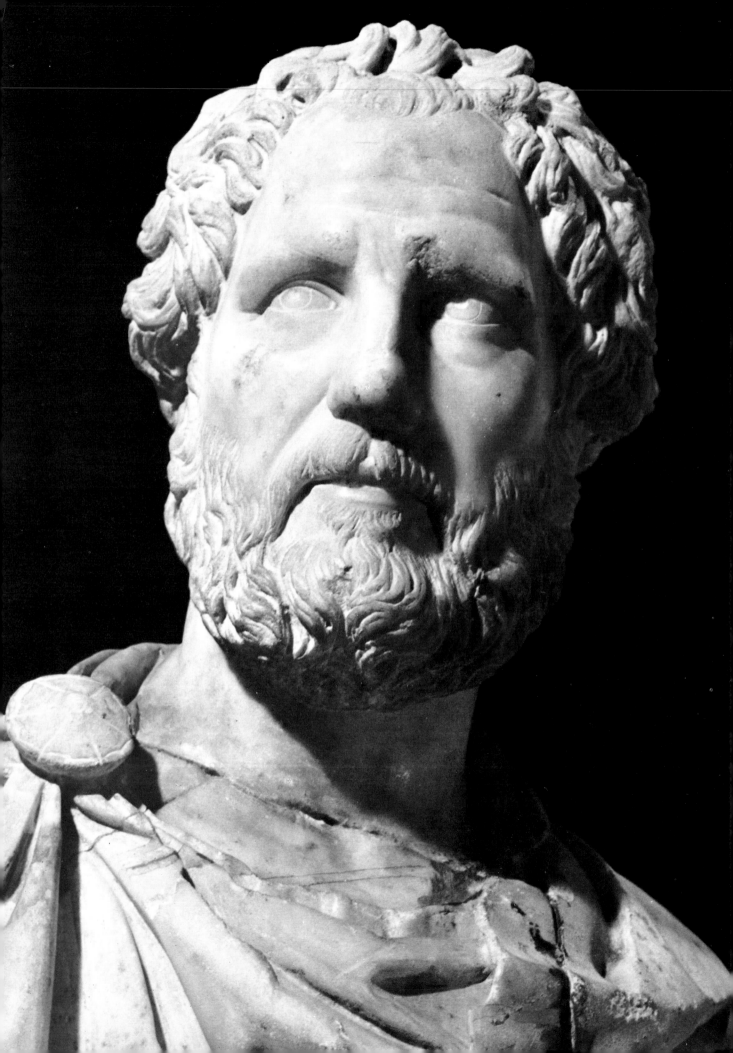

Among the earliest and most remarkable of the many works of art to be seen in Spain are the exquisite paintings in the famous cave of Altamira, which have served as inspiration to many artists of today. Altamira is the name best known in connection with the art of the Stone Age people, and it is usually granted pride of place as the finest and most skilful example of early mural art in the world. This is Leptolithic art: the work of simple hunters. Although little can be known of their origins or way of life, we can assume that for the most part they would have been small family groups wandering for weeks without seeing anyone outside their immediate circle. The animals they portrayed were clearly the creatures they knew and hunted, and the frequent occurrence of spears painted in the animals is usually thought to signify a kind of hunting magic underlying the art.

Like so many of the Spanish caves, Altamira presents a bewildering mixture of engravings, paintings and enigmatic signs. In a low hall lying to the left a short way inside the entrance is the superb painted ceiling of 8 bison and other animals in shades of red, brown and black. At least sixteen bison are grouped in the centre, and lying in peripheral positions around them are two boars, one deer, and another small deer superimposed on a horse. At one side of the ceiling frescoes are a number of examples of the club-like signs known as claviforms, which may be primitive boomerangs.

The animals are multicoloured, outlined usually in dark brown and shaded in with lighter brown and various shades of red ranging from brilliant to pastel. This polychromatic style of painting may have involved some kind of brushwork, or perhaps a technique of wiping the paint on with a fur pad to produce the subtle shading effect.

Altamira records only the last two stages of the Palaeolithic; the nearby cave of El Castillo, also in the Cantabrian range of northern Spain, records much more of the sequence of Palaeolithic occupation of Western Europe.

Monte Castillo is a small conical hill, with a series of four caves round its sides: El Castillo itself, La Pasiega, Las Chimeneas and Las Monedas. These are all adorned with paintings and, like those at Altamira, are characterised by a fine view of the adjacent hills and valleys. It is likely that the choice of such sites reflected the hunter's concern with lookout places for detecting game movements.

3, 7 The paintings at El Castillo are again predominantly of animals, but there are also hand silhouettes made on walls, and many of the strange 2 oblong signs known as tectiforms, which are brightly coloured and formed with lines and dots. The importance of the hand in primitive symbolism is known in other early cultures such as that of Egypt, while the tectiforms have been variously interpreted as buildings, traps and sex symbols.

Of this group of caves the paintings in Monedas are perhaps the latest and most finely executed. The clearest and best preserved are a horse and a reindeer, both in black. The reindeer is rarely shown in Leptolithic art, even in France where it was the staple food; thus its appearance in Spain is particularly important, and probably coincides with its brief appearance in the menu of the hunters in late Magdalenian times, about 11,000 B.C.

The cave of Pindal presents what is almost certainly an example of hunting magic. Here there are eight of the claviform signs previously noted at Altamira, placed just in front of a bison which has either a wound or a spear in its side. In the same cave is an elephant with a large red blob, apparently its heart, on its chest. It seems likely that the animals' hearts were speared ritually by a shaman to ensure success in the hunt.

Stone Age Hunters, Iberians and Romans

Prehistory to c. AD 400

1

MALE HEAD
2nd century AD
white marble
Museo de Historia de la Ciudad, Barcelona

The bust was at one time thought to represent Antoninus Pius; but although its style dates it to his reign or that of his successor, the haggard features and melancholy expression of the subject would appear to be those of a private person, or possibly of a Stoic philosopher held in honour by a citizen of Roman Barcelona, rather than those of the emperor himself, who would have received more idealised treatment.
In the 3rd century it came to be re-used as building material in a tower attached to the wall of the colony. After the Barbarian invasions, sculptures and gravestones were often employed in the construction of city defences, erected to prevent a repetition of the catastrophe.

The art of the Spanish Levant

Probably the most informative of all the cave art ever produced by a hunting community is that of the Mediterranean coastal provinces of Spain. Opinions differ on its age; some think it is as late as the Bronze Age and others argue that it is contemporary with the later Leptolithic. The paintings give virtually no indication of any domestic animals or farming activities; instead the art has the flavour of a hunting society. However, it is quite unlike the earlier Leptolithic art. Here actual hunts are often depicted, featuring stags, ibex and wild boar, and the pictures include humans, usually armed with bows and arrows, drawn in the same style and to the same scale as the animal quarry they are pursuing. In one scene an ox seems to be chasing the hunters, evidently recalling an event that was both exciting and amusing.

These paintings provide probably the best insight into the social institutions of any primitive society of the past. One in the Agua Amarga cave in Teruel shows a band of hunters running across the scene, possibly indicating the tribal group. Some of them have feather head-dresses in American Indian style. No clear sign of a chief or nobles is to be detected in any of the group pictures, and accordingly we may visualise the kind of simple tribal organisation found among modern hunters such as the Bushmen of the Kalahari desert. In such a tribe the leader would be accorded his position solely by virtue of the respect in which he was held.

The two scenes most revealing of social life are both from the Remigia cave in the Gasulla Gorge, Castellón province. The first is probably a war dance. Five men hold bows over their heads as they stand in line; the figure on the right leading the others has a slightly different head-dress, and may be a tribal chief. The second is thought to represent an execution. It shows a row of exultant bowmen in the background, and a recumbent figure full of arrows lying in front. It is difficult to know if he was an enemy or a condemned member of the tribe.

The early farmers

The essentials of an agricultural economy first reached Spain from further east, no doubt mainly by means of seaborne colonists stemming ultimately from parts of the eastern Mediterranean that had been settled by farming communities as early as 7000 B.C. Apparently the first farmers in the western Mediterranean were a people whom archaeologists label the 'Cardial people' from their ceramics, which bear serrated decoration made by the cardium shell. Other early farmers of Spain belong to the Almeria culture deriving from North Africa, but traces of these peoples are still sparse, and their ceramics barely rate as works of art.

A more sophisticated culture grew up with the introduction of metallurgy, probably before 2000 B.C., and for the first time there are traces of settled communities. The small township of Los Millares near Almería, covering over twelve acres, reflects the sudden prosperity brought about by the discovery of gold, silver and other minerals locally. Here we find houses which belonged to skilled artisans, especially metallurgists. From the large cemetery outside the town came indications of considerable wealth: beads of amber, jet and turquoise were found in the graves. The pottery from this and other sites of the time is a new type, decorated with engraved oculi motifs, bands of straight or wavy lines and schematised figures.

The cemetery at Los Millares leads on to another facet of the early farming culture, namely funerary architecture, for it includes stone-lined tomb chambers. Such collective tombs are found very widely in the coastal regions of Western Europe. Usually they are constructed of natural

2

'TECTIFORM' SYMBOL

possibly 20,000–12,000 BC
red ochre
Monte Castillo, Santander province

The paintings at El Castillo were discovered in 1903; the investigation being partly sponsored by the Prince of Monaco and the institute he founded in Paris. This squared sign characteristically divided into three parts is usually known as a 'tectiform' and is a recurring feature in cave art, appearing also in the Altamira caves. Scholars interpret the signs in widely differing ways—as buildings, traps or possibly sex symbols.

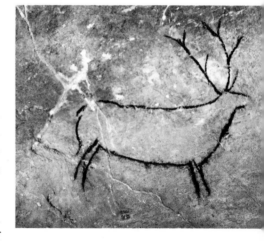

3

THE BLACK STAG
OF LAS CHIMENEAS

manganese dioxide black pigment
Monte Castillo, Santander province

Las Chimeneas is one of a group of four caves (**2**, **7**) in Monte Castillo, all of which contain paintings. The paintings in this cave have never been conclusively dated. The simple black outline and the odd perspective indicate a relatively early date (in the Aurignacian–Perigordian cycle) but recently they have been placed at about 18,000 to 14,000 BC and compared to the stags of Lascaux in France.

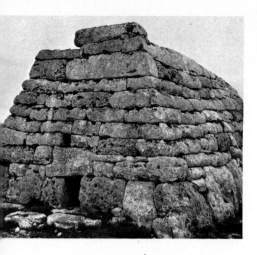

**4
THE NAVETA
OF ELS TUDONS**

*1st millennium BC
Minorca*

Stone buildings, including the Taulas and
Talayots, are characteristic of the late
prehistoric Balearic civilisation, which is
sometimes called Talayotic. They may be
derived from earlier Megalithic tombs, but
the purpose of the Navetas is not known.

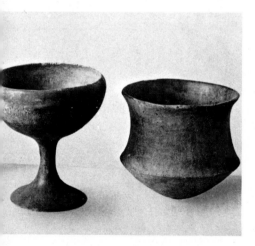

**5
PEDESTALLED CUPS
FROM EL OFICIO**

*Argaric culture, second millennium BC
Museo Arqueológico, Barcelona*

The Argaric culture of Almeria shows a
greater level of wealth than the Los
Millares culture which preceded it in the
same region. These elegant and sophisticat-
ed ceramics were probably the work of
specialist craftsmen.

stone slabs, although some which are clearly related in plan are cut in soft
rock. The general name 'Megalithic' is given to the whole series, but its
original meaning of 'big stones' is appropriate only to a small proportion.
The engraving of designs on the stones themselves, which is characteristic
of those in France and Ireland, is less frequent in Spain, although some
circles and Y-shaped designs are found on the Cueva de Menga in
Andalusia. These correspond with painted designs in caves like La Pileta,
which are thought to be stylised human figures. The more typical Mega-
lithic motifs—the oculi, zigzags, and rows of adjacent triangles forming a
toothed border—occur mainly on plaques of schist and bone sometimes
found in the megaliths or in the settlements related to them. The oculi, in
the form of a pair of eyebrows or sometimes the eyes themselves, probably
represent a 'Great Mother Goddess', who had a fundamental connection
with the Megalithic religion. The way in which megalith building was
adopted across cultural boundaries by quite distinct peoples strongly
supports the idea of a religion spread by missionaries or priests, who
probably travelled by sea as the Celtic saints did 2000 years later.

Some of the finest of the collective tombs are in the province of Málaga
and not far from Antequera; most notable are Cueva de Viera, Cueva de
Menga and Cueva Romeral. Some of this group were carved in the rock,
which was soft enough here, but most, like Romeral, were partly formed
by hollowing into the rock and were then walled and roofed with slabs
hewn from the adjacent soft sandstone. The dolmen of Matarrubilla near
Seville is the centre of a more westerly group. One megalith near Oviedo
has been incorporated into a Christian church. The megaliths of northern
Spain, especially the Pyrenean area, are simpler—usually single rectangular
chambers, having close architectural affinities with those of France. It is
likely that in many areas the building and use of the megaliths continued
well into the second millennium, perhaps as late as 1000 B.C.

Another important cultural development at about this time was the
appearance of the sophisticated ceramics known as 'bell-beakers', which are
consistent over most of Europe. In some areas they are associated with
Megalithic architecture, but in others they appear independently. The
origins of the bearers of these ceramics are uncertain, but it is generally
thought that they were a new people who quickly became absorbed into
the existing society.

During the second millennium B.C., as metallurgy became more com-
mon, the simple copper daggers were replaced by an armoury of fine
bronze weapons. These belong to the El Argar culture, which is named
after a gigantic cemetery of 780 graves. This culture marks the earliest
regular use of silver in western Europe, and the society clearly included
wealthy nobles. In one burial pit, the skull still wore a silver diadem and
the interment was accompanied by pedestalled pottery vases which are
among the most artistic and elegant ceramics of prehistoric Spain.

Archaeology gives no very clear picture of the earlier part of the first
millenium B.C. Our knowledge of the arrival of new peoples is derived
both from the evidence of place names and from the writings of classical
historians. Waves of Celts from central Europe made their way across the
Pyrenees from about the 9th to the 6th century B.C. and colonised the
interior lands; numerous forts testify to the troubled times as they estab-
lished themselves. From about 900 B.C. Phoenician and Greek traders
began to arrive in the peninsula in search of mineral wealth, and they
established settlements along the coast. All these peoples were to play a
decisive part in the flowering of Iberian art.

Desmond Collins

6 *right*

DAMA DE ELCHE

5th century BC or later, limestone
Prado, Madrid

This marvellous bust found at Elche –
possibly of a deity or noblewoman – is the
consummate achievement of early Spanish
sculpture, combining native Iberian and
Greek influences. Although its date has
been hotly disputed, the elaborate head-
dress with heavy side plates (on actual
examples these were almost certainly made
of gold) seems to express the luxurious
tastes of the 5th-century Tartessian
aristocracy. However, the form of the
earrings and the naturalistic treatment of
the head itself suggest that the work may
belong to a later period.

7 *below right*

THE HORSE
OF LAS MONEDAS

15,000–10,000 BC
manganese black pigment
Monte Castillo, Santander province

The paintings of Las Monedas seem to be
the latest of the Castillo Group (**2, 3**) and to
have the finest line. This horse is situated in
a niche opposite a graceful reindeer,
almost certainly contemporary with the
last presence of this animal in Spain about
12,000 BC.

8 *below*

BISON

c. 13,000 BC
ochre and manganese pigment
Altamira caves, Santander province

This animal, with its curious patches of
differential colouring on its rump and
underside, is near the centre of the painted
ceiling of the cave. It is one of the clearest
of the sixteen or so bison which are
grouped together in the panel; those
adjacent are in strange positions, with
heads thrown up, or in two cases crouched,
perhaps in the position of giving birth.

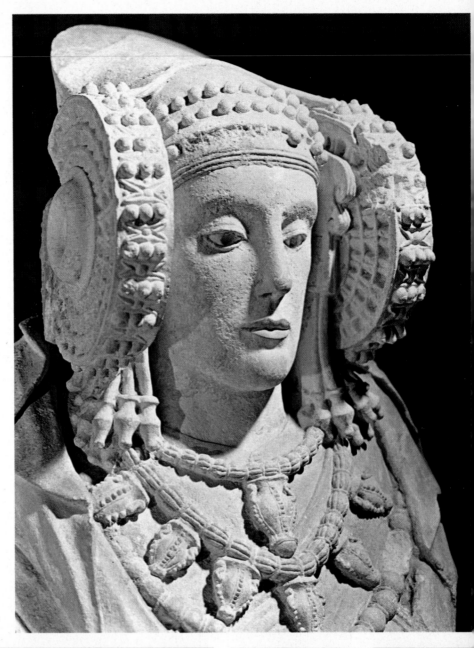

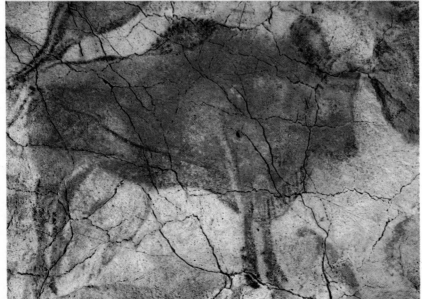

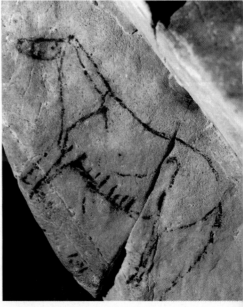

9 *left*

DIADEM FROM JAVEA *detail*
4th or 3rd century BC
gold
Museo Arqueológico Nacional, Madrid

Although this diadem is certainly later in date than that from La Aliseda (**11**) and shows Greek influence, especially in the naturalistic running scrolls, it is still very much a work in the Tartessian tradition. The restrained design and the excellence of the filigree are characteristic of native jewellery. Techniques could easily be taken from Andalusia into neighbouring regions for, in antiquity, goldsmiths were completely dependent on aristocratic patronage for their livelihoods, and would have enthusiastically accepted commissions and offers of employment, even far away from their homelands. Other items from the Javea treasure include gold chains and silver bracelets.

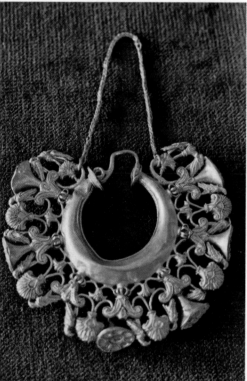

10, 11 *left and below*

EARRING AND DIADEM

6th – 5th century BC
gold
Museo Arqueológico Nacional, Madrid

The proverbial wealth of Tartessos is epitomised by a number of jewellery hoards which have been discovered in southern Spain. A varied collection – earrings, bracelets, necklaces and other objects – from La Aliseda demonstrate the range of artistic influences in Andalusia at the height of its power. The most important here are the filigree work on the diadem and the granulations on the earring, techniques which were learnt from the Etruscans. However, this was no mere copying, and the tiny vultures sitting on palmettes between lotus flowers are more restrained and delicate than anything in contemporary Etruria, where there was a tendency to include too much detail. The reasons for the burial of the hoard are uncertain, but it must be remembered that in antiquity this was the universal method of hiding valuables.

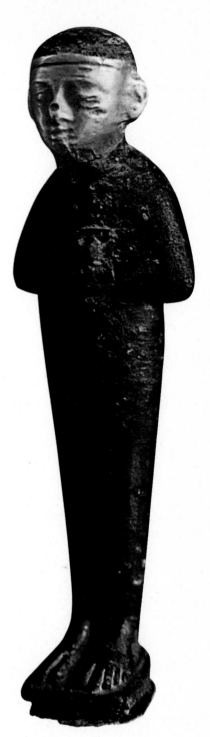

12

A PHOENICIAN PRIEST

not later than 5th century BC
bronze, face covered in gold leaf
Museo Arqueológico Nacional, Madrid

The Phoenician colony at Cádiz (Gades), was certainly the earliest in Spain, although it is now thought to date from the 8th century BC, not the 12th, as was originally believed. Although the purpose of this statuette is unknown, it is strongly reminiscent of Egyptian *ushabti* figures which were placed in tombs. The artistic influences are entirely non-European and fully reflect the extensive eastern trade of the only west Phoenician city whose fleet could rival that of Carthage in importance.

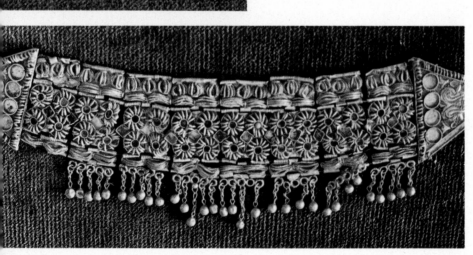

MOSAIC FROM TOLEDO *detail*
2nd century AD
Museo Santa Cruz, Toledo

The floors of dining rooms in Roman houses were often covered with luxurious mosaics, such as this example, which comes from a house on the banks of the River Tagus at Toledo. It is mainly concerned with the changing pattern of the seasons, as represented by the plants, flowers, fruit and birds that occupy panels flanking the octagon. The heavy garland that surrounds the central emblem has the same theme, while a lunette showing two houses and a tree symbolises the need for shelter as autumn lengthens into winter. The emblem itself depicts a selection of edible fishes from the Mediterranean (including a Moray eel – an esteemed delicacy in Roman times). Fish formed a very important part in Roman diet, so that this subject is quite suitable for its setting.

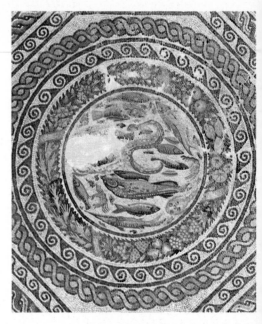

13 *below*
SEPULCHRAL MOSAIC *detail*
late 4th century – early 5th century AD
Museo Paleocristiano, Tarragona

This tomb mosaic from the Christian cemetery at Tarragona shows a scholar called Optimus dressed in the distinctively late Roman *toga contabulata*. He is making a sign of benediction with his right hand and holds a scroll in his left. The hope of resurrection is emphasised both by the flowers of paradise depicted in the background to the figure and by the verse inscription above his head: 'Optimus, the Lord who takes the greatest care of all things, gives you the divine citadels of heaven as he has promised.'

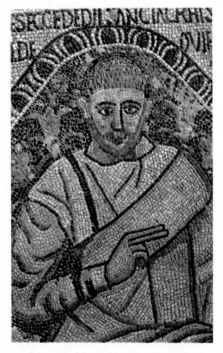

14 *right*
TEMPLE-TOMB

probably late 2nd century AD
Fabara

The tradition of monumental tomb building was widespread in the Roman world. This fine mausoleum dedicated to the Manes (spirits of the ancestors) and to Lucius Aemilius Lupus stands near the river Matarraña at Fabara. It could easily be mistaken for a temple if it were not for a flight of steps inside leading down to the sepulchral vault. The Tuscan columns of the porch present an intentionally sombre effect; fluted pilasters and a simple frieze of eagles holding swags in their beaks give a more graceful aspect to the sides.

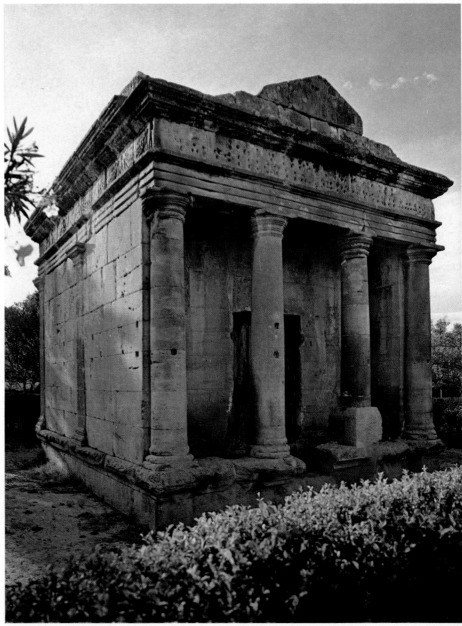

The culture that we call Iberian began in about the 8th century B.C. with the inhabitants of the mysterious city of Tartessos in the Guadalquivir basin – the biblical Tarshish. Everything about these people is enigmatic: they are known from literature and yet their city has not been found; their burial rites suggest that their ancestors came from the Celtic lands of central Europe, but both the architecture of their tombs and the delicacy of their metalwork are perhaps reminiscent of Etruscan art.

The great civilisations of the Near East and of Greece depended on the possession of vast supplies of metal: bronze and iron for industry and warfare, and gold and silver for luxury goods and as a medium for trade. From the earliest times Spain was renowned throughout the Mediterranean for her mineral wealth, and it was this wealth that formed the basis for the remarkable Tartessian culture. Tartessos controlled silver, lead and iron mines; she was also famous for her gold and copper, and her fleet sailed out into the Atlantic to purchase tin at its most important sources of supply, Brittany and Britain. As if all this did not provide riches enough, the land watered by the river Guadalquivir was the most fertile in the peninsula. As a society of merchants and prosperous farmers, peace was in the interests of the Tartessians and the warfare which engulfed the rest of the peninsula scarcely affected them except when their state was attacked by their envious and less prosperous neighbours. Indeed, they seem to stand aloof from the world of western European tribalism, including that of the other Iberian peoples on the northern coast, as a far offshoot of the ancient world of the orient.

As in Etruria, Phoenician traders had brought Greek, Egyptian and Syrian art styles with them, and the Phoenician city of Gades (Cádiz) was particularly influential in introducing Eastern techniques to the Iberian peoples. Thus a figurine from Cádiz and a glass jar from La Aliseda **12** seem to copy Egyptian work, while some ivory plaques and combs from Carmona incised with scenes of warriors and animals recall the art of Syria. If needed these are actually Tartessian copies of eastern objects, they represent the first stage in the development of a truly refined native art. Of all the products of Tartessian craftsmanship, perhaps the finest is jewellery. Here the Phoenician influences are obvious, but just as the Etruscans in Italy imposed their own qualities on their goldwork, so the Iberians took advantage of new techniques to produce even more refined work.

The gold ornaments from La Aliseda and El Carambolo differ in quality **10,11,** and in intention from anything else produced in western Europe before **16** the Roman conquest. Unlike the chieftains of the warring tribes in the north, the kings and nobles of ancient Andalusia formed a secure and established caste whose livelihood was dependent on serf and slave labour in the mines and on the land, rather than on a clamorous following on the battlefield. Prosperity was reflected in everything they produced. Rich dress and ornament were striking features of their society, as the magnificent bust of the *Dama de Elche* found in Valencia testifies. She wears a **6** mantilla on her head and is adorned with a diadem, necklaces and earrings similar to several other pieces preserved in Spanish museums. The splendour of Iberian female clothing is often mentioned by ancient writers, and it appears that women played an important part in public life. The typical male dress was a tunic fastened with a belt bearing a heavy gold clasp such as the one from La Aliseda which shows men fighting lions.

It seems that the people of Andalusia accepted many foreign gods and goddesses and equated them with native deities. Thus the Great Mother Goddess, who had been the chief divinity of much of Spain since the days

16

NECKLACE
FROM EL CARAMBOLO

6th century BC
gold
Museo Arqueológico, Seville

Before the use of signet rings became common, it was customary for an important person to wear his seal as a pendant hanging from a neck-chain. This is one of a group of seven (originally eight) such pendants, which clearly served a purely decorative purpose, for not only would they have been highly impractical to use but they are not set with gems, suitable for stamping into clay or wax. The necklace was probably worn by a woman. Similar objects are known from the East Mediterranean, but the very restrained decoration and the delicate workmanship employed in this example are characteristically Tartessian.

of the megalith builders, was now identified with the Phoenician Astarte or the Egyptian Isis. An alabaster statuette from Tutugi which presents a very eastern-looking goddess flanked by sphinxes and holding a bowl into which milk can flow from two small perforations in her breast, and a bronze horse-trapping of unknown provenance showing a goddess in a ship drawn by birds, are certainly the results of such adaptations. Even beyond Andalusia, amongst the coastal tribes, the Mother was worshipped in Catalonia and Valencia, where she sometimes took the form of the archaic Greek 'girl' or *kore*. A number of statues of sphinxes, deer and, above all, bulls also survive as a reminder that animals too played an important part in Iberian cults.

The offerings made at temples must have been immensely rich. The temple of the Phoenician god Melkart which stood near Cádiz and served the Phoenician colony (and later the Roman city) from at least the 7th century B.C. until A.D. 400 possessed, according to ancient writers, a treasure that included a golden tree with fruit made of emeralds. Further evidence comes from a Roman inscription found near Seville recording a gift of gems and precious metals to the goddess Isis. Such lavish offerings were traditional among the upper classes; poorer people would have given objects of merely token value–trinkets and little statuettes.

The inhabitants of Catalonia and Valencia had the same language and religion as the Tartessians of Andalusia, but in their building methods they aspired to the craftsmanship of the Greeks of Ampurias, on the Catalan coast, and Hemeroskopeion (Denia) on the Alicante coast. However, their settlements, such as that at Ullastret, never assumed the character of true cities, despite fine defensive walls, and their art remained that of a barbarian people. Their greatest accomplishment was the production of painted pottery, which soon came to surpass in excellence the Greek wares sold by the merchants of Rhode (now Rosas) and Ampurias.

Unlike gold jewellery and the best sculpture, pottery is cheap to produce and is thus more suitable for a poorer, more egalitarian society where it is possible to establish a mass market. Greek red-figure and black-figure vessels may have provided the initial stimulus, but the scenes actually painted, with a rather primitive realism, on these wares are concerned with the problems of day-to-day existence rather than with the leisure activities of gods and goddesses. Hunting either on foot or on horseback, dancing and military prowess are prominent themes.

17, 24

The Romans in Spain

Warfare played a large part in the lives of the northern Iberian tribesmen, and they were very formidable enemies. Roman writers speak of them surging into battle leaping in time to music and singing war hymns. Loyalty to leaders was absolute; often warriors would commit suicide on the funeral pyres of their dead chiefs rather than live on to serve another man. It was fortunate for the Romans that their first involvement in Spanish politics late in the 3rd century B.C. was as allies of the native town of Saguntum (Sagunto). The brilliant campaigning of the Scipios won the coastal plain for Rome against the might of the Carthaginians under Hannibal, but there remained a vast rugged hinterland with Celtiberian tribes who refused to be incorporated into the Roman provinces of 'Nearer' and 'Further' Spain. Thus the Romans were not spared the horrors of guerrilla warfare, and for over 200 years generals campaigned against fierce and elusive enemies. However, during this time the peaceful parts of the peninsula were developed; colonies were planted at Italica in Andalusia and elsewhere while the Greek cities of Catalonia continued to

17

VASE WITH
PAINTED HUNTING SCENE
probably 4th century BC
Museo Arqueológico, Barcelona

This vase, found in a cemetery at Ampurias, is deservedly the most celebrated example of a vessel painted in the Iberian manner. It represents two hunters chasing stags; an unusual feature being that the youths are shown almost naked, with a short tunic as their only dress. The sophisticated style of the paintings was partly inspired by imported Greek wares, although these influences are outweighed by the skill of the native craftsman.

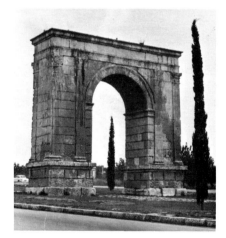

18

THE ARCH OF BARA
early 2nd century AD
near Tarragona

The so-called 'Arch of Bara' was erected out of a benefaction left in the will of Lucius Licinius Sura, Trajan's adviser and general. Unlike the well-known arches in Rome, Beneventum and Orange, this was not a monument intended to glorify the state, and thus it exhibits no sculptural reliefs. Indeed the arch owes its striking beauty to this very simplicity, the excellence of its masonry and its fine proportions; the decoration is limited to two fluted pilasters on either side of the passage-way.

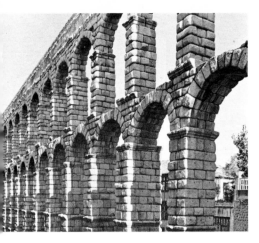

19
SEGOVIA AQUEDUCT
1st century AD (perhaps Augustan)

The finest aqueduct in Spain – a country with extensive remains of these great structures – runs ten miles from the Sierra de Fuenfria to the walls of Segovia, where it dwarfs the suburban houses by its very size (its maximum height is over thirty yards). Originally there was an inscription in bronze letters fixed to a plinth above the lower arcade at a point now in the Plaza del Arzobispo, but now only the holes in the stonework remain. Consequently its exact date and the name of the architect who built it remains a mystery.

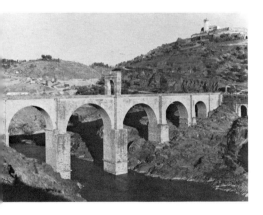

20
ROMAN BRIDGE
AD 105 – 06, Caius Julius Lacer
Alcántara

The bridge over the River Tagus is one of the finest achievements of Roman engineering. It consists of six arches with spans of up to about thirty yards, and has a total length of about 211 yards. Across the centre of the bridge there is a monumental arch dedicated to the Emperor Trajan. At one end stands a little temple carrying an inscription honouring both the emperor and the architect Caius Julius Lacer, who records the completion of his work with the statement: 'The Bridge will stand until the end of time, which noble Lacer made with Art Divine'.

flourish. The romanisation of the whole of Spain was not completed until the early imperial period, when under Julius Caesar and Augustus the Romans abandoned their extreme conservatism and began to explore the possibilities of developing a world order of their own. It is in fact a singular reflection on the character of Roman culture that had the Roman state perished before Augustus, there would have been very little to show for it outside Italy, whereas under Augustus and his successors many buildings were erected in the provinces which commemorated his rule in the most positive way.

The Roman empire depended for its success on a network of self-governing towns. At Tarragona, Cáceres, Barcelona, Saragossa, Seville, Mérida and elsewhere colonies of Roman citizens were founded in which leading native families as well as veterans from the army together created a society that we think of as typically Roman. The benefits of Roman rule were confined almost exclusively to the inhabitants of the cities and the few immensely wealthy landowners with great estates. Spain is exceptionally rich in the remains of Roman towns; as late as the 8th century a Moorish writer exclaimed about one of them: 'Man could not number the marvels of Mérida'. However, the difficult and rugged terrain of the country was hard to bring under control and prerequisities for settled urban life were adequate lines of communication and an efficient water supply. The Roman architects and engineers responded to this challenge by building magnificent bridges and aqueducts, which were commissioned either by the emperor himself or by local communities. Extensive remains of these structures survive in Spain; one of the most splendid is the marvellous bridge at Alcántara, built in A.D. 105–06 by **20** Caius Julius Lacer for the Emperor Trajan. The aqueduct at Segovia, **19** which is still in working order, bore water from the hills ten miles away, and those at Tarragona and Mérida were even longer. In the countryside of Roman Spain such aqueducts would have seemed no more remarkable than railway viaducts do now. Although the Los Milagros aqueduct at Mérida is in a ruined state it is especially interesting as its architect was experimenting with the use of a concrete core and brick facing, and not yet trusting the medium, used two layers of arches to take the thrust of the piers.

In spite of the practicality of the romanised people a sense of history and family piety was a leading feature of their character, and they incurred considerable expense in raising commemorative arches to the dead. These arches differ from those of Gaul both in purpose and in style. Here the emphasis is not on the triumph of the Roman state or on any sort of public celebration, and the arches have a stark and rugged grandeur that relates them to Carthaginian North Africa rather than to the Greek-inspired works of southern Gaul and Italy. The four-way arch at Cáceres, erected by Marcus Fidius Macer as a memorial to his parents, is reminiscent of that of Marcus Aurelius at Tripoli. At Medinaceli another fine arch of unknown purpose survives, although it is much worn and now lacks both the reliefs and inscriptions that once adorned it. The finest one in Spain stands outside Tarragona and is a memorial to Trajan's great general **18** Lucius Licinius Sura, built with money left for the purpose in the latter's will.

The arches of Spain are thus linked to tomb monuments like the Tower of the Scipios, which is also outside Tarragona. Presumably it was part of one of the many cemeteries which lined the roads approaching the city, for the Romans prohibited burial within municipal boundaries. The Tower of the Scipios is not the tomb of the great generals whose name it

bears; it was built in the late 1st century B.C. for a Roman noblewoman of the family Cornelia. The two carved relief figures in the dress of local Spaniards may perhaps represent her slaves. In general the tomb is similar to a group of mausoleums found in North Africa, a fact which emphasises the continuation of close links between the two shores of the western Mediterranean.

Unfortunately most of the great commemorative monuments have lost their statues and inscriptions, but a large number of grave slabs survive, inscribed with the name of the deceased and the name and rank of the person who erected it. Here the features of the dead and his activity in life are recalled, although nothing of the quality of work found in other western Roman provinces is known from Spain.

In the 3rd century A.D. when burial customs changed from cremation to inhumation in response to a growing awareness of the individual's need for salvation in the other world, it became necessary to use stone coffins or sarcophagi. These were sometimes intended to stand above ground and were carved with scenes from classical mythology, often (as in the case of the *Rape of Proserpine* and the *Death of Hippolytus*) having particular reference to death and the underworld. The Romans regarded death with a philosophic calmness and fortitude, and believed that man was born for death as much as for life. The poet Martial, who was born at Bilbilis (now Catalayud) about A.D. 40, wrote in one of his epigrams about the impossibility of taking precautions against death – for 'the day of a man's death is in the hands of fate'.

However, the Roman Spaniards were not morbid – they enjoyed life, and the houses and public buildings within the walls of their towns are evidence of a people who had a high regard for comfort and luxury. The cities themselves were planned in accordance with a system which had been highly developed in Greek Italy and which the Romans made their own – the grid of streets which let traffic pass freely and allowed the air to circulate, while porticoes on each side shielded those on foot from the sun.

If the remains of temples, baths and administrative buildings are fragmentary, places of entertainment are often extremely well preserved. The finest surviving theatre is the one at Mérida which was built by Marcus Agrippa in 18 B.C. and remodelled by Greek artists under Hadrian over 130 years later. The tiers of seats (*cavea*) of the auditorium, the marble paved orchestra and the stage (*pulpitum*) all survive. The Roman theatre did not have scenery as in a modern one but a fixed set of marble columns (*scaena*). At Mérida this is very elaborate, and almost challenges comparison with the marvellous *scaena* of Sabratha in North Africa. At Sagunto another theatre can be seen which, although more damaged than the one at Mérida, is dramatically sited against a hillside. Since the sacred was always close to the secular in the ancient world a feature of particular interest is a little shrine set at the top of the auditorium and possibly dedicated to Apollo, the god of the arts. Similar shrines were often placed in amphitheatres, but here the entertainment was the butchery of man and beast, and it is, not surprisingly, the dreaded goddess Nemesis (Fate) who was invoked. In the amphitheatre at Tarragona a wallpainting was found recently which shows her holding her wheel and walking on a human body. On one side stands a man sacrificing, while on the other is a gladiator fighting a bear. The popularity of this brutal sport was immense. At the amphitheatres in Mérida and in Italica, which is the fourth largest known, the intricate underground arrangement for the entry of wild beasts and the removal of carcasses can still be studied.

As popular, and far more productive of artistry, were the circuses –

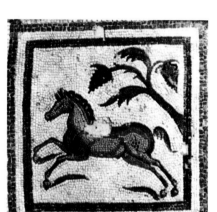

21

RUNNING HORSE
2nd or 3rd century AD
Museo Provincial de Bellas Artes, Saragossa

An important Roman villa situated north of Fraga contained a number of mosaics, including a set of eight panels made for separate insertion into a floor, which were found in the western corridor of the peristyle that surrounds the spacious courtyard. Works of this sort were copied from pattern books by travelling craftsmen, so although the original artist evidently took care with his design, a number of features – for example the expression on the animal's face and the unconvincing rendering of the shadows beneath its legs – betray a certain lack of skill in the man responsible for the actual execution.

horse-racing tracks in which the fine Asturian steeds could be seen to their best advantage in chariot racing. Mosaics from Barcelona and Gerona show such races in progress. It is tempting to imagine these as eye-witness representations of the actual events, but in fact the scenes are stylised and taken from a copy book. Indeed the monuments and statues (such as the Egyptian obelisk and the statue of the goddess Cybele seated on a lion) shown on the central ridge (*spina*) around which the races took place were copied from paintings of the Circus Maximus in Rome.

At Mérida arrangements were made to enable the circus to be flooded so that mock sea-battles could be fought, and an inscription dated to the joint reign (A.D. 337–40) of the three sons of Constantine the Great records that 'Tiberius Flavius Laetus (the governor) ordered that the circus, ruined through age, should be restored with new columns, covered with new works of ornament and flooded with water . . .'

Even before Roman influence had become established in Spain, houses of more or less regular plan had been built in Ampurias and other Greek settlements in Catalonia, but under the empire really imposing dwellings around courtyards (*peristyles*) were constructed. A number of good examples have been excavated at Mérida (Emerita). Although the outer walls would have presented a blank, uninteresting appearance, the interiors were luxurious. At a villa in Italica, the vestibule led into a fine colonnaded courtyard with a fountain in the centre and rooms opening off around it of which the largest was a dining room (*triclinium*). On the opposite side was an open long gallery which may have been used for exercise in the open air, and alongside this at a lower level was a covered corridor (*cryptoporticus*) for use in very hot or very wet weather. Other houses in the town were less elaborate but had a large number of mosaics rather similar to those of Africa, for like the North Africans, Spaniards relished richly coloured geometric patterned or figured floors.

The artists were frequently Greek speakers; Seleucus and Anthus, who signed a mosaic from Mérida showing the Goddess Isis, probably came from the eastern Mediterranean and so in all probability did Cecilianus, whose mosaic of a circus was found near Gerona, and Felix, who worked in a villa at Tossa on the Costa Brava. The range of subject matter is very wide. Some of the mosaics show mythological scenes obviously copied from paintings, as in the fine representation of the Sacrifice of Iphigenia from Ampurias, the Labours of Hercules on a mosaic at Liria and the Triumph of the God Bacchus from Saragossa. Elsewhere we find scenes of daily life, birds, beasts and fishes, or sports such as gladiatorial displays **15, 21** and horse racing.

Houses and public buildings both in the town and in the country often contained rich collections of statuary. There were images of gods, emperors and private persons as well as reliefs to decorate temples and **1, 22** graves, and minor ornaments such as fountains and sundials. They were usually commissioned by wealthy people at the workshops of resident Greek sculptors. It is remarkable that there are no significant local schools as there were in Britain, Gaul and Germany – and often what survives has a poor, lifeless quality that is a sad reflection on the purely conventional interest taken in sculpture by the romanised Spaniards after the native traditions had been eclipsed. However, some very interesting and fine work was produced. A representative collection was found early in this century on the site of a temple of Mithras at Mérida where the Persian **27** god was worshipped by merchants and by soldiers of the Seventh Legion (based on León). Here the Greek artist Demetrios produced a seated Mercury, two statues of the god Chronos and a sea-god.

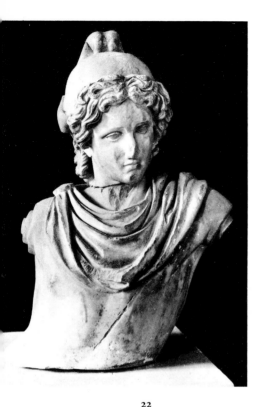

22

GANYMEDE OR PARIS
possibly 2nd century AD
white marble
Museo Arqueológico, Granada

This bust originally formed part of a complete statue showing a reclining youth. Although it is apparently based on an original work made in the 4th century BC it remains uncertain whether it depicts Ganymede, the cupbearer of Zeus, or Paris, the Trojan prince whose seizure of Helen from her husband Menelaus caused the Trojan War. If Paris is intended, the prototype was probably a statue by Euphranor. Classicising works of this nature are typical of the reign of Hadrian, though not confined to that period.

23 *below*

BULL'S HEAD FROM COSTITX

1st millennium BC
cast in bronze
Museo Arqueológico Nacional, Madrid

Mycenean and Celtic influences have been claimed for this bronze head from the late prehistoric Balearic culture of Majorca. One is tempted to link it with the Mediterranean bull cults, best known from Crete.

24 *bottom left*

FRAGMENT OF POTTERY

3rd–1st century BC
painted reddish-brown on a yellow ground
Museo Arqueológico Nacional, Madrid

Many of the best examples of Iberian painted pottery come from south-eastern Spain, where the geometrical forms of Andalusian ceramics blended with figure-painting traditions derived from those of Greece. Despite the relatively small size of this sherd found at Elche, it contains a vignette unsurpassed in quality and in dramatic power. A fierce hunting-dog has just pounced on a large bird which it is about to devour. Another bird, apparently oblivious of its peril, seems to be perching on the creature's back.

25 *below*

HORN PLAYER

probably 1st century AD
limestone
Museo Arqueológico Nacional, Madrid

The fine series of sculptures from Osuna in the south-east of the province of Seville provide a link between Iberian art and work produced in the succeeding period. In this relief depicting a native soldier blowing a war trumpet, the exuberant tribesman is still present, although the instrument, clothing and hairstyle, and indeed even the sculptural technique, is close to the ideal of Classical naturalism.

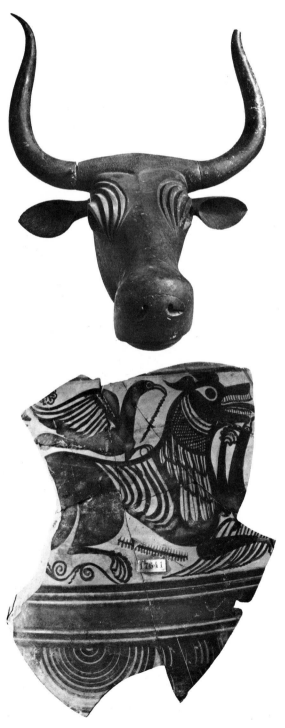

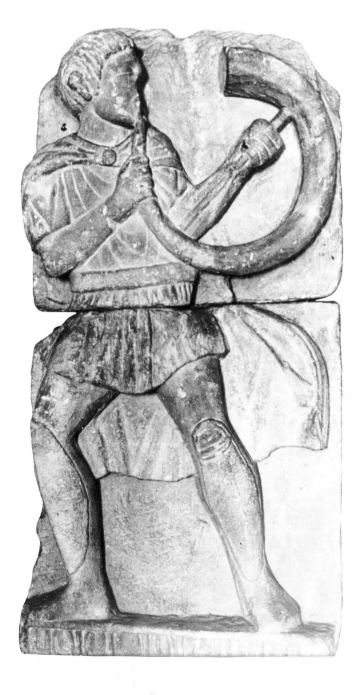

SILVER DOUBLE SHEKEL AND DRACHMA

218–209 BC and 3rd century BC respectively
Museo Arqueológico Nacional, Madrid

The horse and palm tree shown on the reverse of the double
shekel proclaim that it is an official Carthaginian issue; it was
minted at the important colony of Carthago Nova (Cartagena).
It has been suggested that the head on the obverse is a portrait of
Hannibal, Rome's greatest enemy in the Second Punic War. The
drachma shown below is actually of native Iberian workmanship,
although it is clearly based on one struck in the Greek city of
Ampurias, where influences from various parts of the Greek
world mingled and were passed on to the Iberian tribes. The
portrait of the nymph Arethusa was copied from coins minted at
Syracuse, and the winged horse on the reverse was adapted from
the Corinthian currency.

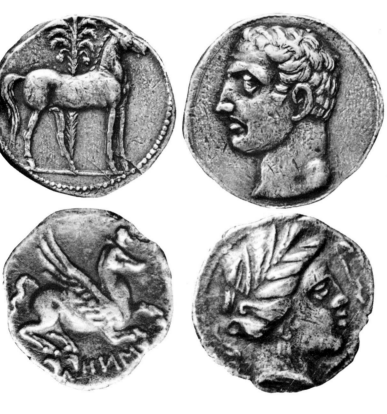

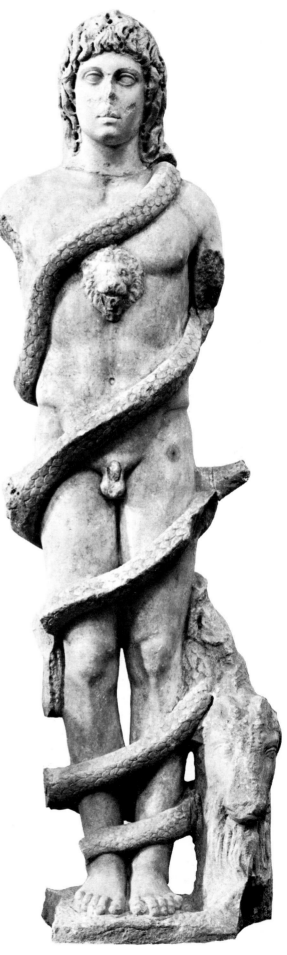

MITHRAIC CHRONOS

end of 2nd century AD
white marble
Museo Arqueológico, Mérida

Although Spain is not as rich in Mithraic remains as many other
countries, an important collection of sculpture connected with the
cult was found at Mérida during the early years of the century.
This statue of Chronos, the Lord of Infinite Time, has youthful
human features instead of the usual lion's head (which is relegated
instead to a merely symbolic position on the figure's chest). A
serpent wound around the youth's body represents the ecliptic –
the apparent course of the sun through the heavens during the
year. The artist responsible for this fine work is unknown, but he
was almost certainly a Greek – perhaps a certain Demetrios who
signed one of the other sculptures in the Mérida Mithraeum.

The Early Christians

In the 3rd century A.D. the confidence of the Spanish provinces as of so many others in the Roman empire was broken when some Germanic tribes crossed the Rhine and moved down from France to sack a number of cities including Tarragona and Barcelona. The physical disruption was less severe than in France (although Tarragona did not fully recover) and the Seventh Legion was able to help some of the stricken communities repair the damage and construct strong defences. The social consequences, on the other hand were decisive. With their faith in the Roman empire shaken, the people increasingly began to seek salvation in the eastern gods, and finally in the Christian religion, which had hitherto been suppressed. When, after years of struggle, Constantine gained control of the whole Roman empire, religious liberty was assured to the Church, which soon eclipsed the pagan cults both in wealth and in influence.

Christian art was based on the techniques and styles of a pagan Rome; only the subject matter was altered. It substituted Christ for Orpheus and saints for philosophers. The skills of the sculptor and mosaicist were turned inwards from the glorification of man to the worship of an unseen God. Unfortunately little trace survives of floor and vault mosaics or indeed of churches themselves, although the 4th-century church excavated at Mérida has pavements, and the mausoleum at Centcelles near Tarragona retains fragments of a mosaic ceiling. However, there are

13 examples of a distinctive type of mosaic-covered sarcophagus that otherwise only occurs in North Africa, which shows either the symbols of Christ – the Chi-Rho or the Agnus Dei – or a portrait of the deceased.

In sculpture we have a rendering of the Good Shepherd supporting a Lamb, from Seville – a type which ultimately goes back to the 'Calf-bearer' of archaic Greek art. There are also a large number of carved sarcophagi from Spanish sites – in some the sculptor has aimed at filling all available space with action in order to fulfil the divine precept 'to preach the Gospel to every creature', for here is the 'poor man's bible' and the artist's role has become identical with that of teacher. Even more interesting is the development of the symbolism that we have already seen on tomb-mosaics. One sarcophagus shows a Chi-Rho surmounting a cross upon which stand two doves while two deer look up from below – here the animals represent human souls who can only find salvation through

28 Christ's sacrifice upon the cross. Another shows St Peter and St Paul, with between them four rosettes and the Four Rivers of Paradise.

The finest Early Christian work in Spain, one of the most beautiful objects produced in late antiquity, gives consummate expression to the political philosophy of the 4th-century empire whereby the emperor as God's deputy holds court in an earthly paradise which mirrors the divine one 'on earth as in heaven'. The Emperor Theodosius was a Spaniard and it

29 is fitting that the great silver dish that celebrates the tenth anniversary of his ascension in A.D. 379 should have been found near Mérida (although it was undoubtedly made in the eastern part of the empire by Greek craftsmen). There are indications that the dish formed part of a hoard buried, in all probability, when the barbarian Vandals invaded the peninsula early in the 5th century A.D. They were soon chased out by the Visigoths who began to arrive not much later as allies of the Romans. Nevertheless, apart from a brief period under Justinian in the 6th century A.D., the Roman Empire was never again to control Spain. Indeed, deprived of the wealth of Spanish mines, generally demoralised and swarming with Barbarians, the Western empire burst asunder and Europe entered upon a new period in its history. Martin Henig

28

THE PETER
AND PAUL SARCOPHAGUS
*late 4th century – early 5th century AD
marble
Museo Paleocristiano, Tarragona*

Although Tarragona suffered crippling damage in the 3rd-century Barbarian raids, it nevertheless recovered to the extent of becoming an important Early Christian bishopric. The 4th and 5th-century sarcophagi from the cemetery were made in the area, and are remarkable both for their severe and economical style and for their widespread use of symbolism. This example is said to depict two apostles. Each figure carries a scroll representing the scriptures and has a *scrinium* (a box for writing materials) at his feet, while between them there are four panels of scroll-work and a central area carved with a laurel wreath, which originally contained a painted inscription. The flanking rosettes and the schematic presentation of the Rivers of Paradise below are intended to signify the four Evangelists.

29

THE MISSORIUM
OF THEODOSIUS
*AD 388
silver with traces of gilding
Museo Arqueológico Nacional, Madrid*

The dish, perhaps the best surviving example of official late Roman silver, was made in the East and given by 'Our Lord Theodosius, Perpetual Augustus' to an important noble. Theodosius is shown seated on his throne handing an edict to a court retainer; on either side of him are his two sons Valentinian II and Arcadius. All three are dressed alike in a distinctive garment fastened at the right shoulder with a jewelled brooch (a special prerogative of the imperial house), while the two guards, probably Germans, on either side of the central group wear torcs around their necks and carry shields. Despite the naturalistic details, the formality of the poses adopted, the nimbus which surrounds each imperial figure as a symbol of divine election, and the symbolic representation of the palace gives the 4th-century court a timeless aspect as a close approximation to an ideal, heavenly order.

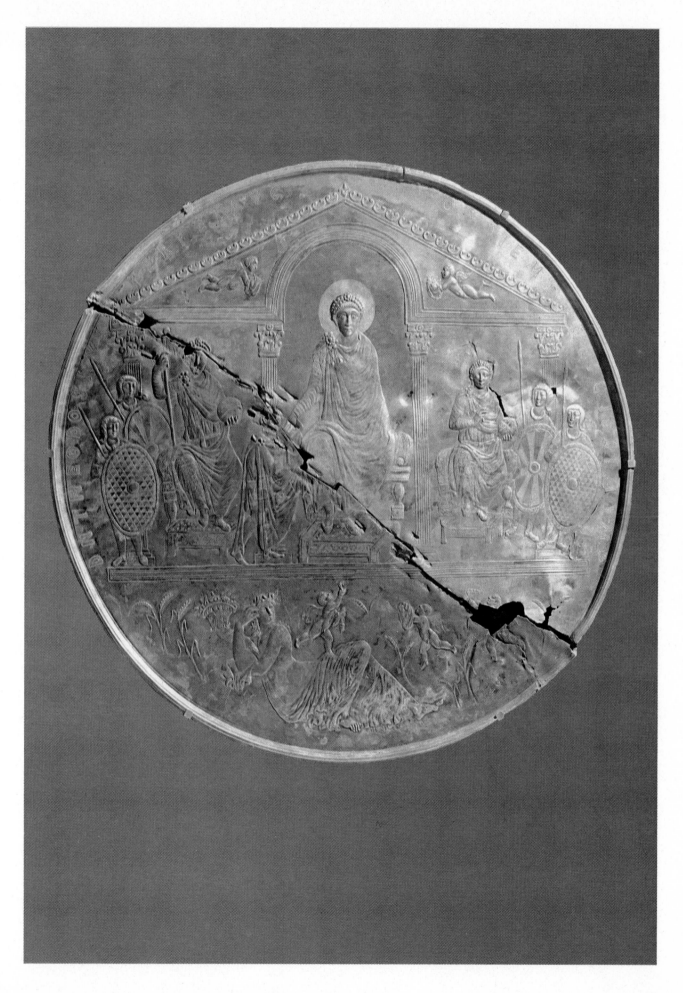

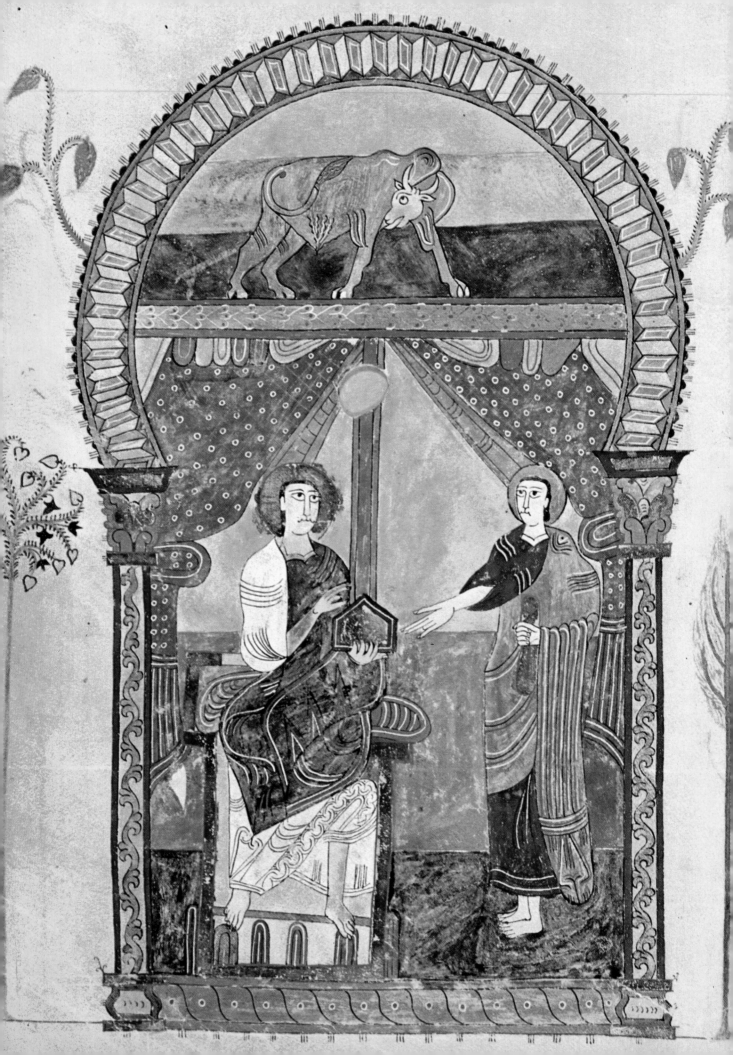

Throughout the Dark Ages, Europe periodically shuddered under the great Nordic and Germanic migrations, as restless tribes swept across the continent regardless of life and property. Rome was too weak to resist the mass advance into the provinces of these so-called Barbarians, and vacillated between aggression and appeasement in a vain attempt to protect the empire. At the beginning of the 5th century, Spain was invaded by the Suevi, the Alans and the Vandals, and then in 414 by the Visigoths, who in the course of several centuries had made their way from the Baltic via Eastern Europe. More powerful and numerous than their predecessors, the Visigoths took advantage of their long-standing ties with Rome to consolidate their occupation of Spain, so that when the Roman Empire finally collapsed in 476, they controlled almost the entire peninsula, and forced the Roman landowners to forfeit two thirds of their estates. Now the Visigoths ceased to be a nomadic tribe and established an absolute monarchy with a landed aristocracy of Visigothic nobles and clergy over-lording a mixture of races including Iberians, Celts, Hispanicised Romans and Jews. Their task of unification was made particularly difficult owing to a clash of religious beliefs between conquerers and conquered. The Visigoths, unlike the Catholic Spaniards, were Arian Christians (a heresy condemned at the Council of Nicea) and the resulting conflict was only resolved when King Reccared embraced Catholicism at the Council of Toledo in 589. Henceforth, Catholicism became the official religion and the Catholic Church became the authority in state as well as spiritual affairs.

Although these years are known as the Dark Ages, the foundations laid by the Classical world were not entirely lost. The Visigoths showed their respect for Spain's Roman heritage by adopting Roman laws and using Latin as the official language of Church and State. Classical traditions also persisted in art and particularly in architecture, though the Visigoths themselves made a valuable contribution to the minor arts. In addition, the invasion of the eastern provinces by the Byzantine emperor Justinian in the 6th century ensured the spread of Byzantine and Middle-Eastern influences. Already, then, the character of Spain was being formed by the gathering together of many cultures, a pattern that was to be repeated throughout her history.

The splendid Visigothic church of San Juan Bautista at Baños de Cerrato near Palencia was founded in 661 by King Recceswinth. It is a well-proportioned three-aisled basilica with projecting rectangular apses and contains columns which were probably taken from the nearby Roman baths. Most interesting are the horseshoe arches of the nave arcades. Although usually identified with Islamic art, the horseshoe motif was in fact not uncommon in late Roman decoration, and existed in Spain long before the Arab invasion. The Visigothic horseshoe arch, however, is a simple affair compared with the later Islamic models, and is never pointed or cusped.

Another Visigothic church, San Pedro de la Nave near Zamora, probably about 700, is built on the Greek-cross plan with barrel vaults and horseshoe arches. The capitals are carved with florets, Maltese crosses, spirals, cables and trailing plants. Those capitals which depict scenes from the Old Testament are more ambitious and are probably later.

The 8th-century basilican-plan church of Quintanilla de las Viñas in the province of Burgos has superb friezes along the exterior decorated with stylised partridges, peacocks and flowers, which are repeated on the horseshoe arch leading to the apse. Fragments of sculpture inside the church include reliefs of blatantly pagan sun and moon discs.

Although Visigothic architecture clearly depended on Roman models,

33, 45

31

The Dark Ages and the Rise of the Caliphate

C. 400–950

30
ST LUKE
from the Gerona Beatus (folio 5 v.)
late 10th century
Archivo de la Catedral, Gerona

The Arab conquest of Spain had far-reaching effects on art and architecture. From the 8th to the 12th century, Mozarabic miniaturists illustrated a Commentary on the Book of Revelations by the monk Beatus of Liebana in a series of superb manuscripts which are, ironically, full of Islamic-inspired images and decorative motifs. In this miniature from the Gerona Beatus, the refined, stylised figures are seen framed in a delicately patterned horseshoe arch.

and the trapezoidal form of the capitals was Byzantine in origin, Visigothic architectural ornament owed much to the Barbarian linear style. The traditional geometric patterns of circles, spirals, ribbons and foliage were taken to a fine degree of abstraction, and where figures occurred more interest was shown in the intertwining limbs than in the bodily form. The best collection of Visigothic sculpture can be seen in the museum at Mérida, where there are lintels, pilasters, friezes and horseshoe arches, incorporating Roman, Byzantine and Barbarian abstract motifs.

These abstract designs also appeared in contemporary metalwork, some of which was influenced by Barbarian traditions and some by refined Byzantine workmanship. The Treasure of Guarrazar, discovered only 100 years ago in a field near Toledo, is a magnificent collection of gold crowns, crosses and pendants lavishly encrusted with rock-crystals, pearls and precious stones. The treasure was presumably buried to save it from the hands of the invading Arabs. Toledo was the capital of Visigothic Spain, and two of the votive crowns from Guarrazar bear the names of the Visigothic kings, Swinthila and Recceswinth; other pieces must have belonged to the clergy and the nobles. The splendour of the goldwork and the extravagant use of gems reveal the wealth of the Visigothic court, which undoubtedly attempted to vie with Byzantium, whose power and prestige were unsurpassed. A similar royal treasure was found in 1926 at Torredonjimeno. Although these products of royal workshops are influenced by the work of Byzantine goldsmiths, the styles of the simple bronze and silver brooches and belt clasps made by local craftsmen are understandably closer to Barbarian models. The eagle brooches, for instance, were taken from a design which recurs all over Eastern Europe.

Under the Visigoths, Spain emerged again as an independent kingdom, instead of a mere province of Rome, and enjoyed political stability for nearly 300 years. The system of elective monarchy which produced great kings like Leovigild, Reccared, Swinthila and Recceswinth was also unfortunately an excuse for unrest and corruption, and as a result, the country lost its sense of unity and loyalty to the crown. Thus widespread disorder eventually opened the way to the conquest of the peninsula by the crusading armies of Islam.

Arab civilisation

In 711 a small Arab and Berber force invaded under Tarik and roundly defeated the Visigothic army under Roderick at the battle of Guadalete. The conquerors soon swept across the entire peninsula, pinning down the remnants of Visigothic resistance in the mountains of Asturias and even advancing across the Pyrenees and into France. After defeating the Arabs at the battle of Covadonga in 718, Pelayo became the leader of the refugee Christians in the north, while Visigothic nobles who remained in the south came to terms with their new masters.

The Arabs called their newly conquered territory al-Andalus, and as was their custom, they allowed the indigenous Spaniards to keep their religion and customs in return for a poll tax. Spaniards achieved positions of influence within the Moslem community, as did many Jews, who under the Visigoths had been treated no better than slaves. The Christians and Jews who remained in al-Andalus were called Mozarabs; they dressed like Arabs and could speak and write in Arabic.

At the fall of the Ommayad dynasty in 750, Abd-al-Rahman fled from Damascus to Spain and set up an independent caliphate with Córdoba as his capital. Islamic civilisation was far in advance of European, and the Arabs brought to Spain the technological and intellectual advantages of an eclectic culture, anxious to acquire and exploit all knowledge whether it

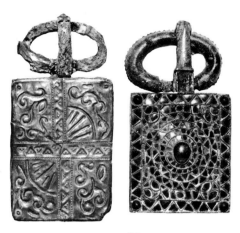

33
BELT CLASPS
7th century
Museo Arqueológico, Barcelona

During the years of the great migrations a vigorous tradition of metalwork was established among the nomadic Barbarian tribes, to whom small ornaments for clothing, armour and harnesses were not only practical but were also possessions to be cherished and admired. These two rectangular belt clasps from the treasure of Torredonjimeno are entirely Barbarian in concept. The one above is inlaid with a network of multi-coloured stones, the one below has a bold design incised into the metal.

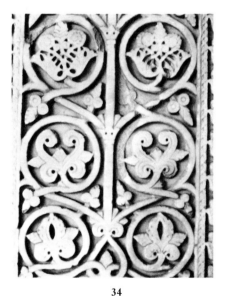

34
ALABASTER RELIEF
mid-10th century
Medina-az-Zahara

The finest artists and craftsmen were brought from Byzantium and North Africa to create the decorations of the palaces at Medina-az-Zahara, and the fragments of deeply carved ornament which remain are outstanding for their perfection of technique. This alabaster relief with its stylised and intertwined leaves is more Byzantine than Islamic in style and was perhaps the work of an artist from Constantinople.

was Greek philosophy, Roman engineering or Jewish medicine.

In order to enhance the prestige of Al-Andalus, Abd-al-Rahman determined to build a magnificent mosque at Córdoba, and work was begun in 785 on the site of an old Visigothic church. Basically square in plan, half the Great Mosque is a peaceful courtyard, the Patio de los Naranjos, shaded by orange trees and with a fountain where the faithful wash before entering. The interior is simply a large hall, divided into aisles by a number **43** of parallel arcades. On one wall is the *mihrab* or sanctuary. The two-tiered **65** arcading is reminiscent of Roman aqueducts, but the weighty structure is elegantly relieved by the slender marble columns, the pink and white brickwork of the arches and the Corinthian capitals. Some of the capitals are Roman or Visigothic, but the most interesting are those specially carved at Córdoba with stylised acanthus leaves, simplified into a new and original Islamic form. These Córdoban capitals became extremely popular and copies appeared in Mozarabic and Romanesque architecture for many years to come.

In the early 10th century, Abd-al-Rahman III built a city outside Córdoba in honour of his favourite concubine, Zahara. Medina-az-Zahara is now an archaeological site, but we are told by enthusiastic chroniclers that no expense was spared on this city of pleasure; mosaics were brought from Byzantium, marbles from Rome and North Africa, there were carved ivory and ebony doors, walls lined with gold and sumptuous decorations of gold and precious stones. The marble palaces with their sweet-scented gardens and orchards are gone, but the fragments which remain of deeply carved capitals and elaborate stucco decoration **34, 49** are evidence of how magnificent they must have been.

Medina-az-Zahara reflected the tastes of a sophisticated and pleasure-loving society, but beneath the surface al-Andalus was torn by grim internal rivalries. There was unrest among the Berbers, and among rebellious Arab princes who initiated a series of uprisings that weakened the caliphate and led to religious intolerance and persecution. It was at the request of a rebel Moslem prince that Charlemagne led his army to Saragossa; on his return his rearguard was ambushed and massacred at Roncesvalles, an incident immortalised in the *Chanson de Roland*.

Asturian architecture

It was Charlemagne, in his capacity as Protector of Christendom, who eventually befriended the disinherited Christians living in the tiny province of Asturias and encouraged their resistance to the Moslem peril. During the reign of Charlemagne's contemporary, Alonso II, known as 'the Chaste', the remains of St James were miraculously found buried in a field above which a star had shone (Campus Stellae). There was a tradition that St James had preached in Galicia, and Alonso declared him the patron saint of Spain and erected a shrine on the site, which later became an important place of pilgrimage, Santiago de Compostela.

The capital of Asturias was at Oviedo, and the architecture that survives in the region is interesting for continuing a tradition of monumentality derived from Rome and leading eventually to the Romanesque. The **37, 38,** cathedral at Oviedo was blown up in 1934, but it has since been restored **39, 44** and the Cámara Santa, remaining from the original church built in 802 for Alonso the Chaste, is still intact. The Cámara Santa is on two levels: **41** the crypt has a low barrel vault and is entirely without ornament; the chapel above has a vestibule and nave with a triumphal arch leading to the apse. The nave contains some superb 12th-century Romanesque sculpture, and among the many works of art in the treasury are several outstanding pieces of Asturian goldsmiths' work. The Casket of the Agates, given to **42, 48**

the cathedral by Fruela II in 910, is plated and embossed and richly decorated with enamels and precious stones. The Cross of the Angels, given by Alonso the Chaste in 808, and the Cross of Victory made by the order of Alonso III to celebrate Pelayo's victory at Covadonga, are both exquisitely jewelled, but the latter is far more elaborate, its background articulated with intricate enamelwork. Alonso III was also the donor of the gilded and embossed casket in the Treasury of Astorga Cathedral.

Also at Oviedo is the Church of San Julián de los Prados (known as Santullano), founded in 839 by Alonso the Chaste. A basilica with three aisles and three apses, San Julián has a remarkable series of wallpaintings in the nave, depicting architectural themes, in the manner of Pompeian decoration, and the apse vaults are painted in the style of Roman coffered ceilings.

Asturian architecture reached its peak in the middle of the 9th century during the reign of Ramiro I. The building now known as Santa María de Naranco on the slopes of Monte Naranco near Oviedo was part of a palace complex, and is a remarkable example of 9th-century civil architecture. The ground floor is divided into several rooms and an exterior staircase leads up to a large hall above with wide, open galleries at each end. The barrel vault has transverse ribs which extend to bands decorated in low relief, and end with medallions between the spandrels of a blind arcade. The medallions are repeated on the exterior of the building. The columns supporting the arcade are grouped into fours and decorated with a Visigothic cable pattern. Although the building is fundamentally Roman, the decoration includes Byzantine features, and the medallions with their stylised plant and animal motifs can be compared with designs on Sassanian textiles.

The church of San Miguel de Lillo, near Oviedo, which was probably Ramiro's palace church, has large windows with fine Byzantine-inspired tracery and sculpture on the door, capitals and bases of the columns. A later outstanding Asturian building is Santa Cristina at Lena, notable for its raised chancel and cable-patterned columns, similar to those at Naranco, and its arcade with latticework panels across the nave. Contemporary with Santa Cristina is San Salvador at Valdedíos, the only Asturian church in which the horseshoe arch appears.

The Mozarabs

Meanwhile in al-Andalus the Mozarabs were living in the heart of a completely different culture. They could not help but admire and assimilate the achievements in architecture and the decorative arts. But all that is left of Mozarabic architecture in southern Spain are the ruins of a rock-hewn basilica at Bobastro near Málaga and the church of Santa Mariá at Melque near Toledo. However, during the 9th century, the unsettled state of al-Andalus, and the intolerance towards the Christian community in Córdoba, precipitated the return to the north of refugee Mozarabs, who took with them memories of Córdoban architecture and decoration, and the Mozarabic churches that remain are those in the northern provinces. At the same time, workshops in León and Castile were infiltrated by craftsmen familiar with the techniques and styles of Islamic art, and their presence is particularly evident in both ivory-carving and metalwork.

The effect on architecture was immediate, and although Mozarabic churches vary in plan and elevation, they have one thing in common – the horseshoe arch. Since León had now replaced Oviedo as the capital of Christian Spain, it was here that the Mozarabs fled, and it is in this region that the earlier Mozarabic churches are found. The monastery of San Miguel at Escalada (consecrated in 913) was rebuilt by Abbot Alfonso and

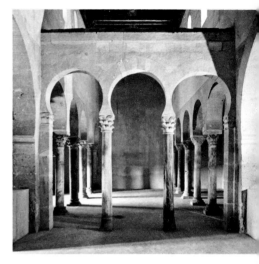

35
SAN MIGUEL, ESCALADA
912–13

San Miguel, one of the earliest surviving Mozarabic churches, is built on the basilican plan with three aisles and three apses separated from the nave by a transept marked by a screen of three arches. The horseshoe arches, the slender columns and the stylised Corinthian capitals are all clearly derived from Córdoban architecture, but so also are the new spatial proportions which give a light and airy feeling to the interior (**47**).

46

37, 44

39

38

35

his fellow monks when they fled from Córdoba San Miguel is built on the basilican plan with three aisles and three apses. The apses (which were important for the Mozarabic liturgy) are square on the exterior and horseshoe in plan on the interior, and are separated from the high nave by a transept and a screen of three horseshoe arches. The nave arcades also have horseshoe arches, resting on slender marble columns whose Corinthian capitals are decorated with stylised leaves directly derived from the Great Mosque at Córdoba San Cebrián de Mazote is similar in plan and decoration. Santa María de Bamba has horseshoe-shaped barrel vaults, and Santiago de Peñalba has a single nave with fluted domes. The only other Mozarabic church of this type is San Miguel de Celanova in Galicia. In Castile the monastery of Suso at San Millán de la Cogolla has Córdoban-inspired rib vaults, and the hermitage of San Baudilio at Berlanga de Duero has a strange semi-circular vault supported in the centre by a stout column from which spring eight horseshoe arches, radiating to the outside walls. This remote hermitage was built in the 11th century at a time when the whole area was a battlefield. Most interesting are the two fresco cycles. Of these, the biblical scenes are related to the work of the Catalan artist of the Maderuelo frescoes now in the Prado, but the non-religious hunting scenes show Islamic influence. The scenes are silhouetted in bold **50** flat colours against a plain background, and depict huntsmen and animals, including an elephant and a camel, in a formal design which loses nothing of the spirit of the chase.

Monastic patronage

These lean years, with Islam in the ascendant, saw the growing importance of monastic power and influence in Christian Spain. Monasteries not only sponsored major art commissions but also employed artists, architects and craftsmen to carry them out. Monastic scriptoriums employed writers, copyists, illuminators and bookbinders who produced a variety of manuscripts for churches and for the court. Thus when it became necessary to discourage Adoptionism, a theory introduced by the Mozarabs that Christ was the adopted son of God, a monk named Beatus in the monastery of Liebana wrote a Commentary on the Book of Revelations in order to stamp out the heresy. The commentary became so popular that it was copied from monastery to monastery and remained an inspiration to miniaturists for over four centuries. Ironically, the Beatus manuscripts are the greatest achievement of Mozarabic art, with images and decorative motifs that are clearly Islamic in derivation. The finest copies that remain in Spain are at Madrid, Valladolid, Urgel and Gerona. The **30** Tavara manuscript (completed *c.* 970) in the National Archives in Madrid was illustrated by the artist Magius and his pupil Emeritus. The figures are stylised and grouped within a formal framework, but their expressiveness, the quality of the draughtsmanship and the use of colour reveal an artist of great sensitivity and imagination. The Valcavado manuscript at Valladolid and the manuscript at Urgel are by followers of this style. However, by the 11th century vigorous Romanesque elements began to take over, as can be seen by the figures in the manuscript at El Burgo de Osma, though the refined decorative arabesques of the surrounds are still Mozarabic-inspired. The expressive linear style of these miniatures had a wide influence on mural painting, sculpture and the decorative arts, long after Mozarabic architecture had been overwhelmed by the tide of the Romanesque.

Mary Orr

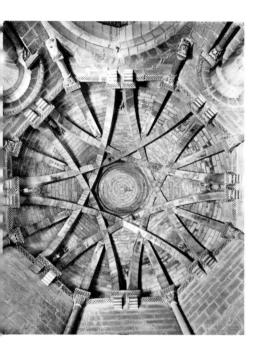

36

SANTO SEPULCHRO

late 12th century
Torres del Rio

The continuing influence of Córdoban architecture is evident in the regular reappearance of new Córdoban features in Christian Spain. This dome with coupled ribs forming an octagonal star pattern is copied from the vestibule of al-Hakam's new *mihrab* (**65**) which was added to the Great Mosque at the end of the 10th century.

37 *below*

GREAT HALL, SANTA MARIA DE NARANCO

842–50, Oviedo

Later converted into a church, this delightful building was originally constructed for Ramiro I as part of a palace complex. The barrel vault of the great hall is supported on the inside by transverse ribs which rest on a blind arcade with composite cable-patterned columns. The decorative bands and medallions are repeated on the end walls and also on the exterior, giving a pleasant continuity to the whole building. Although the decoration is derived from Byzantine art, the total effect possesses an originality which is entirely Asturian.

38 *centre bottom*

SANTA CRISTINA

second half of the 9th century
Pola de Lena

Santa Cristina is another delightful Asturian church, probably built soon after Santa Maria de Naranco (**37, 44**). It has a similar barrel-vaulted nave and cable-patterned columns. The raised chancel is separated from the nave by a triple arcade with latticework panels set into the stonework above the round-headed arches. An ornamental screen between the columns of the arcade is excellently carved with crosses, rosettes and stylised vines.

39 *below*

SAN MIGUEL DE LILLO

842–50
Oviedo

Situated high on the slopes of Monte Naranco not far from Santa Maria de Naranco (**37, 44**), San Miguel was probably Ramiro I's palace church. The present building comprises the high barrel-vaulted nave and the side aisles of the original, but the eastern parts did not survive an earthquake in the 13th century. The windows, with their elaborate, Byzantine-inspired stone tracery, are particularly interesting.

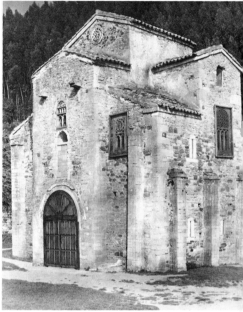

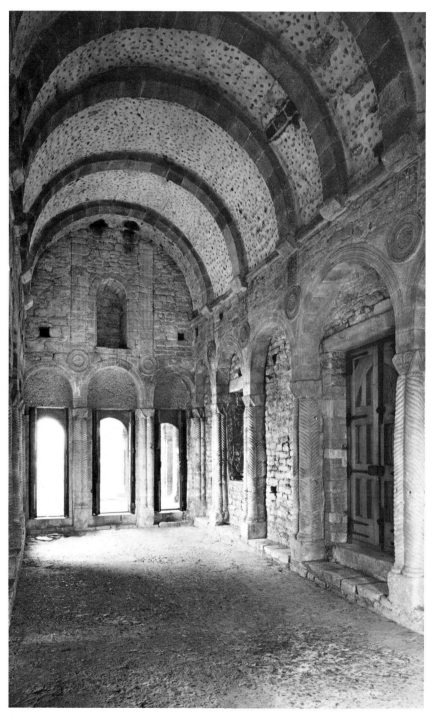

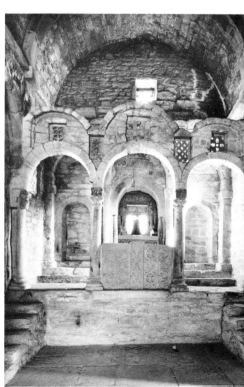

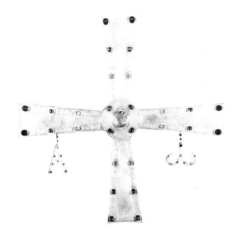

40 *left*

THE PENALBA CROSS

940
Museo Arqueológico, León

The Peñalba Cross was given by Ramiro II to the Church of Santiago de Peñalba in 940. It is made of brass with Mozarabic-inspired engraved decoration and is set with precious stones including a large topaz at the centre. The pendant letters alpha and omega, a reminder that God is the Beginning and the End, are modern replacements, but the type recurs throughout medieval art and can be seen, for instance, in the sculptural decoration of Santa Maria de Naranco near Oviedo (**44**).

41 *bottom*

ARCA SANTA

1075
Cámara Santa, Oviedo Cathedral

The drift back to the north of Mozarabic artists and craftsmen continued throughout the years of the Reconquest, and the art of Christian Spain gained from the range of their skills resulting from their experience of Islamic art. This large silver reliquary chest has repoussé and engraved reliefs surrounded by a decorative *Kufic* inscription, which betrays the artist's background. The chest was presented to Oviedo Cathedral in 1075 by Alonso VI and his sister Doña Urraca.

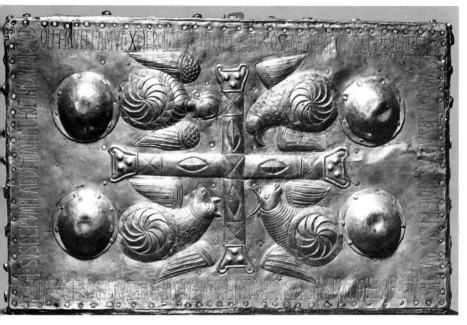

42 *left*

CASKET OF
THE AGATES, BASE

910
Cámara Santa, Oviedo Cathedral

The base of the Casket of the Agates (**48**) is silver, embossed with the four symbols of the Evangelists – the lion of St Mark, the winged ox of St Luke, the eagle of St John and the angel of St Matthew – in the angles of a cross, and with an inscription around all four sides. The symbols have clearly been influenced in style by contemporary Mozarabic-inspired manuscript illuminations.

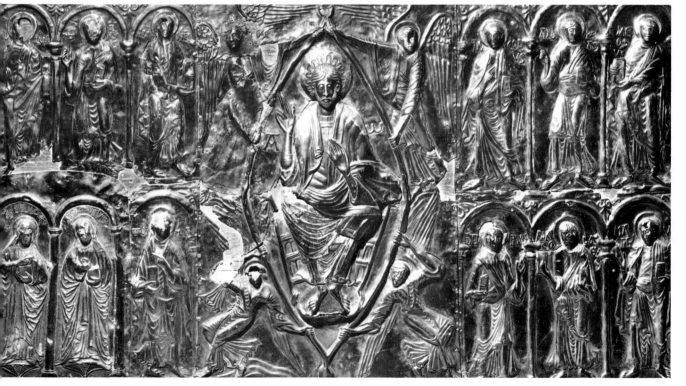

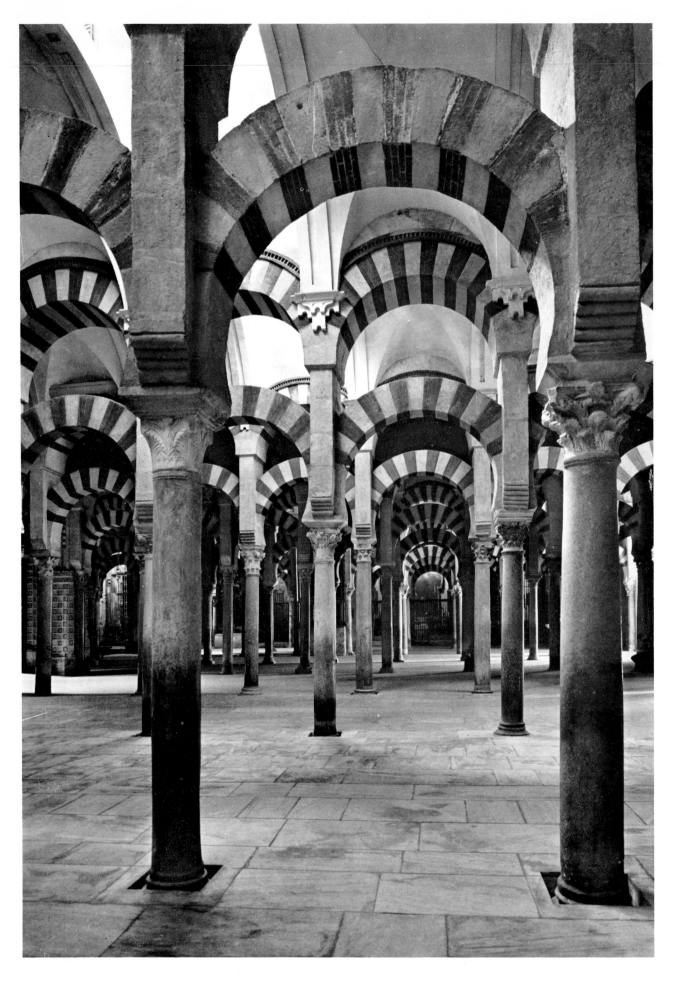

43 *left*

THE GREAT MOSQUE

founded 785
Córdoba

The Great Mosque was founded by
Abd-al-Rahman in order to enhance the
prestige of the newly independent
al-Andalus. As the first mosque in Western
Europe, it caused a great stir and provoked
universal admiration. Later, it was altered
and enlarged, the newly incorporated
structural and decorative ideas were taken
up widely, and reappeared in Christian as
well as in Islamic architecture.

44 *below*

SANTA MARIA
DE NARANCO

842–50
Oviedo

The open galleries at each end lead into a
great barrel-vaulted hall, supported on the
exterior by narrow buttresses and lateral
porches, of which only the north porch
with its outside staircase remains. The
vaulting, the classic proportions and the
original decoration make this a unique
example of 9th-century civil architecture
in Western Europe.

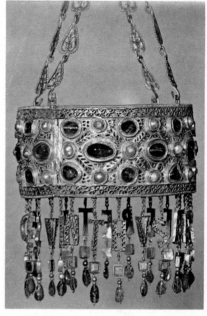

45 *above*

CROWN OF RECCESWINTH

653–72
Museo Arqueológico Nacional, Madrid

In 1858 a farmer at Guarrazar discovered a
hoard of Visigothic jewellery–votive
crowns, crosses and pendants–which has
proved to be one of the most exciting and
magnificent treasures of Dark-Age
Europe. The crown of Recceswinth, which
would have been hung by its chains in
church, is one of the finest pieces. The
heavy gold crown has an outer layer of
pierced goldwork and three rows of huge
sapphires and pearls. The pendant letters
read RECCESVINTHUS REX OFFERET.

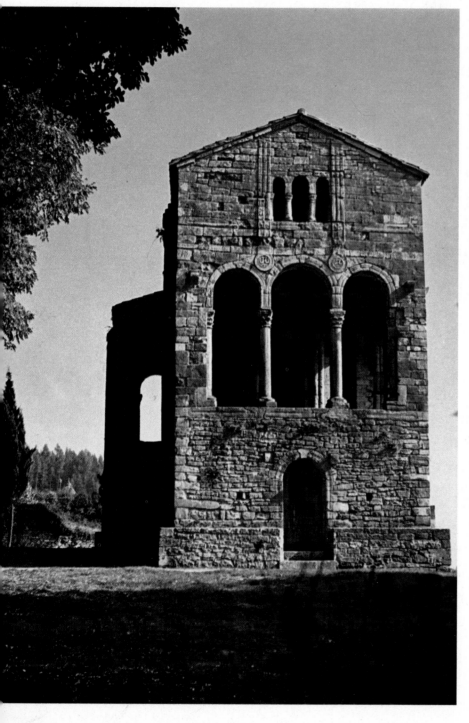

46 *right*
CROSS OF VICTORY

908

Cámara Santa, Oviedo Cathedral

Donated by Alonso III, the wooden cross which comprises the core was said to have been carried by Pelayo at his famous victory over the invading Moslem army at the battle of Covadonga in 718. The cross is richly decorated with precious stones (including a huge amethyst), gold filigree work and the most delicate cloisonné enamelling depicting birds and animals in floral and abstract surrounds. An inscription on the reverse says that the cross was made in the royal workshops at the castle of Guazon.

47 *bottom opposite*
SAN MIGUEL, ESCALADA

912–13

San Miguel was built by monks who had fled north from persecution in Córdoba. The massive east end encloses three horse-shoe-shaped apses. The deep exterior porch along the south side, with its charming arcade of horseshoe arches, was added in 940 and would have been used as a shelter by travellers. The arches are directly inspired by Córdoban architecture and are a recurring feature of Mozarabic churches in northern Spain.

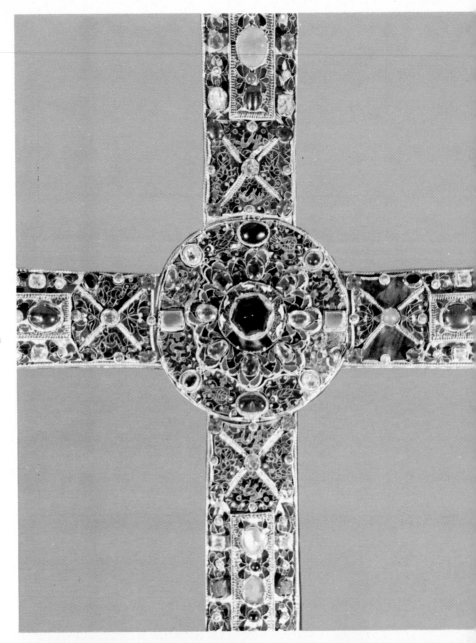

48 *right*
CASKET OF THE AGATES

910

Cámara Santa, Oviedo Cathedral

The Casket of the Agates was given to Oviedo Cathedral by Fruela II and Queen Nunilo in 910. It is a reliquary casket with gold repoussé decoration, boldly inlaid with agates and a variety of precious stones. The centre of the lid, which is in a completely different style, with intricate ribbon and bird enamelling, was probably made at an earlier date outside Spain.

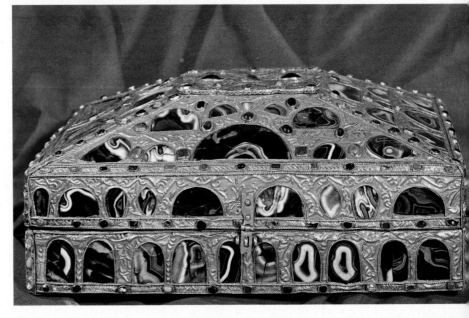

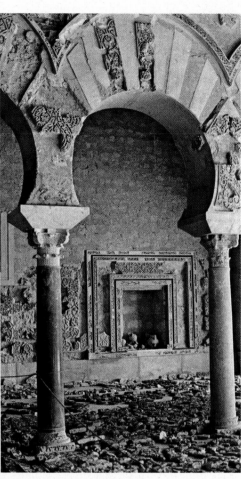

49 *left*

HALL OF THE AMBASSADORS

mid-10th century
Medina-az-Zahara

Medina-az-Zahara outside Córdoba was founded by Abd-al-Rahman III in 936 and named after his favourite concubine. The considerable wealth of the Córdoban court was lavished on this city of pleasure and the fame of its architectural decoration was legendary. For a brief time, at the height of the caliphate, the marble palaces thronged with Córdoban nobility, but now the coloured marble columns and shattered fragments of mosaic and delicate stuccowork are all that remain.

50 *below*

HUNTING SCENE

12th century
fresco
Prado, Madrid

The lower fresco cycle from the 11th-century Mozarabic church of San Baudilio at Berlanga de Duero depicts a series of hunting scenes. The bold masses of colour make an interesting contrast with the more usual linear style of the period. The silhouette effect emphasises the bounding forward of the dogs and the movement of the swaying branches. The formality of the designs indicates Mozarabic influence, as does the inclusion of palm trees and exotic animals, for instance an elephant and a camel.

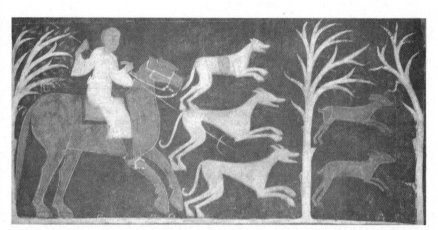

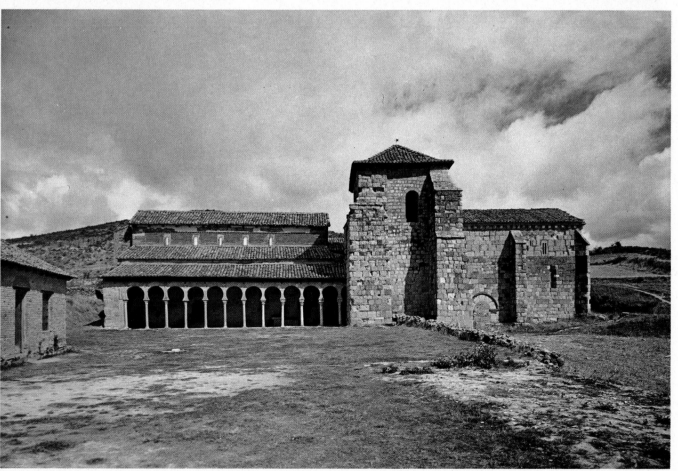

The confrontation of Islam and Christianity in medieval Spain was bound to have remarkable consequences. Each side was convinced that it possessed the unique spiritual truth which must be revealed to the unfortunate unbeliever for his own good. This evangelical obligation was the justification for the Holy War, in reality spasmodic periods of aggression, persecution and mutual suspicion, alternating with long periods of harmony in which Moslems and Christians worked side by side. The profound effects of this link between East and West were long lasting and can be seen even now in the unique character of Spain and in the diversity and quality of Spanish art.

Since the split in Islamic unity in the 8th century, Moslem Spain, al-Andalus, had kept its independence, and had established a glittering capital at Córdoba. By the 10th century, Córdoba had reached a size and splendour rivalling even Baghdad and Constantinople. The nun Hrosvitha of Gandersheim called it the 'Jewel of the World', and the reigns of the caliphs Abd-al-Rahman III and al-Hakam II, who was known as 'the Scholar King', were the most glorious and enlightened in the history of Moslem Spain. Córdoba became an international centre of religion and learning with libraries and schools for the study of philosophy, literature, mathematics, astronomy, medicine and the arts. The city boasted half-a-million inhabitants and numerous palaces, mosques and public baths. Such was the liberal spirit of the caliphate that Gerbert of Aurillac, who later became Pope Sylvester II, was welcomed when he came to study philosophy and mathematics, and such was the prestige of Córdoba that the Byzantine emperor sent mosaicists to al-Hakam II when he wanted to build a new *mihrab* in the Great Mosque.

Sadly, little remains today of architecture from the caliphate, and even the Great Mosque, the second largest in the world, has been reconsecrated 65 as a cathedral. Yet al-Hakam's *mihrab* is still a rare delight and a tantalising reminder of an extravagant and refined epoch. The inner recess of the *mihrab* has a horseshoe arch, lavishly decorated with plasterwork, mosaics and inscriptions in flowing *Kufic* lettering. Inside, it is panelled and domed in marble. In front of the inner recess is a vestibule of three bays, with interlaced cusped arches on two levels and remarkable domes supported by coupled ribs which criss-cross around the centre to form an octagonal star pattern. This type of vaulting was copied throughout Spain and can be seen at Santo Cristo de la Luz, Toledo, the Old Cathedral at Salamanca, San Sepulcro at Torres del Rio and elsewhere.

The skill of Arab craftsmen seen in the decoration of the *mihrab* also encompassed ivory-carving, metalwork, weaving and pottery. Ivory caskets were very popular during the caliphate, and ivory-carving of this period can be recognised by the elaborate decoration and the deeply carved relief. The casket from Zamora, now in the Archaeo-52 logical Museum in Madrid, was made for al-Hakam II in 964, and depicts stylised animals and birds with intertwining leaf and floral patterns. An elegant *Kufic* inscription encircles the lid. The rectangular Leyre casket, made in 1005, has rows of cusped medallions enclosing little scenes of musicians, horsemen and reclining figures, and the surrounds are filled with stylised leaves. Clearly it was still permitted under the caliphate to depict human and animal forms; the widespread Islamic veto did not yet apply to secular art.

The Leyre casket was made as a present for one of the sons of the remarkable al-Mansur, prime minister of the Caliph Hisham II and the most powerful man of his day. He enlarged the Great Mosque at Córdoba. bringing it to its present size, and was notable for counting among his

51
CHRIST IN MAJESTY *detail*
1123
Museo de Arte de Cataluña, Barcelona
This superb wallpainting from San Clemente at Tahull is one of the great masterpieces of Catalan Romanesque art. The painter has taken a traditional Byzantine theme but has given it a new significance, tempering the bold linear technique with remarkable sensitivity in the treatment of the details. The towering Christ is a convincingly omnipotent figure, the huge, elongated head emphasising the divine presence.

wives the daughters of Christian kings. But al-Mansur's power stemmed from his military triumphs, and his devastating attacks across the Christian provinces of northern Spain prefaced a century of disorder and strife. In 997, he outraged Christendom by destroying the cathedral at Santiago de Compostela where the holy shrine of St James had become a place of pilgrimage.

The fall of the caliphate

Soon after al-Mansur's death in 1002, the caliphate collapsed and Moslem Spain was split into small kingdoms known as *taifas*, each with its great fortified palace, or *alcázar*, often pretentious and over-decorated. Some of these *alcázars* survive, including those at Malága, Almería and Saragossa, but they have been greatly restored.

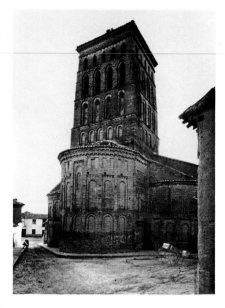

One of the more stable and prosperous *taifas* was Toledo, which managed to retain its reputation for tolerance and culture right through the 11th century. In 1085 the city was won back by Alfonso VI, who styled himself 'King of the Two Religions' and encouraged the establishment of a school of translators of international fame. Perched on its high rock above the Tagus, the entire city of Toledo is now a national monument, an architectural feast of mosques, churches and synagogues, survivals of an artistic unity that overcame differences of religion and politics. The church of Santo Cristo de la Luz (formerly a mosque) is only one of several monuments of the period in which Eastern and Western features are happily juxtaposed.

As the Christian Reconquest gained momentum, land was steadily lost by the weak and disorganised *taifas*. The Moslems who stayed on under Christian rule were called Mudéjars. Like the Mozarabs, the Mudéjars made an important contribution to Spanish art. They were skilled in the use of brick, tiles and plaster, and several of their 'brick Romanesque' churches remain, particularly in the area of Sahagún. San Tirso at Sahagún is a brick basilica with an impressive square central tower, and San 53 Lorenzo, also at Sahagún, is one of the finest churches in this style. It has rows of blind horseshoe arches decorating the apses, and a huge square tower of four storeys over the transept.

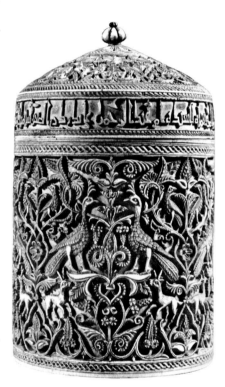

By the end of the 11th century the Moslem princes had become anxious at the steady advance of the Christian kings, and in desperation invited their North African allies, the Almoravides, to come to their aid. The Almoravides were primitive Berber tribesmen and fanatical converts to Islam; not only did they keep the Christian Reconquest in check but they also returned and dethroned the *taifas*, transferring the government of al-Andalus to North Africa. These fierce puritans cared little for tolerance and less for the refined Arab way of life. In despair, the Spanish Moslems again asked for help from North Africa, this time from the Berber Almohades. The Almohades successfully invaded in 1151 and Spain once again became part of the Moroccan Empire. But the Almohades were as fanatical as their predecessors and their persecutions spared neither Arab, Christian nor Jew. They transferred their capital to Seville and set about building a great *alcázar* and a mosque in an attempt to rival Córdoba. Very little remains of the *alcázar* except the façade of the Patio del Yeso with its arcades decorated with carved stucco work. Of the mosque, only the Patio de los Naranjos (Courtyard of the Oranges) and the minaret, the 61 Giralda, remain. The Giralda, built at the close of the 12th century by a Moroccan architect, has cusped and horseshoe arches and panels of decorative brickwork. Compared with the exuberant style of the caliphate, the decoration is very restrained. Large areas have been left quite plain, but the contrast serves to heighten and enhance the decorative features.

52
THE ZAMORA CASKET
964
ivory
Museo Arqueológico Nacional, Madrid
During the years of the caliphate, the generous patronage of the wealthy and sophisticated Arab nobility resulted in intense artistic activity. Ivory caskets were particularly fashionable and are outstanding for the depth of the carving and for the refinement of the elaborate designs. The Zamora Casket was made at the request of al-Hakam II as a gift for his favourite wife. The design depicts stylised animals and birds in intertwining foliage, and an elegant *Kufic* inscription encircles the lid. The casket was formerly in the possession of Zamora Cathedral.

38

53

SAN LORENZO, SAHAGUN

12th – 13th century

After the Reconquest, a number of Moslems, unwilling to leave their homes, remained under Christian rule. Several of their brick Romanesque churches remain in the area of Sahagún, where there was evidently a large settlement. San Lorenzo has apses decorated on the exterior with two rows of blind horseshoe arches, and over the crossing rises a fine square central tower.

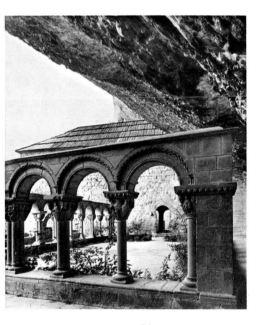

54
CLOISTER OF
SAN JUAN DE LA PENA

late 12th century
Huesca province

Dramatically situated under a cliff at the end of a narrow gorge, San Juan is notable for its fine sculpture, a typical feature of Romanesque pilgrimage churches. The capitals in the ruined cloister are carved with wonderfully expressive figures, full of freedom yet disciplined to fit the structure. The Mozarabic-inspired horseshoe arch in the background is the south portal of the upper church, consecrated in 1094.

The Almohades also contributed to the traditional Islamic artistic fields, and in numerous workshops craftsmen continued to carve and mould and weave with skill and imagination.

It was with the fusion of Arab and Berber traditions that the true 'Moorish' style of Spanish art was now established. Until the disastrous battle of Las Navas de Tolosa in 1212, Moorish Spain regained its prestige in the fields of science and philosophy, giving birth to the great Jewish scholar Maimonides and the great Arab philosopher Averroes, who introduced Aristotle to Western Europe. Thus it was the eclectic spirit of Islam, together with the translators working at Toledo, that kept alive the knowledge and achievements of antiquity and both stimulated and fed the cultural revolution of the European Middle Ages.

Romanesque pilgrimage churches

Medieval intellectual curiosity was revitalised by the wisdom of antiquity and inspired Christian theologians both to make reforms within the Church and to reaffirm to the laity the importance of spiritual values. The reforms of the Benedictine monks of Cluny became the medieval religious ideal. Cluny itself achieved a unique status in spiritual and temporal affairs; her abbot dealt directly with the pope and her patrons included royalty and the nobility who were grateful to be mentioned in her prayers. Cluny put great emphasis on lay piety and encouraged the mass pilgrimage as a visible expression of religious devotion. When, following the Saracen invasions, the pilgrimage to Jerusalem became hazardous, the shrine of Santiago de Compostela in north-west Spain emerged as an acceptable alternative. Cluny stimulated the cult of St James and set up churches and hospices along the pilgrimage route, resulting in a most valuable interchange of architects and craftsmen across the Pyrenees.

A Pilgrims' Guide written in about 1140 tells us the sites of the pilgrimage churches and gives useful hints on where to eat, where to water the horse, local customs and the character of the people. The guide tells us that pilgrims crossed the Pyrenees by the passes of Roncesvalles or Somport, and if by the latter, ended their first day's journey at Jaca. The cathedral at Jaca, begun in 1054 but finished much later, is one of the oldest Romanesque cathedrals in Spain. The problems of accommodating and separating clergy and pilgrims, and the need for saying Mass every day, were solved here as in other pilgrimage churches, by extending the aisles and adding more apses. The sculptural decoration of the capitals, west door and apse includes Visigothic ornament and figures of athletes, dancers, and animals which are based on Classical models but are here carved with typically Romanesque boldness and expressionism. Islamic influence can be seen in the depth of the carving and the delicacy of the infinitely repeating patterns, and also explains the ribs of the dome of the crossing. It was from the fusion of these diverse elements with features from France that Spanish Romanesque architecture gradually evolved.

The exceptional sculptural decoration is a special feature of Romanesque churches along the pilgrimage route. Not far from Jaca, dramatically situated under a cliff at the end of a narrow gorge, is the monastery of San Juan de la Peña, one of the earliest in Spain to adopt Cluniac reforms. In the ruined cloister are some superb capitals, carved with figures of men **54** and animals that are full of life and freedom yet are disciplined to fit the structure. Two of the finest sculptured portals are at the monastery of San Salvadore at Leyre, and the church of Santa María la Real at Sangüessa. There are also several Romanesque churches with fine carving at Estella, which is often called the 'Toledo of the North' because of the number and beauty of its monuments.

However, the most inspired Romanesque sculpture in Spain is to be found in the cloister of Santo Domingo de Silos. Hidden among the barren cliffs of Castile, Silos has remained aloof from history and, although the church has been rebuilt, the 12th-century cloister is almost intact. The cloister is on two storeys, and at each corner there are eight huge angle-panels with relief sculptures of scenes from the last days of Christ's life. The awkward postures and stylised drapery may seem tame compared with the rippling energy of some French Romanesque sculpture, yet the head of Christ in the Emmaus panel and the figure of Doubting Thomas do not lack feeling and drama, and the compositions have a simplicity and refinement which is immensely moving. The capitals at Silos depict a glorious variety of figures and scenes, outstanding for their originality and beauty of execution. Some of the figures and the decorative motifs are related to Islamic ivory-carving, only here the intricate details of the ever-repeating patterns have been wonderfully translated into stone.

A splendid gilded and enamelled altar frontal from Silos is now in the Provincial Museum in Burgos. In the 12th and 13th centuries, enamel was extensively used for the decoration of church plate and vestments, and the finest medieval enamels were made at Limoges. The Silos altar frontal is of the Limoges school and depicts Christ in Majesty surrounded by an arcade of saints, in the style of the more usual painted altar frontals.

A notable stopping place on the pilgrimage road was León. The 12th-century church of San Isidoro adjoins an earlier one (finished in 1067) of which only the Panteón de los Reyes, the mausoleum of the Spanish kings, remains. The Panteón was the portico of the early church, which was the first Romanesque building in Spain. The intricate carving of the beasts and foliage on the capitals inside is typically Mozarabic, but the complex designs have a Romanesque formality which is basically architectural. The sculpture of the later church derives from the earlier models, but is more expressionistic and sometimes even grotesque. The 12th-century frescoes on the vaults of the Panteón are remarkable for their boldness and realism. The paintings represent well-known biblical themes, but the artist has confidently cast aside tradition to create a series of vivid narratives full of personal details. The architecture and sculpture of León and Jaca had a profound influence on Romanesque art in north-west and central Spain.

When Ferdinand I captured Seville in 1063 he brought the relics of St Isidore to León, where they lie, wrapped in an Arab cloak, in a magnificent silver reliquary. The beautiful ivory crucifix which Ferdinand gave to the church in 1063 is now in the Archaeological Museum in Madrid, but in the Treasury of San Isidoro there are other ivories: the Mozarabic cross of Santiago de Peñalba, and a 12th-century enamel casket. Also at León is the agate chalice of Doña Urraca, the daughter of Ferdinand I and the founder of the later church. The chalice is encrusted with cameos, precious stones and gold filigree work in the Visigoth style.

The evolution of Spanish Romanesque architecture is continued at the church of San Martín at Fromista. San Martín has all the characteristic features of the Romanesque; barrel vaults, round-headed arches, composite piers and imaginative sculpture, but the harmony of the architecture and decoration makes it a model of Romanesque church design.

The culmination of Spanish Romanesque architecture, and the end of the pilgrimage road, is in Santiago de Compostela, begun in 1076. Built on a vast scale with a huge ambulatory and barrel-vaulted nave, Santiago achieves the massive grandeur and symmetry that were the goals of Romanesque architects throughout Europe. Internally, little has changed

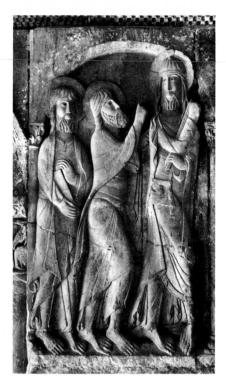

55

THE ROAD TO EMMAUS

early 12th century
cloister, Santo Domingo de Silos

The angle-panels of the cloister at Silos are carved with scenes from the last days of Christ's life. The Road to Emmaus shows Christ as a pilgrim, displaying on his purse the scallop-shell symbol of St James of Compostela. The clinging draperies of the large, flattened figures are delicately articulated by fine double lines.

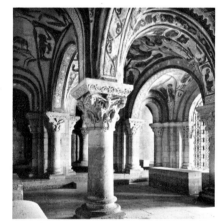

56

PANTEON
DE LOS REYES

1054–67
San Isidoro, León

The west portico of the 12th-century Church of San Isidoro is a royal pantheon (finished in 1067), and one of the first Romanesque buildings in Spain. The Mozarabic-inspired sculptural decoration had an important influence on Spanish Romanesque sculpture, and the vault frescoes of well-known biblical themes are remarkably original.

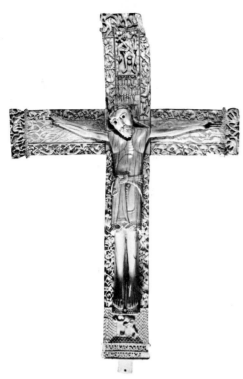

57
IVORY CRUCIFIX

1063
Museo Arqueológico Nacional, Madrid

This most precious example of Leónese ivory carving was one of the many gifts presented to San Isidoro at León by Ferdinand I and Queen Sancha. The stark simplicity of Christ is contrasted with the drama of the Last Judgment depicted in the background, where tormented figures frantically struggle up to heaven or tumble down to hell.

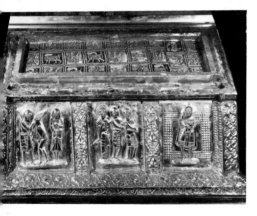

58
**RELIQUARY
OF ST ISIDORE**

1063
silver-gilt
Treasury of San Isidoro, León

The saint's relics were presented to the Church of San Isidoro in 1063, the year of its consecration. The panels on the back of the shrine show from left to right: God Clothing Adam, the Expulsion from Eden and a portrait of the donor, Ferdinand I.

and it still retains the essential spirit of Romanesque. On the high altar stands a silver reliquary with a seated statue of St James (*c.* 1211) decorated with clusters of jewels. Architecturally, Santiago is identical with its contemporary, the church of St Sernin at Toulouse, and thus demonstrates the evolution of an international Romanesque style. However, its sculptural decoration has an expressionism that is uniquely Spanish.

The late 11th-century sculpture of the Puerta de las Platerías includes stylistic features from León and Jaca, but here the graphic character of the Romanesque predominates, and some of the figure-carving is exaggerated to the point of caricature. The artist of the 12th-century Pórtico de la Gloria was Master Mateo, and his subject was the Church Trium- **64** phant. Compared with the solemnity of the Puerta de las Platerías the carving is full of warmth. The figures have natural, relaxed postures and there is a direct appeal to the onlooker which demands a response.

The crusading orders
Santiago de Compostela was an uplifting climax to an arduous pilgrimage, but piety in the Middle Ages meant action as well as prayer. The medieval combination of religious and military fervour is epitomised by Sancho the Great of Navarre. Compared with the Arab princes, Sancho the Great and his fellow knights living in the Asturias were sober and impoverished, yet they offered long and brave resistance to the threat of Islam. In his endeavour to further the Christian cause, Sancho naturally appealed to the monks of Cluny. The reports which Cluny subsequently sent to Rome led the pope to declare a Holy Crusade for the Reconquest of Spain. Thus in 1064, the first crusaders entered Spain, over thirty years before the first crusade to the Holy Land. In the battles that followed, Christian Spain steadily won back land from the *taifas*. These were the exhilarating days of the warrior knights who built the walls of Avila and the fortress-monastery of Loarre and whose exploits have been cherished **66** and immortalised in the legend of El Cid. However, in spite of the common cause, attempts to unite the northern provinces were repeatedly frustrated by the disastrous fragmentation of land between rival sons and the failure to control the wealth and power of overmighty knights, not the least of whom were those crusading orders whose allegiance was only to Rome. The Knights Hospitalers of St John of Jerusalem founded the monastry of San Juan de Duero at Soria, where the picturesque ruins of the 12th-century cloister epitomise the conflicting influences in Spanish art. **71**

The art of Catalonia
One northern province which developed independently was Catalonia. Isolated from the rest of Christian Spain by the Moslem stronghold of Saragossa, Catalonia was forced to look north to France and east to the Mediterranean, from which Lombard and Byzantine influences were drawn. A great centre of learning in Catalonia was Ripoll. In 1008 the enterprising Abbot Oliba made Santa María at Ripoll the first monastery in Spain to adopt Cluniac reforms. He also established a library and altered the abbey church in 1020–32 to make it the finest Romanesque church in the province, and the magnificent 12th-century sculptures of the west door are still intact. On each side of the door, the entire wall is covered with **62** carvings of biblical and secular scenes, including incidents from the history of the monastery, arranged in six horizontal bands. The monumental carving of the main figures and the details of the small genre scenes are equally vivid and expressionistic. Stylistically linked to Ripoll are the churches of San Vicente at Cardona and San Clemente at Tahull, where massive stone vaults and distinctive arcading are evidence of Lombard influence.

Catalonia is famous for its superb 12th-century wallpaintings and the finest of all are from San Clemente at Tahull. The artist, who is known as the Master of Tahull, has taken the traditional Byzantine theme of Christ **51** in Majesty, but his broad linear technique and the sensitivity of the details give the figures a new life and significance. The frescoes are now in the Museum of Catalan Art in Barcelona, and others which have been rescued from certain deterioration are now in the art museum at Vich. These two museums also contain examples of the carved and painted church furniture which the monastery workshops of Catalonia produced in such profusion. The wooden altar frontals depict vivid narratives in bold, contrasting colours; the crucifixes and statues are carved with simplicity and strength.

The presence of Mediterranean features in so much Catalan Romanesque art was the direct result of her political situation. The 11th-century **69** Tapestry of the Creation at Gerona is like a Roman mosaic pavement with the figure of Christ at the centre. Also at Gerona are more medieval textiles, goldsmiths' work, statues, and a fine Beatus manuscript.

The Cistercian monasteries

The decline of the Cluniac order in the 12th century was balanced by the rise of the Cistercians. Alfonso VII invited Cistercian monks from Narbonne and Toulouse to establish foundations in Spain, and their presence had an immediate impact on Spanish architecture. Cistercians rejected elaborate sculpture and decoration and the massive grandeur of the Romanesque in favour of the slender columns, pointed arches and cross-vaulting which characterise Gothic architecture. The most important transitional cathedrals in Spain, combining elements from both styles, are Salamanca, Zamora, Lérida and Tarragona. The old cathedral at Salamanca and the cathedral at Zamora both have unusual central domes, apparently Byzantine-inspired, with two tiers of arcaded lights and charming scaly tiles covering the exterior.

The Cistercian monasteries of the 12th and 13th centuries are notable for their size and simplicity. One of the largest and best preserved is **59** Santa María at Poblet. Begun in 1166, it is a vast complex of buildings, including royal apartments, wine cellars, kitchens, libraries and dormitories. The pointed barrel vaults of the church and the slender columns of the cloister arcade are far removed from the ideals of Ripoll and Santiago de Compostela.

The Convent of Las Huelgas at Burgos, another great Cistercian foundation, was built on the site of a summer palace by Alfonso VIII and his wife Eleanor of England. The church was built over two periods and includes a small Romanesque cloister and a chapel in pure Almohade style. Several of the rooms have stucco decoration, ceilings in the Mudéjar style and beautiful honeycomb squinches. Among the many royal tombs are those of Alfonso and Eleanor, exquisitely carved and resting on the lions of León and Castile. In the museum of the convent is an Almohade **70** banner from the battle of Las Navas de Tolosa; it is richly coloured and woven with silk and metal threads in wonderfully intricate patterns.

The battle of Las Navas de Tolosa in 1212 was the crucial blow in the holy Crusade against Islam. Alfonso VIII had persuaded the Christian provinces to unite in order to make this supreme effort against the common enemy, and Moorish Spain never really recovered from its devastating defeat. However, although the success of the Reconquest was now assured, Moorish art was to achieve a final flowering in Granada, which became the capital of the only remaining Moslem state.

Mary Orr

59 *below*

SANTA MARIA
DE POBLET

last half of the 12th century

During the 12th century, Cistercian monks from France brought to Spain new spiritual and architectural ideals. They disapproved of the worldliness of the Cluniac Benedictines, and their preference for moderation extended to their church building. The Monastery of Poblet not far from Tarragona, founded by Ramon Berenguer IV, Count of Barcelona in 1150, has a new elegance of form which can clearly be seen in the slender columns and pointed arches of the cloister arcades.

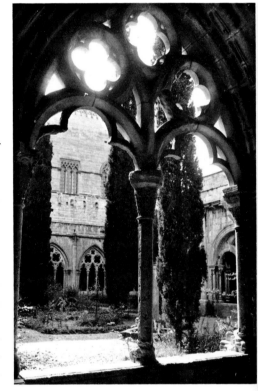

60 *below*

DESCENT
FROM THE CROSS

last half of the 12th century
wood
Museo Arqueológico Episcopal, Vich

The expressionism and spirituality that
characterise Spanish art can be seen in this
Catalan wooden sculpture from Erill-la-
Vall. The drama of the situation is
emphasised by a framework of stark
gestures, but the despair suggested by the
ravaged body of Christ is relieved by the
serenity of the bowed head and the tender
expressions of Nicodemus and Joseph of
Arimathaea.

61 *right*

THE GIRALDA

1184–1197
Seville

The Giralda was originally the minaret of a
mosque begun under the Almohade sultan,
Yusuf II, and completed in 1197. Com-
pared with Córdoban architecture, the
decorative brickwork is very restrained.
Large areas have been left quite plain, but
the contrast serves to heighten and enhance
the decorative features. The Giralda is now
the bell tower of Seville Cathedral.

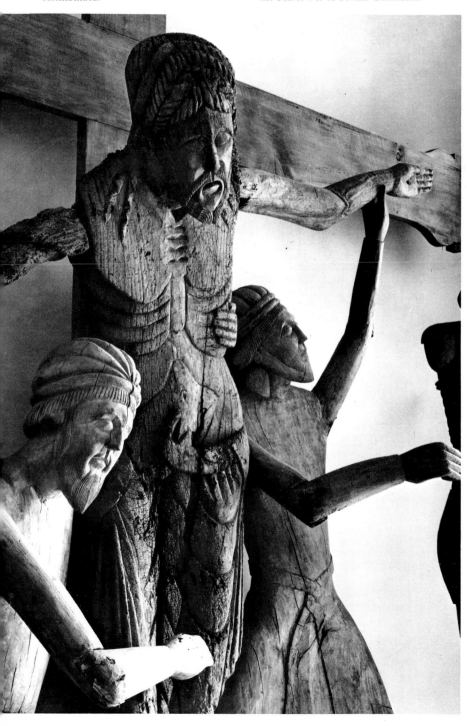

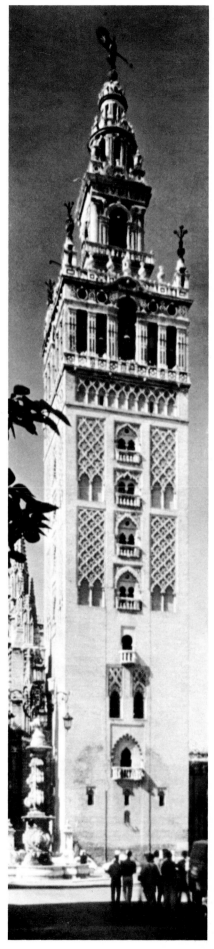

62 *below*

SANTA MARIA, RIPOLL

mid-12th century

The entire west front of Santa María at Ripoll is covered with bands of sculpture depicting biblical and secular scenes, including incidents from the history of the monastery. The arrangement of the sculpture into horizontal bands derives from Lombardy and can be compared with that on the west front of San Zeno, Verona. The monumental carving of the main figures and the details of the small genre scenes are equally vivid and expressionistic.

63 *below*

CLOISTER, SANTO DOMINGO DE SILOS

early 12th century

Silos was an important detour on the pilgrimage route to Compostela. Pilgrims made the journey to the monastery in the hills near Burgos to venerate the relics of St Dominic of Silos, its 11th-century reforming abbot, who had remarkable powers of healing. During the first half of the 12th century, enlargements were made to accommodate the pilgrims, and a cloister was built the sculptural decoration of which is outstanding for its originality and beauty of execution.

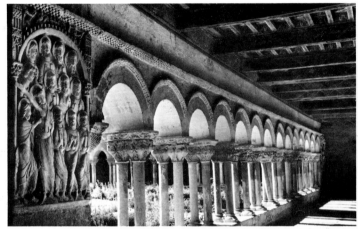

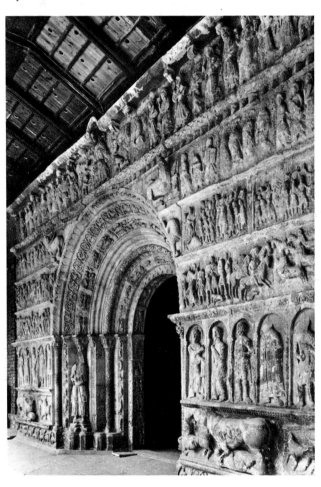

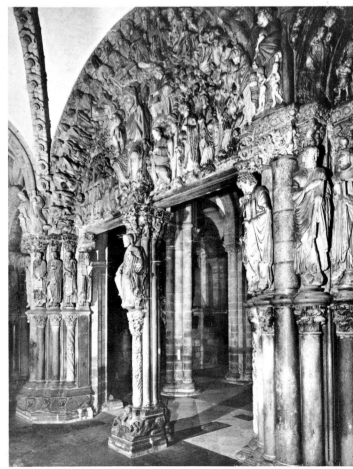

64 *right*

PORTICO DE LA GLORIA

1168–c. 1200
Master Mateo
Cathedral of Santiago de Compostela

Compared with the tormented figures of the earlier Puerta de las Platerías the figures of the Pórtico de la Gloria represent a different world. Here the pilgrims are greeted by a benign St James, while above his head Christ in Majesty is surrounded by a throng of angels and framed by the twenty-four Elders of the Apocalypse. On the door jambs smiling apostles and prophets echo the optimistic spirit of the Church Triumphant.

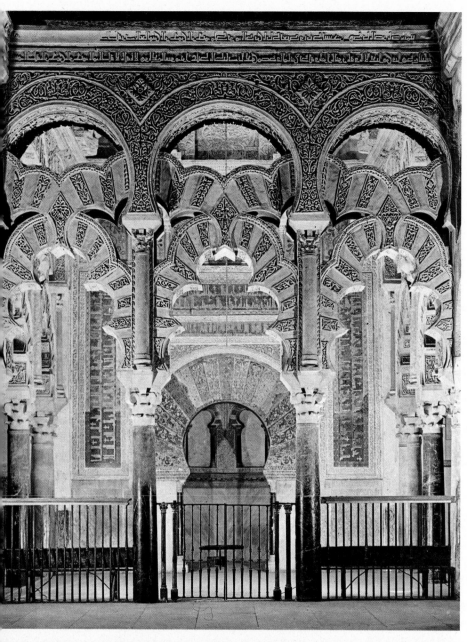

65 *left*

MIHRAB

965
Great Mosque, Córdoba

The *mihrab* and its vestibule were part of major extensions made to the Great Mosque by al-Hakam II who, determined to build the most splendid mosque in the Islamic world, sent for craftsmen from Byzantium to carry out the work. A double arcade of arches decorated with lacy plasterwork surrounds the entrance to the inner recess, the wall of which is covered in mosaics including a flowing inscription in gold recording the date of the work.

66 *below left*

CASTLE OF LOARRE

last half of the 11th century

Perched on a barren rock in the remote foothills of the Pyrenees, Loarre is a typical medieval fortress-monastery whose inmates were as ready to take up the sword as they were to spend their days in prayer. The original castle was recaptured from the Moslem invaders by Sancho Ramirez V, the great warrior knight who built the present church. Linked in style to the architecture of Jaca Cathedral, the church is outstanding for its harmony of form and decoration.

67 *below*

CHALICE OF DONA URRACA

end of the 11th century
treasury of San Isidoro, León

This splendid chalice was presented to the church of San Isidoro by Doña Urraca of Zamora, the daughter of its other great benefactor Ferdinand I, and the sister of the equally illustrious Alonso VI. The chalice is made from carved onyx, extravagantly encased in gold and set with pearls and precious stones. The artist has enlivened the surface with granulated filigree decoration including an inscription around the waist which reads IN NOMINE DNI VRRACA FREDINADI.

68 *below*

CHRIST IN MAJESTY

mid–12th century
pigmented wood
Museo de Arte de Cataluña, Barcelona

This well-preserved wooden statue is from Olot in the province
of Gerona, and the donor was Don Enrique Battló. The richly
painted robe signifies that the figure depicted is Christ in
Majesty rather than the Crucified Christ, and the formality of the
pose and the strictly disciplined folds of the robe and sash
emphasise the authority of the serenely impassive head. The
pattern of red medallions on a blue ground is in imitation of a fine
Byzantine silk.

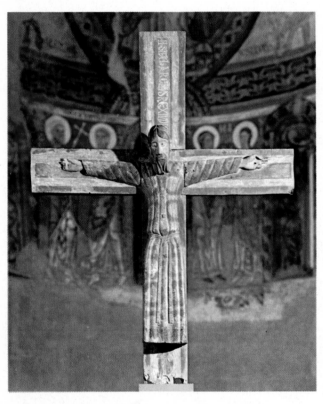

69 *far right*

TAPESTRY
OF THE CREATION

early 12th century
Museo Catedrálico, Gerona

The design of this famous embroidery is arranged like a Roman
mosaic pavement. The figure of Christ at the centre is surrounded
by radiating panels showing night and day, earth, air and water,
the creation of Adam and Eve and the creatures of the earth. At
the corners are figures representing the four winds, and along the
lower edge is the story of the True Cross. Square panels along the
other three sides depict the months and the seasons.

70 *below*

BANNER OF LAS NAVAS DE TOLOSA

12th–13th century
Convent of Las Huelgas, Burgos

The battle of Las Navas de Tolosa in 1212 ended in a disastrous
defeat for the Almohade army, and assured the ultimate success of
the Christian Reconquest. One of Alphonso VIII's trophies was
this fine Moorish banner, with intricate floral and geometric
patterns exquisitely woven in silk and gold. Islamic textiles were
highly prized in Christian Spain, and echoes of their decorative
motifs frequently occur in Spanish art.

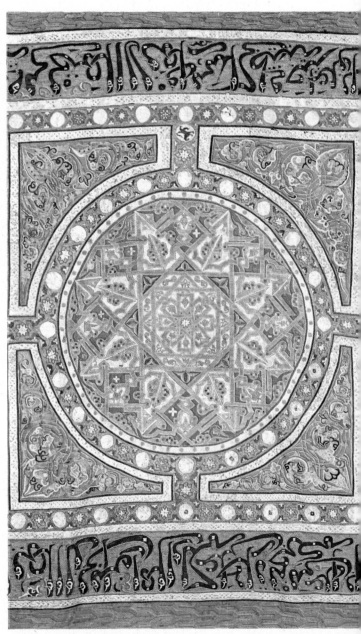

71 *left*

CLOISTER OF SAN JUAN DE DUERO

late 12th century
Soria

The great crusading orders of knights, who owed allegiance directly to Rome, played an important part in the Reconquest of Spain. The Monastery of San Juan de Duero at Soria was founded by the Knights Hospitalers of St John of Jerusalem. The picturesque ruins of the 12th-century cloister present a medley of horseshoe doorways and interlaced arches juxtaposed with round-headed arches and historiated capitals, almost epitomising the conflicting influences in Spanish art.

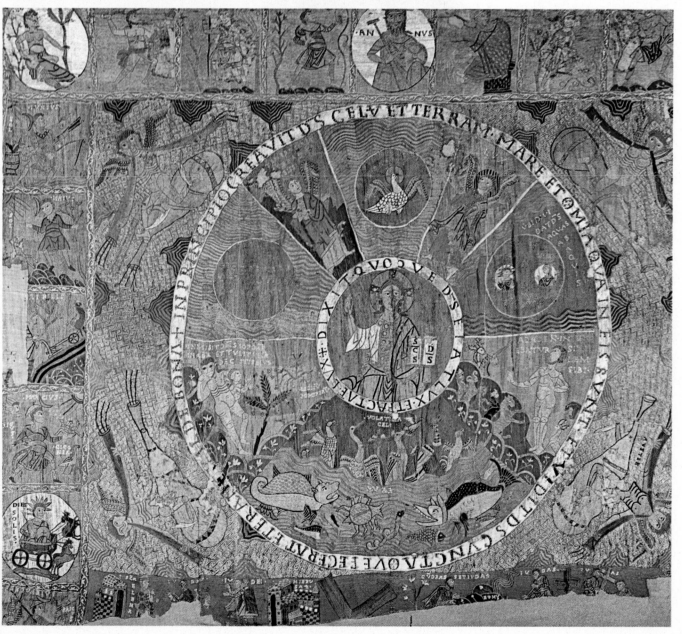

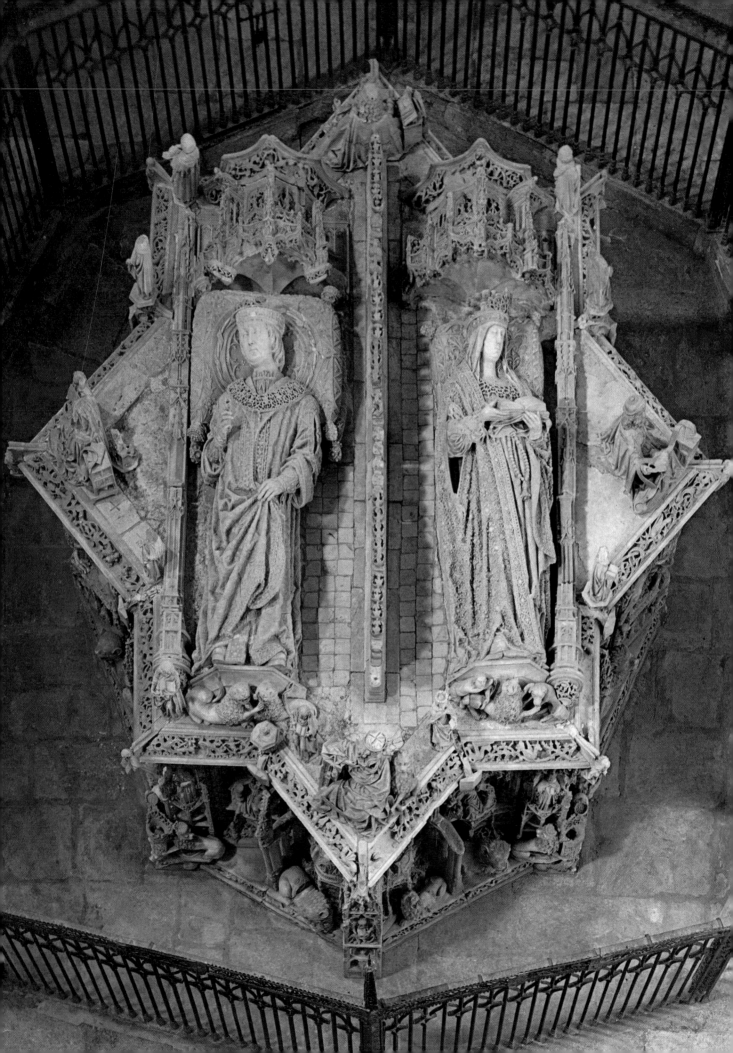

The Reconquest was triumphantly continued by Alfonso IX's son, Ferdinand III, to whom fell Córdoba and finally Seville in 1248. With the fierce military and religious fervour which characterises many outstanding Spaniards he reconsecrated the great mosque at Córdoba as a cathedral and made Moslem captives restore to their rightful place the bells which al-Mansur had snatched from Compostela in 997. Only Granada remained untaken and, indeed, was allowed to survive until 1492 because of the quarrels that split the Christians for more than two centuries. The basic issue, both in Aragon and Castile (which by now incorporated the kingdom of León), was the struggle for power between the king and his nobles, which had always been a problem and became more acute with the collapse of the Moslem enemy. No longer could the king resort to raiding and conquest to fill his coffers, nor could an adventurous nobleman like El Cid carve out an independent kingdom for himself in enemy territory. The king now had the difficult task of settling his enlarged kingdom, and almost every disputed succession not only brought interference from other states but also gave ambitious nobles an opportunity to build up their own power. The monarchy often found allies amongst the cities, which were prospering rapidly now that the Moslem threat to their security had been finally removed. By the mid-13th century, their growing importance, particularly as a source of royal revenue, was recognised by their admission to the *cortes*, the royal parliaments where the Church and nobility were already represented.

Major cities like Burgos, León and Toledo demonstrated this increased sense of importance by rebuilding their Romanesque cathedrals in the compelling High Gothic style of northern France – already hinted at in Cistercian buildings – which French architects and craftsmen were helping to spread through many parts of Spain.

French influence had been considerable in Castile for almost two centuries and ties were particularly close at this time: Ferdinand III and the cultured Louis IX of France, both canonised after their deaths, were cousins. The cathedral at Burgos was begun in 1221 by its bishop, Maurice, whose effigy is in the centre of the choir. He was well aware of the developments in French and German architecture because only two years previously he had been sent on an embassy through France to Germany to bring back Beatrice, the daughter of the duke of Swabia, to marry Ferdinand. Although the pinnacles and crockets of the exterior spring from a later, German source, the plan and elevation of Burgos are basically French. Some of the sculpture, dating from the first stage of building, is by workers from Amiens, notably that on the tympanum of the south portal, the Puerta del Sarmental. The figure of Christ in the centre occurs again over the slightly later Puerta de la Coronería, only this time in a more expressive way which must have been congenial to the Spanish.

The foundation stone of the great cathedral at Toledo was laid by Ferdinand a few years after that of Burgos. It was built on the site of the old mosque and it is interesting that Mudéjar elements appear in the arches of the gallery. This gallery was possibly by the mason Master Alfonso, who later designed the chapel of the Jeronymite convent of Guadalupe nearby in an even more confident Gothic-Mudéjar style. Although it is difficult to pick out the fundamentally Gothic origins of Toledo cathedral from the architectural accretions of later centuries, it is just possible to see that its proportions, like those of Burgos, stress volume rather than soaring height and that the windows are too small to give the weightless impression found in many French cathedrals.

The purest example of the French High Gothic style in Spain is León

The Triumph of the North

1212–1516

72

TOMB OF JUAN II
AND
ISABELLA OF PORTUGAL
1489–93
Gil de Siloe active 1486–99
alabaster
Charterhouse of Miraflores

Isabella the Catholic commissioned this memorial to her parents from Gil de Siloe, a Flemish sculptor who had been in Castile from 1486. It is a virtuoso piece, incorporating scenes from the New Testament and sixteen lions guarding the royal arms as well as the intricately carved effigies themselves. The face of the king is thought to be a genuine, if posthumous, portrait. Although he was an inadequate ruler, he handed on to his daughter a real interest in painting and was one of the first of a long line of Spanish kings to build up a collection.

80 Cathedral, which has the characteristic elevation of arcade, triforium and high clerestory linked from floor to vault by a single soaring shaft. After its incorporation in Castile, León was no longer a royal capital, and its cathedral might never have been started at that time but for the determination of the prelate Don Martín Fernández who was appointed to León in 1254. His cathedral followed Rheims in many ways, particularly in its extensive use of stained glass and bar tracery. Even the outer walls of the triforium below the clerestory are glass, and nearly all of it is original. It is believed that the architect Master Enrique and his sculptors' and glaziers' workshops were in direct contact with their French counterparts in centres such as Rheims, Chartres, Amiens and Paris. Certainly some of

79 the delightful sculpture of the main west door could easily be French. This is also the case with some of the sculpture of Pamplona Cathedral in Navarre, which reached a fresh height of excellence in the 14th century. Pamplona was later to be enriched by works commissioned directly from French sculptors, such as Janin Lomme of Tournai, who executed the imposing tomb for Charles the Noble, King of Navarre, in 1416.

In the stained glass at León and in the cloister at Burgos there are representations of Castile's most cultured monarch, Alfonso the Wise, son of Ferdinand. He was renowned for his great scholarship, for not only did he actively encourage the new universities at Palencia and Salamanca, but he also compiled the first comprehensive history of the Spanish people and an advanced legal encyclopaedia. He had the good sense to adopt Castilian, instead of Latin, as the official language, and he wrote a number of narrative poems, called the *Cantigas*, in honour of the Virgin Mary. These

78 were copied out and exquisitely illustrated in a French style, possibly by a lay miniaturist rather than by a monastic scriptorium. Alfonso's reign was brilliant culturally but politically it was a disaster, ending with his deposition by his second son in 1284. This was merely the beginning of a series of disputed successions, civil wars, and foreign interventions which were to prevent any extensive patronage of the arts in Castile. Not until 1402

95 did work start in Seville on the largest Gothic cathedral in the world.

Catalan architecture

In contrast, across the peninsula, Catalonia was enjoying a period of great prosperity. Jaime I, known as the Conqueror, had fostered the interests of the traders by capturing the Balearic islands of Majorca and Minorca from the Moors before reclaiming Valencia for Christendom in 1238. Sicily, southern Italy, Sardinia and Corsica fell to his successors, and Catalan armies were victorious as far afield as Greece and Asia Minor. Until 1386 Barcelona was the most powerful city of the Mediterranean.

Barcelona started to build its cathedral in 1298 in a plainer Gothic style than any in Castile, adopting rather that already followed in Tarragona. This was comparatively simple in construction although highly decorated inside. Obviously this simplicity stemmed from the Cistercian ideal to which Catalonia remained true in her fashion for the next two centuries. The exterior of Barcelona is very austere because the side chapels are built within the buttresses and therefore flush with the side walls. Inside there are three aisles, the side ones being of almost the same height as the nave, and open galleries over the side chapels, devices which all contribute towards a feeling of extreme spaciousness, even though the cathedral walls are only pierced by small windows. This spaciousness characterises most of the Gothic cathedrals in Catalonia and made them very suitable as preaching churches for the mendicant orders who had become an invigorating force in the church in the 14th century. Santa Maria del Mar, which stands alongside Barcelona harbour, was probably used by the

73

PUERTA DEL SARMENTAL

c. 1230
Burgos Cathedral

Although Gothic in form and in various points of detail, the south door of Burgos Cathedral still recalls the spirit of Romanesque, which had by this time become archaic in France. Here two anonymous sculptors from Amiens have produced a Gothic work which breathes a classical poise and clarity. Lining the architrave are the twelve apostles and above them is a serenely impassive Christ in Majesty, set within the triangular tympanum. The figures of the evangelists are bowed over their desks so that they fit into the triangular shape and their symbols take up the remaining space.

74

TOMBS OF
INFANTE DON FELIPE
AND HIS WIFE

1274
attributed to Anton Pérez de Carrión
Villalcázar de Sirga, Palencia

Alfonso X's eldest son, the infante Don Felipe, who died before coming to the throne, was buried in the fine 12th-century church just outside Palencia, which belonged to the Knights Templar. His tomb and that of his wife, Leonor Rodriguez de Castro, are carved with scenes of mourning. Although the Gothic style had been actively promoted by the Castilian royal family there is little evidence of its influence in these tombs. They were probably commissioned from a local sculptor who was still working confidently and imaginatively with Romanesque traditions in mind.

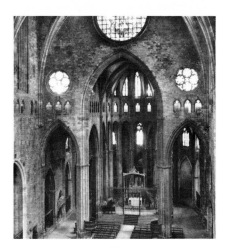

75
GERONA CATHEDRAL
13th–14th century
Guillermo Boffiy

This view shows the gigantic single nave supported by immensely thick buttresses, finally yielding to the choir and its side aisles.

76
THE HOLY WOMEN
AT THE SEPULCHRE
detail
1345–46
Ferrer Bassa 1285?–1348
Convent of Pedralbes

This is one of a series of paintings which cover the entire wall and ceiling surfaces of a small chapel in the convent of the nuns of St Clare near Barcelona. They are the only surviving murals by the Aragonese court painter, who is recorded steadily at work on altarpieces from 1324. Painted in oil and miraculously well preserved, they reveal a bold and original talent. Although the composition of some of the scenes, depicting the joys of the Virgin and the Passion of Christ, indicate some knowledge of contemporary Italian painting, the simple massing of colour and unmistakable gestures are very much Bassa's own.

friars who sought to involve themselves in the world rather than retreat into a monastic community.

Both Palma Cathedral and Gerona make up in size and elegant proportions what they lack in decorative impressiveness. Both were built slowly over two centuries: Palma is 397 feet long and the main vault is almost 140 feet from the ground; Gerona boasts the widest Gothic span of **75** seventy-three feet across the nave, which is the combined width of the choir and aisles. The canons of Gerona had originally planned to have three aisles, but their architect Guillermo Boffiy then wished to have an aisleless nave in keeping with the current enthusiasm for hall-churches. Realising that there was no precedent for such a wide span the canons summoned a committee of architects from France as well as Spain, over half of whom opposed the scheme. Nevertheless the project was carried out successfully.

Ultimately, this taste for broad proportions and limited ornament stemmed from the Roman spirit which still pervaded the Mediterranean. This can be seen too in the interest taken in secular architecture, with which Barcelona, as the chief trading town, is particularly well endowed. The royal palace was enlarged in 1359 by a large crypt-like hall called the Salon del Tinell, over which Martin I built an elegant Council Chamber in 1404; both are roofed in a single span by enormous arches. In 1416 a group of parliament buildings were started, one surmounted by a vigorous relief of St George and the Dragon by Pedro Johan and another possessing a courtyard surrounded by slender pointed arches. Among other public buildings were a town hall built some time after 1399 and an exchange (*lonja*) used by the merchants. A later, more heavily ornamented 15th-century *lonja* is in Palma, designed by the sculptor Guillermo Sagrera who also worked on the cathedral. The pillars which support the rib-vault roof have remarkable spiral flutings copied in the Silk Exchange at Valencia. **96**

The creations of Gothic gold- and silversmiths which embellish the cathedrals are another indication of civic prosperity. At Gerona, there is a superb altar begun by the sculptor Master Bartolomeu in 1320 and finished by the goldsmith Pere Bernec between 1345 and 1380 with enamel reliefs and a baldachin. In the sacristy of Barcelona Cathedral stands the finely worked silver-gilt throne of Martin II, which is in a pure Gothic style, as well as a silver and gold reliquary and an enamelled processional cross.

Foreign influences in painting

Catalan painting remained as pre-eminent in Spain in the 14th and 15th centuries as it had been in the Romanesque period. Wallpaintings had become a rarity in Gothic building, however, and their place was taken by retables, elaborate altarpieces made of several tiers of painted panels whose construction is echoed by those sculptured in stone or wood. Among the latest and most remarkable wallpaintings are those in the convent of Pedralbes near Barcelona, which had been built by Jaime II (who also founded Palma Cathedral) and his wife Elisanda, who was the first abbess. The chapel next to her tomb is decorated with a series of murals executed by the royal painter Ferrer Bassa in 1346, depicting the life of the Virgin **76** Mary. Surprisingly, the original contract for this work stipulated that the painting should be carried out in oils, then a rarity in Spanish painting where tempera was generally used. The style, although close to that of Trecento Sienese painters like Simone Martini, has an engaging quality of forthrightness reminiscent of Giotto. Catalonia of course had close commercial ties both with Italy and with the papal court at Avignon where Simone Martini had worked.

The breadth of Bassa's style is not evident in the work of his successors

who preferred to concentrate on Sienese elegance. One of these painters was Pedro Serra who belonged to a family of artists in Barcelona. He executed a number of retables depicting Old and New Testament scenes. **77** By the beginning of the 15th century their courtly style began to look rather old-fashioned compared with the innovations of International Gothic introduced by Luis Borrassá. His paintings and those of his successor Bernardo Martorell show a lively interest in the details of an **85** everyday environment without losing any spirituality in the main figures. Borassá's *Retable of San Pedro* at Tarrasa and Martorell's great altarpiece at Barcelona Cathedral are both outstanding works.

Elsewhere in Spain foreign practitioners of International Gothic as well as some notable Spaniards exerted a considerable influence. The German Marcal de Sax worked in Valencia, the Frenchman Nicolás Francés in León, and the Italian Nicolás Florentino (Dello Delli) in Salamanca. Their work was commissioned by rich donors as well as prelates; and some of them also turned their hands to manuscript illustrations.

In the 1440s, however, a highly significant work was commissioned by the city councillors of Barcelona for their municipal chapel from Luis Dalmau, a Valencian who had been in the service of the king, Alfonso V of Aragon, before his retirement to his new kingdom of Naples. Alfonso had earlier sent the painter to the Low Countries where it was clear that revolutionary artistic developments were taking place. Dalmau must have made a close study of the work of Jan Van Eyck, because his *Retable of the* **100** *Councillors* has exactly the same bulky figures, the same realistic attention to detail and the same distant landscape as Van Eyck's *Ghent Altarpiece*. This was the beginning of a Flemish influence which was to spread throughout Spain as in Europe. Jaime Huguet applied the Flemish observation of detail to the human face and clothing and painted striking portraits in his retables, several of which are now in the Museum of Catalan Art in Barcelona. However, like Bartolomé Bermejo, whose moving Italianate *Pietà* is in the cathedral museum, he only took what he wanted from the Flemish style. Both artists often kept the lavish gold **102** backgrounds of earlier Gothic work and their combination of decorative richness with strength of characterisation is distinctively Spanish.

Granada and Moorish influence

Whilst Aragon and Castile built great churches filled with the gifts of the devout, deflected from time to time by political crises, the Moors in Granada were also continuing to build as if they would be in Spain for ever. The fabulous Alhambra was developed on a fortress site by members of the new Nasrid dynasty, notably by Yusif I from 1334–54 and Mohammed V until 1391. Their two palaces, the Palacio de Comares and the Palacio de los Leones, are composed of a number of units: passages, halls and open patios alternate and interlock, giving marvellous vistas through many parts of the building and occasionally out to Granada below. Almost every interior wall is decorated with exquisite patterned and coloured stucco and the ceilings and arches are encrusted with stalactite **86** pendants, worked by the numerous Moorish craftsmen who had chosen to stay in Granada rather than return to North Africa after the Reconquest. The largest hall in the Palacio de Comares is the Hall of the Ambassadors, where the Sultan of Granada received foreign embassies. The lower part of the wall is lined with a mosaic of enamelled tiles, the upper part is entirely covered by *Kufic* inscriptions and stylised flower and star patterns worked into the plaster. The star patterns are repeated in inlaid cedar in the domed ceiling. Stalactite mouldings embellish the ceiling of the Hall

77
VIRGIN,
CHILD AND ANGELS
Pedro Serra 1343 ? – after 1405
tempera on panel

Museo de Arte de Cataluña, Barcelona

Pedro Serra was a member of a family studio which dominated Catalan painting in the second half of the 14th century and was in its turn dominated by the Italian fashion for elegance and refinement. Their altarpieces are painted with the bright precision of miniaturists, the faces and hands delineated by the most delicate and yet certain of brushstrokes. Such expressiveness, as can be seen here, compensates for the static courtly pose. The pet goldfinch is a symbol of the Passion.

78 *below*

CANTIGAS OF ALFONSO X

The Escorial, Madrid

Alfonso the Wise of Castile commissioned a group of lay miniaturists to illuminate the songs he had written to celebrate the miracles of the Virgin Mary. He probably drew on popular stories of his day, and thus the illuminations give a picture of life in 13th-century Spain as well as telling a story with wit and economy. Although they are French in style, the inclusion of oriental motifs indicates artists who were well acclimatised to Spain. The lions and castles are symbols of the royal house of León and Castile.

79 *bottom right*

THE WHITE VIRGIN

late 13th century
León Cathedral

The richly carved west front of León Cathedral follows the design of Chartres and Rheims, and this statue from the central portal is modelled on the famous *Vierge Dorée* in the south transept at Amiens. It is believed that the mason who sculpted this masterpiece previously worked at Burgos. Although the subject was often represented in Gothic art, this Virgin and Child are memorable for their dignity and geniality.

80 *below*

LEON CATHEDRAL

1258–1303
Master Enrique and Juan Perez

Narrower and more fragile than its predecessors at Burgos and Toledo, León Cathedral best represents the Gothic ideals of 13th-century France, which had been adopted as a matter of ecclesiastical prestige in northern Spain. The nave is flooded with light from the stained-glass windows, one of the oldest series in Europe. The long processions of apostles, saints, patriarchs and kings under Gothic canopies recall the illuminations in manuscripts.

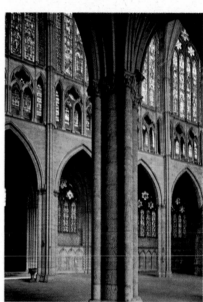

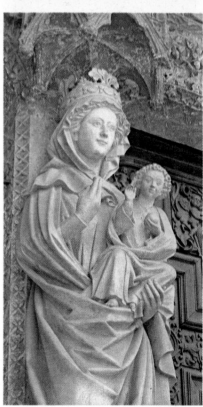

81 *right*

GATE OF JUSTICE

1348
The Alhambra, Granada

The main entrance to the Alhambra shows
how Nasrid architects, famous for their
fragile stucco decoration, could also build
strongly and austerely in brick. The
horseshoe arch set in the square flank tower
has an open hand sculpted on its keystone,
symbolising the Moslem law and giving
the Gate of Justice its name. Inside the arch
is a gate with the original Arab locks, an
inscription in praise of its builder Yusif I
and a vaulted niche containing a wooden
Virgin and Child which was inserted by the
Catholic Kings after they conquered
Granada in 1492.

82 *right*

THE COURT OF LIONS

second half of the 14th century
Alhambra Palace, Granada

The Alhambra is one of the most remark-
able creations of Islamic architecture. The
last part to be built was the harem area,
accessible only to the royal family and their
servants. Four halls open onto the Court of
Lions, which is named after the stone
animals supporting the fountain in the
centre. Compared with the lacy delicacy of
the surrounding arcades the lions are
crudely carved, possibly because free-
standing sculpture was rarely attempted by
Islamic artists.

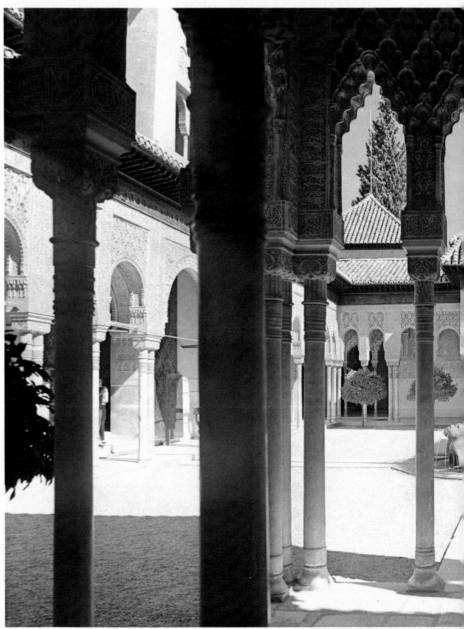

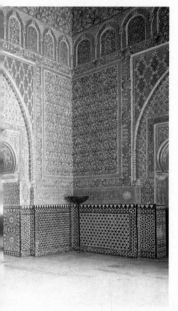

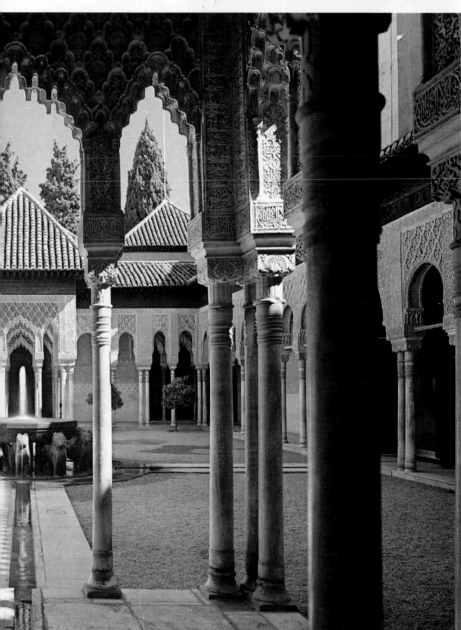

83 *left*

THE ALCAZAR, SEGOVIA

11th – 15th century

Mounted on a rocky spur between the two rivers Eresma and Clamores, the Alcázar of Segovia was one of the favourite residences of the Castilian kings for several centuries. Its external appearance is that of a fairly typical 15th-century European castle. The decorative brickwork, however, is a hint of the extent of Mudéjar work within, where the fortress turns into a palace. Several of the rooms are decorated with Mudéjar stuccowork and marquetry. These improvements were mainly carried out for the English queen Catherine and her son and grandson, Juan II and Enrique IV.

84 *top middle*

HALL OF THE AMBASSADORS

1364–66
Alcázar, Seville

The palace at Seville is a measure of the admiration felt by Pedro I of Castile for the Moorish way of life. Having diligently salvaged as much as he could of the earlier *alcázar* he then set about constructing courts, halls and gardens based on those of the Alhambra. By using workmen and materials sent from Granada by Mohammed V he achieved a fair imitation. This splendid hall with its triple doors, its dado of mosaic tiles, its tapestry-like stucco walls and arcaded frieze was later to be the scene of Charles V's marriage.

55

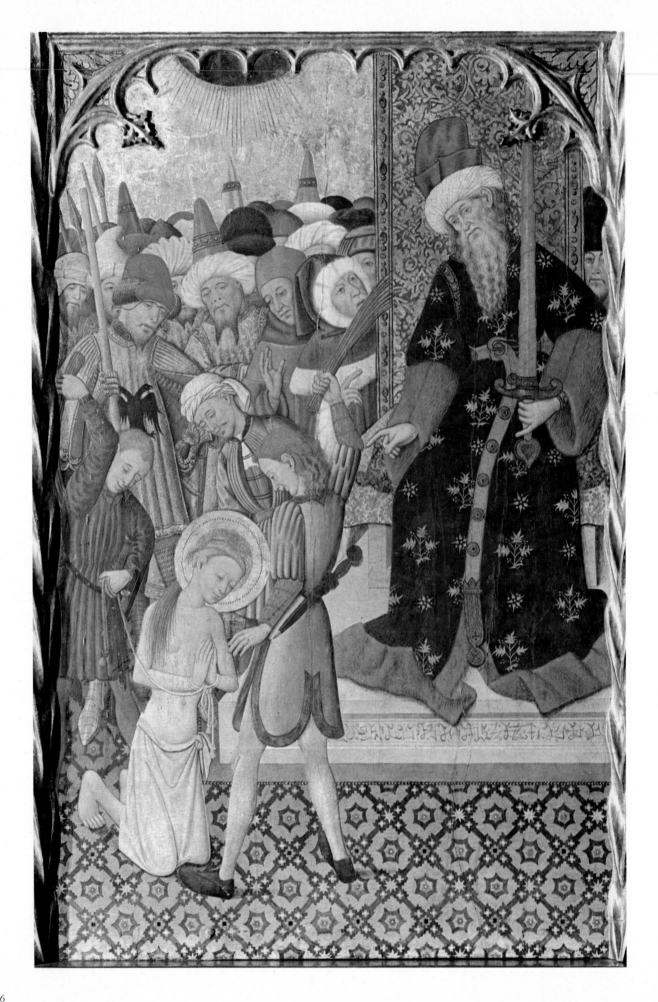

85
MARTYRDOM
OF ST EULALIA

c. 1450
Bernardo Martorell, d. 1455
tempera on panel
Museo de Arte de Cataluña, Barcelona

Working within the International Gothic idiom, Bernardo Martorell made the stories of the bible and the saints meaningful to people of the day by including contemporary details. Although the martyrdom of Eulalia took place in Mérida under the Romans, the oppressors here look rather like Moors. Martorell was a sensitive draughtsman; the naked body of the saint with its marks of blood has a poetic quality, as have some of the onlookers' faces.

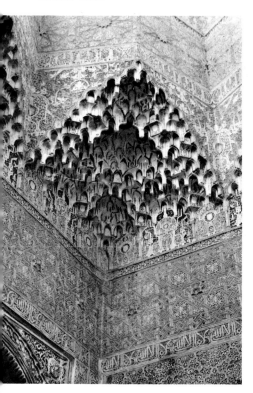

86
HONEYCOMB
MOULDING

second half of the 14th century
stucco
Alhambra Palace, Granada

This honeycomb of stalactite mouldings in the Alhambra Palace forms part of the base of a cupola which in turn supports a fantastic vault of the same stalactites (*mukkarnas*). By breaking up the surface of the ceiling in this way the Moorish workers were able to achieve an effect of insubstantiality, an effect also aimed at on the intricately patterned walls and the openwork of the arches in the court arcades.

of the Two Sisters, where the effect of being inside a honeycomb is even more striking. This is only one of four halls which look out through canopies of arches and delicate marble pillars onto the famous Court of Lions. The fountain here is a reminder of how the Moors used water with **82** conscious artistry to please the senses and refresh the spirit. Not far away, poised on a hill overlooking the Alhambra, is the little summer palace called the Generalife, whose gardens are cooled by cascades of water.

Even in these citadels of pure Nasrid architecture, however, European influences are evident. The arrangement of the Court of Lions, which is surrounded by pillars, is not unlike a monastic cloister; and in the Hall of Kings, there are ceiling paintings which depict a medieval scene of knights and ladies. Clearly, cultural and commercial traffic with Christian Spain, where Granada exported large quantities of silk, carpets and ceramics, was not a one-way business.

In earlier times the Christian monarchs had been antagonistic to the sophistications of al-Andalus; now, at closer quarters, they found the Moorish way of life overwhelmingly attractive. Alfonso XI built himself a palace with patios and cusped horseshoe arches as far north as Tordesillas, but undoubtedly the finest Mudéjar palace in Spain is the Alcázar at Seville. This was built by Pedro I of Castile, at the height of one of the most difficult dynastic crises Castile had known, and at much the same time as the Alhambra. As many of the craftsmen were loaned by Mohammed V it is not surprising that the Patio de las Doncellas is reminiscent of the Court of Lions or that the Hall of the Ambassadors, which has a magnificent gilded boxwood ceiling inlaid with mirrors, recalls its original at Granada. Yet, whereas all the decoration of the Alhambra is restricted to the interior, at Seville the main façade is also decorated with stucco and glazed tiles. Superb stuccowork can also be found in the synagogue of El Transito in Toledo, which was built for Pedro I's Jewish tax-gatherer Samuel Levi in 1366 by Meir Abdeli. This building is a fascinating combination of various elements, indicating the inevitable mixing of different cultures in medieval Spain. The open plan is traditionally Jewish, as are the inscriptions on the walls; the wooden ceiling and most of the decorative detail is Moorish, but even here certain Gothic elements can be distinguished. An earlier synagogue in Toledo, which had a large Jewish community, is Santa María la Blanca, built on the lines of **97** the mosque at Córdoba with aisles and horseshoe arches.

The highly skilled Mudéjar plasterers and bricklayers were employed to build churches, chapels and monasteries for the Christians in many parts of Spain. Alfonso X had used them in 1258–60 for his Royal Chapel in Córdoba, which has an impressive ribbed dome. More characteristic of Mudéjar architecture are the free-standing brick belfries built in several Aragonese towns from the 13th to 15th centuries; these are either square or octagonal and decorated with tiers of trellis pattern and blind horseshoe arcading, occasionally mixed with bands of coloured tiles. Calatayud and Teruel each have several examples of such belfries with a pleasant decoration of plain and patterned brickwork.

Traces of Mudéjar craftsmanship are strikingly present in many of the castles built by the kings and their noblemen in the 15th century, intended as an aggressive expression of their own ascendancy as well as being genuine defences in troubled times. Often they had heavily battlemented and turreted exteriors which concealed a life of luxury within. Charles the Noble summoned Mudéjar craftsmen to decorate the fine apartments and terraces of his castle at Olite in 1402–19, an act of deliberate eclecticism on his part, as Navarre was dominated by French craftsmen. Castile,

named after the hundreds of castles that had been built there as a defence against the Moslem invasions 700 years earlier, has many outstanding examples. The imposing castle of Escalona near Toledo was given by Juan II to his prime minister and favourite, Alvaro de Luna, who built himself an elaborate Mudéjar palace complete with a tilting yard within its walls. Two other of Juan's courtiers, who were opposed to de Luna, had competing castles built at Torrelobatón and Fuensaldana near Valladolid. More lavishly decorated and romantically situated is the Alcázar of Segovia, developed by Juan II and his son, Enrique IV, who was so much in love with the East that he wore oriental clothes. The most obviously Mudéjar in external appearance, however is the castle of Coca which was finished in 1500 by one of the Fonseca family. Built of pink-coloured brick of different shades which form banded patterns, this castle has the octagonal turrets and intricate plan of Moorish fortresses. Inside some rooms and passages there are wallpaintings employing the abstract, interwoven motifs of Moorish art.

Flamboyant Gothic in Castile

In the meantime, another stylistic influence was impressing itself on patrons – that of Flamboyant Gothic, which was carried into Spain by a fresh spate of northern craftsmen, including many from the Low Countries and Germany. Gothic was still considered the most suitable style for important ecclesiastical buildings, and Flamboyant Gothic was immediately attractive to the Castilians, who were already devoted to intricate decorative effects. It especially lent itself to the last stages of cathedral building when spires, cloisters and memorial chapels were added.

One of the first private chapels in this style was built onto the cathedral at Toledo from 1435–50 for Alvaro de Luna as his family burial place. The last stages of its decoration involved the master-artist of Toledo, Anequin de Bruselas, who came from Brussels. He worked a fine tracery of ogival arches and naturalistic foliage around the chapel walls in stone and later went on to add the pinnacled lantern and spire, and to design the Puerto de los Leones, which is flanked by lions bearing heraldic shields. His style was transmitted to a whole school of craftsmen, among whom were Juan Aleman, his own nephew Enrique Egas who later became master-artist himself, and Juan Guas, the son of another foreigner. Meanwhile, the bishop of Burgos, Alonso de Cartagena, had brought back a German architect, Juan de Colonia (Hans of Cologne), from his visit to the Council of Basle in 1442. He also set up a workshop of different kinds of craftsmen, who were to bring new ideas to Spanish architecture. Their first work was to complete the west front of Burgos by crowning the twin towers with openwork spires, which were just about finished when bishop Alonso died in 1456. The pierced latticework of the spires, filled with a great variety of tracery patterns, is a direct importation from Rhineland cathedrals such as Freiburg. Nothing could be further from the Gothic cathedrals in Catalonia than the northern spikiness of the crockets and pinnacles and the deliberately decorative quality of the stonework.

These same qualities were emphasised later by Juan de Colonia's son, Simón, who went on to surpass his father's achievement. In his two outstanding buildings, the church of the Carthusian monastery of Miraflores and the Constable's Chapel in Burgos Cathedral, we find that the ogival arches have lost their Gothic upsurge, and are hung with an incredible fretwork of little figures which are meticulously detailed in themselves and yet dissolve into an abstract pattern from a distance. In both buildings there are huge eight-pointed star vaults filled with pierced tracery let into the roof above. Somehow Flamboyant Gothic has been transmuted into

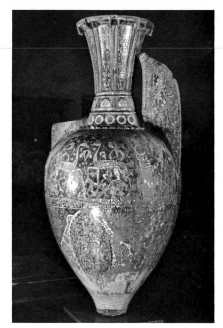

87

THE ALHAMBRA VASE
14th century
The Alhambra, Granada

Ceramic workshops developed in Málaga under the Nasrids. There the tiles which were used in the decoration of the Alhambra were made, as well as large plates and vases of the ambitious size and shape shown above. The pointed base suggests that it was intended to be hung in a metal stand. The decoration is organised into distinct units, not unlike the areas into which the walls of the Alhambra Palace are divided. It consists of arabesques, confronted animals and lettering painted in gold lustre and cobalt blue.

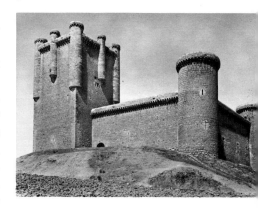

88

TORRELOBATON CASTLE
15th century
near Valladolid

This formidable edifice has a square keep 150 feet high with bartizan turrets and heavy machicolations. It is only one of many castles still preserved in Castile that indicate the extent of self-aggrandisement among 15th-century Spanish nobles.

something very close to Moorish work – something uniquely Spanish. The same sort of synthesis of styles had been achieved earlier by Anequin de Bruselas and Juan Guas in Toledo, where close contact with Mudéjar art made a blending of southern and northern styles less surprising. Onto this new style was superimposed a heraldic element, first glimpsed in the Puerto de los Leones in Toledo and then emphasised by Guas on the façade of the Infantado Palace in Guadalajara, where there hangs the armorial shield of the Mendoza family supported by satyrs. Simón de Colonia followed Guas in using vast escutcheons for decorative effect.

The Catholic Kings and the forging of a nation

In the political sphere a union of immense significance for Spain had taken place. This was the marriage of Isabella of Castile, Juan II's daughter, with Ferdinand of Aragon in 1469 (the Catholic Kings). Neither of them were in direct line for their respective thrones, but within the next ten years all obstacles fell away and Aragon and Castile were united under their joint rule. The queen's religious zeal combined with the king's military and diplomatic ability were to be the making of Spain. Feudal anarchy, which had plagued the country for so long, was stamped out by means of a strong centralised government. Then, as a matter of national pride and as a way of welding national unity, religious uniformity was strictly enforced by the New Inquisition. As with all strong political measures, there were victims and losses, especially among the Jewish community, which had long been in disfavour in spite of its valuable contribution to Spain's cultural life over centuries. In 1492 all unconverted and thus 'disloyal' Jews were expelled. The Mudéjar synagogue of El Transito was taken over by the Knights of Calatrava, one of the four military orders.

Ferdinand and Isabella were energetic builders as well as administrators. In 1476 they celebrated their victory over the king of Portugal, which extinguished his claim to the Castilian throne, by founding the royal **89** church of San Juan de los Reyes in Toledo. The exterior and the nave have a majestic simplicity, but the transept is decorated by a combination of festooned arches, canopies, statues, open balustrades, eagles and crowns. Ferdinand and Isabella had intended it as their burial place and their initials appear in many places, as do their coats of arms. Gothic inscriptions in their praise are worked into the walls, as in Moslem buildings, **265** and appear again on the friezes of the delicately fenestrated cloister.

Later on, in 1492, Guas was commissioned to build the College of San Gregorio in Valladolid by Isabella's confessor, Don Alonso de Burgos. The façade, like a giant retable, is mainly Gothic in detail but it is so intricately carved that its effect is almost oriental. It is a continuation of the style that Guas had used for the Infantado Palace in Guadalajara and shows how much he, like other foreign artists, had been stimulated by what he saw in southern Spain. However, far from slavishly following Moorish work, he became gloriously inventive. Though the arches of the upper gallery of the cloister are filled with opulent, fringed filigree work and the main doorway is intricately cusped, the wierd battlementing of broken **105** twigs and the hairy escutcheon bearers spring from a northern imagination. At the same time, the pomegranate tree scaled by cupids indicated that Guas was also receptive to Italian ideas. Indeed, the front of the Infantado Palace is studded with bosses which are reminiscent of the Schifanoia palace at Ferrara in Italy, built in the 1460s.

Exactly the same superficially ornate quality can be found in the sculpture of the period, which influenced architecture as much as architecture influenced it, employing and developing many of the same devices. **93** Saragossa, Seville and Toledo cathedrals have superb examples of retables

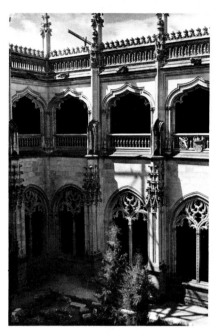

89
CLOISTER
1494–1510
Juan Guas and others
San Juan de los Reyes, Toledo

The church of San Juan de los Reyes, intended by Ferdinand and Isabella as their burial place, is Guas's most distinguished achievement within the main Flamboyant Gothic tradition. Although the inside of the cloister, like the interior of the church, is highly decorated, the exterior is comparatively simple, with plain walls and only the window tracery and mouldings for adornment.

made by workshops of craftsmen under the direction of one or several masters. The leading sculptor of the Isabelline period was undoubtedly Gil de Siloe who came from Antwerp and was working in Burgos by the middle of the 15th century. To the Constable's Chapel he contributed the wooden retable of Santa Ana, which has a mere nine compartments containing gilded and painted figures. At the end of the century he conceived a far more ambitious retable for the chapel of the Carthusian monastery of Miraflores which Simón de Colonia had built. This has a composition based on circles rather than rectangles and it supports over twenty complex scenes carved in wood; some of these are moveable and could be changed to suit the different festivals of the year. Also by Siloe are the alabaster effigies of Juan II and his queen which were commissioned by **72** Isabella in 1486 for the Miraflores chapel. They are placed in a starshaped tomb which echoes the vaults above. The figures are carved with a precision which attempts to recreate the details of jewellery and brocaded fabric. To one side is the kneeling effigy of their son Don Alonso, who would have reigned instead of Isabella had he lived. The sculpture round his memorial is incredibly complex and it is hard to know if the work was conceived by Siloe or Colonia. Siloe sculpted a relief of himself, a tiny figure in spectacles, at the base of the tomb.

In spite of the decoration, the faces of the effigies, like the dozens placed in the retable around the tortured figure of Christ, have a naturalistic human quality. The same is true of most Spanish sculpture at this time, which had long been under the influence of Burgundy, where expressive sculpture was developed under the Fleming Claus Sluter. A tender humanity appears in the terra-cotta work of Lorenzo Mercadente on Seville Cathedral, and in Sigüenza Cathedral there is a beautiful effigy of a **90** young knight reading a book.

This knight was called Martín Vázquez de Arce and he was killed on the plain of Granada. The continued existence of Granada as a Moslem state had been a thorn in the flesh of Ferdinand and Isabella in the early part of their reign. They had made inroads in 1482 by capturing Alhama, but it needed a concerted national effort and a dynastic crisis among the Nasrids for Granada to be finally conquered in 1492. At last, after 800 years, the Reconquest was completed. The event is reflected in art not only in the tombs of certain nobles killed there (such as the Constable of Castile, whose wife continued work on the Burgos Cathedral chapel after his death at Granada) but in subject matter as well. The pomegranate tree on the façade of San Gregorio is an allusion to Granada, which means pomegranate. And among the reliefs on the lower choir stalls of Toledo Cathedral are some by Roderigo Alemán showing the conquest of Granada as a dramatic event with horsemen lined up to attack the Moslem fortress.

When the Catholic Kings entered Granada they were impressed with what they found. Although they destroyed the main mosque they took great care of the Alhambra and entrusted its restoration to Moorish craftsmen, a tacit acknowledgement of how much Moorish art had stimulated and enriched Spanish art generally for centuries past. For themselves they planned a royal burial chapel, thinking that Granada was a more significant place for their mortal remains than San Juan de los Reyes in Toledo. The chapel was designed by Enrique de Egas, now the master-artist of Toledo, who also planned a pilgrims' hostel in Santiago de Compostela under Isabella and Ferdinand's direction.

The fashion for Flemish and Italian styles

Isabella herself was devoted to Flemish painting, and her inventory lists works by Rogier van der Weyden and Dirck Bouts as well as a triptych

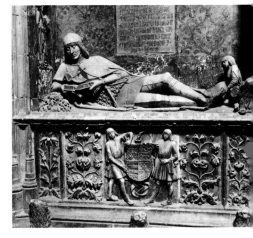

90
TOMB OF
DON MARTIN
VAZQUEZ DE ARCE
c. 1495
Sigüenza Cathedral
Don Martín Vázquez de Arce was killed at the age of twenty-five, while helping 'certain people of Jaén in the plain of Granada', as the Gothic inscription tells us. He is dressed as befits his knightly status in chain mail and armour with a red cross upon his breast and his squire kneeling at his feet, but his eyes are bent dreamily upon a book. The carving of the figure itself is entirely Gothic, but the round-headed arch above and the symmetrical plant motifs on the sarcophagus look forward to the Renaissance.

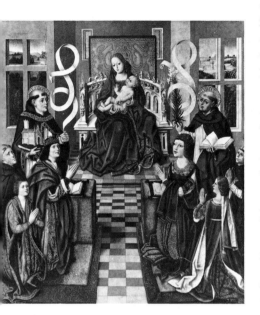

91
THE VIRGIN
OF THE CATHOLIC KINGS
Prado, Madrid

It is tempting to believe that the picture was directly commissioned by Isabella, but unfortunately there is no evidence of this, and no means of identifying the artist. He was evidently a Castilian, painting within the realistic Flemish tradition so much admired by the queen. The panel shows her in prayer at the feet of the Virgin and Child and two saints, accompanied by Ferdinand and two of their children. Also to be seen are Father Tomás de Torquemada, the Inquisitor-General, and Pedro Martire de Angliera, author of the first history of America, *Decades de Orbe Novo.*

by Juan de Flandes, the court painter; some are now displayed in the sacristy of the Royal Chapel at Granada, and there are others in the Royal Palace in Madrid. Flemish realism had been introduced to Castile by Jorge Ingles in the 1450s, and this influenced Castilian artists more strongly than Dalmau, Huguet and Bermejo in Aragon. The stark emotional expressiveness of Flemish painting was developed in later years by the Gallego brothers, amongst others, who collaborated on various works in and around Salamanca. The more versatile of the two was Fernando, who had great feeling for light and space as well as for the sculptural modelling of faces and hands, a notable feature in later Spanish painting. An interesting departure from the usual altarpieces is the vast mural which he executed for the University of Salamanca, possibly with Pedro Berruguete, who had been his pupil before going to Italy in the 1470s to work for Duke Federigo di Montefeltro of Urbino.

It is tempting to see Berruguete's hand in the Salamanca University mural because the intellectual astrological scheme no longer has a strictly Gothic look, but has been injected with a quality which people of the time would have labelled 'antique'. Berruguete had been in Italy during the crucial years of the early Renaissance and although he remained basically Flemish by training and inclination, he was nevertheless influenced by some of the artistic innovations of the time. Some of his pictures, such as *St Dominic and the Albigenses*, include architectural back- **99** grounds which show a grasp of perspective and a controlled mastery of grouping in the crowd scenes. But like most Spanish painters he never became entirely committed to foreign influences; he still sometimes used gold backgrounds and paid attention to the folds and the decorative details of garments, as earlier Gothic artists in Spain had done. He did, however, bring a new spirit of gentle humanity to his work.

Renaissance elements had made their appearance in Spanish architecture as early as 1490, when Cardinal Pedro González de Mendoza encouraged Lorenzo Vazquez to incorporate a Classical doorway in the College of Santa Cruz in Valladolid, which became the official capital of Spain after the conquest of Granada. The cardinal is typical of the handful of patrons, drawn from the noblest families, who were responsible for spreading Renaissance ideas in Spain. Most of them would have travelled to Italy and have seen how much the ducal courts there were at the centre of the immense intellectual and cultural activity of the time. Although the humanistic ideas they helped to introduce were basically inimical to the religiosity prevailing in Spain, architectural and artistic devices from Italy found an easy access, just as Moorish motifs had done earlier. Renaissance-inspired buildings were planned, appropriately, for the university town of Salamanca by two generations of the Fonseca family.

Not surprisingly, Ferdinand, who had taken possession of Naples for Aragon again in 1504, also favoured the fashion for the Italian style and chose a Florentine, Domenico Fancelli, to create the monument which should be a perpetual reminder of the glory and achievement of the Catholic Kings in the Royal Chapel at Granada. This monument, carved in Carrara marble, is separated from the nave by a magnificent wrought iron grille (*reja*) which is also in a Renaissance style, by the Spaniard Bartolomé de Jaén. *Rejas* like this with elaborate floral cresting had become an essential part of Spanish church and cathedral furniture, and superb examples can be found in most of the chief cathedrals. They reflect the growing wealth of the country – a wealth that was increased by the precious metals which flowed in after Columbus's discovery of America.

Richard Benedict

92 *right*

WEST FRONT, BURGOS CATHEDRAL

13th – 16th centuries
Juan de Colonia and others

Rising magnificently from the side of a hill, Burgos closely follows the design of contemporary French cathedrals. The lower part was built in the 13th century; the openwork spires, reminiscent of Freiburg, were added by the German Juan de Colonia in the 15th century. The central lantern, which was designed by his grandson in 1540, adheres to the pinnacled style of Flamboyant Gothic, though it incorporates some Renaissance details.

93 *centre*

MAIN ALTARPIECE *detail*

1498–1504
gilded and painted larchwood
Toledo Cathedral

Designed by a number of craftsmen under the direction of Enrique de Egas, this colossal altarpiece rises in five vertical rows of reliefs showing scenes from the New Testament. Each life-size relief is recessed beneath its own highly decorated canopy and vault. The lowest central space (to the right of this picture) is reserved for a silver-gilt monstrance.

94 *below*

ALTAR FRONTAL

c. 1370
silk and gold thread
Guadalupe Monastery

Gothic embroidery successfully attempted the same animated narrative scenes from the gospels as painting and sculpture. Indeed, painters usually supplied the cartoons, and obviously in return gained inspiration from the patterned brocades and raised gold thread work. Altar frontals were often commissioned as gifts to the Church; this one is associated with Enrique II, the successful pretender to the throne of Pedro I of Castile.

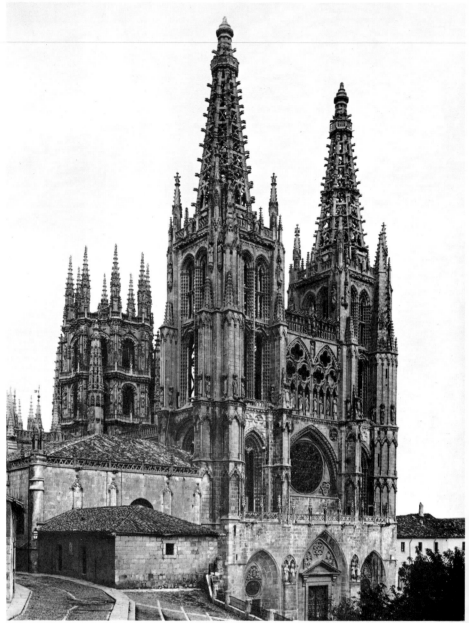

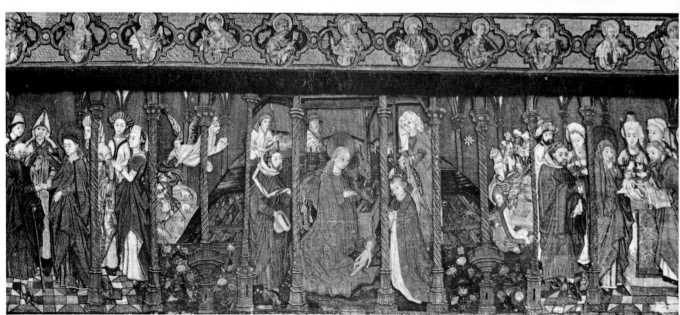

95 *bottom right*

SEVILLE CATHEDRAL

1402–1506

The great mosque at Seville had been used as a cathedral for 150 years before the chapter decided to build the largest Gothic construction in the world. Although the first architect was probably French, he was clearly influenced by the Spanish taste for broader proportions combined with immense height. Seville was to become the model for later Gothic cathedrals such as Salamanca and Segovia, built in the Renaissance period. The star vaults were designed early in the 16th century.

96 *below*

LONJA DE LA SEDA

1483–98
Pedro Compte, d. 1506
Valencia

Valencia was one of the most prosperous medieval cities, importing and producing many traditionally Moorish wares, such as pottery and silk. This *lonja* was where the merchants met to buy and sell silk, which was then distributed throughout Europe. Its vaulted roof is supported by spiral columns which had already been introduced in another fine *lonja* in Palma. The outside shows signs of Italian influence.

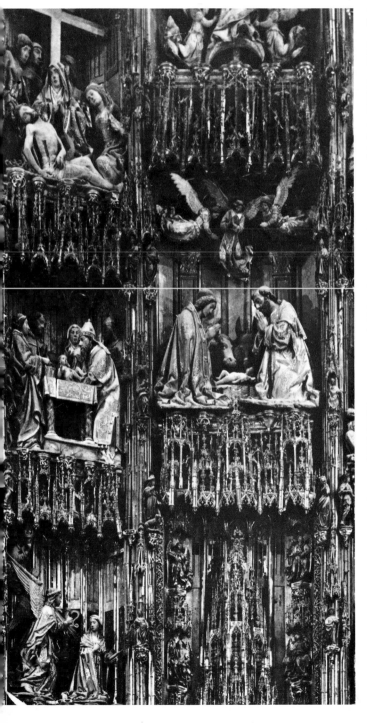

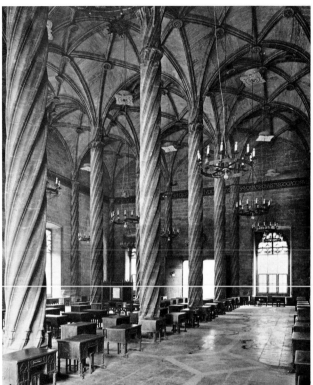

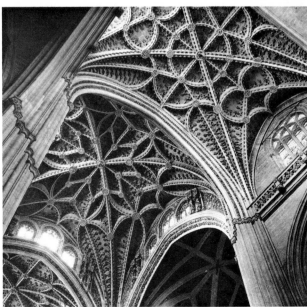

97 *right*

SANTA MARIA LA BLANCA

13th century
Toledo

Although many Gothic craftsmen were Jewish, they left behind
little concrete evidence of their own culture; indeed, the main
contribution of the Jews was in the realm of thought. They were
obviously quite content to have their synagogue built in the style
of a mosque by Mudéjar workmen. In 1405 it was seized by the
Christians and given its present name. Some of the decoration on
the capitals and the spandrels between the arches is unique.

98 *top centre*

NORTH TOWER, TOLEDO CATHEDRAL

1380–1452
Anequín de Bruselas and others

The lantern and spire, reaching to a height of 295 feet, were added
by the Flemish architect to the existing five storeys soon after he
came to the Mudéjar city of Toledo to direct the cathedral works
for the primate of Spain. The lantern is embellished with pinnacles
and the spire is encircled by three bands of horizontal rays
suggesting the Crown of Thorns. Below is the deeply recessed
Puerta de los Leones.

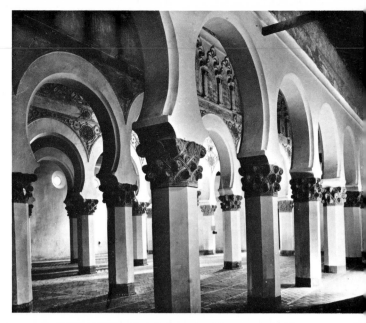

99 *right*

ST DOMINIC AND THE ALBIGENSES

c. 1485–95
Pedro Berruguete c. 1450–1504
oil on panel
Prado, Madrid

After the death of the Duke of Urbino, Berruguete returned to
Spain with an international reputation. He found patrons of equal
eminence in Spain; his work was commissioned by no less
personages than Torquemada, the Inquisitor-General, and
Cardinal Ximenes de Cisneros, the primate of Spain. In this
altarpiece the subject is ostensibly that of St Dominic's campaign
against the Albigensian heresy in the 13th century, but clearly it
refers to similar purges under Torquemada and Cisneros. The
painter had learnt much in Italy; the figures are perfectly propor-
tioned and schematically arranged against the architectural back-
ground.

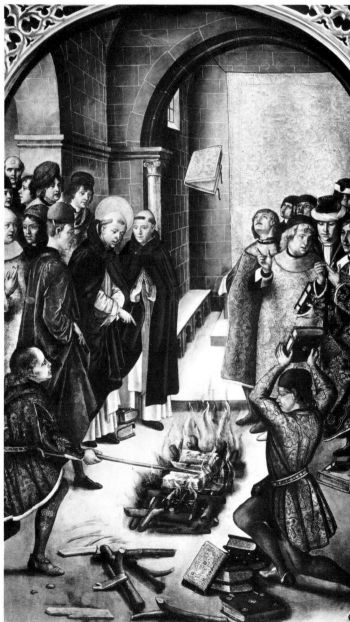

100 *far right*

VIRGIN OF THE COUNCILLORS

1445
Luis Dalmau, active 1420–60
oil on panel
Museo de Arte de Cataluña, Barcelona

This altarpiece was commissioned by the councillors of Barcelona
for their municipal chapel in 1443. As was often customary
throughout European painting, the donors are included in the
composition, paying homage to the Virgin in company with
saints and angels. They are painted with a bulky realism which
stands in contrast to the lyricism of Catalan painting of the time
and is clearly a result of Dalmau's training with the Van Eycks in
Bruges in the early 1430s. Indeed, the faces of the angels and the
distant landscape are so reminiscent of the Ghent Altarpiece that it
seems likely Dalmau knew this work well.

101 *left*

ST THECLA
AND THE SNAKES

1426–33
Pedro Johan d. 1445?
alabaster relief
Tarragona Cathedral

Pedro Johan, son of a Greek slave, was probably Catalonia's leading sculptor in the first half of the 15th century before more ornate styles took over. This panel from the main altarpiece of Tarragona Cathedral shows how he, like Ghiberti, could lay out his relief in several planes to create a sense of perspective, and how at the same time he invested his subject with considerable energy. The evil water snakes whip away from the virgin martyr in a terrific flurry.

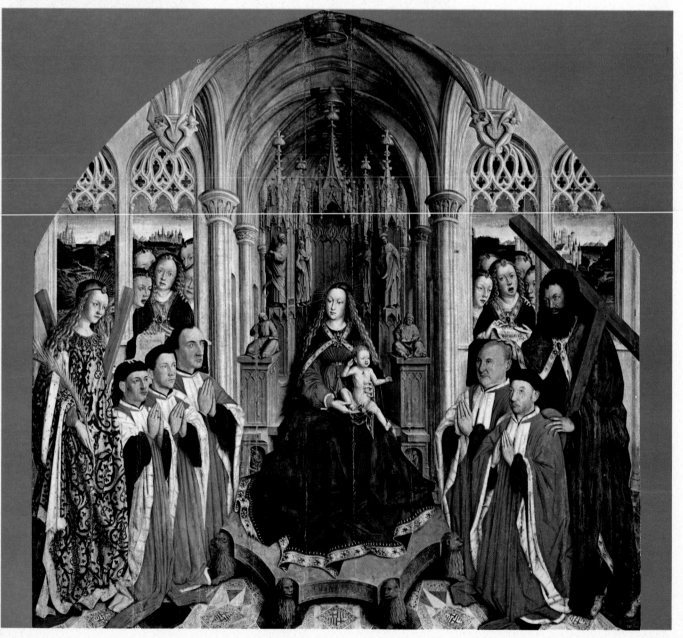

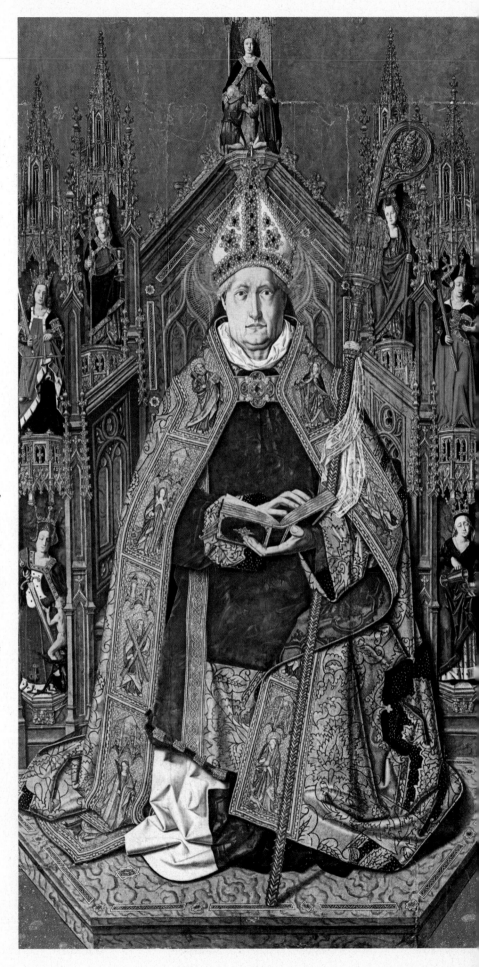

102 *right*

ST DOMINIC
OF SILOS ENTHRONED

1474–77
Bartolomé Bermejo, d. 1498
oil on panel
Prado, Madrid

This is one of the finest works of the
Córdoban painter Bermejo who, unlike
most Spanish painters, was not tied to a
particular centre but moved around many
Spanish towns and may even have been to
Flanders. Certainly the quality of his colour
and the superb rendering of the saint's face
show a complete mastery of Flemish
techniques. The realistic female figures,
who represent the Seven Virtues, are
curiously at odds with their ornate
architectural setting and the lavish gold
background, yet form a combination
which is profoundly Spanish.

103, 104 *centre right*

CONSTABLE'S CHAPEL
AND VAULT

c. 1482–94
Simón de Colonia, d. 1511
Burgos Cathedral

Situated behind the high altar at Burgos is
the richly sculpted Constable's Chapel.
This was planned by the Constable of
Castile, Don Pedro Fernandez de Valasco,
as a family burial place. After his death in
1402 his widow, Doña Mencia de
Mendoza, continued to supervise the work,
and her arms, as well as his, are massively
represented on the walls. The chapel
represents the triumphant combination of
styles which Simón de Colonia achieved.
To Flamboyant Gothic elements he added
the even more delicate hanging fretwork
of Moorish work and devised the superb
vault (**103**) filled with stone tracery in the
shape of a star open to the sky. The central
boss of the star is decorated with a
Presentation at the Temple and with
pendant figures of saints. The main
altarpiece, a Renaissance work by Diego de
Siloe and Felipe Vigarny, also shows a
Presentation below the dramatic
Crucifixion.

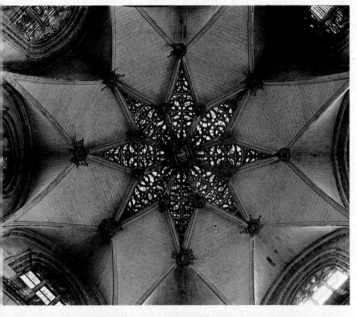

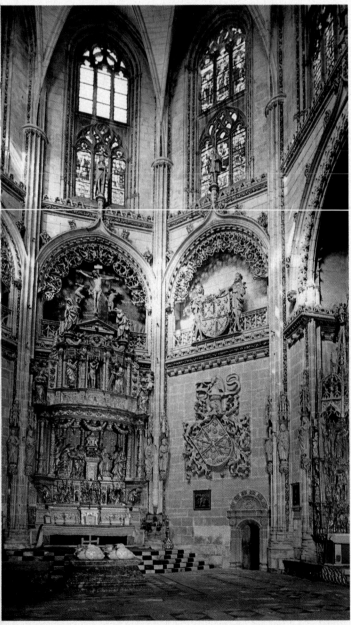

105 *below*

SATYRS

1492
Juan Guas, d. 1495
College of San Gregorio, Valladolid

These are two of eight satyrs which stand in eye-level niches beside the main door of the college. They are only one of many fantastic elements which Guas managed to incorporate into the façade, drawing on the northern culture of his forbears, as well as being influenced by Moorish and Italian ideas. These satyrs, or woodwoses, were probably originally drawn from a pagan tradition and adopted as heraldic bearers in 15th-century Germany and France. Guas also uses them subsequently on the façade of the Infantado Palace in Guadalajara. Although they are unlike anything else in Spain, their highly textured hairy bodies made them suitable devices for the richly decorated effects of Isabelline architecture.

'Sire, God has been merciful to you; he has raised you above all the kings and princes of Christendom to a power such as no sovereign has enjoyed since your ancestor Charles the Great. He has set you on the way towards a world monarchy, towards the uniting of all Christendom under a single shepherd.' When chancellor Gattinara addressed these words to his imperial master, the recent splendour of Charles V's coronation still lingered in his memory and gave to his pious hopes the ring of conviction.

On 23 October 1520 Charles, bearing Charlemagne's golden crown upon his head, armed with his sword and clad in his tunic, was proclaimed Holy Roman Emperor at Aachen. Charlemagne had been crowned in Rome, but now it was deemed expedient to please the restive German princes, for Charles had inherited a political situation of daunting complexity, exacerbated by the religious strife occasioned by the Reformation, which had begun in 1517.

At this time Charles had already been king of Spain for four years, the first Hapsburg to rule in the country. His mother Joanna the Mad, daughter of Ferdinand and Isabella, had been made queen of Castile on her mother's death in 1504, although she was clearly unfit to rule. Charles was first recognised by Ferdinand as heir to the throne of Aragon, and then on his own insistence he was proclaimed king of Castile also, instead of merely regent for Joanna. Thus this shy youth of sixteen, whose life had been spent in the Netherlands, became the first king of a united Spain with the foundations of her overseas wealth truly laid.

Charles was born in 1500, and as his father Philip the Fair had died in 1506, his upbringing was supervised by his aunt the Archduchess Margaret, a beautiful, cultivated widow. A firm grasp of political issues governed her choice of mentors for Charles. Adrian of Utrecht (later Pope Adrian VI) was the spiritual adviser who laid the foundations of his steadfast allegiance to the Church. An even more powerful influence was the Burgundian Grand Chancellor Chièvres who, as Charles subsequently admitted, dominated his will entirely. Chièvres encouraged the boy to take an interest in courtly pursuits, so despite a frail physique he became a superb horseman, taking great pleasure in the joust.

Charles's shyness turned in old age to melancholy withdrawal, and conversation too was painful for him. A lisp made him a poor linguist and, notwithstanding his careful education, he was such an indifferent Latin scholar that in his last years he was forced to beg a dispensation from the Inquisition, for he wished to read the Gospels in French as he could not manage the Latin version.

However, one passion of his life he indulged freely, the patronage of artists, and his wide-flung political power facilitated the acquisition of superb works as lesser rulers sought his favour. His aunt undoubtedly fostered his aesthetic judgement, for she herself amassed a fine collection which she proudly displayed to Dürer. All these factors do much to explain the international character of Spanish royal patronage and the way in which indigenous features of Spanish art were sometimes suppressed or modified by foreign influence.

Therefore it is not surprising that one of Charles's first acts on his arrival in Spain in 1517 combined filial piety with his role as patron. On the death of her husband his mother, Joanna, had become incurably insane; each night for six months she had walked, candle in hand, around his coffin, periodically ordering that the lid be raised so that she might confirm that his body had not been snatched from her. Domenico Fancelli, who was sculpting the tomb of the Catholic Kings, had been commissioned to execute Philip's tomb, but had failed to complete it.

Hapsburg Patronage and the Influence of Italy

1516–C. 1600

106

CHARLES V AT THE BATTLE OF MUHLBERG
1548
Titian c. 1487/90–1576
oil
Prado, Madrid

This portrait presents a contrast to Titian's earlier work: the handling is freer, the shadows deeper and the colours glow more fitfully. The design is based on the equestrian statue of Marcus Aurelius, which was then believed to represent the Emperor Constantine and was an especially apposite model for this commemoration of a victory that had an overtly religious aim.

Now Charles decided to expedite matters. He had clearly admired Bartolomé Ordóñez's beautiful Renaissance screen in Barcelona Cathedral, which he had seen shortly before, and he may also have been repelled by Fancelli's old-fashioned monument to his uncle Prince Juan. In any case Charles promptly transferred the commission to Ordóñez, who was able to invest his figures with generous rhythms and deep emotional feeling. But the enterprise was ill-fated for the sculptor died at Carrara while he was engaged on the tomb.

Charles's involvement in Europe and his wish to be an effective emperor brought a succession of political and military crises. By 1525 his fortunes seemed at their nadir: 'When I sat down to think out my position I saw that the first thing at which I must aim and the best that God could send me, was peace. Peace is beautiful to talk about but difficult to have, for as everyone knows it is difficult to have without the enemies' consent. I must therefore make great efforts—and that too, is easier said than done. However much I scrape and save it is often difficult for me to find the necessary means.' His prospects improved with the news of the French defeat at Pavia, but to his courtiers' astonishment he forbade any celebration, ordering services of thanksgiving instead.

The spread of Classicism

This noble austerity, which was a pronounced feature of his character, also marked the style of the designs which Pedro Machuca devised for his palace in Granada, its stark Classical mass challenging the delicate exotic beauty of the Moorish pleasure gardens of the Alhambra. The architect had been in Rome and may even have been Raphael's pupil. Thus his familiarity with the High Renaissance buildings of Bramante, Sangallo and Raphael inspired the circular courtyard reminiscent of the latter's Villa Madama, and the unusual axis of the entrances of the south and west sides recalls Giulio Romano's innovations two years earlier at Mantua. Yet the detailing of much of the building shows typically Spanish Plateresque elements: the crisp, chaste lines of Classically-inspired Renaissance ornamental motifs are converted by a cursive organic rhythm into a superabundant efflorescence.

But perhaps these decorations were not inappropriate, since the erection of the palace commemorated the happiest event in Charles's life, his marriage to the lovely Portuguese Infanta Isabella, of whom he was so deeply enamoured that he neglected all cares of state for several months. During this period Renaissance culture became firmly established in the Spanish court, which welcomed foreign scholars. Of these, the chief luminary was Baldassare Castiglione, the Papal Nuncio, whose idealistic book *The Courtier* must have appealed to the monarch's finer feelings.

Classical learning also began to permeate the teaching in the universities and among the first to yield to the lure of Humanist thought were the scholars at Alcalá de Henares. Yet despite their venturesome modernity they were still obliged to comply with the dictates of the Inquisition and refused admission to the converted soldier Ignatius Loyola because his fervour was feared and suspect. Paris was more liberal, and thus the Society of Jesus was founded by a Spaniard in a foreign land.

Not unnaturally the university buildings reflected the avant-garde interests of the intelligentsia within, and Alcalá was one of the first secular structures to boast Renaissance features. Built around 1519, Pedro de Gumiel's University Hall (*Paraninfo*) contained a strange amalgam of Mudéjar decoration in the painted wooden ceiling, with the elaborate stucco ornaments in the gallery proliferating indiscriminately on pilasters, arcading and entablature. Later, in 1537, Rodrigo Gil de Hontañón

107
108

113

115

110

107
MONUMENT
TO PRINCE JUAN
1511
Domenico Alessandro Fancelli 1469–1518
marble
San Tomás, Avila

When Fancelli arrived in Spain in 1510 his style was already cast in the mould of late 15th-century Italian sculpture, and had little in common with that of the High Renaissance developing in Florence and Rome. The overall effect is one of a precise, symmetrical design, with each figure contained by a shell-headed niche.

108
MONUMENT
TO
PHILIP THE FAIR
1519–20, marble
Bartolomé Ordóñez, active c. 1500–20
Royal Chapel, Granada

Ordóñez was a native of Burgos, which boasted one of the finest examples of Gothic tomb sculpture, Gil de Siloe's monument to Juan and Isabella of Portugal. But Ordóñez's royal monument is quite different in style, expression and structure. He studied in Florence, probably under Andrea Sansovino, and his lively eye quickly appreciated the essential features of the Renaissance. When Ordóñez died most of the sculpture was completed, but the whole was not assembled until 1603.

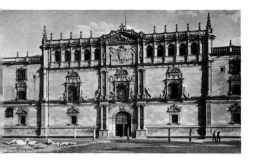

109
UNIVERSITY, ALCALA DE HENARES
1537–53
Rodrigo Gil de Hontañón 1500/10–77

Rodrigo was the son of one of the most celebrated architects of the earlier generation, Juan Gil. He was a cultivated man, preoccupied with arithmetical theory, which formed the basis of his treatise *Com pendio de arquitectura simetria de los templos conforme a la medida del cuerpo humano*. The façade comprises two overlapping squares which enclose the central area of the frontispiece. Its refined design was much appreciated and it was acclaimed amid rejoicing and fireworks.

110
UNIVERSITY HALL
1519
Pedro de Gumiel
University of Alcalá de Henares

The style known as Cisneros, of which de Gumiel was one of the chief exponents, is a fusion of the three major trends in early 16th-century Spanish architecture: Mudéjar, Plateresque and an imperfect sense of Classical forms. The Moorish-based Mudéjar occurs in the ceiling, while the Plateresque is reserved for the intricate wall decoration that almost obscures the Classical elements in the structure. The patron at Alcalá was Cardinal Ximenes de Cisneros, who was famed for his learning and the immense political power he had wielded during the reign of Isabella.

designed the façade of the university in what is known as the Second Plateresque style, a more restrained version of the earlier style. Here a splendid frontispiece of superimposed orders, crowned by a pediment, is redolent of the Classical influences prevailing in Spain, while the detailing of the window surrounds introduces a note of delicate extravagance. 109

Charles V and Titian

In 1530 Charles left for his papal coronation, which was in Bologna, not in Rome as he hoped. The rulers of the smaller Italian states viewed his progress uneasily and some sought to curry favour by offering works of art from their collections. Thus he was introduced to the works of one of the greatest Italian geniuses, Titian. In February 1533 Titian delivered a portrait of the emperor with a hunting dog. It was not such a penetrating likeness as the later portrayal of Charles in an armchair, now in Munich, because it was based on an earlier picture by the German artist Seisenegger – a fact which reminds us of the difficulties encountered by artists, for great men were often reluctant to waste time in prolonged sittings. But sometimes such borrowings were inevitable; such was the case in Titian's portrait of the Empress Isabella. 116

In May 1540 Isabella died in childbirth. It was a terrible blow, for although much of their life was spent apart while Charles dealt with the turbulent problems of Germany and Italy, he confided all his worries to the empress in long letters couched in the formal, deferential tone which he still maintained in a relationship which touched his emotions most intimately; even his enemies paid tribute to the regal restraint with which he always conducted himself. The loss of his wife cast a blight over his life which he never entirely banished, and in the early years of his bereavement he asked Titian to execute a portrait based on an engraving by Hollar. Titian had never seen Isabella, yet he was able to invest her with the blend of fragile beauty and decorum that Charles found so appealing. To us the portrait appears a little cold, but it corresponded to the lonely widower's mood and he refused to be parted from it until his death. 115

This success cemented Titian's friendship with the emperor, and in 1548 he joined the Imperial court at Augsburg. The previous year on the morning of April 24th Charles scored his greatest victory, defeating the Protestant Elector John Frederick of Saxony at Mühlberg. His aim was twofold, to restore the Hapsburg monarchy in Bohemia and to secure a triumph for the Church. Later Titian painted Charles's adversary, a thickset corpulent man clad in the plain functional armour in which he was captured. It offers a telling contrast to Titian's portrait of Charles himself riding into battle, which captures his extreme valour and resolution in the set of his jaw and the discreet splendour of the suit of armour. 106

These characteristics must explain the extraordinary loyalty that Charles inspired in his generals. Extraordinary, because even his most faithful commanders felt perplexed by his strange indifference and his niggardly recognition of their courageous exploits in his service. Yet despite the scurvy treatment meted out to the faithful Pescera, his son the Marqués del Vasto unselfishly laid all his brilliant intelligence at the disposal of the emperor. Titian has left us a vivid record of Del Vasto addressing his troops on the eve of battle, and the figure of the general claims our attention as effectively as his exhortations roused the spirits of his soldiers. 112

The influence of Italian Mannerism

The ramifications of Hapsburg power attracted foreign artists as well as scholars to Spain. One of the earliest to arrive was the hapless hot-head Torrigiani, who was banished from Florence because he had broken Michelangelo's nose, presumably while they were both working in the

Medici sculpture garden in Florence under the supervision of Bertoldo. The latter taught Torrigiani to respect fine craftsmanship—a quality which is notable in his most influential work remaining in Spain—the vital,
148 tautly constructed polychrome terra-cotta statue of *St Jerome*. Notwithstanding Charles's patronage Torrigiani's sojourn in Spain ended in tragic ignominy. Once more his temper was his undoing: in a fit of rage he destroyed a statue of the Virgin which a patron had rejected, the Inquisition imprisoned him and he died on hunger strike. Another Florentine who found favour with Charles was Jacopo Florentino. The heightened note of tragedy with which he imbued the *Entombment of*
125 *Christ* reminds us that Spain led to as a profound a modification in expressive mood in these Italian artists as contact with Italy induced in the work of the Spanish painters and sculptors who journeyed there.

Indeed two of these Spaniards, Pedro Machuca and Alonso Berruguete, played a leading role in the inception of Italian Mannerism. Berruguete, the son of the painter Pedro, was one of the greatest sculptors of the 16th century. Yet for some inexplicable reason Charles was cool towards him and, after a brief encouragement of his talents on the sculptor's return from Italy, spurned his services altogether. Thus Berruguete did not figure in the retinue accompanying the king to Germany in 1520 and the sculptor was forced to fall back on the patronage of courtiers and the Church.

Around 1504 Berruguete had travelled to Florence where he fell under the spell of Michelangelo's genius, and traces of this enthusiasm are visible in the heavy recumbent forms of the guard in the *Resurrection* which offers a disquieting contrast to the graceful realisation of the figure of Christ. Although much of his work consisted of polychrome
III, 145 woodcarvings, both the *Resurrection* and the *Transfiguration* in Toledo were carved in alabaster. This fragile stone enabled the artist to execute the most subtly fluid transitions in surfaces and to endow his figures with an urgent, rhetorical vigour that is almost Baroque. Berruguete's desire to impose on stone the malleability of clay or wax surfaces stemmed largely from a delight and skill in wax modelling which he learned in Florence, though it was also one of the aesthetic preferences of Mannerism.

The enclosure of the choir at Toledo was a demanding enterprise and Berruguete shared the task with two artists who had already attracted attention as champions of the new Italianate forms—Felipe Vigarny, who has left us a fine Renaissance-style profile relief of the great Cardinal Cisneros, and Diego de Siloe. The Frenchman Vigarny arrived in Burgos in 1498. Although he seems not to have visited Italy his only royal commission, the high altar of the Chapel Royal in Granada, was a remarkably early and spirited attempt to grasp the eccentric proportions exemplifying structural design in the new Mannerist style.

But Diego, who was the son of the celebrated sculptor Gil de Siloe, was the more original, complex artist. In his youth he travelled widely, and like Berruguete he went to Florence, where he too submitted to Michelangelo's powerful personality. Wisely, however, he never attempted to rival the great Florentine's daunting imagination, and his sculptures manifest a gentler mood, resulting in the tender classicism which animates the relief of the *Virgin and Child* on the choir stalls of San Jerónimo, Granada. Closer scrutiny reveals an agitated ripple in the drapery design and a great play on the encircling bracelets of flesh in the Christ-child's body. These restless elements recall Diego's powerfully inventive imagination: as an architect he invested structures with a surprising panache,
117 particularly evident in his Golden Staircase in Burgos Cathedral.

Most of the Spanish artists who visited Italy did so in their youth and

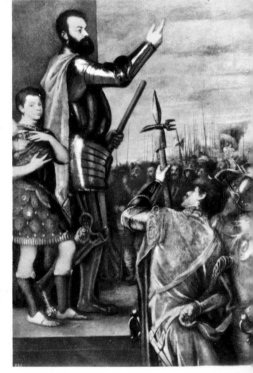

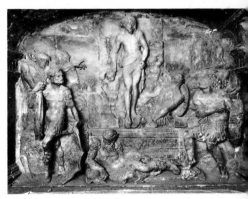

III THE RESURRECTION
c. 1517, Alonso Berruguete c. 1488–1561 alabaster, Valencia Cathedral

Berruguete had only just returned from Italy when he carved this relief, and it is still deeply imbued with Florentine influences, especially that of Michelangelo. Sansovino also probably inspired him; the flexible grouping of the soldiers recalls the Italian's designs for the Duomo façade.

112 *left*

THE MARQUES DEL VASTO ADDRESSING HIS TROOPS

1541
Titian c. 1487/90–1576
oil
Prado, Madrid

Here Titian has created both a portrait of one of Charles V's most resourceful and loyal generals, and the record of a dramatic moment; few could convey so simply the power of the general's words over the faceless horde of brutish mercenaries who made up the armies of that time. The picture arrived in Spain in the 17th century and may have belonged to Charles I.

113 *bottom*

COURTYARD OF THE PALACE OF CHARLES V

begun 1527
Pedro Machuca, active c. 1517–50
Granada

Part of the old Moorish Alhambra had to be destroyed to make way for the Renaissance palace which Charles caused to be built for himself and his young bride, Isabella. The great circular courtyard is one of the purest examples of the High Renaissance style in Europe. Its heroic scale may have been inspired by Hadrian's villa at Tivoli. The lower storey is a severe Tuscan Doric and the upper storey Ionic; there is no hint of Mannerist syncopation in the equidistant placing of the columns.

114 *left*

SALA DE LA CHIMENEA

1527–68
Pedro Machuca, active 1517–50
Palace of Charles V, Granada

The same austerity distinguishes much of the interior of the emperor's palace as occurs in the exterior elevations (**113**). In this room it is most pronounced because of the plain walls and the severe divisions of the barrel-vaulted ceiling; also there is an absence of the Plateresque devices which occasionally lighten the effect elsewhere in the building.

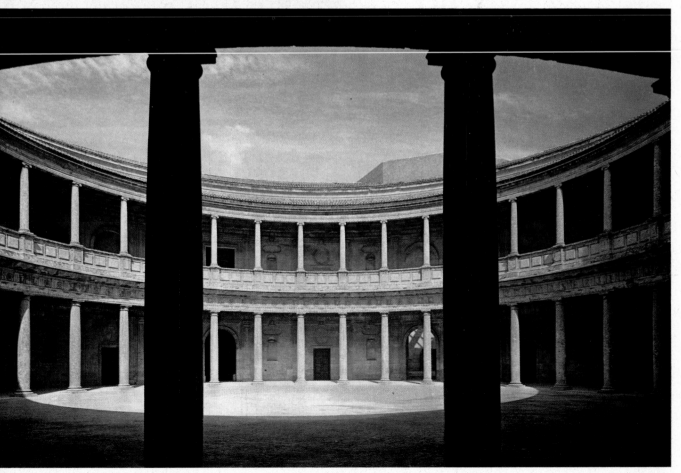

THE EMPRESS ISABELLA

1548
Titian c. 1487/90–1576
oil
Prado, Madrid

This was almost certainly the portrait
Titian executed for the emperor while he
was employed at the court at Augsburg.
The clear line of the brow, the regular
curve of the eyelids and the delicate nose
suggest that Titian may have idealised the
empress's beauty and made her appear
considerably younger than she actually
was at her death. Possibly Charles had
described his queen as she first appeared to
him when he claimed her as a bride, a
lovely petite girl of nineteen.

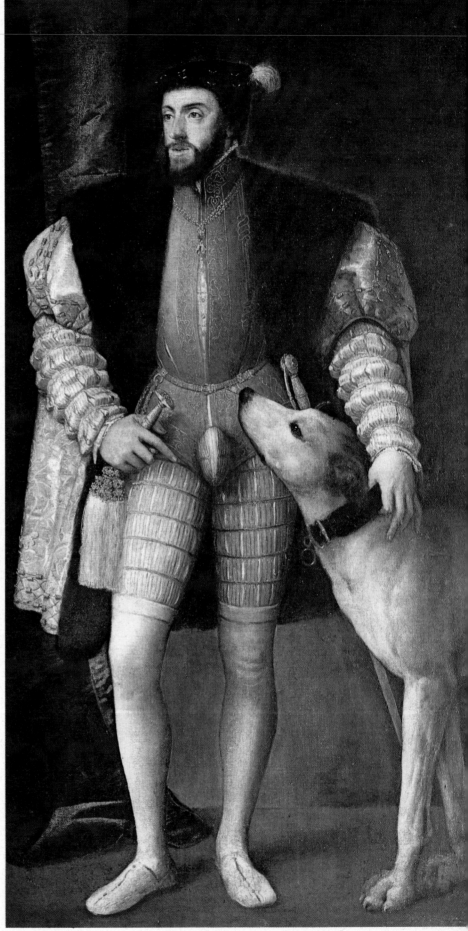

116 *left*

CHARLES V
WITH A HUNTING DOG

1533
Titian 1487/90–1576
oil
Prado, Madrid

While the stiffness of the pose may in part
be due to Titian's reliance on Seisenegger's
portrait which was sent to him to copy, it
may have been intentional; the emperor
was noted for his dignified bearing, which
bordered on the autocratic. Certainly
Charles was well pleased with the work
and Titian was appointed Portraitist-in-
Ordinary. Later, in 1623, Philip IV
dispatched it to England as a present to
Charles I, but on Charles's death it was
returned to Spain.

117

THE GOLDEN STAIRCASE

1519–23
Diego de Siloe c. 1495–1563
marble
Burgos Cathedral

Diego's staircase is a splendid extravaganza
which pays tribute to the Spanish love of
theatricality in architecture. Originally it
was painted as well as gilded; the paint and
much of the gilding have disappeared but
the effect still surprises by its audacious
disregard for the articulation of the
building. The structure of the staircase is
Renaissance and one of the earliest
examples of its kind in Spain, but the lively
flourish of sculptural decoration artfully
obscures the stark design.

although the sojourn was a formative experience, once they returned to
their native land they never left it. Consequently the Renaissance features
became obscured or modified by local taste and the overall spirit of their
works evince qualities which can be regarded as specifically Spanish. In
architecture it was discernible in the delight in extravagant ornament
which often covers the entire surface, as on the façade of Salamanca Uni- **118**
versity, and in the prolixity of Plateresque – so called because the densely
curling motifs are in such high relief that they resemble the forms beaten
out from behind associated with the silversmith's craft. Consequently,
while the individual devices were based on Classical sources, the end
result was infinitely more exuberant and sensual in its effect. This dislike
of the more restrained aspects of the Renaissance and avoidance of the
learned classicism beloved of the Italian Mannerists enabled the sculptors
to endow their figures with a free, wild, almost elemental emotion, such
as the misery wracking the mourners in Juan de Juni's *Pietà* or the spiritual
rhetoric of Berruguete. Because of the dominance of Church patronage
the subject matter was almost exclusively religious. Also the painters
concentrated on emotional rather than intellectual problems, which led **147,**
to crowded compositions, vivid colour contrasts and agitated silhouettes. **146, 149**

Philip II and the Escorial

The mid-century witnessed a dramatic change in Spanish affairs, which
was to have repercussions on artistic styles and attitudes. As early as 1543
Charles authorised his sixteen-year-old son Philip to act as regent while he
was absent, occupied with the central European campaigns. On this
occasion Charles wrote a long, admonitive letter to his son in which his
concern about matters of state was reinforced by the natural anxieties of a
father: 'Be a friend to justice, my son. Command your servants that they
be moved neither by passion, nor by prejudice, nor yet by gifts . . .
After the manner of Our Lord temper justice with mercy, in your bearing
be calm and reserved. Say nothing in anger . . . Listen to good advice
and take heed of flatterers as you would of fire . . . You would do wisely
to take no pleasure in the company of those who are forever making
unseemly jokes.

'With God's grace, my son, you are soon to marry. May God be pleased
to give you grace to live soberly in that state, and to get sons . . . There-
fore let me entreat you to keep watch on yourself and not to give yourself
overmuch to the pleasures of marriage. An undue indulgence may not
only injure your own health, but that of your heirs; it may even cut short
your life . . . And so I advise you shortly after marriage, to find some
excuse for leaving your wife, and do not come back to her very soon,
nor yet stay with her very long.'

Eventually Philip married four times, although only his third wife,
Elizabeth of Valois, won his heart. His heirs were disappointing; Don
Carlos was a dangerous lunatic and Philip, the issue of his last union, was
an ineffectual young man, while his second match with Mary Tudor,
queen of England, had proved emotionally and physically barren.

For some time all Charles's ventures had failed: he quarrelled with the
pope, fought the French, his revenues shrank miserably, and Mary's
inability to bear an heir rendered his northern policies void. On 25th
October, 1555, he summoned the most illustrious member of the realm
to attend upon him in the great hall of the castle in Brussels. Charles
arose, frail and ashen, to announce his abdication in favour of his son;
the entire assembly wept unashamedly.

Philip's succession was to change the face of Spain; the reason is re-
vealed by Sánchez Coello's portrait of the king. It is executed in the **129**

118

ENTRANCE,
UNIVERSITY LIBRARY

1525–30
Salamanca

The identity of the architect of this portal is
uncertain, but it is one of the best examples
of the first phase of Renaissance Plateresque
decoration. It is ornate and exuberant, yet
more rationally adapted to the main
structural precepts of the façade than is the
case in De Gumiel's treatment of the
University Hall at Alcalá (**110**). As in much
near-contemporary work in France, the
source of inspiration would appear to be
that of the 15th-century Certosa at Pavia
rather than the austere Roman High
Renaissance.

smooth enamel-like technique typical of mid-century court Mannerist
painting throughout Europe. Although Sánchez Coello had spent his
childhood in Portugal, he studied in Flanders, and he quickly assimilated
the formalised, dignified style of his master, the internationally famed
Dutch court painter Antonis Mor, who combined stylish design with a **128**
relentless honesty in characterisation. But in Philip's portrait the very
correctness of the brushwork and the impeccable detailing suggests
that even the artist's brush was enmeshed in the elaborate etiquette
that controlled every act in the Spanish court. This cool depersonalised
style was exactly suited to the subject; the spectator is riveted by the
figure of the king, his rigid deportment, the austere elegance of his
dress, the fingers compulsively telling the beads and, above all, by the
intimidating aloofness of his gaze.

His pallor confirms his disdain for the robust pleasures of the chase,
indeed he rarely stirred beyond the confines of the palace. Rather he was
obsessed by religion, bureaucracy and justice. The latter, as the Venetian
ambassador noted, 'is his favourite interest and in so far as its administra-
tion concerns him, he does his duty well.' Unfortunately Philip refused
to delegate; all state documents received his scrutiny, which slowed
everything down to such a degree that frustrated diplomats commonly
jested that if death came from Spain they would be immortal. Disastrous
too was his laconic response to his generals' and admirals' impassioned
pleas for supplies, money or reinforcements which were met by concern
about foul language in the ranks, rather than their victuals or armaments.

To facilitate the administration of his extraordinary policies Philip con-
ceived an audacious scheme and summoned the architect Juan Bautista de
Toledo from the Low Countries to implement it; thus began one of the
oddest building projects of the epoch. The Escorial, which outwardly **119**
fuses elements from Filarete's Ospedale Maggiore in Milan with those of
Diocletian's palace at Split, was, nevertheless, based upon a spiritual
symbol instead of architectural theory or example. The ground-plan of
this vast edifice was inspired by the instrument of St Lawrence's martyr-
dom, the grid-iron. It was no accident that the office of the Inquisition
was housed within its walls.

It is a formidable building, soberly articulated by granite pilasters
whose shallow relief does little to lighten the severity of its façade;
indeed their calculated intervals seem redolent of the authoritarian spirit
prevailing within. Despite the use of Classical detailing it bears little
resemblance to contemporary Italian buildings with their sophisticated
witty variants on antique architecture and decoration. Furthermore, the
effect of steely greyness is enhanced by the way in which the steeply
pitched slate roof echoes the colour of the slopes of the Guadarramas
beyond. Originally the English were to supply the slates but they found
it difficult to comply with the contract dates and Philip, growing im-
patient, cancelled the agreement. One curiously anti-Classical note is
struck by the dormer windows whose outlines are like eyebrows raised in
perpetual disapproval on the face of the building. These were the invention
of the second architect, Juan de Herrera, who took over the supervision
of the project in 1572, five years after Juan Bautista's death.

The need to provide accommodation for the court and administrative
offices proved to be of secondary importance to Philip compared with his
desire to erect a monastery, chapel and mausoleum on the site – all of
which he achieved, though not without difficulty. He was especially
dissatisfied with the designs submitted for the chapel, which was the last
part of the vast complex to be completed, in 1582. Many famous Italian

119

THE ESCORIAL

1563–82

*Juan Bautista de Toledo d. 1567, and Juan de
Herrera c. 1530–97*

Because the architects decided to use the
local stone quarried from the nearby
mountains, the palace was quickly and
irreverently nicknamed the 'slag heap'—a
singularly inapposite choice for this
severely calculated structure. No other
monarch created such an effective emblem
of his reign; in both design and purpose it
embodied Philip II's rectitude, austere
tastes and obsessive devotion to God and
to duty.

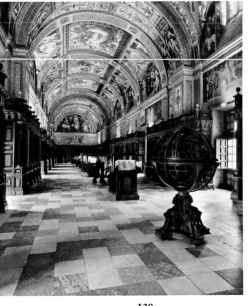

120

THE ESCORIAL LIBRARY

1590–02

Pellegrino Tibaldi 1527–96

In 1585 Philip II summoned Tibaldi to the
court from Milan where he had spent
many years as an architect and painter in
the employ of St Charles Borromeo,
Cardinal of the Roman Church. While the
king rejected Tibaldi's design for the
Escorial chapel he greatly admired his
prowess as a painter, and Tibaldi spent
eight years painting in the cloisters and
decorating the library.

architects were invited to tender designs, including Vignola and Palladio,
but all to no avail. Finally Herrera modified Bautista's original plan,
though he retained the favourite Spanish proportionate ratio of 2:3–the
very feature that the Italians had forcefully criticised.

Yet when the time was ripe for the decoration of the interior to begin
Philip summoned Italian, not Spanish, artists to the Escorial. With the
exception of Federigo Zuccaro and two Milanese artists–the sculptor
Pompeo Leoni and the painter Pellegrino Tibaldi–none of these was
notably gifted, but they were competent in the technique of fresco
painting, a skill in which most Spanish artists were deficient.

Tibaldi was among the second group of Italians who arrived between
1583 and 1586. He was entrusted with a task of great magnitude, the
decoration of the ceiling of the splendid library. The theme chosen was the **120**
Liberal Arts, and much of the embellishment of the rest of the palace was
similarly secular in character.

But this should not mislead us: another of Philip's most cherished
wishes was that the gallery levels of the chapel might be adjusted so that
they would coincide with those of the adjacent royal suite. The reason
for this was that the king wished his bed to be so placed that he could
see the Blessed Sacrament on the high altar beyond, visible through a
grille in the wall. Naturally the high altar embodied the climax of the
chapel interior and the task of designing this vast superstructure fell to
Pompeo Leoni.

Pompeo was the son of the sculptor Leone Leoni who had established a
workshop in Milan, where many of the carvings for the high altar were
carried out. However, both father and son enjoyed a long connection
with the imperial court, making their debut in 1551; Leone worked for
Charles V at Augsburg and Pompeo was employed at Innsbruck by
Cardinal Granvelle, a man who struck terror into the hearts of the citizens
of the Low Countries, but was a discerning judge in artistic matters,
favouring Brueghel with his patronage. Soon after Philip's accession
Leone and Pompeo came to Spain engaged on commissions for portrait
busts, monuments and statuary.

Only a brief spell of imprisonment at the hands of the Inquisition
marred more than twenty years continuous success for Pompeo in Spain,
and Philip honoured him with the commission to devise the floats and
triumphs to celebrate his marriage to his fourth wife, Anne of Austria,
in 1570. The high altar of the Escorial chapel occupied him from 1579–91.
Its splendour is tinged with morbidity because of the dark-hued jasper and
bronze and the ponderous complexity of its structure. However Philip
was clearly delighted with this effect and he instantly ordered the sculptor
to create a joint monument for himself, his father and their consorts. **126**
Pompeo's style complements Sánchez Coello's achievements in painting.
His finely-chased forms are taut and the carefully deployed ornament is
fastidiously described. An added sumptuousness was provided by the
gem-encrusted costumes which require the assistance of skilled Spanish
craftsmen for their setting.

In 1576 the king's heart must have been gladdened by a gift of a rare
Italian masterpiece dispatched to him from Francesco Maria de' Medici,
the Grand Duke of Tuscany. It was a life-size crucifix in black and **121**
white marble by Benvenuto Cellini. At first Philip thought it might sur-
mount the high altar but eventually it was affixed to the retrochoir in the
chapel.

By an ironical twist of fate the piece was inspired by a vision Cellini
had had when he was imprisoned in Castel Sant' Angelo, having been

121

CRUCIFIX
begun 1554, marble
Benvenuto Cellini 1500–71
The Escorial

During the sack of Rome Cellini energetically defended the city against the forces of Charles V. Ironically, he was later accused of having stolen priceless jewellery during the fighting, and in 1537 he was imprisoned in the Castel Sant' Angelo, where his deprivations caused a series of visionary experiences. This intense religious feeling inspired the life-size crucifix, which was originally intended for his own tomb.

122

SPAIN RESCUING
RELIGION
c. 1570
Titian 1487/90–1576
oil
Prado, Madrid

Like so many of Titian's compositions this occupied him for many years. Originally it was an allegory of the Capitulation of Vice before Virtue, but over thirty years later, in 1566, he transformed it into this typically Counter-Reformation theme calculated to appeal deeply to Philip's conception of his role as a Catholic monarch. In 1625 the picture was considerably repainted by Vincencio Carducho, but he took care to preserve the conception.

accused of looting during the sack of Rome in 1527. The authorities immediately brought him wax so that he might immortalise his experience, and on his release he began to translate these ideas into Carrara marble, a material which he found exceedingly friable and difficult to carve. But then Cellini was used to working in gold and bronze which made quite different demands on his skill. He was so thankful at regaining his freedom that he vowed to reproduce his vision upon his tomb, but later he offered the crucifix as a gift to Eleonora of Toledo, the wife of Duke Cosimo de' Medici, who for some inexplicable reason declined it. Eventually Cellini forgot his earlier noble sentiments and sold the piece to Duke Cosimo.

The whole mood of the decoration of the Escorial chapel recalls the king's introspective fanaticism which marred his piety and rendered him incapable of the noble detachment which his father could command, as on the occasion of his visit to Luther's grave. Charles was accompanied by his advisers Granvelle and Alva, two resolute enemies of Protestantism, who urged the emperor to cast Luther's remains from the coffin; the emperor rebuked them quietly, saying 'He has met his judge, I wage war upon the living, not upon the dead.' The rhetorical authoritarianism of Titian's picture of *Spain Rescuing Religion* reflects Philip's conception of his **122** special role in world affairs.

Titian never enjoyed the close friendship with the king that he had experienced with Charles, yet he had a shrewd insight into another, more secretly shameful aspect of his nature. Over a period of many years Philip commissioned a series of erotic mythologies for his private titilation which were known as the *Poesie*. In a letter to the king Titian boldly ventured to make his meaning plain: 'Since the Danaë, which I sent your majesty, is seen from the front I wanted to send this second poesie, for the sake of change, to show the woman from the opposite side, that the room for which these pictures are destined may appear even more delectable. Soon I shall send the Perseus and Andromeda, which will offer yet another aspect than the two earlier pictures and the same is true of the Medea and Jason.'

It was perhaps as an antidote to his own sensuality that Philip, who also collected Flemish paintings, pored over the hallucinatory images of Hieronymus Bosch's *Garden of Earthly Delights* and the awful warning of his **131, 13** infernal conflagrations, spurning the gentle tenor of Memling's vision **124** admired by his father. Undeniably Philip's religiosity was tainted by sadomasochism, but he was not unique in this respect: death, physical pain and the purging power of fire held the Spanish imagination in thrall during most of the century. One of the great mystical writings of the century, by St John of the Cross, was entitled *The Living Flame of Love*, and St Teresa of Avila described with poignant physical accuracy the sensation of sweet pain as the arrow of divine love pierced her soul. A lesser known mystic, Luis of Granada, probed the sufferings of Calvary, and similarly, the object of St Ignatius Loyola's *Spiritual Exercises* (which were widely read and practised at all levels of society) was to make the believer relive the Passion of Christ. These traits were partly attributable to Counter-Reformation piety and occurred in other countries too, but they reached their apogee in Spain. Even the tenderness of an artist like Luis de Morales proves deceptive on closer inspection; the angular concentration of his designs, the morbid pallor of the flesh set against the funeral blackness of his backgrounds all suggest an underlying melancholy.

Naturalistic incident in religious painting was strictly taboo in pictures commissioned for the court; even Juan Fernández de Navarrete, an artist

123 bottom left
THE RESURRECTION

Bartolomé Ordóñez, active c. 1500–20
wood
choir stalls, Barcelona Cathedral

The dramatisation of the scene is a tribute both to Ordóñez's powers of invention as a designer and his capacity to invest a hallowed theme with new life, unsurpassed until Michelangelo's late drawings. The astonishment of the guards is conveyed through the agitated grouping, but his real masterstroke was his decision to place the figure of Christ diagonally so that he truly cleaves the air.

124 below
TRIPTYCH: THE ADORATION OF THE MAGI

Hans Memling 1430/40–1494
oil
Prado, Madrid

The triptych belonged to Charles V, whose aunt also owned a work by this master. It is typical of Memling's work; the resemblance of the central panel to that of his more celebrated *Floreins Altarpiece* in Bruges shows how cleverly he could endow a single theme with minute but charming variants. Though Memling's style stems from Rogier van der Weyden his mood is very different: Rogier's passion gives way to a tender tranquillity in a technique that is deftly sensitive.

125 bottom right
THE ENTOMBMENT

1520
Jacopo Florentino c. 1476–1526
Palace of Charles V, Granada

Before his arrival in Spain Florentino had been primarily a painter; he was trained by Ghirlandaio. According to Vasari he was a lazy, garrulous youth who spent most of his time in the role of an assistant, first to Pinturicchio and then to Michelangelo. In Spain his latent powers as a sculptor were revealed, and in this commission for Charles V the tragic expression goes beyond the formal gestures of liturgical drama; the figure on the left is a powerful embodiment of doleful weariness.

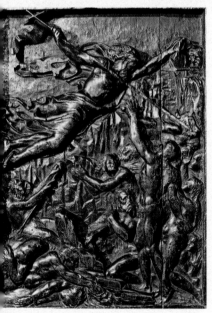

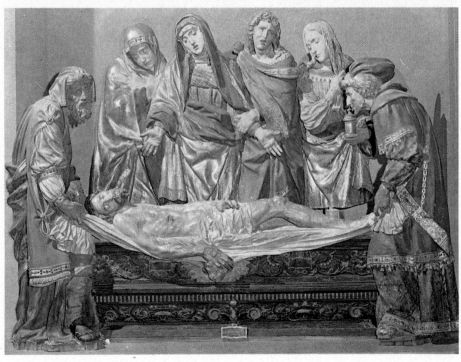

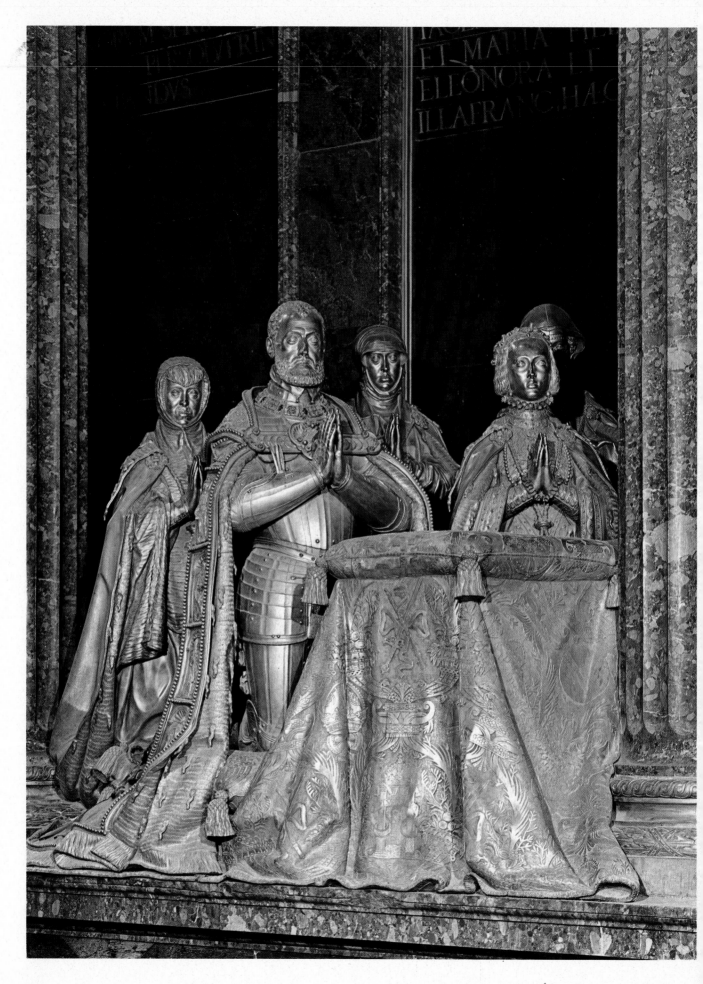

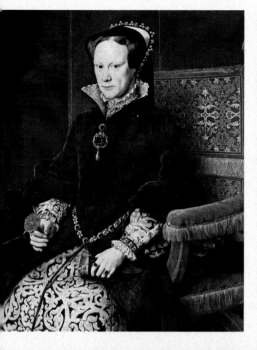

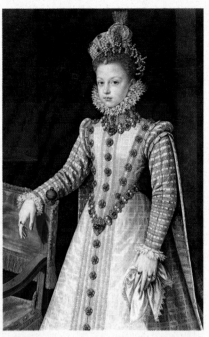

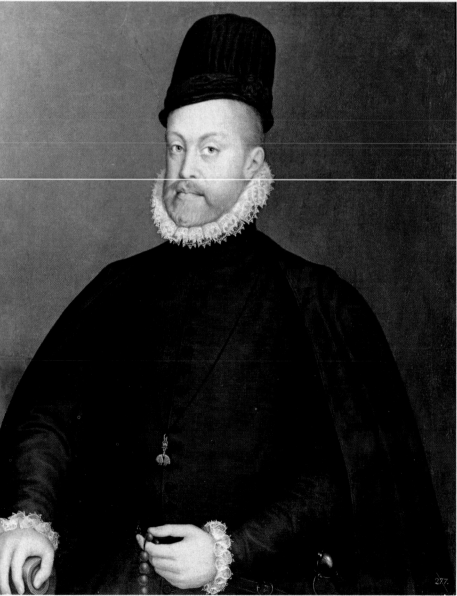

126 *far left*

THE MONUMENT OF CHARLES V AND HIS FAMILY

1591–98
Pompeo Leoni c. 1533–1608
bronze
The Escorial

The importance which Philip II attached to this work can be gauged by the fact that he promised to pay Pompeo an extra fee for every month saved on the time allowed for the commission in the contract. The cloaks were made to be removed, and were heavily encrusted with gems, which were set by Jacopo de Trezzo the Younger and Gian Paolo Cambiagio. The convention of representing the monarchs and their consorts kneeling was traditional in Spanish royal funerary sculpture.

127 *left*

THE INFANTA ISABELLA CLARA EUGENIA

c. 1577
Alonso Sánchez Coello 1531/2–1588
oil
Prado, Madrid

Here Sánchez Coello combined an expression of physical frailty with one of youthful arrogance, which stresses the royal status of Philip's daughter. Wisely, the painter lavished meticulous care on the recording of the details of her elegant costume, above all he was fascinated by the superb intricacies of her jewelled cap, which sets off her beauty to perfection. The rather stiff pose and plain background are characteristic of court portraiture at this time.

128 *top centre*

MARY TUDOR

1554
Antonis Mor c. 1519–76
oil
Prado, Madrid

Antonis Mor was one of the most celebrated portraitists of the 16th century and his fame took him as far afield as Rome, Madrid and London, where he went in 1554 to paint the queen shortly before her ill-fated marriage to Philip II. It is a poignantly honest record; the marks of the suffering she endured when Henry VIII rejected her mother, Catherine of Aragon, are countered by an inflexibility of bearing recalling the fanaticism of her beliefs.

129 *left*

PHILIP II

c. 1575–80
Alonso Sánchez Coello 1531/2–88
oil
Prado, Madrid

By the time that Coello portrayed the monarch his style as a court portraitist had achieved a rare balance between the rival claims of decorative arrangement and characterisation; indeed, he deploys the accessories in such a way that they enhance the revelation of the personality of the sitter. The modelling of the head is exceptionally refined. Coello enjoyed an unusual fame; his royal likenesses were even sent as gifts to the Emperor of China.

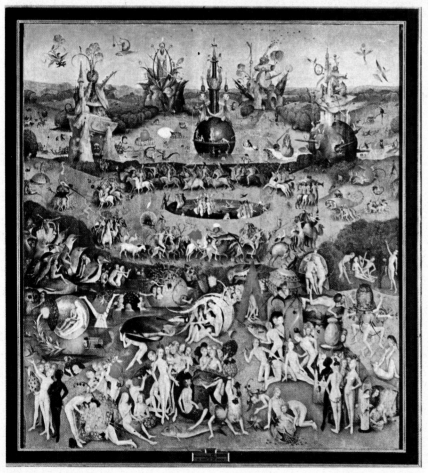

130 *left*
CHARON
FERRYING A SOUL
ACROSS THE STYX

Joachim Patenir, working 1515–24
oil
Prado, Madrid

Despite affinities between Patenir and
Bosch (**131, 132**) there are great differences
in their vision. The figures play a minor
role in Patenir's painting; Dürer rightly
praised him as a landscape artist. His vistas,
inspired by the craggy views outside his
native Dinant, were superbly suited to his
themes, particularly in this painting, in
which he tempers the Last Judgment
theme with Classical overtones. By the
mid-16th century his works had become
very popular in Spain, and Felipe de
Guevara regarded him as the equal of
Van Eyck.

131, 132 *left*
THE GARDEN OF EARTHLY
DELIGHTS

centre and right panels
Hieronymus Bosch c. 1450–1516
oil on wood
Prado, Madrid

As early as the 17th century Bosch was
regarded as a heretical artist, and the clue to
the precise meaning of his works has long
since been lost. His scenes of infernal
conflagration, however, enjoyed a wide
popularity among the European cognos-
centi, and the most renowned collector of
these panoramas of concupiscence and its
punishment was Philip II, to whom the
triptych belonged. The artist's immediate
stimulus was undoubtedly provided by the
witch-hunts that were rife in Northern
Europe at the turn of the century – them-
selves an outcome of the wave of
eschatological fear that engulfed men at
that time. If, as some believe, it was a late
work, it could be exactly contemporary
with Erasmus's *The Praise of Folly*,
published in 1509, but while the latter was
a satire, the purpose of Bosch's work was
clearly admonitive.

whom Philip normally admired, found himself temporarily under a cloud
due to the inclusion of such details. The temptation must have been great,
since his facility in portraying animals had been gleaned from the example
of Jacopo Bassano in Venice. No such irreverent distractions mar the
Beheading of St James, where the sharpest accents are reserved for the cruel
impact of the blade cleaving the saint's throat.

The Vision of El Greco

Ten years later, in 1581, Philip commissioned another artist, El Greco,
to treat a similar scene in the *Martyrdom of St Maurice and the Theban*
Legion. Both artists had learned much from Titian and Tintoretto, but
while Navarrete cautiously adapted the Venetians' manner to suit his
own limited imaginative goal, Greco evolved a strikingly individual
style. It was, however, a style which proved antipathetic to Philip,
who rejected the canvas out of hand. At least his objections were overtly
aesthetic: 'the picture does not please his majesty, and that is no wonder
since it pleases few.' The true reason may lie in Greco's discreet relegation
of the carnage to the middle distance; the visionary emphasis alone is
obviously insufficient reason for his displeasure, since he was delighted
with an even more transcendental idea which Greco had presented to
him shortly before.

The Dream of Philip II celebrates the welcome victory of Christendom
over the Turk at Lepanto. It shows Philip kneeling in adoration of the
Holy Name of Jesus, accompanied by his father, the pope and the doge
of Venice. The holy monogram was adopted by the Jesuits, and its
appearance here demonstrates the success of the society in overcoming the
earlier obstacles raised by the entrenched ecclesiastical powers. The gaping
jaws of hell are behind the king and the scene within echoes Michel-
angelo's *Last Judgment* which El Greco had seen in Rome. The writhings
of the damned would have gratified Philip's loathing of sin and heresy.

In 1586 his intolerance of heretics and infidels culminated in the disas-
trous edict ordering the expulsion of the Moors and the Jews which had
catastrophic repercussions on the commercial prosperity of the land. To-
wards the end of the century neither the gold and silver from the vast
empire in the Carribean and the Americas, nor the increased revenues
accruing from the annexation of Portugal in 1580 could do much to
relieve the poverty of the average Spaniard.

The bold piratical sallies against the Spanish merchantmen laden with
the spoils of colonisation carried out by intrepid British sea captains like
Sir Francis Drake aroused a slow steady anger against the English in
Philip's breast. Worse still, Elizabeth had sent troops to help the Dutch
Protestant rebels in his northern lands. Unluckily too Granvelle, the
only sagacious adviser who might have stayed the king's hand, died
in 1586. A few months later preparations were initiated for the Armada
offensive, a fiasco which finally cost Spain 10,000,000 ducats. Larger and
larger loans were requested from foreign bankers, many of whom were
reluctant to incur the risk and nervously refused to make new advances.
By the end of Philip's reign the burden of the national debt had become
crippling. All kinds of stop-gap measures were resorted to, including the
wholesale trafficking in the sale of offices, which in turn ended by petri-
fying all agricultural and commercial effort in the local communities.
Only death in 1598 preserved Philip from the final humiliation of eco-
nomic nemesis; he bequeathed his son liabilities four times greater than
those he had inherited from Charles V.

Thus when El Greco settled in Toledo in 1577 grass sprouted in the
streets of the former capital city and sheep nibbled within its walls. Even

133
134
153

when allowance has been made for the artist's personal eccentricities, the fact that on his death an inventory of his effects showed that there was only sufficient furniture for two out of the twenty-four rooms in his house seems to speak for the condition of the entire community.

As we have seen, El Greco did not find favour at court, though the success there of other Venetian-trained artists may have fostered false hopes of future prosperity, encouraging his decision to put down roots in Spain. Initially he had received his training as a Byzantine icon painter, but around 1558 when he was a youth of seventeen he left his native island Crete, which was still a Venetian possession, and journeyed to Venice where his style was transformed by contact with Titian and Tintoretto. From there he visited Rome, where he made friends with the most celebrated miniature painter of the day, Giulio Clovio. However, he seems to have upset the Roman painters by his failure to respond unreservedly to Michelangelo's genius – years later he told Pacheco, Velasquez's father-in-law, that 'Michelangelo was a good man who did not know how to paint.' Possibly he found his colour rather dull, for Greco's eye reacted to the stimulus of colour with unusual alacrity and sensibility.

Spain transformed his colour in two ways at once, releasing his palette from the conventional enrichment of Venetian hues, and investing it with colour harmonies which were at once intensely personal and expressive. Obviously Greco's first impressions of the land counted for much; above all the painful contests between spring and winter which characterised the landscape around him in late March: the silvery green of wild myrtle, thyme and rosemary, the snowy peaks if the steel-grey Guadarramas, and the sparsely-cultivated plateau revealing strips of ploughed red earth edged with trees whose foliage is of such a painful green that they resemble daggers piercing the skyline. Finally there are the skies, where the clear sapphire air is suddenly obscured by the charcoal darkness of the storm, rent only by clouds resembling tattered rags tossed about in the empty vastness. Greco alone has given pictorial expression to its wild elemental force, and perhaps just because he was a foreigner his eye registered its uniqueness with a peculiar vividness.

Certainly these cool tones seeped into his first major commission carried out in Toledo, the *Trinity and Assumption* for San Domingo al Antiguo. Also he abandoned the more relaxed ample folds typical of Italian painting in favour of heavier yet more agitated shapes. Repose has no place in his art, which is essentially ecstatic.

Toledo was a rich diocese and Greco was assured of steady employment by the dignitaries of the numerous churches, monasteries and convents in the see. One characteristic of these Spanish churches was to make just as indelible an impression upon him as the landscape had done. In the later pictures such as the *Burial of Count d'Orgaz*, cool tones are complemented by more resonantly lustrous pigments, amber, emerald, ruby, amethyst and onyx; the same tints that flashed and gleamed from the dim recesses of the sanctuary of many an ill-lit Castilian church.

Apart from occasional portraits of the local hidalgos and clerics Greco's art was almost exclusively religious, but its fervent spirit extended beyond the rigid orthodoxy embodied in the maxims of the Inquisition or the recent promulgations on religious art agreed on at the Council of Trent, and it is infinitely more subjective. Yet one of his most compelling pictures was the portrait of the Grand Inquisitor; even today its sharply penetrating characterisation strikes a chill in the beholder. It recalls that one of the functions of the Inquisition was not only to purge the heretical soul in the bright flames of the *Auto da Fé* but to guard against any individual

133
THE BEHEADING
OF ST JAMES
1571
Juan Fernández de Navarrete 1526–79
oil
The Escorial

In Philip II's eyes the peak of artistic excellence was attained by Titian, and naturally the monarch was attracted by the works of those Spanish artists who had been to Italy and studied under the illustrious Venetian. Among these was Navarrete, nick-named 'El Mudo' because of his deafness. The king not only demanded a rigorous orthodoxy from his artists but forbade the inclusion of any distracting secular detail, so that here the martyrdom is presented with a disconcerting starkness.

THE MARTYRDOM
OF ST MAURICE
AND THE CONVERSION
OF THE THEBAN LEGION
1582
El Greco 1541–1614
oil
The Escorial

The failure of this picture to win the king's favour determined the subsequent course of Greco's career in Spain; debarred from court patronage he turned his attention to ecclesiastical admirers of his strange imagination. The discrepancies of scale between the foreground and the middle distance, the off-centre composition, the rhetorical poses and elongated proportions are part of the general legacy of Italian Mannerism, but he combines them in a special way which, allied to the cool yet vivid colour, creates a mood of supernatural intensity.

135
CUSTODIAS
16th century
Enrique de Arfe c. 1510–74
silver
Toledo Cathedral

The earliest custodias were made in Spain about 1400, and during the 16th century they became particularly large and elaborate, and were sometimes formed in the shape of temples.

excesses of devotion among the faithful. Thus it maintained an equally vigilant surveillance over the importation and writing of books tainted with Protestantism (such as Erasmus's *Handbook of the Christian Soldier*, which was translated into Spanish, or Juan de Valdés's *Dialogue of Mercury and Charon*) and the activities of the Spanish mystics, especially the ardent reformers like St Teresa of Avila and St John of the Cross.

The latter were engaged in purging the Carmelite Order of any trace of laxity, and St Teresa founded a new branch of the Order, known as the Discalced Carmelites. Needless to say the defenders of the old rule became her implacable foes. When St John was appointed confessor to the Convent of the Incarnation at Avila in 1572 the conflict was approaching a climax which culminated in his abduction and imprisonment at Toledo in 1577.

While he was in prison he wrote some of his finest mystical poems, including *The Spiritual Canticle*, *Although t'is Night* and, possibly, the *Dark Night*. During this period the saint and El Greco may have met. In any event the quality of St John's verse corresponds most closely to El Greco's painting and clearly the artist was strongly attracted to the mystical interpretation of spiritual truth.

Although St Ignatius Loyola urged the faithful to meditate so that they could relive in their own senses the agonies of crucifixion or the torments of the damned, and in 1595 Antonio Possevino, enlarging upon the decrees of the Council of Trent, instructed artists that Christ must be depicted 'bleeding, afflicted, spat upon, with his skin torn, wounded, deformed, pale and unsightly', we look in vain for this precise delineation of bodily suffering in El Greco. Rather his conception is an agony of soul and more pervasive. Except for the pallid light imparting an ashen hue to Christ and the mourners in the *Crucifixion*, the terrible desolation is not conveyed **150** by physical horror–indeed contrary to Possevino's recommendation Christ is almost calmly benign. The misery is transmitted to the Virgin, St John and the impassioned Magdalene. The light flickering across the forms accentuates the nervous agitation of pose, drapery or gesture. The effect is curiously fluid, recalling El Greco's habit of modelling his figures in wax prior to painting them. This was quite a common practice, but no other artist exploited the molten quality of the wax in his final translation of the idea into paint. It accorded well with his strange elongated proportions, which allied to the sameness of all his faces endows his sacred themes with a haunting timelessness, at once remote and immediate. Nor is it surprising since his imagination was also nourished by the Greek dramatists, and his library boasted copies of the epics of Homer and the plays of Euripides.

Towards the end of El Greco's life the writers Gongora and Cervantes settled in Toledo, but if he met the author of *Don Quixote* the painter clearly refused to be deflected by the writer's earthy common sense. Instead he held fast to the image of the ascent of the soul proclaimed by St John of the Cross.

'The dreadful force of dazzling light
Blinded me as aloft I flew,
The greatest gain that ere I knew
Was made in blackness of the night.
But love it was that won the day;
Blindly, obscurely did I fly;
I soared aloft and soared so high
That in the end I reached my prey.'

(St John of the Cross) Maria Shirley

136 *right*

MATER DOLOROSA

1560
Juan de Juni, active c. 1544–77
Museo Nacional de Escultura, Valladolid

Probably of French origin, Juan de Juni enjoyed a considerable
reputation in Spain and he continued to be admired by artists in
the following century. Though there are traces of Italian influence
in his sculptures it is unlikely that he ever visited Italy, and his
mature works are saturated with the spiritual intensity common to
Spain. Every detail and compositional twist is redolent of the
Virgin's tragic anguish, and in his ability to recreate a purely
mystical agony in physical terms he foreshadows Bernini.

137 *below*

THE BAPTISM OF THE MOORS

1520–21
Felipe Vigarny c. 1470–1543
painted wood
Granada Cathedral

At the bottom of the enormous retable in the Capilla Mayor there
are two painted kneeling statues of Ferdinand and Isabella,
probably by Diego de Siloe, which are remarkable as portraits.
Fittingly, the retable is carved with scenes illustrating their greatest
triumph – the conquest of Granada, and the expulsion and
enforced baptism of the Moors.

138 *below*

CHRIST AT THE COLUMN

Diego de Siloe c. 1495–1563
polychrome wood
Museo Nacional de Escultura, Valladolid

Diego had worked in Naples with Ordóñez, and the poignant
rhythms with which he invested the figure suggest that they
shared the same emotional intensity. The pathos is increased by the
realism of the painting, exaggerating the weals left by the
scourging. Yet the interpretation has a double implication; it
invites our pity, but conversely, as Christ tenderly fingers the
column and the knotted rope, he seems to welcome his suffering.

139 *below*

ST CHRISTOPHER

Alonso Berruguete c. 1488–1561
polychrome wood
Museo Nacional de Escultura, Valladolid

Berruguete employed the traditional elaborate methods for the
colouring of his woodcarvings. Many successive stages were
necessary before the flesh (*encarnado*) and the drapery (*estofado*)
were tinted: size priming, polishing, gesso underlay, an earth red
ground and finally gilding. As a finishing touch part of the
pigment was deftly scraped away so that a delicate lustre shone
through from the gilding beneath.

140 *right*

MADONNA AND CHILD

Luis de Morales c. 1520/5–1586, oil
Prado, Madrid

Despite his considerable gifts of expression and design Morales
remains a mysterious figure. Nothing is known of his origins,
although it is assumed that he may have trained under a Dutch
master, Sturmio, who was active in Seville from 1537–55. In the
treatment of the Christ-child's head the modelling is exceptionally
fine. Like all Morales's compositions he has rendered a simple
theme complex by dwelling upon contrary twists and directions
in the two figures.

141 *below*

THE RESURRECTION

c. 1510
Fernando Yáñez de la Almedina, active 1506–c.1531
oil
Valencia Cathedral

One of the earliest Spanish painters to respond to the lure of the
Renaissance was Yáñez, who was in Florence only a few years
before he executed this picture. There he was admitted to
Leonardo's circle and may even have assisted in the *Anghiari Battle*
cartoon. Although he clearly tried to create a balanced
Renaissance type of design, the seated figure to the left introduces
a disconcerting asymmetrical note.

142 *left*

ROTUNDA, GRANADA CATHEDRAL

begun 1528
Diego de Siloe c. 1495–1563

When Ferdinand and Isabella conquered Granada, the last
stronghold of the Moors, the triumph of Christianity was
complete in Spain. Siloe's great rotunda was a memorial to this
event. Its circular form had both a practical and a symbolic
purpose: it allowed a perpetual procession in adoration of the
Blessed Sacrament to circulate around the altar, thus expiating the
shame of the Moorish occupation, while also employing as the
basis of the design the Renaissance symbol of God, the circle.

143 *below*

SAN ESTEBAN

begun 1524
Juan de Alava active 1503–37
Salamanca

During this period Spanish architects were trying to throw off the
remnants of Gothic design and structure, but there are odd
contradictions in their solutions: in most of the buildings erected
between 1515 and 1525 Renaissance novelties vie with older
forms, such as the pointed arch. San Esteban is no exception; the
buttresses resemble Renaissance pilasters, but the flying buttresses
are crowned by Gothic pinnacles with the traditional crockets and
finial ornament. The windows too show the same indecisiveness.

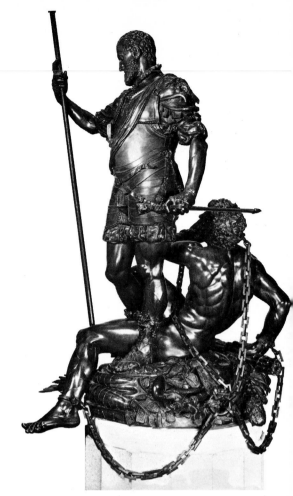

144 *right*

CHARLES V RESTRAINING FURY

1549–64
Leone Leoni 1509–90
bronze
Prado, Madrid

Leoni belonged to an exalted artistic circle in Italy and counted
Titian and Aretino among his friends. Thus it was not surprising
that he attracted the attention of Charles V and was active at the
courts of both Augsburg and Brussels. Though he never went to
Spain he executed several royal statues. His ambitious and
elaborately designed sculptures typify the style of mid-16th-
century Italian Mannerism. This example was completed by his
son Pompeo.

145 *below*

THE TRANSFIGURATION

1543–48
Alonso Berruguete c. 1488–1561
alabaster
Toledo Cathedral

The spiritual excitement evident in so much of Berruguete's art
reached its climax in the works carried out for Toledo Cathedral,
culminating in the superb rhetoric of the *Transfiguration*. The
ground, the gestures and the drapery become part of a symphony
of convoluting rhythms which not only deliberately suppress the
stony quality of the material but also stress the supernatural
quality of the event. Berruguete conveys the personal intensity of
Spanish religious feeling better than any other sculptor.

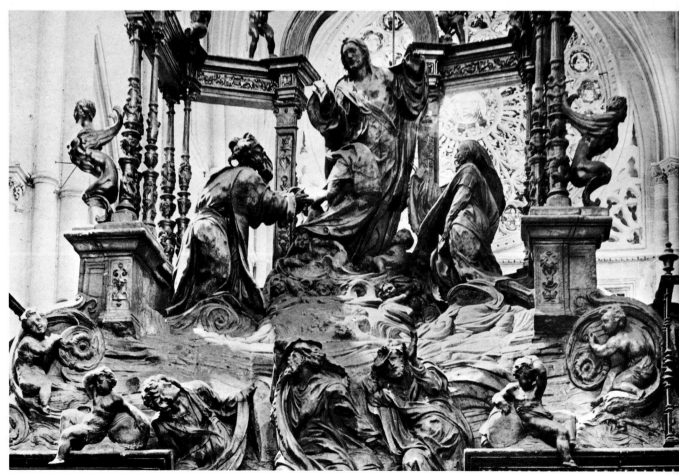

146 *below*

THE DESCENT
FROM THE CROSS

1547, oil
Pedro de Campaña 1503–c. 1580
Seville Cathedral

Campaña's major works were all conceived
in Spain, although he was born in
Brussels and only settled in Seville after
extensive travels in Italy. Owing to the
pre-eminence of sheep farming in Spain
and Seville's significance as the main centre
for the export of wool to Flanders, there
was a considerable Flemish element in the
population of the city and their art was
often admired. Campaña's knotty irregular
forms reflect his Northern origins, while
the composition is Mannerist.

147 *bottom right*

THE ADORATION
OF THE SHEPHERDS

1555
Luis de Vargas 1506–1568
oil
Seville Cathedral

Luis de Vargas's powerful sense of design
may have resulted from his prolonged
residence in Italy, which lasted about
twenty-eight years. While he was there he
mastered the craft of fresco painting, which
led to his ability to compose his figures on a
monumental scale. Luis also fell under the
influence of Vasari; he is essentially a
Mannerist artist both in style and in
execution.

148 *below*

ST JEROME

c. 1525, terra-cotta
Pietro Torrigiani
1472–1528
Museo Provincial de Bellas Artes, Seville

Torrigiani travelled widely and his
connections with Spain were forged early.
In Rome he worked for the notorious Pope
Alexander VI and even fought in the forces
of his infamous son, Cesare Borgia. His
links with the Hapsburgs began with his
employment by Margaret of Austria in the
Netherlands, and eventually he settled in
Spain. Most of the works he carried out
there were executed in terra-cotta and
reflect his Florentine training. Unhappily,
the bust he made of Charles V's bride after
her wedding has disappeared.

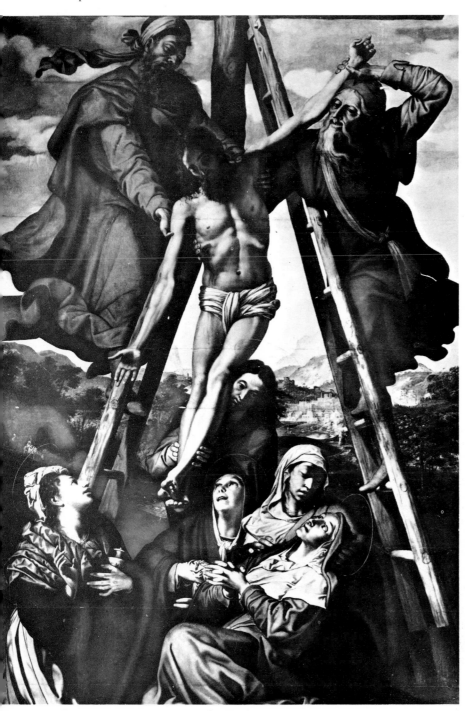

149 *below*

THE NATIVITY

1530
Vicente Juan Macip c. 1475–1545
oil
Segorbe Cathedral

Macip was one of the principal artists in Valencia, where the local
painters greatly admired Italian innovations, especially those of
Raphael. However, he seems to have sought inspiration from the
Venetians also and may even have visited north-east Italy. The
closely packed design shows stronger affinities with the art of
Sebastiano del Piombo or Pordenone. The shepherds press about
each other and around the column, intensifying the emotional
nature of the event.

150 *below*

THE CRUCIFIXION

c. 1590
Domenikos Theotocopoulos, called El Greco 1541–1614
oil
Prado, Madrid

By the 1590s El Greco's formal idiosyncrasies had become
pronounced, reflecting the mystical exaltation which formed part
of the spiritual climate of the period. Closer scrutiny of this
picture reveals some unusual iconographic innovations: the angels
are exultant, extending their hands to catch the precious blood as a
child might delight in a fountain. In earlier representations it was
customary for an angel to bear a chalice, thus stressing the
Eucharistic meaning.

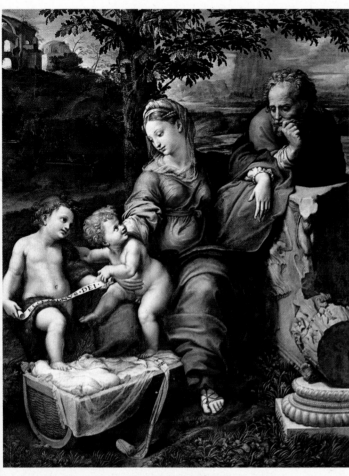

151 *left*

THE HOLY FAMILY
WITH
ST JOHN THE BAPTIST

c. 1518
Raphael 1483–1520
oil
Prado, Madrid

Raphael was much admired in Spain during the 16th and 17th
centuries, and many examples of his work, either originals or
copies, found their way into Spanish collections. Towards the end
of his life many of the works attributed to Raphael were largely
executed by assistants from his drawings; this is probably the case
here. The presence of the ruins in the foreground and on the
hillside bear witness to the archaeological pursuits which occupied
him increasingly in the years of Leo X's pontificate.

152 *below*

DANAE

1553
Titian 1487/90–1576
oil
Prado, Madrid

Even before he ascended to the throne Philip began to
commission the *Poesie* series from Titian. Originally they were
intended to decorate a single room, but now they are widely
scattered, only one or two pictures remaining in Spain. Titian
began to paint these mythologies when he was over sixty, and the
style is rich, free and diverse in colour and handling, though he
avoided vivid pigments, preferring instead more delicate or
sombre half tones affording evocative contrasts.

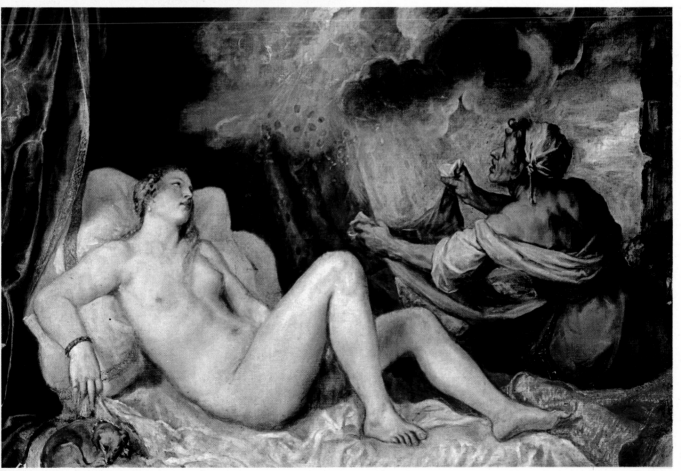

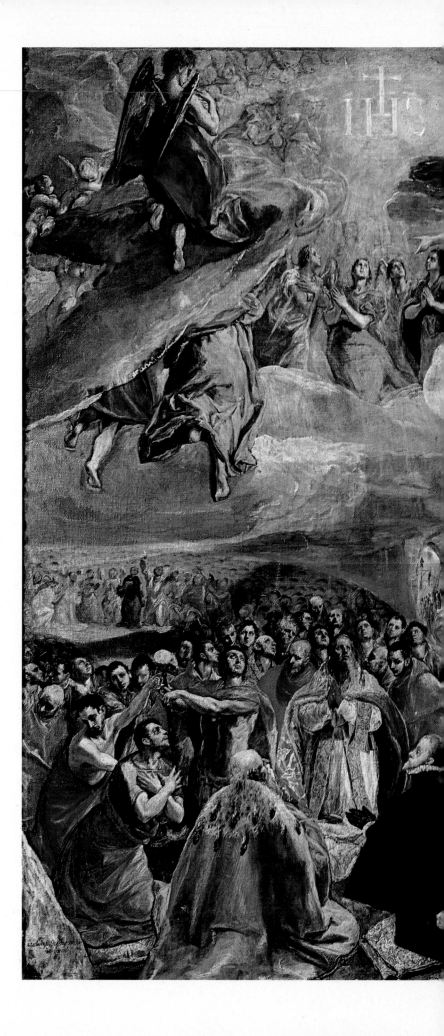

153 *right*

THE DREAM OF PHILIP II

1579
Domenikos Theotocopoulos, called
El Greco 1541–1614
oil
The Escorial

Philip II's delight in this picture encouraged
Greco's hopes of success at court; however,
it was probably the subject rather than the
treatment that appealed to the king.
Indeed, it could hardly fail to, since it
embodied all his religious and secular
ideals, encompassing the idea of omnis-
cient glory of God, the concept of the
united desire of the rulers of Church and
State blessed by his will, the torments of
the damned, and finally the triumph over
the infidel enacted at the Battle of Lepanto.

154 *far right*

THE RESURRECTION

1608–10
Domenikos Theotocopoulos, called
El Greco 1541–1614
oil
Prado, Madrid

Like many artists of this period El Greco
was influenced by engravings of works by
Northern artists; the source of this example
was an engraving by Galle after a
composition by Antonie Blocklandt. The
final result, however, bears scant
resemblance to the spirit of the Flemish
piece. By this date the visionary in El Greco
had outstripped his hold on material
reality, and he concentrated on a super-
natural truth which throws the guardians
of law and logic into startled confusion.
Only an artist so completely indifferent to
circumstantial exactitude would have
painted the soldiers naked.

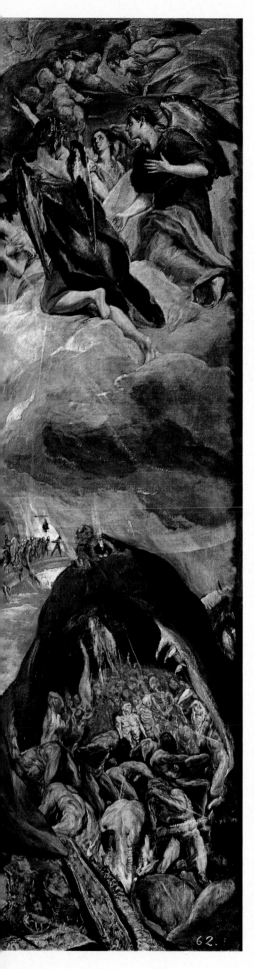

'But is it not true', replied Don Quixote, 'that her great height is accompanied and adorned by a thousand million intellectual graces? One thing you cannot deny me, Sancho. When you stood close to her, did you not smell a spicy odour, an aromatic fragrance, something unutterably sweet to which I cannot give a name? I mean an essence, an aroma, as if you were in some rare glover's shop?' 'All I can say', answered Sancho, 'is that I got a sniff of something rather mannish. It must have been because she was running with sweat from the hard work.' 'It would not be that,' replied Don Quixote, 'you must have had a cold or smelt yourself. For well I know the scent of that rose among thorns, that lily of the field, that liquid ambergris.' 'It is quite possible,' replied Sancho, 'for very often there's that same smell about me that seemed to be coming from the Lady Dulcinea. But it is not surprising, for one devil is like another.'

When Cervantes published *Don Quixote* in 1604 he not only cut at the roots of chivalrous idealism, but struck a glancing blow as well at the general current of unworldliness that marked the previous epoch. The knight errant's goals were patently absurd; yet this lunatic dreamer was the catalyst which released the rich fund of common sense commanded by his squire, Sancho Panza. To each preposterous assertion Sancho offered a racy, pungent retort. This pithy wit runs as a constant strand through Spanish writing and observations; even artists felt its caustic lash, and one anonymous poet taunted Pacheco:

'Who painted you thus, oh Lord,

So dry and insipid?

You will tell me that pure Love,

But I can tell you Pacheco did it!'

Humour, a sharp eye for detail and a respect for sensuous truth created the climate for the emergence of what was to be the dominant style in Spanish art during the first thirty years of the century, that of Realism. Sancho would have felt quite at home among the tipsy devotees of Bacchus in Velasquez's celebrated picture of *The Topers*. Spanish painters 169 were not unique in turning their attention to peasants, beggars and humble objects, but the pictorial manifestations of this novel awareness of an area of life disregarded in the previous era were more richly varied in Spain than elsewhere. Surprisingly, the first picture to usher in the new style was probably painted in 1593 for the Escorial during Philip II's reign by the Florentine artist Bartolomé Carducho.

By 1600, copies of works by the Italian arch-Realist, Caravaggio, began to appear in Spain, accelerating the development of the style. The appeal of these pictures was immediate, and local artists were spurred on to emulate their salient features, especially the savagely opposed light and shade. Caravaggio's scenes contained few middle tones and little reflected light, the eye was plunged into deepest gloom or arrested by some abruptly lit detail which, however, was of great significance in the depiction of the subject. Everything which was superfluous to the subject itself was eliminated. Some of the Spaniards, for instance Francisco Ribalta, followed him to these lengths, though other painters, like Carducho, were less extreme. By the time the latter painted his *Last* 156 *Supper* in 1605 the movement was well established. Yet it would be wrong to see this outburst as a mere desire to imitate some foreign novelty; its appeal was obviously due to more pervasive factors. One of the astonishing features of its rapid spread was the way in which a number of El Greco's pupils spurned the transcendental asceticism of their master in favour of something more palpable.

Mysticism and the Birth of Spanish Realism

C. 1600–1700

155

THE IMMACULATE CONCEPTION

Bartolomé Esteban Murillo 1617–82
oil
Prado, Madrid

Like all the principal Sevillian painters during this century Murillo was often called upon to depict this popular subject, and his treatment of the theme is so characteristic that it often obscures his wider achievements as an artist. Today his pictures are sometimes condemned as sentimental, but it would be fairer to note the way in which the fluid soaring rhythms of the design and the easy, relaxed nature of the pose, coupled with the suffused atmospheric modelling and the rendering of the cherubim extends beyond the Baroque, anticipating the gentler lyricism of the Rococo.

At the turn of the century Toledo was a hub of intellectual activity;
law, mathematics, geometry and astronomy claimed the attention of the
most vigorous minds in the city and, as we have seen, Cervantes was
there to curb any tendency towards the abstractly esoteric. Several of
these early Toledan Realist painters were also committed to the religious
life. The most gifted of them, Luis Tristán, was also a priest, while 157
another, Juan Sánchez-Cotán, ended his days as a Carthusian lay brother in
Granada.

Mention of Sánchez Cotán brings to light a further consequence of the
Realist revolution, the emergence of still life as a subject in its own right.
Sánchez Cotán and later Zurbarán brought something quite distinct to the 158, 15
form. Unlike those late 16th-century experimenters–including the youth-
ful Caravaggio in Italy, or Alonso Vázquez in Spain, who had delighted in
elaborate highly artificial still-life arrangements which they incor-
porated into genre or mythological themes–these two Spaniards relied
on the austere impact of a few carefully selected and placed items. In
Sánchez Cotán's case this reflected his own pious frugality; his appetite was
notoriously meagre. The objects he chose were invariably those that
would grace a poor peasant's table: loaves, cabbage, gherkins, cheese or
water-melons. Abundance has no place in his art; these foods make their
appearance singly, each one meticulously scrutinised and recorded. Al-
though these little canvases reflect the artist's spiritual state, in a broader
sense their austerity is redolent of the generally depressed economic state
of the country, recalling that the century opened with an outbreak of
plague and famine.

But although few places maintained any semblance of real prosperity,
an exception to this was Seville. This great inland port built on the
banks of the Guadalquivir basked, even in the 15th century, in an affluence
based on the supremacy of the woollen industry, the products of which
were shipped north to be woven in Flanders. In 1503 Ferdinand and
Isabella had issued a decree establishing the famous Casa de Contratacion,
whose function it was to control and measure the importation of gold
and silver from the new overseas colonies. Besides this it also provided a
training school in navigation where aspiring pilots learnt how to negotiate
the recently discovered trade routes. The presence of this establishment
ensured the commercial success of the city, even though the short-sighted
laws governing its mode of operation finally helped to bankrupt the
country as a whole. Furthermore, Seville's geographical position made it
safe from those sudden forays by foreign maritime adventurers which
wrought such havoc at Cádiz in the 16th century. The continued pre-
eminence of sheep farming, which ruined Spanish agriculture elsewhere,
allied to profitable sidelines such as the importation of cocoa and tobacco,
all helped to bolster the local economy still further. Consequently by the
turn of the century Seville was not only the richest port, but one of the
greatest centres of artistic activity.

Because of the economic situation few cities maintained an active
building programme, but Seville and Alcalá de Henares (which is largely
a 17th-century city) encouraged the creation of ecclesiastical and civic
architecture. At the close of the previous century Juan de Herrera's fine
exchange in Seville had been completed, and over the next twenty years
a number of interesting structures were planned, erected or decorated.

During this period one of the most important architects in Seville was
Miguel de Zumárraga, who was responsible for the church of the Sag-
rario, begun in 1615. He repudiated the more delicate linear style of
Herrera in favour of a bolder, plastic effect, emphasising the depth of

158

**A WINDOW WITH CARROTS
AND A BUNCH OF CELERY**

c. 1603–4, oil
Fray Juan Sánchez-Cotán 1561–1627
Museo Provincial de Bellas Artes, Granada

Cotán was born near Toledo and was
trained by a still-life painter, Blas del Prado.
At first he entered into the sophisticated
intellectual circles of the city, studying
mathematics and architecture with El
Greco, whose paintings he admired and
owned, but it made no impression on his
own style. About the time that he under-
took this work he forsook the world and
became a Carthusian lay brother, and from
then on his still-life groups reflect his
dedicated spirituality far more effectively
than his conventional religious pictures.

159

**STILL LIFE WITH
FOUR VESSELS**

Francisco de Zurbarán 1598–1664
oil
Prado, Madrid

Zurbarán's most celebrated still-life pieces
are more self-consciously elegant in their
arrangement than this example. Here,
however, he has created a delicate counter-
point by the juxtaposition of the objects
and by their subtly varied scale and
textures, while they are at the same time
unified by the artfully contrived intervals
in the placing of the vessels. The fall of the
light adds vivacity to the surfaces and
density to the volumes.

recessions and projections which are unified by a series of reiterated
horizontals. It was a discreet move towards Baroque, a novelty indeed at
a time when much new Spanish building was still rooted in formulae
advanced in Serlio's famous mid-16th-century treatise or Palladio's *I
Quattro Libri dell' Architettura*, the first book of which was not translated
into Spanish until 1625, when it was published in Valladolid.

Naturally the convolutions of Northern Mannerist strapwork also exer-
ted a strong fascination upon the Spaniards. In Seville it was modified by
the influence of Mudéjar decorative practices and applied in stucco to the
façade of San Pedro. Stucco, altogether a less durable material than stone, **160**
was very much cheaper, and its revival indicates that even Seville was
affected by the wave of inflation which had trebled the cost of living in
the first decade of the century.

In Sevillian painting at this time three main trends were evident.
Firstly, that exemplified by Juan de Roelas and Francisco Herrera the Elder,
whose style was influenced by the Venetians, particularly Tintoretto
and Veronese. Roelas, especially, seemed to thrive on large-scale commis-
sions which taxed him to the utmost, and none more so than the huge
painting for Seville Cathedral depicting the defeat of the Moors. It **162**
was painted in 1609 and it is likely that the choice of subject matter
reflected the outlook surrounding a political act of heartless bigotry.
For in the same year Philip III (who had reacted instinctively against his
father's excessive sense of duty by giving himself up to the pleasurable
pursuits of women, hunting and the collection of works of art) suddenly
decided to expel the Moriscos. Even Cardinal Richelieu, who was not
over given to tender sentiment, remarked that it was 'a barbarous stroke'.

Secondly, another group of painters flourished in Seville who eschewed
grand manner themes altogether, preferring instead to paint simple
scenes of peasants and artisans eating. While none of these artists was very
talented, their *bodegones*, as this type of picture is called, were important
not only because of their popularity, but because they helped to foster
the spread of Realism in the area. Even the arch-academic theorist
Francisco Pacheco saw some virtue in their efforts.

Pacheco, the master and subsequently the father-in-law of Velasquez,
represents the third trend: the correctness of mode, both in execution **163**
and in presentation of the image. His establishment, unlike that of most
artists, was not solely a workshop but also an academy of painting. He
wrote a treatise on painting which, although some of it makes dry
reading, contains flashes of insight that make us realise how he remained
the devoted admirer of Velasquez long after the latter had repudiated
many of the older man's ideas. 'The most important of the three parts
into which we divide colouring is relief', he writes, 'it is the most im-
portant because perhaps sometimes you might find a good painting lack-
ing beauty and delicacy ... Many spirited painters such as Bassano,
Michelangelo, Caravaggio and our Spaniard, Jusepe de Ribera, did with-
out beauty and delicacy but not without relief.'

This intellectual acumen guaranteed Pacheco's standing among the
intelligentsia and minor nobility of Seville. Probably it also accounts
for his appointment as chief censor of the Inquisition; he spent much
time pondering the niceties of doctrinal presentation and his contention
that 'the aim of paintings is the service of God' sounds like a proposition
from the Catechism.

Velasquez's earliest canvases were *bodegónes* and they are marked by a
sober, accurate perception. Pacheco gives us a clue as to how Velasquez
achieved this effect: 'I stick to a live model for everything and it would be

fine if I could have it before me always, not only for the head, body, hands and feet, but also for fabrics and silks and everything else . . . And with my son-in-law (Velasquez) who follows this method, one can also see the difference from all the others because he always works from life.'

Velasquez's Realist pictures combine two features: a profound grasp of the textural surfaces of the subjects he depicts and a dense earthy coloration based upon ochres, umbers and a dark indigo blue, all heightened sparingly with an impasted white. Like the notorious improviser Caravaggio, who was constantly altering his pictures as he went along, Velasquez too was prone to change his mind as the painting took shape upon the canvas. This, allied to the current Realist predilection for dark priming, partly accounts for the opaque quality of his pigments. Possibly there was also a deeper, more instinctive cause, for these pigments occur in the work of nearly all the southern Realists, whose ochreous coloration seems to be essentially indigenous, part of the baked, dusty soil which clogged the pores and bit deep furrows into the faces of the simple men and women depicted. Although Velasquez's themes were often unpretentious, they were imbued with an element that was to remain constant, an ability to invest a man with a dignified reserve, while discreetly probing the intimate secrets of his personality. Later this insight was to make him one of the greatest portraitists of all time.

One great masterpiece of this formative period in Seville stands out 168 from all the rest, the *Adoration of the Magi*. In this painting Velasquez was precariously poised between the rival claims of Realism and the newly emergent Baroque style; rose, gold and green challenge the umbrous depths and the design has suddenly attained a bold flexibility. No wonder that four years later in 1623 the Count-Duke Olivares, Philip IV's chief minister, was to summon him to the court at Madrid.

Velasquez's departure left the field open for his two most serious rivals, Alonso Cano and Francisco de Zurbarán. Of the two, Zurbarán was the greater painter, and Cano the more versatile artist, being proficient also in sculpture and architecture. Cano and Velasquez had been fellow pupils at Pacheco's academy and both warmly admired the sculpture of Juan Martínez Montañés, known as the 'God of Wood-Carving' whose statues Pacheco was sometimes called upon to colour.

Montañés settled in Seville when he was about twenty and instantly found it congenial. Previously he had been occupied in Granada where he saw the great royal commissions of the 16th century and was well equipped to profit from the stimulus of a cultivated milieu. He was soon accepted by, and mixed freely with, the poets and philosophers of the metropolis. Like Pacheco, Montañés was a devout man who scrupulously tried to embody in his carvings the nuances of religious meaning dictated 161 by his patrons. This is true not only of the moving *Christ of Clemency*, which haunted the imaginations of Velasquez and Zurbarán for many 172 years, but also of the *Immaculate Conception*.

The Sevillians were unusually devoted to the latter subject. While theologians had always hotly debated the doctrine, it was invariably a cherished belief among the faithful and one which gained ground rapidly as the laity in southern Europe learned with angry dismay of the furious attacks made by Northern reforming iconoclasts upon the images of the Virgin. At last, in 1615, the Seville Carmelites wrote to the Spanish hierarchy imploring them to put pressure on the pope to make a definite pronouncement on the belief. When the news of the papal assent reached Seville the local ecclesiastics regarded it as their particular triumph. Numerous theological treatises expounding the doctrine were published

160

SAN PEDRO
1624
Seville

Whenever periods of indigence coincide with creative vitality in ornamental design, stucco is apt to enjoy a renewed popularity; it is not only cheaper than stone but it is also a very flexible material to handle. On this Sevillian church the decoration is unique, since it reconciles the local delight in interweaving motifs derived from Moorish craftsmanship with Mannerist classicism in the design of the façade as a whole.

161

THE CHRIST OF CLEMENCY
1603–06, polychrome wood
Juan Martínez Montañés 1568–1649
Seville Cathedral

The cathedral authorities had very definite ideas about the interpretation that the sculptor should follow in this instance, and instructed him to make Christ appear, 'alive before His death . . . looking at any person who might be praying at His feet, as if Christ Himself were speaking to him and were lamenting that what He is suffering is for him who is praying, and thus the eyes and features should be of some severity and the eyes completely open.'

162

ST JAMES
DEFEATING THE MOORS
1609, oil
Juan de Roelas c. 1558/60–1625
Seville Cathedral

This enormous picture, measuring eighteen by twelve feet, was Roelas's masterpiece. Like many artists during this period he was ordained a priest, and this, coupled with the fact that his formative years were spent at Valladolid, the seat of Philip III's court, probably gave to this image its force and conviction, for the theme commemorates Philip's recent order to expel the Moriscos.

in Spain, and in 1620 Pacheco painstakingly wrote down the attributes that artists should employ in representations of the Immaculate Conception. 'In this most lovely mystery the Lady should be painted in the flower of her youth, twelve or thirteen years old, as a most beautiful young girl, with fine and serious eyes, a most perfect nose and mouth and pink cheeks, wearing her most beautiful golden hair loose ... Man possesses two beauties, namely body and soul, and the Virgin had both beyond compare ... But Christ Our Lord, not having an earthly father, in everything resembled His mother who after Her son was the most beautiful being created by God ... She should be painted with a white tunic and a blue mantle ... She is clothed in the sun, an oval sun of whites, sweetly fusing it with the sky. She is crowned by stars, twelve stars arranged in a light circle between rays parting from her sacred forehead. The stars are painted as very light spots of pure dry white excelling all rays in brightness ... An imperial crown should adorn her head which should not hide the stars. Under her feet is the moon. Although it is a solid planet, light and transparent above the landscape as a half moon with the points turned downwards ...'

As a sculptor Montañés was free to ignore some of the more recondite precepts, but Zurbarán, Cano and Murillo repeated the formula with varying degrees of infidelity for many years. Montañés art, however, was not only learned. Many of the calls made upon his skill were for a kind of art which demanded an image with an immediate appeal and meaning; the carving of statues for the celebrated religious processions, when relics, images, and *custodias* were borne along the streets on floats on the principal feast days of the Church and especially in Holy Week.

Another artist who excelled in this field was Gregorio Fernández, from Valladolid, whose finest piece of popular devotional carving was the *Pietà* To enhance the naturalism of the piece the eyes were made of 173 glass. Obviously the subtleties desirable in a work to be contemplated quietly in a church would have been out of place amid the tumult of the street processions, and instead the artist had to exaggerate the movements, emotions and character of his subject so that the populace would be instantly stirred by sorrow, penitence, and awe, and sometimes even incited to spiteful mirth by the caricatured ugliness of the renderings of the impenitent thief or Judas.

As in the previous century many Spanish sculptors were engaged on the construction and embellishment of high altars, which became increasingly sumptuous as the century advanced. It seems incredible that only thirty-three years separate the restrained Montañés altarpiece in Santa Paula, Seville, and Bernardo Simón de Pineda's high altar of the Seville 187, 188 Carídad, in which Pineda forged his vast enterprise into an integrated, if dramatised, entity, as exuberantly Baroque as a conception by Bernini. One reason for the evolution of these grandiloquent structures lay in the need to provide a climax and focus for that peculiarly Spanish architectural feature, the *coro*. The Spanish choir is so extensive that it not only occupies the usual position east of the crossing but also embraces the greater portion of the nave. As if to underline its special character it is usually confined by high, splendidly adorned choir stalls which virtually turn it into a special enclosed unit within the main body of the cathedral.

Naturally, architectural activity in Madrid, which Philip II had made the capital in 1561, was centred on the requirements of the court; two buildings of markedly disparate purpose epitomise the ethos of Philip IV's reign, the foundation of the Collegium Imperiale and the erection at Olivares's behest of the Buen Retiro Palace on the outskirts of the city.

163

THE IMMACULATE
CONCEPTION

Francisco Pacheco 1564–1654
oil
Seville Cathedral

The complicated sources of Pacheco's imagery are delightfully revealed in his treatise. 'In the case of the moon I followed the learned opinion of Father Luis del Alcazar . . . who says, "The painters usually turn the feet of this figure upwards. But it is evident among mathematicians that if sun and moon face each other, both points of the moon have to be turned downwards so that the figure is not standing on a convex." This was necessary, so that the moon, receiving its light from the sun, would illuminate the feminine figure standing upon it.'

164

THE HOLY FAMILY

1631, oil
Vincencio Carducho 1576–1638
Prado, Madrid

The great contrast in conception, modelling and colour between this idealised picture, and Ribera's contemporary *Martyrdom of St Bartholomew* (**166**) helps to explain Carducho's deep antipathy for Realism.

Appropriately, a Jesuit, Francisco Bautista, was chosen for the first task, since the Collegium was a singular institution designed to equip the sons of the nobility to take their active place in the administration of society. Not only were they provided with the conventional groundwork in theology, philosophy and the liberal arts, but a modern pragmatic slant was introduced by the teaching of the new disciplines of economic, military and political science. Their instruction was entrusted to the Jesuits, who were now the acknowledged leaders in the field of education: even Roger Bacon writing on pedagogy urged the reader to 'Consult the Jesuits, for nothing better has been put into practise.'

The wisdom of instilling a practical grasp of affairs into the scions of the ruling caste is amply illustrated by the fact that in 1625, the very year in which the Collegium was instituted, Olivares, alarmed by the decline in agriculture, tried to inject new life into the cultivation of the land by inviting Flemish farmers to settle in Spain. Furthermore, only two years later, Philip IV was forced to repudiate his debts to foreign creditors—thus bankrupting the greatest banking house in Europe, that of the Fuggers, in the process.

1627 was also a crucial year for Velasquez, affecting his status at court. A competition was held upon the theme of Philip III and the expulsion of the Moriscos. The competitors were Eugenio Caxés, Vincencio Carducho, Angelo Nardi and Velasquez, who was declared the winner, much to Carducho's disgust. Following this success he was appointed Usher of the Chamber, a post which carried with it the privileges of a free apartment and the services of a physician and apothecary.

Not only did Valesquez supplant Carducho in royal favour but his art itself was antipathetic to the artist, who believed that all painting should **164** spring from religious devotion. His frustration and loathing of his successful rival was vented in the *Dialogues on Painting, its Justification, Origin, Essence, Definition, Classes and Distinction*, published in 1633, in which he forcefully criticised the new Realist style, with its implicit disregard of 'beauty'. Its pages contain many sly digs at Velasquez, especially in the essay on Caravaggio, whom he literally regarded as an artistic Antichrist. There was, however, another reason for Carducho's treatise: it was a plea for the social elevation of the artist, and Velasquez, a nobleman by birth, declined to associate himself with this demand.

Furthermore Velasquez's rise at court had been meteoric. Initially he was lucky in his friends. The Count-Duke Olivares, who was the king's favourite and the most powerful man in Spain, probably first heard of the artist through their mutual friend the poet Francisco de Rioja, who was a frequent visitor at Olivares's house in Seville in 1619. In 1622, when Velasquez paid a short visit to Madrid, he was befriended by Juan de Fonseca, a former canon of Seville Cathedral who was now the king's chaplain. Eventually it was Velasquez's likeness of the poet Luis de Góngora that excited every courtier's admiration and led Philip IV to commission a portrait from him. The king was so pleased with the out- **170** come that he declared he would sit for no one else. Philip was a few years younger than Velasquez and took an instant liking to the artist. Their friendship lasted until the painter's death, and scarcely a day passed without the monarch coming into the studio to watch him at work.

Like his illustrious predecessors Philip was a discriminating judge of art, sharing their delight in Titian's genius, and many more fine examples of the Venetian master's work found their way into the Spanish royal collection during his reign. Velasquez now had the freedom of the king's picture galleries and he too discovered in Titian's canvases a lifelong

source of inspiration. Undoubtedly his response was both quickened and enlarged by a new friendship: during the summer of 1628 Rubens arrived in Madrid.

In 1603, while he was in the service of the Duke of Mantua, Rubens had visited the court of Philip III at Valladolid. On that occasion disappointments attended his stay; rain rotted the paintings he was bringing as a gift to the king's favourite, the Duke of Lerma, and when he reached the court he found the palace deserted and everyone absent on a hunting expedition. Nor could he follow them easily because he was not only encumbered by the bulky crates containing the damaged canvases but he was also accompanied by six magnificent horses and a state coach which his master, the Duke of Mantua, sent as an offering to the king. In many ways the visit was frustrating, as we know from Rubens's letters to Annibale Chieppio, the duke's secretary in Mantua. Many weeks were lost in the tedious repairs to the rain-soaked copies of Raphael's paintings. However, the Duke of Lerma was delighted with the result, and commissioned Rubens to execute paintings for him.

At the outset the circumstances of Rubens's second visit were scarcely more auspicious, for he was engaged on a diplomatic mission of great delicacy on behalf of the regent of the Netherlands, the Infanta Isabella, the object of which was to bring about a reconciliation between Spain and England, thus weakening the power of the Dutch. He tells us: 'the Infanta wished my journey to be so secret and immediate that she would not permit me to see any of my friends, not even the Spanish Ambassador or the Secretary for Flanders resident in Paris ... I cannot penetrate the secrets of princes, but it is true that the King of Spain had ordered me to come post-haste.' Actually it was Isabella who was importunate and wore down Philip IV's initial reluctance to entrust such a difficult embassy to an artist. Rubens soon overcame the king's misgivings and a mutual love of art evidently made Rubens's sojourn pleasurable and rewarding: 'This prince is obviously very fond of painting, and in my opinion he is gifted with excellent qualities. I already know him personally, as my rooms are in the palace and he comes to see me nearly every day.' Not only did Philip make a rare concession and sit for the Flemish master but he was to remember him again when he wanted a vast series of decorations for the Torre de la Parada in 1636. Much of Rubens's time was occupied in making copies of the royal Titians. They were rarely exact reproductions but were free interpretations transforming the Renaissance designs into rich Baroque inventions. It was Velasquez's task to conduct the famous visitor around the royal collections, and they spent many hours discussing the merits of their contents. They also watched each other at work and Rubens, who painted at tremendous speed, was amazed at the Spanish artist's slow deliberation and his habit of pondering the problems of a painting for a long time without touching the canvas at all.

Although Rubens's stay lasted barely a year its impact was prolonged. Philip continued to admire his genius, and many of the finest Rubens paintings in the Prado, including *The Garden of Love* and *The Three Graces*, belong to his last years. The latter was commissioned by Philip's brother the Cardinal Infante Ferdinand, whose arrival in Brussels shortly before had been greeted by a spectacular series of triumphal decorations created by Rubens.

These masterpieces were dispatched to Spain at a time when Velasquez had already assimilated the lessons learnt during his first visit to Italy from 1629–31, a voyage that Rubens was probably instrumental in

182

165

THE MEDICI GARDENS

1630, oil
Diego Velasquez 1599–1660
Prado, Madrid

The gardens of the Villa Medici led Velasquez to create two landscapes that are unique among his works in their vivacity of touch and perception. This example has often been compared to the work of Corot and the Impressionists, but unlike the latter its immediacy was almost certainly suggested by the atmospheric freshness of antique painting which he had seen in Rome.

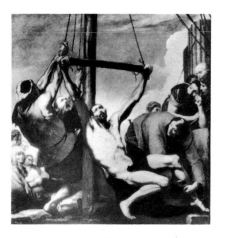

166

THE MARTYRDOM
OF ST BARTHOLOMEW

1630, oil
Jusepe de Ribera 1591–1652
Prado, Madrid

Whereas most of the earlier Realist pictures by Ribera and others had achieved their startling effects by the depiction of forms emerging from murky backgrounds, in this painting Ribera pitted the action against a clear cerulean sky. However, nothing is shirked, the terrible tug of the arms wrenched upon the cross beam, the tormented anguish of body and spirit are expressed with a harshness which defies the squeamish. Above all the sweaty body and shaggy armpits and the hideous exertions of the assailants are balanced by the enigmatic detachment of the women.

arranging. It was a liberating experience for Velasquez, but not without its complications. He set out in the company of General Spinola, the commander-in-chief of the Spanish armies in Italy. Rumours were rife in the Italian courts that Velasquez was a spy; in Venice there were real fears for his personal safety, so that he never stirred abroad without a bodyguard. Despite these alarms Venice brought to him the great revelation of the genius of Tintoretto, an artist whom he revered for the rest of his life. In Rome Velasquez was honoured with special apartments in the Vatican, which enabled him to copy Michelangelo's and Raphael's frescoes whenever he chose. But he missed court life and became lonely and dejected. As the Roman summer advanced and the heat became oppressive he removed to the Villa Medici at Tivoli, where he painted the

165 gardens. These views mark him out as one of the great pioneers of landscape painting; his touch was so deftly vivacious that he captured all the sunny dappled freshness of the scene.

On the last stage of his journey Velasquez visited his fellow countryman Jusepe de Ribera in Naples. 'Lo Spagnoletto' (the little Spaniard), as the Italians called him, settled in Naples in 1616. Very little is known of his origins; we cannot even be sure of the identity of his master, though he may have been Francisco Ribalta, as both artists were interested in the problems of realistic presentation. Possibly some early disappointment influenced his decision to live abroad, since many years later he made an embittered riposte to a suggestion that he might return to his native land: in Spain, he declared, he would be honoured the first year and forgotten the next.

Inspired by Caravaggio's late works, Ribera adopted a dark palette and a similarly direct method of painting. Often he used old beggars,

167 grimy and grinning, dressed up as the philosophers and mathematicians of antiquity. While he paid minute attention to all the harsh irregularities of texture or features, the overall design of these pieces evinced a largeness and simply dignity which made him both popular and influential. At the time that Velasquez called upon him he must have just completed

166 one of his most powerful paintings, the *Martyrdom of St Bartholomew*. A bright sky replaces his familiar dark backgrounds, lighting up the hideous torments of the rack. Despite its harrowing physical veracity it is an intensely spiritual image. Ribera, like so many artists of this period, was a fervent believer.

Later, his life was clouded by the seduction of his daughter by Philip IV's illegitimate son Don John of Austria. The artist became obsessed by the tragedy, executing a series of pictures showing the unfortunate girl

191 in the guise of the penitent Magdalene. Rejecting the bituminous shadows and stark highlights of his earlier Realist phase, he now favoured a softer, more fluid handling, silvery tonality and warmer colours.

Meanwhile, Philip eagerly looked forward to the return of his favourite painter. A special task awaited him. During his absence the queen had given birth to an heir, Don Baltasar Carlos, now an imperious toddler of eighteen months. Velasquez endowed him, even at that tender age, with all the dignity accruing to a royal personage, which he contrasted poignantly with the cowed surliness of his little playmate, one of the court dwarfs. This remarkable double portrait is now in America. In 1635 Velasquez again immortalised the young prince, this time alone,

193 cantering along on his pony. The equestrian portrait of the young heir was destined to hang in the hunting lodge of the Torre de la Parada together with a similar likenesses of his father and uncle, Don Fernando. About this time Velasquez also portrayed Olivares on horseback. In

167
ARCHIMEDES
Jusepe de Ribera 1591–1652
oil
Prado, Madrid

Ribera enjoyed a widespread fame due to his brilliant etchings, which he carried out soon after his arrival in Naples. Even Rembrandt admired them, incorporating some of the motifs into his own pictures. Possibly the sharp tonal contrasts Ribera obtained in this medium encouraged him to evolve a painting technique which is almost brusque in the delineation of the forms. Here he audaciously conjured up the grimy poverty of the cheeky old beggar by the sheer economy of the design and absence of softening middle tones.

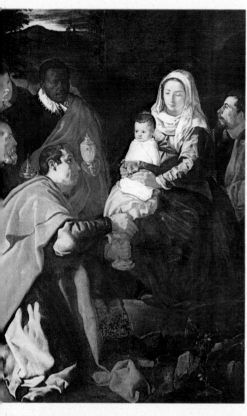

168 *left*

THE ADORATION
OF THE MAGI

1619
Diego Velasquez 1599 – 1660
oil
Prado, Madrid

The year in which Velasquez painted this picture was particularly momentous for him. Not only did he sign on his first apprentice – possibly to assist him in the execution of this canvas – but he also married Pacheco's daughter. Among the witnesses was Francisco de Rioja the poet, who was also a friend of Olivares and may have brought the young painter to the Count-Duke's notice when he stayed in the city that year. It is not known whether Olivares saw the *Adoration*, which was the first painting to show the full range of Velasquez's gifts.

169 *below*

THE TOPERS

1629
Diego Velasquez 1599 – 1660
oil
Prado, Madrid

The subject of this painting has remained tantalisingly obscure, although the central figure indubitably represents Bacchus. At this time Velasquez's style was undergoing a rapid series of transformations, and the individual figures are treated in very different ways. This variety arose partly from the presence of Rubens at the court; their discussions about the masterpieces in the Spanish royal collections enlarged Velasquez's awareness of other masters' qualities. The open-air setting was a daring prelude to the later portraits set against the Gaudarramas.

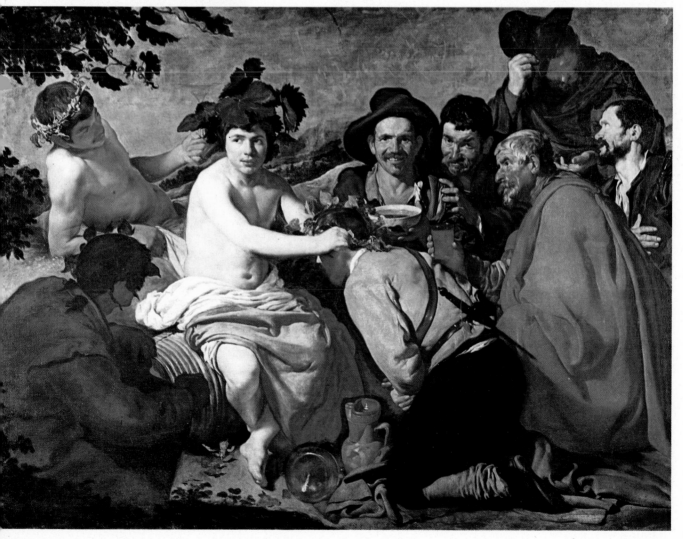

170 *below*

PHILIP IV ON HORSEBACK

1634–35
Diego Velasquez 1599–1660
oil
Prado, Madrid

In the painting of the prince (**193**) Velasquez captured something
of a young child's excitement during his early-morning ride;
the king in this painting moves at a more considered pace, and in
order to preserve the mood of steady regal progress the artist
avoided the abrupt decline in the landscape. In Italy he had had
ample opportunities for prolonged study of similar themes, above
all the Marcus Aurelius statue in the Capitoline square. The
importance Velasquez attached to these paintings is also manifest
in the fact that they were entirely by his hand.

171 *right*

ADAM AND EVE

1507
Albrecht Dürer 1471–1528
oil
Prado, Madrid

When Dürer designed these panels he had just returned from a
prolonged stay in Venice; the figure of Adam was inspired by
recollections of Andrea Rizzo's sculpture of Adam in the Doge's
Palace, while the technique is a tribute to his admiration for
Giovanni Bellini. In the sinuous, elastic outlines of the bodies
Dürer anticipates some of the characteristics of Mannerism. The
panels originally belonged to Queen Christina of Sweden and
later entered the collection of Philip IV.

172 *right*

THE IMMACULATE CONCEPTION

1629–31
Juan Martínez Montañéz 1568–1649
polychrome wood
Seville Cathedral

Pacheco's dry theological pedantry had little bearing on Montañés's conception of this theme, and he maintained a masterly balance between spirituality and sensuous grace. In this he was aided by the elaborate process of finish that typifies Spanish wood carving – the coarser fibres of the material are obscured by the successive overlay of gesso, gilding and paint. In his youth he was privileged to see the Duke of Alcalá's splendid collection of antiques, and a certain classical repose is discernible in his arrangement of the figure and the draperies.

173 *below*

THE PIETA

1617
Gregorio Fernández 1576–1636
polychrome wood
Museo Nacional de Escultura, Valladolid

Earlier in the century the court had been established at Valladolid and, not surprisingly, Fernández made his artistic debut as an assistant to a follower of Pompeo Leoni. Yet it is clear that his vision and emotional range was quite distinct from that of the Italian Mannerists. The tragic sincerity of his gestures and expression recall Juan de Juni (**136**), and though the composition is less tempestuous, it is clear that Fernández greatly admired the earlier sculptor. Already the ample drapery, supple movement and depth of feeling anticipate the Baroque, though he avoids stylised rhetoric.

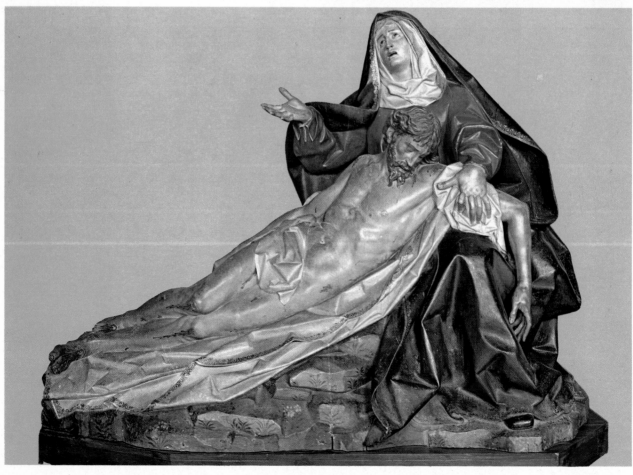

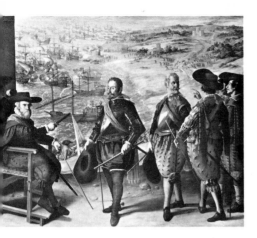

174

THE RELIEF OF CADIZ

1634, oil
Francisco de Zurbarán 1598–1664
Prado, Madrid

The painting, which celebrates the quashing of Lord Wimbleton's ill-fated foray into Cádiz in 1625, was one of the scenes of victories during the Thirty Years War decorating the Hall of Realms in the Buen Retiro Palace. Although Zurbarán had modified the severity of his style, the commission still presented special problems, such as that of relating the topographical background with the lively vividly coloured costumes and the likenesses of their wearers. The gouty defender of the city, Fernando Giron, is shown seated because of his infirmity.

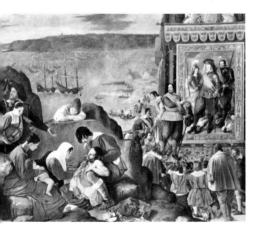

175

THE RECOVERY OF
BAHIA IN 1625

1635, oil
Juan Bautista Mayno 1578–1649
Prado, Madrid

Mayno's popularity at court stemmed from his employment as Philip IV's drawing master in the king's childhood. In 1611 he had joined El Greco's circle at Toledo, but Mayno's style is so much closer to that of Roman painting at the turn of the century that it seems likely that he trained here. Owing to his priestly duties, Mayno's output was limited, but his skill is well demonstrated in this picture, which was part of the decoration of the Hall of the Realms.

this case the principal minister was not enjoying a hunting sortie, but was conducting a battle from afar: a reference to his supreme power during the Thirty Years War.

The war had begun in 1618, three years before Philip ascended the throne and appointed Olivares as his chief counsellor. Three factors precipitated the conflict: the Dutch repudiation of the truce of 1609, the need to consolidate Hapsburg power which embraced both the Spanish and the Austrian dynasties, and the desire to champion the Catholic cause against the northern reformers. From the first the war made disastrous inroads into Spanish reserves of gold and manpower. The need to economise was felt at all levels of society, and sumptuary laws to curtail expenditure were introduced. Philip himself popularised the simple starched lawn collar which replaced the vast expensive ruffs as fashionable attire almost everywhere, except in Holland, where the Dutch obstinately clung to the older mode of dress as a calculated snub to the Spaniards.

Olivares was able, ruthless and intelligent and during the early stages of the war Spain gained some notable triumphs, although by 1640 the tide had turned decisively against her. Five years earlier matters had come to a head between Olivares and Richelieu; and France had declared war on Spain. Thereafter Richelieu was quick to fan the fires of discontent within Spanish lands. The Portuguese rebelled and unrest broke out in the Spanish provinces, especially in Aragon where Castilian hegemony was strongly resented. Even more depressing was the failure of Spanish vessels to arrive at Seville and discharge their customary silver cargo. Throughout the century Spanish maritime power had been sadly declining. Its final eclipse was due in no small measure to the Spanish failure to grasp the significance of the invention of the man-of-war, with its superior speed and armament, while conservative Spaniards continued to rely on the cumbersome galleon. No wonder that Olivares wrote: 'The year (1640–41) can undoubtedly be considered the most unfortunate that the Monarchy ever experienced.'

In truth Olivares had been guilty of a fatal miscalculation, believing that if Spain subdued the Dutch all their wealth would buttress the Spanish fortunes. As events turned against him and people began to question the wisdom of his policies he reacted with violent, hysterical fury. Even Philip's confidence was sapped. In 1643 Olivares was summarily dismissed.

But before his fall from grace he had been instrumental in creating the circumstances for the issuing of the greatest series of royal commissions from Spanish artists, the decoration of the Hall of Realms in the newly built Buen Retiro Palace. The motives behind its erection were unedifying. Philip was a cultivated man but was inept in his management of affairs of state or international relations. This was convenient for Olivares because it ensured his authority, but in order to deflect the monarch's attention still further he played on the king's weakness for petty sexual intrigues for which the Buen Retiro was to provide the ideal setting.

All the major talents in Spanish painting were enlisted to adorn the hall with depictions of notable victories in the Thirty Years War, while **174, 175,** these in turn were surmounted by a frieze of ten panels by Zurbarán **194** representing the Labours of Hercules – the traditional allegorical commemoration of royal conquest.

A single event stood out from all the rest, the surrender of Breda in 1625. Not only was it a remarkable feat of military tenacity but it was also a rare triumph of human dignity and compassion. Spinola's treatment of his skilful adversary Justinus of Nassau fired everyone's imagination, including that of the poet Pedro Calderón who immediately wrote a play

176 *right*

THE RELOJ TOWER

1676–80
Domingo de Andrade c. 1639–1712
Cathedral of Santiago de Compostela

The belfry is erected on a 14th-century base, refaced by Andrade
to reconcile it with the style of his upper section. This section
introduces a new note of plastic exuberance into late 17th-century
Spanish architecture, anticipating the Churriguesque style of the
next generation. The Reloj Tower excited widespread admiration
and was frequently copied.

177 *below*

THE QUINTANA PORTAL

1658–66
José Peña de Toro, d. 1676
Cathedral of Santiago de Compostela

Throughout the Middle Ages Santiago de Compostela had been
one of the greatest shrines and centres of pilgrimage in Christen-
dom, but by the mid-17th century its popularity had declined, and
in a vigorous attempt to reassert its pre-eminence the authorities
determined to refurbish the fabric of the cathedral, entrusting the
task to Peña, whose most famous contribution was the Quintana
portal. The rather fussily decorated doorway is uncomfortably
squeezed in between columns of a giant order.

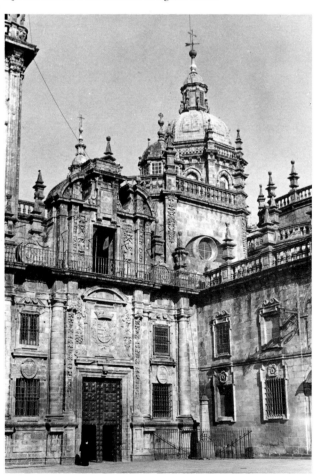

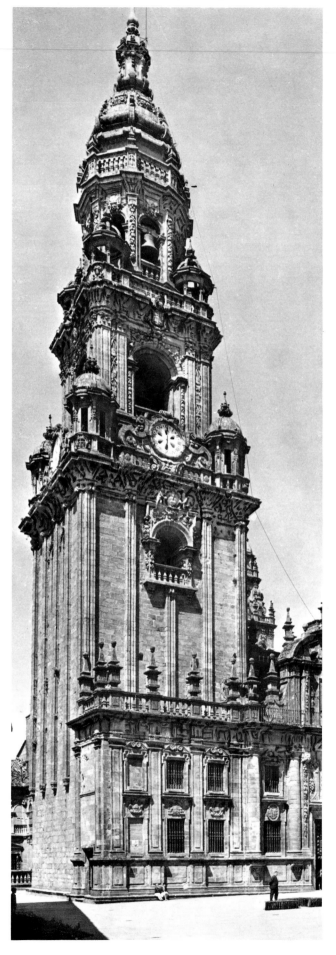

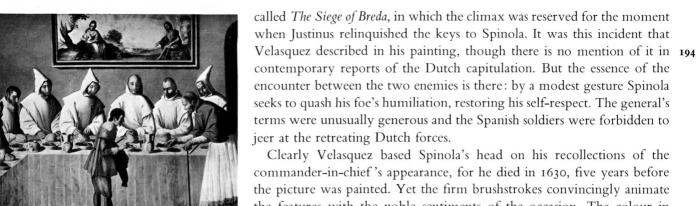

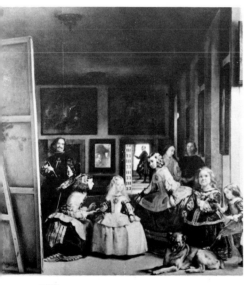

178

ST HUGH OF GRENOBLE
VISITING THE REFECTORY

c. 1633, oil
Francisco de Zurbarán 1598–1664
Museo de Bellas Artes, Seville

The dominant creamy whiteness of the
Carthusian habit allows Zurbarán full play
in the skilful manipulation of the support-
ing hues of the vessels, meats, the saint's
vestments and the boy's costume, all of
which are most delicately orchestrated.
Similarly the textures are meticulously
defined, but these details only serve to
accentuate the austere dignity of monastic
life.

179

LAS MENINAS

1656, oil
Diego Velasquez 1599–1660
Prado, Madrid

Velasquez may have been inspired by Van
Eyck's *Arnolfini Wedding* which was then
in the Spanish royal collection. However,
the total effect is infinitely complex in its
social and psychological implications.
While the accurate description of the
room, (which was formerly part of the
suite of Prince Baltasar Carlos and was
later allocated to the painter as a studio and
office) is discreetly handled, Velasquez
reserved his most lively brushwork for
the figures of the little princess and her
attendants.

called *The Siege of Breda*, in which the climax was reserved for the moment
when Justinus relinquished the keys to Spinola. It was this incident that
Velasquez described in his painting, though there is no mention of it in **194**
contemporary reports of the Dutch capitulation. But the essence of the
encounter between the two enemies is there: by a modest gesture Spinola
seeks to quash his foe's humiliation, restoring his self-respect. The general's
terms were unusually generous and the Spanish soldiers were forbidden to
jeer at the retreating Dutch forces.

Clearly Velasquez based Spinola's head on his recollections of the
commander-in-chief's appearance, for he died in 1630, five years before
the picture was painted. Yet the firm brushstrokes convincingly animate
the features with the noble sentiments of the occasion. The colour in
this painting is exceptionally delicately orchestrated and the cool tones
of the seemingly burning waste is a sublime imaginative stroke: the
fires and fury of war have been extinguished by the victor's chivalry,
and the whole scene is bathed in a searching limpid light.

The other artists who contributed to the scheme ranged from the older
generation of artists to the youngest: Caxés, who died before he could
finish his pieces, El Greco's erstwhile follower Juan Bautista Mayno,
Valesquez's embittered rival Vincencio Carducho (who was allocated three
scenes), Zurbarán, and finally two young painters, Antonio Pereda and
Jusepe Leonardo.

Ironically, Leonardo's *Talking of Breisach* celebrated the recent victory
of 1633; it was almost the last military exploit to gladden Spanish morale.
Leonardo was one of the most gifted artists at court and strongly in-
fluenced by Velasquez. Pereda's rise in favour was cut short prematurely;
Olivares loathed Pereda's sponsor, the architect Juan Bautista Crescenzi,
and when he died the Count-Duke lost no time in venting his spite on the
unhappy artist.

All the battle scenes had one common feature, a dependence upon
engravings for the topographical details. Even the background in
Zurbarán's *Relief of Cádiz* is curiously linear. Successful though Zurbarán's **174**
Buen Retiro pictures were, his imagination was more vividly engaged
when envisaging sacred themes. His religious paintings range from single
figures of saints to more complicated groupings. Zurbarán's saints rarely **196**
yield to passion or rhetoric, but express an inner repose and certitude.
Nevertheless the design of the pose of these standing figures is deftly
and interestingly composed. Each form appears uniquely memorable.
The concentrated, almost sparse effect of these paintings serve as a re-
minder that the Spanish population declined by more than 2,000,000
between 1594 and 1723. Even today a solitary peasant traversing the
empty plains imprints his outline upon the mind with unusual complete-
ness. Zurbarán was a native of Estremadura, and the dry earthy pigments
and uncompromising realism of some of his early pictures mirror the
poverty of the area, although he could revel in a diversity of colour and
texture.

Inevitably Zurbarán was much in demand among the monastic com-
munities in Seville; above all the Carthusians and Mercedarians competed
for his services. These monastic paintings, permeated by a sober truthful-
ness of form and characterisation, offered a corrective to the secular pre-
occupations of the court. It must not be forgotten, however, that much of
Philip's IV's melancholy sprang from his superstitious fear that his political
and economic reverses were a divine punishment for his amatory excesses.

Spanish spirituality was distinguished by three main traits: popular
devotion, the need to subjugate the individual will by the restraints of

178 the religious rule (which is expressed in Zurbarán's painting of *St Hugh visiting the Refectory*) and a renewed interest in mysticism occasioned by the publication in 1638 of the meditations of St John of the Cross, which were avidly read by every section of the literate public.

One result of this belief in the validity of individual spiritual experience, coupled with the Counter-Reformation affirmation of the unity of body and spirit, was the unmitigated honesty which imbued the Spanish portrait. Zurbarán's monks (obviously the heads are portrait studies) may share a community of purpose, but it is rooted in personal resolve. Nowhere is this concept of the uniqueness of personality more relentlessly explored than in Velasquez's portraits of the court dwarfs, who are either immortalised singly or take their place with the royal family in that mic- 179 rocosm of the court, *Las Meninas*.

Other artists, including Dürer, Leonardo da Vinci and Jacques Callot, had been fascinated by ugly halfwits and caricatured their hideous grimaces and inept actions with a mordant humour. Velasquez offers no comment on the mutilated natures of the simpletons and dwarfs whose role in life was to proclaim their infirmities for the cruel sport of the king and his courtiers. Appropriately, the series was hung in the Buen Retiro, a salutary antidote to the high splendour of the victories.

Much of Velasquez's time was spent in the performance of his duties as a courtier, and late in life his faithful service was rewarded by his admission to the Most Noble Order of Santiago. All Spaniards were acutely conscious of social distinctions and this signal honour clearly gratified the artist. Among those who had cause to rejoice in his trusted position at court was his old fellow student, Alonso Cano, who arrived in Madrid in 1638. The summons came from Olivares, but Velasquez may well have heard of Alonso's recent scrapes in Seville and intervened on his behalf. Cano was a strange man, feckless, witty, amiable and quick tempered by turns: he had been imprisoned for debt and had attacked a fellow painter in a duel. Paradoxically his most ardent desire was to embrace the religious life. Here laziness hampered him for he could not bring himself to tussle with the rigours of Latin grammar, nor could he master the complex arguments of theology. Eventually Philip took pity on him and he was appointed a prebendary of Granada Cathedral.

186, 189 Cano's last year at Granada saw him actively engaged as painter, sculptor and architect. The design for the cathedral façade not only represented the climax of his career, but it was also the last great Classical Baroque invention before Spanish architecture was overwhelmed by the florid extravagance of 18th-century Churriguesque.

155, 195, 197 The last great artist to dominate the century was a painter, Bartolomé Murillo. He has often been faulted for his overt sweetness, but this should not blind us to his many qualities. Invariably the design is expressive and felicitous, and as a colorist he was superb. True his ambitions were limited; unlike Velasquez he was not concerned with any objective or critical view of society.

It is fitting that the art of the century should culminate in work of a painter; during the entire period architecture and sculpture paled before the diverse grandeur of painting. No cultivated Spaniard would have quarrelled with Palomino's assertion: 'Is there any eloquence greater than that represented by painting? . . . When the picture expresses inner emotions, its noble deception not only acts powerfully on your friends, but enraptures everybody else . . . Such is the efficacy of painting's illuminated and shaded lines!'

Maria Shirley

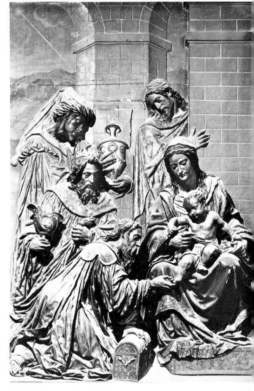

180

ADORATION OF
THE SHEPHERDS

1610–13
Juan Martínez Montañés 1568–1649
Church of San Isidro, Santiponce

The *Adoration* is one of four reliefs from an audacious scheme which also contained life-size figures of saints and of the donors, Pedro de Guzman and his wife, who commissioned the decoration of the high altar of San Isidro. Montañés discreetly fused a warm tender grace with a strict compositional discipline, so that the design is classically frontal and symmetrical. Yet the detailing of the drapery and modelling of the heads is richly handled and counteracts the severity of the arrangement.

181 *left*

PORTRAIT OF
MARIE DE' MEDICI

Peter Paul Rubens 1577–1640
oil
Prado, Madrid

In this portrait we can see why Rubens
won such acclaim as a court portraitist,
for he proclaims the charm of the sitter
without sacrificing the truth that she was
a stout middle aged widow. Because of his
dual role as artist and diplomat Rubens had
known Marie de'Medici intimately in
moments of both triumph and adversity;
his famous laudatory allegorical cycle in
the Louvre was first exhibited as part of
the sumptuous wedding decorations for
Henrietta Maria's marriage to
Charles I. Later when, in 1631, she
hastily fled from France, Rubens attended
her at the behest of Philip IV.

182 *left*

THE THREE GRACES

1638–40
Peter Paul Rubens 1577–1640
oil
Prado, Madrid

Among the late works by Rubens to find
their way into the Spanish royal collection
were *The Three Graces* and *The Judgment of
Paris*, of which the Infante Ferdinand
explained, 'the artist doesn't wish to cover
the nudity of the figures because this is
regarded as the value of the painting.'
That this assertion was a true reflection of
the way Rubens prized sensuous richness
in the rendering of flesh is confirmed by
his delight in the sculptures of Duquesnoy.
He wrote, 'It is not art, it is nature herself
who has formed them, and the marble
seems softened to flesh'.

183 *right*

ST PETER

c. 1631–2
Jusepe de Ribera 1591–1652
oil
Prado, Madrid

The anti-idealisation of the subject, which was a natural con-
comitant of Realism, led Ribera to adopt a style of handling which
recreated the living surfaces of the wrinkled visages of old men.
Often his effects are less schematised than those of Caravaggio,
who inspired him, and this is due in no small measure to his
technical prowess. So assured was his handling that he placed the
final accents–such as those heightening the whiskers–or the
deepest shadows, upon a wet underpainting.

184 *far right*

ST BRUNO

c. 1635–40
Manuel Pereyra 1588–1683
polychrome stone
Real Academia de Bellas Artes, Madrid

Little is known of Pereyra's origins beyond the fact that he was
Portuguese. However, he was fortunate in attracting the attention
of Philip IV, whose regard for his work is attested by the award of
the Knighthood of Santiago–a rare honour indeed for a sculptor.
Unlike most Spanish sculptors he avoided excited action; the
mood of his works is reticent and profound, and thus ideally
suited to the presentation of one of the major themes of con-
templation in the 17th century, that of death.

185 *right*

THE TRINITY

1636–37
Jusepe de Ribera 1591–1652
oil
Prado, Madrid

Ribera's deep religious faith invested this traditional image with
new life and intensity, bringing this most sacerdotal theme into a
more immediate relationship with the spectator. This is true not
only of the way in which he conceived the figure of God the Father
as both tender and austere, but above all in the conception of
Christ, who sinks back exhausted with his arms flung wide. The
treatment of the nude is essentially 17th century in conception,
with the sharp focus on bodily truth and rejection of ideal
proportions.

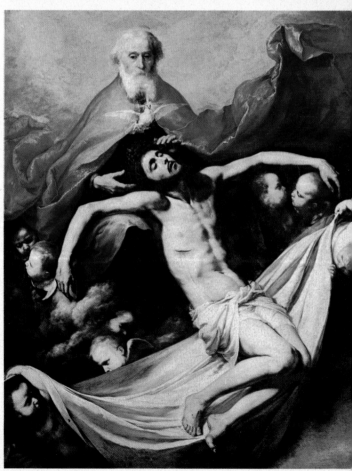

186 *left*

ST DIEGO OF ALCALA

1653–57
Alonso Cano 1601–67
Palace of Charles V, Granada

For many years Cano abandoned sculpture, but he returned to it
late in life, when at Granada he created some of his finest works,
including the over-life-size figure of St Diego. In his youth he had
deeply admired Montañés, but later his style and expression
achieved an entirely personal vein. The taut pose and inner
withdrawal of the saint is the antithesis of the more overt rhetoric
of so much contemporary Baroque sculpture in Southern Europe,
and undoubtedly springs from his own spiritual preoccupations
just prior to his admission to Holy Orders.

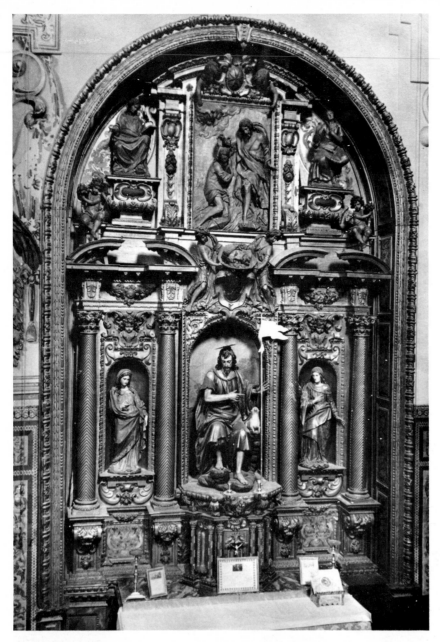

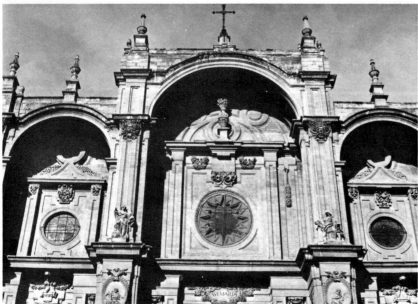

187 *left*

THE ALTAR OF ST JOHN THE BAPTIST

1637–38
Juan Martínez Montañés 1568–1649
and Felipe de Ribas 1609–48
Church of Santa Paula, Seville

Montañés's major contribution to this altarpiece was the seated figure of St John, whose pose may have been derived from a seated figure of Christ in a medieval Judgment tympanum. However, Montañés invests the image with new meaning by skilfully adjusting the pose so that the saint's downward glance engages the worshippers' emotions.

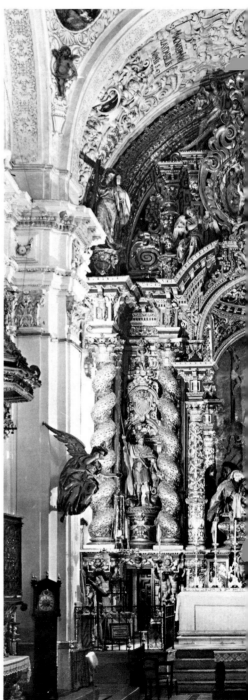

188 *below*

THE HIGH ALTAR

1670–73
*Bernardo Simón de Pineda, Pedro Roldán and
Juan Valdés Leal*
The Caridad, Seville

De Ribas, who was responsible for the
architecture of the Santa Paula altarpiece
(**187**) also introduced into Spain the
favourite Baroque motif, the twisted, or
Solominic, column, which influenced
Pineda's richly inventive structure in the
Caridad retable. But this overtly theatrical
piece is essentially a corporate enterprise,
with Roldán contributing the dramatic
illusionistic sculptures and Valdés Leal
adding the final lustre and painting.

189 *bottom left*

GRANADA CATHEDRAL

1664
Alonso Cano 1601–67

Cano's career as an architect began when
he worked for the court at Madrid, but it
was not until the last years of his life, when
he returned to his native city, Granada,
that his gifts were fully realised. The
cathedral is one of the boldest conceptions
of Spanish Baroque; the integration of the
vigorous forms and the ornamental
detailing is a rare achievement in Spain.

190 *below*

ANGUSTIAS CHURCH

1597–1604
Juan de Nates
Valladolid

This is one of the most striking Spanish
Renaissance façades. From the outset
Nates seems to have recognised the need
to relate the treatment of the upper and
lower zones of the wall surface, both
sections of which are punctuated by niches
containing sculptures. Whereas an Italian
architect would probably have employed
the Tuscan, Doric and Ionic orders, Nates
used the Corinthian order throughout.
The crowning pediment, embracing the
total extent of the façade, provides a
satisfying climax.

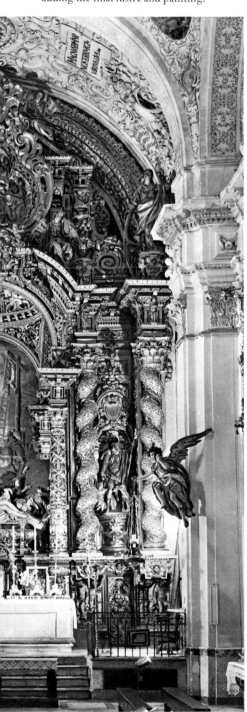

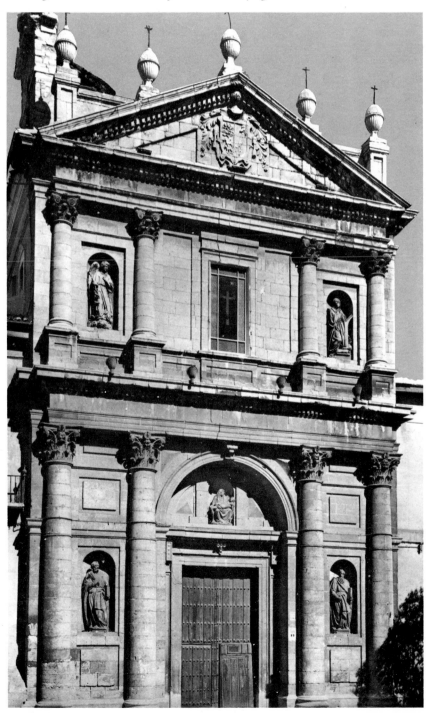

191

THE PENITENT MAGDALENE

Jusepe de Ribera 1591–1652
oil
Prado, Madrid

This is one of a series of paintings of his
daughter which Ribera carried out
following her seduction by Don John
of Austria. The artist, who had strong
religious and moral convictions, never
recovered from the humiliation of this
event and the theme became an obsession.
In these paintings the silvery tones and
fluid brushwork of Ribera's later manner
conjured up the sad desolation of the desert
both as a material and spiritual reality. This
emptiness conveys the loneliness of the
penitent girl.

192 *right*

ST BERNARD EMBRACING CHRIST

c. 1620–28
Francisco Ribalta 1565–1628
oil
Prado, Madrid

Towards the end of his career Ribalta
discarded the varied influences which
marred his earlier works, making them
disappointingly inconsistent in form
and vision. He was probably trained by
Navarrete, but this late work bears no
trace of the older artist's influence; the
profound realisation of the spiritual
longing for Christ experienced by St
Bernard is conveyed by a stark simpli-
fication of the modelling and sharp
contrasts of light and shade. The simplicity
is deceptive, however, for the design of the
figures is complex.

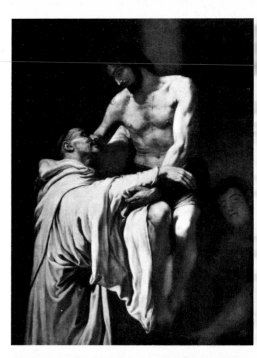

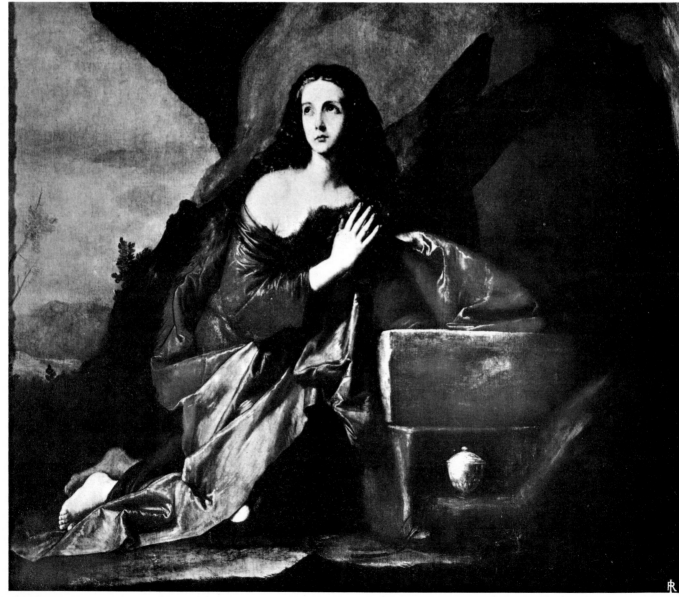

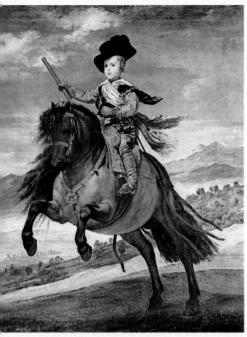

193 *left*

DON BALTASAR CARLOS ON HORSEBACK

1634–35
Diego Velasquez 1599–1660
oil
Prado, Madrid

One of a series of equestrian portraits
commissioned for the Hall of the Realms,
it was intended that, together with the
companion portrait of the king, it should
dominate the celebrated room. In the free
handling of such details as the silken fringe
of the sash caught in the wind, Velasquez
marvellously adjusted his touch to the
extreme youth of his sitter. The landscape
painting, which is unusually broad, conveys
the exhilarating openness of the country-
side, while the fresh mountain air bestows
a flush of colour on the little boy's all too
delicate complexion. Not long afterwards
he caught a cold and died.

194

THE SURRENDER OF BREDA

1634
Diego Velasquez 1599–1660
oil
Prado, Madrid

By the mid-1630s Velasquez's handling
had achieved a new freedom. His colours
became increasingly luminous, and he was
able to fuse the figures with their surround-
ings in a way which the other decorators
of the Hall of Realms were unable to equal.
Although the figures occupy the fore-
ground, he avoided the frieze arrangement
that inspired Renaissance artists; instead,
the whole composition converges on the
central exchange between Spinola and
Justinus.

195 *below*

THE ADORATION
OF THE SHEPHERDS

Bartolomé Esteban Murillo 1617–82
oil
Prado, Madrid

Murillo's early style was based on the
local Sevillian Realist tradition, and
the gradual softening of his style seems to
reflect the general trends of mid-century
painting rather than any direct stimulus
from outside; he never went to Madrid.
Here the emphasis is still strongly Realist in
the dark shadows and accentuated high-
lights. The emotional intensity of his
religious faith is tempered by the honest
characterisation of the shepherds, recalling
his success in portraying beggars and
young vagabonds.

196 *bottom right*

THE VISION OF
ST PETER NOLASCO

1629
Francisco de Zurbarán 1598–1664
oil
Prado, Madrid

One of Zurbarán's most important
commissions came from the Shod
Mercedarians in Seville, who ordered a
series of twenty-two canvases representing
the salient episodes in the life of St Peter
Nolasco; this is among the finest and shows
his Realist style at its most concentrated.
At the time it was painted Velasquez had
removed to Madrid and Murillo had not
yet emerged as a threat to Zurbarán's
supremacy in Seville. Few painters could
have rendered the crucified apostle so
palpably, while retaining the distinction
between his manifestation as a vision and
the physical reality of his namesake rapt in
contemplation.

197 *left*

THE EDUCATION OF
THE VIRGIN

Bartolomé Esteban Murillo 1617–82
oil
Prado, Madrid

Sevillian devotion to the Virgin encouraged
the extension of the painters' imagery.
Pictures appeared by Zurbarán representing
the Immaculate Heart of Mary, and
Zurbarán's great rival, Murillo, brought
all his finest talents to bear on this scene—
a subject which supplanted the older theme
of the Presentation of the Virgin in the
Temple. A simple grandeur in the com-
position preserves the mood of solemn
intimacy, while sharp notes of scarlet or
prussian blue challenge subdued bronze
and creamy hues; similarly the modelling
is deftly accented.

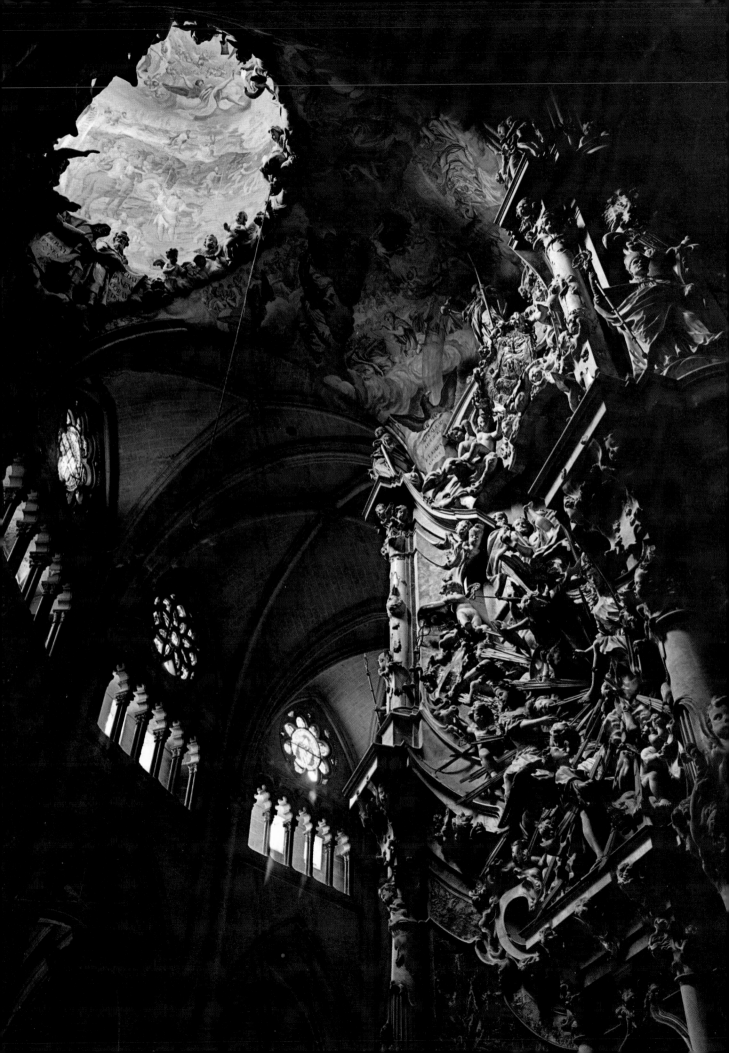

The 18th century is commonly called the Age of Reason, and art histories sometimes divide it into three stylistic periods: High Baroque, Neoclassical and Rococo. However, all these terms suggest a unity of taste and outlook which is far from the reality of Spain.

Although superficially Spain had been a united kingdom since the end of the 15th century, in practice the divisions within the peninsula were still marked at the beginning of the 18th. The accession of the Bourbon Philip V in 1700 might appear a unifying event, but there was still considerable support, particularly in Catalonia, for the other claimants to the Spanish throne, the Archduke Charles of Austria, and Philip was not effectively king of Spain until Barcelona fell in 1714. Even then the country was far from united; a powerful nobility contributing to the divisiveness. Many aristocrats not only owned whole towns and villages as part of their estates; but they also held civil and criminal jurisdiction over them and levied certain taxes which made areas of the country virtually independent states. There were economic divisions in the country too, and not merely between the different classes. Although Philip suppressed many of the provincial customs barriers in 1714 and 1717, he was unable to remove those of Navarre and the Basque provinces. He made attempts to break the monopoly of the American trade which brought exceptional wealth first to Seville, and after 1717 to Cádiz, but no other ports could profit from it until 1765. Many parts of the country were isolated from one another by appalling communications. Improvements to roads were put in hand in 1718, yet their reconstruction made no real headway until after 1747, and the main routes still required to be put in order between 1767 and 1777. As late as November 1775, the English traveller Henry Swinburne had to delay his departure from Barcelona for several days in order 'to give the roads time to dry.' There was no system of stage coaches linking the capital with the principal provincial cities until 1763. So great was the mental distance between Madrid and most of the rest of Spain that it was still difficult in 1787 to obtain a credit note in the provinces that would enable a payment to be made in the capital.

In such conditions artistic taste naturally tended to vary from one region to another. Equally, of course, the power to collect works of art, build great buildings or encourage crafts was in different hands in different parts of the country. In Seville and Cádiz, and to some extent in Barcelona and other ports, merchants held the purse strings, as did the Church in the seven cities, 395 towns and 3494 villages that were their property. The nobles controlled fifteen cities, 2286 large and 4267 smaller towns as well as their country estates. Not until the middle of the century did a standardised 'good taste' begin to spread throughout the peninsula as a result of official policy, and the move towards uniformity was a very gradual one. The early years of the century reflect the various economic and social divisions of the country in strikingly varied cultural patterns.

The court was traditionally an international centre for art. But Philip and his French and Italian queens brought foreign art and architecture to Spain in a way that greatly extended the pattern of their predecessors. French painters like Jean Ranc, Louis-Michel van Loo and Michel-Ange Houasse and the sculptor Robert Michel lived and worked in Madrid. Under the influence of Philip's second wife, Isabel Farnese, Italian art and music were also brought to Spain. The king employed the painters Amigoni and Solimena and bought works by Bellini, Dughet, Panini and Carracci, while his wife's collection included paintings by Francesco Bassano, Correggio, Guido Reni, Tintoretto and Watteau.

7, 219
3, 215

Royal Palaces, Museums and Academies

1700–C. 1900

198

THE TRANSPARENTE

1728–32
Narciso Tomé, working 1715–42
Toledo Cathedral

On its completion this *transparente* altar was described in a poem printed in 1732 as the eighth wonder of the world. Tomé himself carved the marble and jasper, worked the bronze and painted the ceiling. The original idea of concealing the source of light (visible, however, in this photograph) to give an added theatrical effect to the altar and the circles of painted and sculptured figures above it was subsequently imitated in a number of churches elsewhere in Spain.

The Royal palaces

Philip's main object in bringing art and architects from France and Italy was to create palaces whose status could rival that of Versailles, which he had known as a child. The first to be built was La Granja at San Ildefonso, on the wooded slopes of the mountains near Segovia. Work was begun in 1719 under Teodoro Ardemans, the Master of the Royal Works, who was a Spaniard of Prussian extraction, but most of the work on the building itself and its grounds was by foreigners. The Versailles-style park was lavishly designed by René Carlier and laid out by another Frenchman, Boutelou. Areas in the rock were blown out with gun-powder and filled with earth for trees to be planted. Water was piped from the hills to fountains (decorated by French sculptors) to enable the jets to rise to greater heights than any others in Europe. Their crystal clearness was remarkable too, in contrast to the muddy Seine water in the fountains at Versailles which fell 'like a stinking fog' in the 18th century.

After Ardemans's death, two Roman pupils of the painter Carlo Maratta – Procaccini and Subisati – added the ends of the garden façade and the north and south courtyards. Later additions during Ferdinand VI's reign were the work of another Italian, Sacchetti, based on a design by Filippo Juvara. The latter, who was also an Italian, gave advice on the interior too. On his suggestion a large number of Dutch and Flemish paintings were bought in Rome in 1735 to hang in the palace, including several works by Van Dyck, Jordaens and Teniers.

Sometimes, as in the case of the palace at Aranjuez, where a considerable 16th-century structure was still standing, it was difficult for Philip's foreign architects to eradicate the Spanish character of buildings they modified. In Madrid, however, the fire at the old *alcázar* in 1734, which is said to have started at a carouse in the painter Jean Ranc's apartment, left a space for an entirely new structure. The Italian Juvara planned an immense palace, drawing inspiration for details from Versailles and the Louvre, each façade being about 1,600 feet long and three storeys high. Sacchetti, who took over the work on Juvara's death, radically altered the design to make it fit on the original site. Although his palace was only about a quarter the size of Juvara's, its extra three or four storeys gave it the grandeur Philip required, and the extent to which it ultimately dominated the western side of the city can be plainly seen in Goya's view of Madrid from across the Manzanares in his *Pradera de San Isidro*.

The Spanish Baroque tradition

The palaces at Madrid and San Ildefonso were quite unlike most other buildings in Spain at the time. Their exterior decoration of urns and sculptured panels, Corinthian columns and statues was strongly in the Italian tradition and relatively chaste. Spain had had its earlier Italianate buildings, of course, in the 16th and earlier 17th centuries, but it also had decorative traditions of its own, such as the Moorish and the Plateresque. These styles sometimes made ornament an end in itself rather than an element underlining the form or significance of a building. The late 17th century had seen an increase in the use of such decorative features, and the great Spanish architects of the early years of the 18th century are notorious for their delight in them. Leonardo de Figueroa, for instance, used great corkscrew columns with Corinthian capitals to support the dome of San Luis in Seville, and the upper part of his porch for the College of San Telmo in the same city towers unfunctionally above the building behind it. Despite the apparent concern with the visually spectacular, however, Figueroa's architectural features often have a meaning in relation to the building, and the doorway of San Telmo reminds us of the original

199

CUT-CRYSTAL PLAQUE

late 18th century
Félix Ramos
Museo Arqueológico Nacional, Madrid

The glass factory at La Granja was started in 1728 and was under royal patronage from 1734. Charles III enlarged it, and the engraved crystal plaque of the palace was made during the reign of Charles IV when the techniques of engraved glass were being developed at the factory. Ramos was the best-known craftsman at La Granja at that time. The classical border is typical of the taste of the period.

function of the college as a school for navigators. The balcony above it is supported on the backs of four aborigines from Spain's overseas territories, who are in turn borne up on the head and arms of another native in the centre of the lintel of the door itself, rather like a circus act in stone. The corkscrew columns used in San Luis, which are a frequent feature in retables and church façades at the turn of the century, may well be symbolic too. They are known as Solomonic (*Salomónicas*), and according to Fray Juan Ricci that architectural order expressed the highest virtues of Christ and the Blessed Virgin, whirling the eye heavenwards.

Another early 18th-century building whose highly decorative façade has a strongly symbolic purpose is the palace of the Marqués de Dos Aguas in Valencia, remodelled by the painter Rovira Brocandel in 1740– 44. The entire sculptured composition of the elaborate doorway refers to **231** the marquis's estate at the town of Dos Aguas (Two Waters). The Virgin with a rosary in a niche above the door is the patron of the town – her benevolent protection is indicated by cornucopiae, downward-shining rays, rich curtains, ribbons and tassels. The wealth of the estates on the two 'waters' is symbolised by watersnakes, swans and palm-trees, while the rivers themselves (presumably the Júcar and San José) are represented by two gods who pour out alabaster water from urns in rich streams on either side of the door. The walls of the house itself are painted to look like watered silk (Dos Aguas is also noted for silk-worms) and were stuccoed in the 19th century to retain the effect.

Some of the most impressive Spanish interior decoration of the period is equally meaningful in relation to buildings. The white dove of the Holy Spirit perches amongst cherubs and foliage in the beautifully stuccoed dome of Nuestra Señora de la Victoria in Málaga, to make heaven more dramatically tangible than it tended to be when painted. The artist to whom this work is generally ascribed, Francisco Hurtado, was also responsible for the *transparente* in the tabernacle of the charterhouse at El Paular near Rascafria (Segovia), where heaven is again made palpable by bathing the area behind the altar in unearthly light from above. Particularly loaded with symbolic detail is the more famous *transparente* of **198** Narciso Tomé in Toledo Cathedral. Everything about it relates to the Mass, so that people walking behind the high altar would be encouraged to meditate upon the highest mysteries of the Church. Christ and his Apostles sit at the Last Supper below the highest level where heaven is depicted in paint, and rays of glory emanate from the sacramental bread below them. On either side of the altar and on the ceiling, Old Testament parallels with the Mass repeat the message of redemption.

These expensive and spectacular new projects in Spanish churches and palaces probably reflect the economic recovery of the country after the War of the Spanish Succession, as well as the wealth and taste for drama of the organisations or individuals responsible for the buildings. Numerous cathedral developments were put under way in the 1720s and 30s; most of these were in the traditional Spanish manner but some were in keeping with French taste. The eastern seaboard had the strongest links with the rest of Europe, and these are reflected in the cathedrals at Valencia and Murcia. Conrad Rudolf, a German trained in France, began his curved design for the main entrance to Valencia Cathedral in 1703, **232** but most of the work on it was done later, and it was not finished until 1740. Between 1736 and 1749 Jaime Bort Miliá built his curved Rococo façade for Murcia Cathedral. Elsewhere, in Gerona and other parts of **233** Catalonia, Italian influences were strong, and find their expression in Pedro Costa's façade for Gerona cathedral. The south of Spain, however,

200
ROYAL PALACE, MADRID
1738
Giovanni Battista Sacchetii, d. 1764

The south façade was conceived as the main entrance to the vast square-shaped palace. The strong line of pilasters and massive columns emphasises the height and ensures its impact even without recourse to the rich sculptural surface which a Spanish architect, following the Baroque tradition, might well have favoured in the first half of the 18th century. Sacchetti originally lined the balustrade at the top with statues–some of which now adorn the Retiro gardens and the Plaza de Oriente in Madrid–and other large statues and decorative elements were tried in various positions for short periods. The first stone was ceremonially laid on the 7th April 1738, and Sacchetti retired from the Palace works between 1757 and 1760.

201

SOLDIER SMOKING
AND DRINKING

David Teniers 1610–90
Prado, Madrid

Teniers's work was much admired in the 18th century for its naturalistic qualities, even by the arch-priest of Neoclassicism, Mengs, and it was used as a model for some of the early tapestries from the royal factory. The present scene was one of a number of small paintings of everyday and low-life subjects in the collection of Isabel Farnese at La Granja, and may have been among those bought for her in Rome in 1735 on the advice of Juvara.

stood apart from these alien developments. There are Spanish sources for Vicente Acero y Acebo's new façade for Guadix Cathedral which occupied the architect from 1714 to 1720, and for Acero's completely new cathedral (inspired by that at Granada) for Cádiz on which he was engaged until 1729. Also in the Spanish tradition were Fernando de Casas y Nóvoa's Obradoiro Front for Santiago Cathedral, dating from the 1730s, and Alberto Churriguera's upper section for the main façade of Valladolid Cathedral above Herrera's 16th-century entrances.

Urban architecture

If a rich church could afford developments of this magnitude – and many impressive new altars and choir-stalls date from the same period – so could some of the municipalities. The archbishopric of Valencia had an income of £400,000 in the 18th century and Toledo was far richer. Yet the municipality of Barcelona had no difficulty in raising a large sum from import duties to build its new Exchange in 1772. Some architecture at the beginning of the century, however, had political overtones. Catalonia had sided with the Archduke Charles in the War of the Spanish Succession, and in Barcelona a French-style fortress was built and the city's defences were replanned to impress the power of Philip on the minds of its inhabitants. The Arsenal is one of the few buildings from this fortress to survive today. In 1717, at royal command, a new university was begun at Cervera to supplant existing Catalan institutions as well as to encourage learning. Improvements to Madrid and other cities were less obviously political. In the capital, Pedro de Ribera, an architectural 'heretic' according to the Neoclassics, built the Toledo bridge (commissioned in 1719), laid out gardens by the Manzanares, put up new churches and the Conde-Duque barracks, and constructed new quarters for the
206 Hospice of San Fernando with a notoriously elaborate decorative portal, to house the poor of Madrid more elegantly. In Salamanca, increased prosperity and the spirit of competition no doubt encouraged plans for a new square, which was commissioned from Alberto Churriguera in 1728. A series of fine buildings plot Salamanca's 18th-century expansion, including Churriguera's College for the Military Order of Calatrava and extensions to the Jesuit church as well as the square itself. In Seville, an important government development was the building of the Tobacco Factory, conceived on Classical lines by Ignacio de Sala in 1726 but not completed until around 1766.

Eighteenth-century decorative arts

A by-product of the construction of important new palaces and churches and the modification of existing public and private buildings was an increased demand for internal furnishings: mirrors and chandeliers, curtains, tapestries and carpets, china and porcelain, as well as paintings and sculpture.

In many cases traditional centres merely increased or continued their output on traditional lines. The superb chandelier made for Palma Cathedral at the beginning of the century came from the workshops of Juan Matons, a silversmith from Barcelona, which had long been a centre for jewellery and remains so today. Seville was traditionally an important source of tiles, both religious and secular, and Moorish patterns and hunting scenes which had always been popular went on being produced in the 18th century much as before. The provinces of Catalonia, Valencia
224 and Aragon had also had flourishing earthenware industries from early times, producing tiles and plates, and the potters from Talavera de la Reina (Toledo), who had been famous in the 16th and early 17th centuries, went on to manufacture polychrome work between 1696 and 1723.

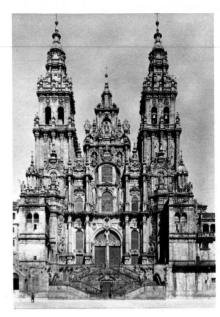

202

THE OBRADOIRO

1667–1750
José Peña de Toro, d. 1716
and Fernando de Casas y Nóvoa,
working 1711–94
Cathedral of Santiago de Compostela

The south tower was completed by Peña between 1667 and 1670, and Fernando de Casas added the central panel and the north tower between 1738 and 1750. Casas's tower is a replica of Peña's, but the centre panel is highly original and contains one of the largest glass windows to be made before the Industrial Revolution. The object is to give as much light as possible to the nave and galleries. The architectural pattern is a set of variations on the rounded arch of the main doorway. Windows above and on either side echo it, and link up with the arcade on the side of the towers.

203

SACRISTY OF THE
CHARTERHOUSE

c. 1720–30
Granada

The artist responsible for the rich stucco decoration is not known; nor is the exact date of its construction. The work is less dramatic and more formal in its wave rhythms than Spanish Baroque had tended to be in late 17th-century Andalusia, and the basic design – bays for chests to hold vestments – is very traditional, and has a number of precedents in Spain, dating from the 16th century. A simple harmony of colours, predominantly brown and white, contributes to the overall unity of effect.

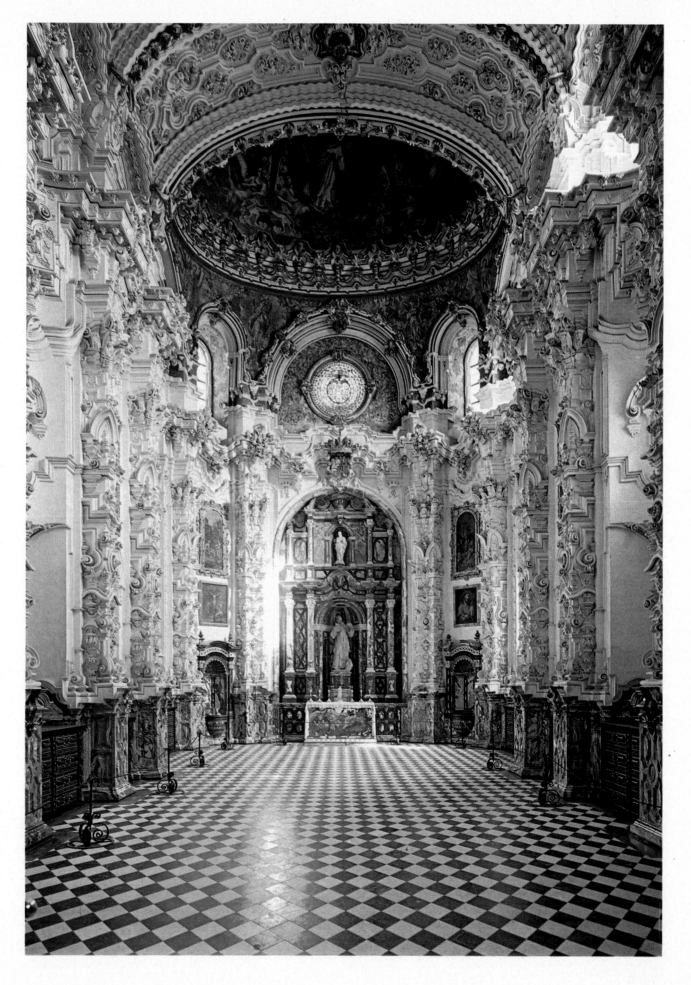

204 *right*

THE THRONE ROOM

1764
Giovanni Battista Tiepolo 1693–1770
Royal Palace, Madrid

The basic theme of Tiepolo's allegorical ceiling is the might of the
Spanish monarchy. The cornice is lined with people from the
various provinces and overseas dominions of Spain in their
regional dress and with the products of their area. At the far end
on the left a painted stone monument to Charles III's greatness
rises into the sky; Faith watches over it on the far left
(concealed here by the chandelier from the Royal Glass Factory at
La Granja). The stuccoed figures in the corners represent Spanish
rivers, and the medallions, the work of the French sculptor
Robert Michel, symbolise the elements.

205 *below*

SALA DE GASPARINI

c. 1760–70
Matteo Gasparini, d. 1774
Royal Palace, Madrid

Gasparini, who was brought to Madrid from Naples by Charles III
in 1760, was responsible both for the gilded stucco flower and
fruit patterns in the Chinese taste on the ceiling, and for the floor
of this room. Some of the special furniture for the palace was also
made to his design. The chandelier came from the Royal Factory
at La Granja.

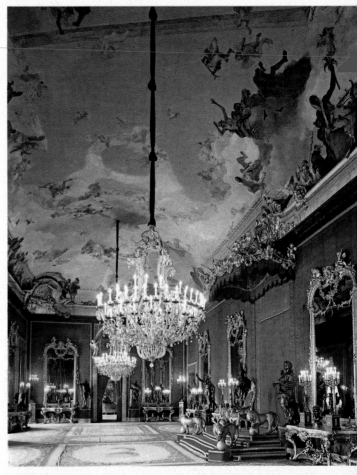

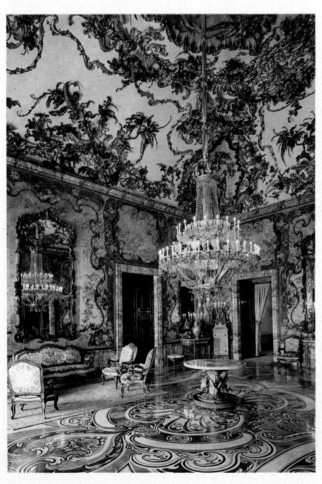

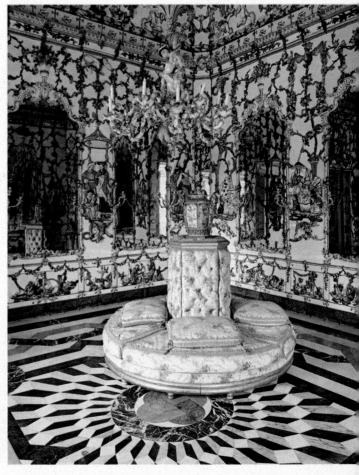

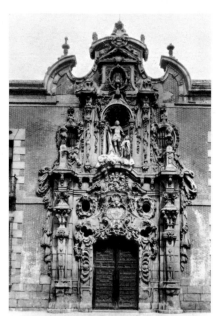

206

HOSPICE OF
SAN FERNANDO

c. 1722–30
Pedro de Ribera c. 1683–1742
Madrid

To the Neoclassics Ribera's work was
sheer madness, and his 'absurd' buildings
were listed so that no innocent person
should be falsely accused of having
perpetrated them. His imaginative
treatment of the San Fernando façade
marks a high point in his use of rich
sculptured decoration, by which the lines
of pillars and arches are here virtually
concealed. The textile motifs may
be in part symbolic and not mere
decoration since the pauper women who
occupied the building were required to
spin. They also imitate in stone the
simulated curtains round some late
17th-century retables.

207 *left*

THE PORCELAIN ROOM

1760–65
Giuseppe Gricci, d. 1770
Royal Palace, Aranjuez

These porcelain figures and patterns
constitute one of the earliest examples in
Spain of chinoiserie, which was much in
vogue in European palaces by the middle of
the 18th century. Made at the Buen Retiro
factory in Madrid to decorate the king's
study at Aranjuez, the figures and their
settings were modelled or supervised by
Giuseppe Gricci, who signed some of the
work in 1763, two years before the room
was completed. Gricci became Director of
the San Fernando Academy in 1766, but
nearly all his work was for the china
factory, whose products were, until 1788,
intended exclusively for the king.

The more striking developments in the decorative arts, however, came
as a result of the initiative of one or two individuals and of the king.

The manufacture of tapestries in Spain was essentially a royal affair.
Philip V, attentive to the decorative needs of his new or improved palaces,
invited a Dutch craftsman, Cornelius Vandergoten, to start a factory at
Madrid in 1720. This, the Royal Factory of Santa Barbara, was run by
the Vandergoten and Stuyck families until its decline during the reign
of Ferdinand VII. The early designs were by foreign artists in the royal em-
ploy, like Van Loo, Proccacini, Amigoni and Houasse, with copies of
Teniers, but later, during the reign of Charles III, the factory began to
produce works to original Spanish designs, by Goya among others.
Between 1775 and 1792 Goya himself made more than sixty cartoons **208**
depicting scenes from Spanish life, to decorate the palace of El Pardo,
near Madrid, and the Escorial.

Fine glass and porcelain, whose manufacture was certainly stimulated
by the establishment of royal factories, developed initially as a result of
private enterprise. The man responsible for the first expansion of the glass
industry in Spain was Juan de Goyeneche, whose drive so impressed
Philip V that he claimed that if Spain had two such citizens she would
have no need to envy the economic progress of other countries. Goye-
neche gathered craftsmen in glass from traditional centres like Cadalso
to start up a factory in the new town he created for the purpose called
Nuevo Baztán, not far from Alcalá. Since he was granted a monopoly
by the king for certain types of sheet glass he might well have been really
successful had not his European competitors dumped their products in
Spain and cut their prices to a third. Goyeneche's enterprise succeeded
relatively where other attempts in the same field had completely failed,
and the foundations were laid for a more ambitious factory under the
aegis of the crown.

When Goyeneche abandoned his glass projects, one of his craftsmen,
a Catalan called Sit, started up on his own near the Palace of La Granja,
and soon awoke the interest of the queen in his work. A royal factory
followed, and during Charles III's reign, with the help of French, German
and English craftsmen, a high standard was reached in cut crystal as well **199**
as sheet glass for mirrors. Thereafter the factory continued to flourish
until it was hit by the recession following the Peninsular War and passed
into private hands in 1828.

In a similar way, the manufacture of fine china and porcelain was
first established in Spain in the 18th century as a result of a private in-
dividual's initiative and finance, although it ultimately benefited from
royal patronage. The individual in question was an Aragonese aristocrat,
the 9th Count of Aranda, who opened a porcelain factory in 1727 in a
Valencian town called Alcora, which belonged to him. Valencia had
always been a potting region; some twenty-four potters already worked
in the town and an agreement with them enabled Aranda to make a
start. Since it was in the economic interest of Spain to produce luxury
goods at home and avoid expensive imports, royal licences were granted
for the importation of the finer raw materials in 1729 and 1730, and a
further sanction was granted in 1744 and renewed on a number of occa-
sions. Artistic direction was foreign from the first. Joseph Olerys from
Marseilles was put under contract in 1728, and another Frenchman,
Roux, is credited with the introduction of the Bérain style from the
Louis XIV period, which greatly enhanced the prestige of Alcora ware **210**
in its early days.

The 10th Count of Aranda, who was to become an important political

figure in the reign of Charles III, encouraged new developments when he took over the factory in 1749. Porcelain busts, emulating those produced elsewhere in Europe, were modelled to order, and attempts were made to equal the quality of Sèvres and Meissen china by employing master potters from France and Saxony. Much later, in 1786, the most promising Valencian craftsmen were sent for eighteen months training in Paris to acquire expertise – a common way of encouraging new crafts in Spain at the time. Unfortunately Aranda did not get an adequate return on his investments. Local imitators undersold Alcora ware and its products were, in any case, only marketed in Madrid and Saragossa, the provincial capital itself handling only the less expensive items. After Aranda's death in 1798 his heir, the Duke of Hijar, evolved some new techniques but also made economies, reducing the general standard of the work. Subsequently the factory declined seriously in the 1830s and 40s and was finally bought up in 1851.

The two Arandas had been concerned to develop a flourishing industry on their estates partly to demonstrate that Spain was capable of producing high-quality goods and partly to keep some of their dependents occupied gainfully. Charles III, who was responsible for the development of the Buen Retiro factory, Alcora's only serious competitor in Spain, clearly wanted to show that his court could rival other European courts in its magnificence, while avoiding the economically disastrous importation of luxury goods from abroad for the furnishing of his palaces.

Charles's first china factory was started when he was King of the Two Sicilies. His enthusiasm had been fired by some of the Meissen porcelain which his wife María Amalia had brought with her from Saxony as part of her dowry. A Flemish craftsman, Livio Schepers, and his son Cayetano were the mainstay of his establishment in Capodimonte, near Naples, and Cayetano, together with most of the personnel from the Naples factory, crossed to Spain in three ships with all their equipment and a good supply of paste a few months after Charles succeeded to the Spanish throne in 1759. They soon occupied a specially constructed factory in the gardens of the Buen Retiro Palace, which also housed a workshop for gilding brass and another for cutting and polishing stones. The director of the factory was an Italian called Gricci, a modeller who was married to the elder Schepers's daughter, and the main work was to furnish porcelain plaques and other decorative objects for the new royal palaces whose construction was now complete. Gricci's masterpiece was **207** a room decorated in porcelain with Chinese motifs for the Royal Palace at Aranjuez. Cayetano Schepers, or his son Carlos, was probably responsible for the magnificent but more restrained porcelain room with plaques of Classical pastoral subjects in the Royal Palace at Madrid. Although many of the plaques and figures produced by the factory were in fact inspired by Classical subjects, they were by no means cold in their **222** execution; flowing movement and emotional situations are often found in Buen Retiro porcelain of the early period. In one panel in Gricci's room at Aranjuez a Chinese boy sits almost apprehensively on a swing between two trees, while elsewhere in the same room a Chinaman is executing a clog-dance or *zapateado*. In small groups, a native in a turban climbs up a tree to escape from a leopard, and Andromeda's body twists in restrained anguish as she stands chained to a rock.

Neoclassicism and the academies

A more determined move towards Neoclassic ideals is found in later work from the Buen Retiro factory, in part the result of the employment of Spaniards trained in the newly established academies. It was in the 30s

208

THE PARASOL
1777
Francisco de Goya y Lucientes 1746–1828
oil on canvas
Prado, Madrid

This tapestry cartoon for the Santa Barbara Factory was handed over by the artist on the 12th August 1777 and valued at 1500 *reales* (about £16 10s at the period). The finished work was to hang over a doorway in the dining-room of the princes of Asturias in the Palace of El Pardo. The strong diagonals and pyramidal composition are typical of Goya's early tapestry work under Mengs's supervision. In later cartoons he was to use a more subtle palette (without the obvious contrasts of strong reds and blues) and less rigid structures.

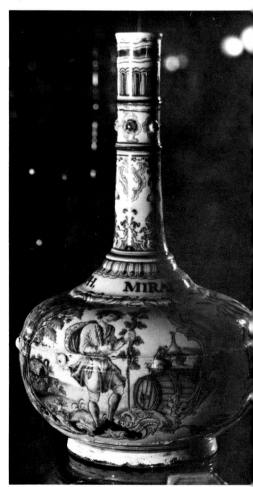

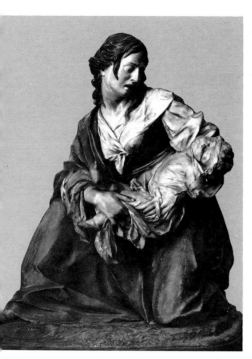

209

MASSACRE OF
THE INNOCENTS

c. 1794–1808
José Ginés 1768–18
clay with polychrome decoration
Real Academia de San Fernando, Madrid

A pupil of two academies – the San Carlos at Valencia and the San Fernando at Madrid – Ginés produced some of the finest Classical sculpture in Spain at the end of the 18th century. Commissioned with other artists by Charles IV to work on scenes for the royal crib, he made a series of unexpectedly dramatic and dynamic figures and groups showing the *Massacre of the Innocents*, in which only the folds in the garments betray the sculptor's Classical training.

210

ALCORA CHINA BOTTLE

c. 1730
Museo de Arte de Cataluña, Barcelona

This early Alcora wine bottle, decorated with the figure of a young Bacchus, a wine butt and vines, bears the name of the person for whom it was made (Joseph Mirauete) at the base of the neck, a common practice in Spain. The smiling, clothed Bacchus is a traditional reminder of the happiness which accompanies drink in moderation. More riotous Bacchic scenes were depicted on other Alcora products.

and 40s more particularly that the king, backed by a group of enlightened aristocrats and scholars, began to encourage academies to improve the artistic taste and output of the country. Those who were familiar with other European countries knew the lack of esteem in which Spanish culture was held – a satirical map of the 1740s noted that Spain was 'the ruin of all the Fine Arts'. For patriotic motives therefore they sought to bring Spanish taste into line with that of the rest of Europe, curbing its supposed artistic excesses, and imposing Classical order. But there were utilitarian reasons behind the foundation of the academies too; they contributed to the general good of society, since they improved both the standard of architecture and the saleability of national products.

It was Philip V who first approved the creation of an academy of arts in Madrid in 1744, which one of his court painters, Van Loo had been urging for some time. The statues were finally approved under Ferdinand VI in 1749, by which time the first scholars had already been sent to Rome to study, and one or two students had begun to attend classes regularly in Madrid. 1752 was, however, the first year in which students enrolled in numbers, ninety-eight in all; some the sons of silversmiths, others of carpenters or furniture makers, one or two from silk manufactories, and one from the earthenware factory at Talavera. In 1753 Valencia followed Madrid with the Academy of Fine Arts of Santa Barbara, and Saragossa, after an abortive project in 1754, asked for royal permission to raise money for an academy in the 1770s and was finally granted statutes in 1792. The initiative for these and other academies came as much from private individuals, particularly aristocrats, as from the king, but those actively involved formed a small group within Spanish society.

The students of the various academies were soon applying their Classical training to painting, sculpture, architecture, china and furniture all over the country, although the old decorative traditions sometimes persisted. To improve facilities, patrons of the arts gave drawings and Classical sculpture to the academies, and the fine collection of Greek and Roman statues which Philip V had bought (originally belonging to Queen Christina of Sweden) could be studied in the Palace of La Granja at San Ildefonso. But despite official encouragement, the development of Neo-classicism in Spain might well have been less rapid had Classical aesthetics not been taught in many schools, notably in those of the Jesuits before their expulsion in 1767.

In the realm of fine art, a key role was played in the raising of standards and formation of taste by two painters brought to Spain by Charles III: Mengs and Tiepolo. Mengs came first in October 1761, and was soon **226, 227** given the same generous salary of 105,514 reals a year which Corrado Giaquinto had enjoyed under Ferdinand VI. Tiepolo came eight months later in 1762 with his sons Domenico and Lorenzo. Other Italian artists to be brought to Spain at this period included Gricci, who has already been mentioned, and Matteo Gasparini, who arrived in 1760 to carve **205** and decorate much of the more Rococo furniture in the Madrid palace. Charles also added many Italian paintings to the royal collection, including five Vaccaros, two Albanis, two Cortonas, a Crespi, a Mantegna and sixteen Luca Giordanos.

Tiepolo's major works in Spain were ceilings for the Royal Palace at **204** Madrid, although he also did seven altar paintings for San Pascual, Aranjuez, and a half-dome for the Colegiata Chapel at La Granja. Like the other artists in the king's pay, he was supposed to supervise students' work in the Academy, but he does not seem to have had much impact by comparison with Mengs. The fact that his paintings for Aranjuez

131

were removed during his lifetime suggests that he did not long retain the royal favour.

Mengs, on the other hand, could do no wrong, and was soon the great arbiter of taste at court and guide to the more promising Spanish painters. Goya's brother-in-law Francisco Bayeu was his assistant until 1765, and Mariano Salvador Maella, who had studied in Italy after a period at the Academy in Madrid, was working under Mengs's direction in the royal service from 1769. Painting at the tapestry factory was also under Mengs's control, and even an individualist like Goya seems to have organised his early cartoons and decorative paintings according to the master's Classical formulae, arranging groups of figures in pyramids, preferably in odd numbers, and showing faces from as many different angles as possible.

Mengs's Neoclassic theories gained still wider currency after his death. His essays were published in Spanish in 1780, and one had appeared in the sixth volume of Antonio Ponz's *Travels in Spain*, a work written from a strongly Neoclassical viewpoint, and designed to make the Spanish public more aware of their artistic and architectural heritage. Raphael, Correggio and Titian were regarded as the great masters, although Rembrandt was not despised; nature herself was to be studied as well as art. But particularly influential was Mengs's admiration for Velasquez, which no doubt encouraged younger artists like Goya to study and copy a style which was freer and much more bold than Mengs's own.

Goya made a series of etchings after Velasquez in 1778, and this was the first work to bring him before the wider Spanish public. Portrait commissions at the court soon followed, particularly after his painting of the king's principal minister, the Count Floridablanca, in 1783. From 1786 he was formally retained by the king to paint tapestry cartoons, and by 1799, when his court salary was suddenly tripled, he was at the height of his fame. Despite his view that the individual should be encouraged to go his own way in art, many of the Neoclassic principles remained with him to the end of his days.

Neoclassicism was primarily a power at court. But contacts between the San Fernando Academy and academies in the provinces soon ensured that the main centres were in line. Provincial building projects were submitted for approval to Madrid, and the royal architects were naturally much in demand. Sabatini, a close friend of Mengs, rebuilt the Convent of Santa Ana in Valladolid, and specified that Goya and Ramón Bayeu should do paintings for the remodelled chapel. Ventura Rodríguez's buildings and those of his pupils also took Neoclassicism to many parts of the country. The Academy of Medicine in Barcelona, built in 1761, and the new façade built in 1783 to replace the Gothic original at Pamplona Cathedral are fine examples of Rodríguez's own work, and the façade for the cathedral at Lugo (1769) that of a pupil, Julián Sánchez Bort. An enlightened aristocracy also helped to spread the style even to the most out-of-the-way places. In his travels round Spain, Ponz noted approvingly that the Duke of Hijar had built 'decent' churches, with academic architects and paintings by Goya and Bayeu, in several of his villages in the 1770s and 80s: Puebla de Hijar, Urrea de Gaén and Vinacei. The nobility built themselves new country houses in the Neoclassical taste outside the main centres of population. Ventura Rodríguez built a splendid palace before 1775 for the king's brother, the Infante Don Luis, at Boadilla del Monte. Here the infante housed a fine art collection including works by, or attributed to, Rembrandt, Peter de Vos and Teniers, and he commissioned sculpture from Felipe de Castro and Manuel Alvarez, both leading academicians. The dukes of Osuna erected a country house not far

211

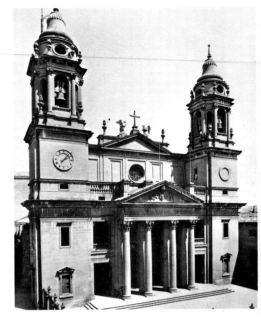

211

PAMPLONA CATHEDRAL
1783
Ventura Rodríguez 1717–85
Built to replace a Gothic façade, Ventura Rodríguez's severely Classical portico between two square towers was his last important work. Despite the formal austerity the double columns, window openings and doorways create a strong pattern of light and shade.

212

THE PRADO
designed 1787
Juan de Villanueva 1739–1811
Madrid

The building was originally to have had a covered walk in front of it, with a colonnade and rotunda in the centre. A change of plan led to the enlargement of the pavilions at the north and south ends and the abandonment of the walk, and the exposed west façade then required more decorative treatment. Villanueva put the colonnade at first floor level and built out the centre with massive columns and a portico. Two sections of equal length (subdivided into two equal parts) balance one another on either side of this.

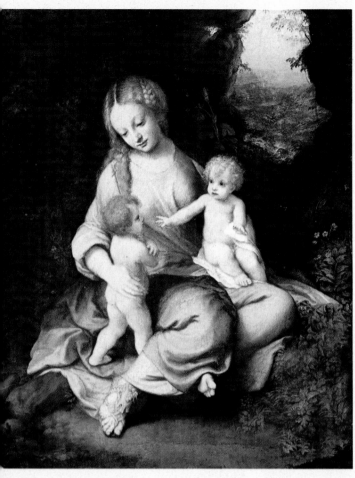

213 *left*

THE VIRGIN
WITH THE INFANT JESUS AND ST JOHN

attributed to Correggio 1494–1534
Prado, Madrid

Correggio's work was particularly highly prized in the 18th century. His chiaroscuro, composition and colouring were praised by the great arbiter of Spanish taste, Mengs, who singled out *The School of Love* in the Duke of Alba's collection (now in the National Gallery, London) and a *Virgin and Child with St John* in the Royal Palace at Madrid. This, a different treatment of the latter subject, was originally in Isabel Farnese's collection.

214 *below*

BOAR AND DEERHUNT

1545
Lucas Cranach 1472–1553,
wood
Prado, Madrid

This is Cranach's second version of a hunt which was organised by the Elector of Saxony for Charles V in Moritzburg in 1544. The elector stands in the middle of the foreground in a green costume and black hat with white and yellow feathers. Charles V is one of the figures on the left wearing the Order of the Golden Fleece. The earlier version belonged to Philip IV and is also in the Prado. Both that and the present painting followed in many respects Cranach's stag-hunting scene of 1529, painted for the Elector Frederick the Wise (now in Vienna). This work may have been one of the paintings bought in Rome in 1735 for Isabel Farnese on the advice of Juvara.

215 *below*

VIEW OF THE GARDENS AT SAINT-CLOUD

Antoine Watteau 1684–1721
oil on canvas
Prado, Madrid

This, together with a companion painting by Watteau depicting
a marriage contract being signed and a dance in the open air,
formed part of the collection of Isabel Farnese, Philip V's second
wife. They hung in the king's apartments in the Palace of La
Granja alongside works by, or attributed to, Andrea del Sarto,
Guido Reni, Veronese, Parmigianino, Bassano, Brueghel, Martin
de Vos, Wouvermans, Murillo and Ribera. This scene shows the
Fountain of Neptune; the movement from dark foreground to
light middle distance is typical of Watteau's painting, as is the
disposition of figures which adds to the decorative effect.

216 *right*

ALLEGORY OF ASTREA AND PEACE

Corrado Giaquinto 1699–1765
Prado, Madrid

Giaquinto was first invited to Spain in 1753 by Ferdinand VI to
replace the painter Amigoni and to execute some of the ceilings in
the Madrid palace. He stayed on during the early years of Charles
III's reign, returning to Naples in 1761. As Director General of the
San Fernando Academy he exerted a considerable influence on
younger Spanish artists, particularly on Antonio González
Velázquez. This allegory of the reign of Justice and Peace
(who are shown embracing) was formerly in Charles III's
collection and hung in the dining and reception room of the
palace at Madrid in the 1770s.

BACCHANAL

Michel-Ange Houasse 1680–1730
Prado, Madrid

Houasse was invited to the court of Philip
V in 1715, where he painted several
members of the royal family as well as
some religious pictures. A large number of
Classical nude subjects (paintings and
sculptures) decorated the royal palaces,
and the Bacchanal was Houasse's
decorative but restrained contribution.
More influential in Spain later in the
century were his small scenes from every-
day country life which hung on the walls
of the Palace of La Granja.

218 *right*

CHARLES III AT TABLE BEFORE THE COURT

c. 1780
Luis Paret y Alcázar 1746–89
oil on panel
Prado, Madrid

The controlled grouping of the figures
may well owe something to Paret's
Classical training at the San Fernando
Academy, while the elegance and panache
is probably due to the French painter
Charles de la Traverse, who taught Paret
in Madrid when he was in the entourage of
the French ambassador. However, the
verve and luminosity are Paret's own. The
palace where the scene is set has not been
identified: Aranjuez has been suggested,
but El Pardo, which was hung with
tapestries at the period, is also a
possibility. The king was wont to feed his
hounds at lunch and dinner as part of the
palace ritual. Paret has signed the painting,
in Greek, as by 'the son of his father and
mother'. When in Italy he studied the
language, as well as the art, of antiquity.

PHILIP V
AND HIS FAMILY

1743
Louis-Michel van Loo 1707–71
oil on canvas
Prado, Madrid

Van Loo was summoned from France to
Madrid in 1737. This life-size masterpiece
of the royal family was painted six years
later, and hung in the Buen Retiro Palace.
Philip V's eldest son, the future Ferdinand
VI, stands on the left, Philip Duke of
Parma in the centre, and the future Charles
III on the extreme right; their consorts sit
by them. However, the queen, Isabel
Farnese, is clearly the centre of the
composition. She faces the viewer most
squarely and the more prominent lines on
the marble floor lead to her. The
painting may have been made to celebrate
the ascendancy of the family after the
Treaty of Worms in September 1743 and
that of Fontainebleau in October of the
same year.

220

THE FAMOUS AMERICAN,
MARIANO CEBALLOS

1825
Francisco de Goya y Lucientes 1746–1828
lithographic crayon and scraper
Biblioteca Nacional, Madrid

This is the first of the four bull-fighting
lithographs made by Goya in 1825, only
three years before his death. Earlier, in his
Tauromaquia series of etchings of 1816, he
had shown Mariano Ceballos riding a bull,
but here the violence of the bull-fighter is
more sharply registered, and an aggressive
crowd is placed in the background. At the
end of Goya's life he saw bull-fighting, not
as a picturesque subject to be treated with
the public demand in mind, but as a human
activity which he could use, like war and
Carnival, to express the dark and barbarous
side of man's nature.

from Madrid and decorated it with a variety of small and large canvases
by Goya.

New directions

Neoclassicism remained a widely accepted aesthetic doctrine in art
and letters in Spain until the third decade of the 19th century. However,
already at the end of the 18th some writers and artists were beginning to
show an interest in originality and in their personal feelings, which,
although of small consequence according to Neoclassical canons, were
two of the essential qualities of Romantic art and literature in the 19th
century. In art Goya is the supreme example, and indeed his decorative
paintings for the dukes of Osuna already show him moving in this
direction. Nearly all of them are composed according to Classical pre-
cepts, and several of them – *The Swing*, now in the Duke of Montellano's
collection, and *A Picnic* in the National Gallery, London – take pastoral
subjects which were much used by Classically-minded painters in the 18th
century. However, some of the subjects are highly original, like the scene
from the play *El hechizado por fuerza* in the National Gallery, London, or
witchcraft scenes like the one now in the Lazaro Galdiano Museum,
Madrid, in which a group of hideous hags forms a Mengsian pyramid
around a he-goat at a nocturnal coven.

Goya, like Blake in England, clearly felt that his own vision of things
was more important than artistic conventions. He was not the first Spaniard
in the 18th century to make a virtue out of originality but he was the
first to apply it to unconventional subjects. A series of small paintings on
which he was engaged in 1794 gave him the opportunity, he said, of
'making observations which it is not normally possible to make in com-
missioned work, where the imagination and inventive powers of the
artist cannot have full play'. Twenty years later he proudly called him-
self an 'original painter' on the title-page of the *Tauromaquia* series of
etchings. That the public was prepared to approve of his new approach
is evident from the commission of witchcraft paintings by the dukes of
Osuna, and from the preface to the poems of an Aragonese poet, Father
Boggiero, published in 1817, in which Goya and the poet are praised
for the 'invention, imagination, happy powers of expression, novelty,
singularity, and that *je ne sais quoi* which makes original genius original'.

Possibly this new vein in Spanish art was really a re-emergence of
the stylistic freedom which Figueroa and Tomé had enjoyed at the
beginning of the century. But Goya could work with unconventional
subjects as well as in an unconventional style, since the public he was
working for was changing. A new class of collectors had sprung up, who
respected the artist and refrained from dictating to him. Commerce and
industry gave birth to a more prosperous middle class which flourished
at the end of the century. When Ponz had travelled round Spain in the
70s and 80s the private collectors he mentioned were mostly aristocrats;
those who were not were leading merchants or government officials of
ministerial rank, like Goya's friends Bernardo de Iriarte (who had works
by the 'most classical artists' including Murillo and Mengs) and Sebastián
Martínez, who had works by, or attributed to, Titian, Leonardo da Vinci,
Velasquez, Murillo and Cano in his residence in Cádiz. By the end of
the century, however, there were important paintings in collections
whose owners are totally unknown today, and not even mentioned in
books of the period. A notable instance is Leonardo Chopinot, who
bought the collection of painter Francisco Bayeu when he died in 1795.
This consisted primarily of works by Bayeu and his brother Ramón
and included numerous copies by them of paintings by Van Dyck,

Velasquez, Corrado Giaquinto, Tiepolo and Mengs. After Chopinot's death and that of his wife, the chief minister, Godoy, acquired the collection and it was found to contain works by, or attributed to, David Teniers, Dürer, Murillo, Paul Potter and Ruysdael as well as others by Bayeu and Goya.

The fact of the matter is that it was possible to build up an interesting collection, particularly of old paintings, in 18th-century Spain with relatively little money. According to Godoy, the French taste for silk hangings caught on in Spain in Philip V's time, and rich houses no longer bothered to keep paintings on their walls. Many subsequently found their way into the cheapest market in Madrid, the Rastro, which still exists today, and thence into the collections of the more perceptive people like, apparently, Bernardo de Iriarte. Unfortunately, however, the economic state of Spain at the end of the century was more propitious to the selling of collections than to their acquisition. An expanding economy reached its high point between 1792 and 1796, but then inflation set in. War with France in 1793–95 and then with England and finally the Peninsular War seriously damaged the country's finances, and although Godoy was able to build up a formidable collection from other Spanish sources at this period, many paintings and other works of art were sold to foreigners and permanently lost to Spain.

The Spanish government had taken measures against the exportation of works of art as early as 1779. But little could be done to prevent their extraction while the Peninsular War was being fought between 1808 and 1813. It is true that the 1st Duke of Wellington acquired part of his collection now at Apsley House as a gift from the king of Spain for his services in the war, but Marshal Soult pillaged and looted extensively during the campaigns, and an English dealer called Buchanan arranged for a number of works by Velasquez, Murillo and Ribera to be brought to England while the war was on. Masterpieces like Velasquez's *Venus and Cupid* (the so-called *Rokeby Venus*) and Correggio's *The Education of Love*, both of which had been in the collection of the dukes of Alba until 1802 and subsequently in Godoy's, came to England at that period, and it was not long before the Iriarte and Altamira collections were up for auction in Paris and London.

But if disturbed times and social change saw many art treasures sold abroad, they also gave birth to new kinds of art in Spain as elsewhere in Europe. Among the most impressive works produced in Europe at this period were prints and etchings, which were in a sense mass-produced to satisfy a new classless demand. Print-making served initially in Spain to carry Neoclassic art, or the works Neoclassics admired, to a wider public. A leading figure in Charles III's reign was Mengs's son-in-law Luis Salvador Carmona, who had been sent to France to study engraving. At the end of the century, Antonio Carnicero, another court painter, made a series of carefully drawn bull-fight etchings which were extremely popular. And Goya himself apparently envisaged that his *Caprichos* would reach a wide public when published in 1799, since he declared he was speaking a universal language, that is, one which all would understand.

The opening of public galleries where people could study and enjoy works of art which had previously been in private collections and royal palaces, and thus were known to very few, also helped to change the position of art in early 19th-century society. The Louvre had opened in 1793, and the San Fernando Academy in Madrid printed its catalogue and prepared to open in the autumn of 1817. Previously the academy had only shown works on special occasions, but since Godoy's collection had

221

221

CAN'T ANYONE
UNTIE US?
Capricho No. 75
Francisco de Goya y Lucientes 1746–1828
etching and burnished aquatint
Biblioteca Nacional, Madrid

222

THE UNHAPPILY
MARRIED COUPLE
before 1783
Buen Retiro porcelain
Museo Arqueológico Nacional, Madrid

The uneasy twisting of the couple is not untypical of the groups of figures in movement or expressing emotion which were carried out at the Buen Retiro factory during Charles III's reign under the direction of Carlos Schepers. In treating the same theme Goya (**221**) goes much further than the Buen Retiro artists. The unfortunate couple's urge to separate is more violent and far more passionately expressed. Goya's own commentary suggests that the pair had been forced into matrimony, and a bird of evil symbolically oppresses them. While the real social and human problem was a matter of concern to Goya, the Buen Retiro artist used it as a pretext for a decorative piece.

been deposited there in 1816 more frequent openings doubtless seemed appropriate. Now the public was to be allowed in from 8 a.m. to 2 p.m. on days when it was not wet or muddy, although there were strict instructions to the attendants to keep out possible causes of disturbance like nursing mothers, children under eight, shoeless or ill-clothed persons and people armed with sticks or parcels. If the galleries were too crowded at any time the main doors were to be closed. Some of the wind was taken out of the academy's sails, however, in 1819, when Ferdinand VII created a Gallery of the King's Museum on the suggestion of his second wife Isabel of Braganza. Paintings from the various royal palaces were to be placed in the Prado – a building originally planned by Juan de Villanueva between 1785 and 1787 as a science museum. Three rooms were soon hung, but the riots over the Constitution in 1820 delayed progress considerably, since lead was stripped from the roof and damp affected ceilings. Despite this setback and the fact that many of the paintings were still awaiting restoration, the catalogue was printed and two rooms and the great gallery opened in 1828 with 755 paintings of the Spanish, Italian, French and German schools. A group of paintings by living or recently deceased Spanish artists was included, and Dutch and Flemish paintings were to be on show as soon as a further room was ready. The Prado took some of the same precautions as the academy and was only open on Wednesday and Saturday mornings and closed when it was wet. Only foreigners with passports could get in on other days of the week, but people of all classes (assuming they had a 'sense of beauty') were welcome to study and even copy works at the appointed times.

212

As the public for art became larger the themes of art became more public too, especially at the time of the Peninsular War, when patriotic themes in art and literature became *de rigueur*. But the manner in which these themes were treated varied considerably from one artist to the next. Classical tenets were no longer universally held, although many still clung to them others sought a personal viewpoint and at the same time showed a deep human concern for the world around them. Thus we can contrast Asensio Juliá's prints of the Marqués de la Romana liberating Galicia or of Wellington and Napoleon – carefully composed and heavy with symbolism – with Goya's *Disasters of War* and his paintings of the 2nd and 3rd May 1808, which show ordinary people suffering rather than the triumphs of generals. Unfortunately there were few artists in Spain to follow in Goya's footsteps, and many artists used Neoclassic clichés even when expressing the sufferings of the society in which they lived. A case in point is the work of Aparicio: in paintings like *The Famine in Madrid* and *Glories of Spain*, which were famous in their time, the political ideas are as conventional as the style. Starving people stand in decorative groups, and the treatment of the folds in their clothes is clearly imitated from Classical sculpture. Equally Neoclassical is the work of Madrazo, whose *Death of Viriato* was an allegorical study of wartime treachery and revenge in terms of Spanish medieval history.

Under Ferdinand VII, between 1814 and 1820, liberal Spanish writers and artists lived in semi-retreat, or went to France or Englànd. The brief constitutional period of three years which followed gave them an opportunity to express themselves more freely, but absolutism was restored in 1823 and the liberals fled the country in large numbers until Ferdinand's death in 1833. In view of their inevitable isolation in an intolerant and bigoted society, it is not surprising that the greatest Spanish works of the period were not the result of a commission, to be exhibited in the Academy or hung on the walls of nobles' palaces, but were painted as the expression

of personal anguish in a small country retreat just outside Madrid, directly on to the plaster of the artist's dining room and living room. These were **238, 239** Goya's Black Paintings, an unparalleled series of meditations on age, destruction and human bestiality painted around 1819, which shock and move us still as if they had been painted yesterday. How distant these paintings and some of Goya's late drawings seem from the scenes of St Anthony preaching to a crowd, which he had painted round the cupola of the little church of San Antonio de la Florida by royal command in 1798. And how distant in their turn were these from the early religious frescoes of Goya and Bayeu in the dome of Saragossa Cathedral. Goya's career moved from an initial reluctant respect for the hierarchy towards open hostility, just as Spanish society moved in the 18th century from an absolutist society, in which artists were employed by aristocrats, the church or the king because they would paint, sculpt or design what the hierarchy wanted, to a freer society in which the artist was respected by many and admired for his personal vision, and for the contribution he could make to the society in which he happened to live. Under the old régime buildings and art could be beautiful, and occasionally they were original. But only at its overthrow could art begin to be more overtly personal and free.

Nigel Glendinning

223 *below*
STUCCO-WORK
1771–86
F.X.A. Pedraxas, born 1736
Sagrario Chapel, La Asunción, Priego de Córdoba

The survival of local decorative traditions from earlier periods until well into the second half of the 18th century can be plainly seen in Pedraxas's stucco-work at Priego, completed in 1786. The artist was employed in several other Priego churches (he was born there) and also elsewhere in Andalusia.

224 *right*

POLYCHROME TILE PICTURE *detail*

early 18th century
Museo de Arte de Cataluña, Barcelona

The detail shows cups of chocolate being
handed round and gallant conversation in
progress at an open-air party in a
gentleman's garden; the fountain seen here
in the right-hand corner is in the centre of
the piece. The picture originally filled an
archway over a door or window in a
house in Alella. Such tile pictures were
particularly common in Catalonia and
Andalusia and continue earlier practice.

225 *below*

STILL LIFE

c. 1772
Eugenio Luis Menéndez de Rivera 1716–80
Prado, Madrid

Menéndez (or Meléndez) was born in
Naples and studied in Rome, but spent
most of his life in Spain, where he worked
in Madrid with Van Loo. His father, also
an artist, was one of the earliest proposers
of a Spanish academy of art on the lines of
those existing in Italy. A specialist in
accurate and decorative still-life paintings,
Menéndez at one stage set out to depict for
the king's apartments at Aranjuez, all the
varities of food produced in Spain.

226 *right*
MARQUESA DEL LLANO *detail*

c. 1773
Anton Raphael Mengs 1728–79
Real Academia de San Fernando, Madrid

Mengs probably painted this portrait of the marquesa at the age of nineteen, and made a replica of it, when she was in Italy with her husband, who was ambassador in Parma. Certainly both painter and sitter were in Rome from June to September 1773, and both were friends of Mengs's great patron Azara. In this, one of the first paintings of a Spanish lady as a *maja*, the marquesa wears the regional dress of La Mancha, the province from which she came, for a masked ball.

227 *right*
QUEEN MARIA AMALIA
OF SAXONY *detail*

c. 1766
Anton Raphael Mengs 1728–79
Prado, Madrid

This was almost certainly a posthumous portrait of Charles III's queen, who had died in 1760 at the age of thirty-six. The pose, and the composition with column and curtains in the background, seems predictably Classical, but the transparent quality of the black lace is beautifully rendered and the limited range of colours is most sensitively and harmoniously controlled.

228 *left*

MARY MAGDALENE

c. 1724
polychrome sculpture
Pedro Duque Cornejo 1677–1757
Charterhouse, Granada

Although he was a pupil of Pedro Roldán –
a master of the naturalistic style in religious
sculpture in Seville in the 17th century –
Cornejo's work showed a preference for
the movement, dramatic contrasts and
emotional tensions of the Spanish Baroque.
His particular skill in rendering skin
texture and clothing impressed even his
strongest Neoclassical critics, and despite
the obviousness of the skull and penitent
hand on breast of his *Mary Magdalene*, the
tense fingers and the facial expression make
the image far more than just a study in
flowing lines and conventional emotion.

229 *top centre*

FOUNTAIN FIGURE

1722–42
Palace of La Granja, San Ildefonso

The fountains at La Granja were the work
of a group of artists led by the French
sculptors René Fremin, Jean Thierry,
Jacques Bousseau and Antoine and
Hubert Dumandre. Most of the allegorical
figures are derived from Cesare Ripa's
Iconologia. Classical deities and subjects
preponderate, especially the legends of
Diana, which were particularly appropriate
to the hunting-lodge character of the
palace.

230 *left*

VIRGIN WITH THE
DEAD CHRIST

Torcuato Ruiz del Peral 1708–73
Santa María de la Alhambra, Granada

Ruiz del Peral, like many other 18th-
century artists in the Spanish provinces, did
not feel the impact of European taste and
Neoclassicism, but continued to work in
the native tradition. He carved the pulpit
in Guadix Cathedral in 1737, and worked
for thirty-two years, from 1741, on the
choir stalls there. The *Virgin with the Dead
Christ*, while typical of his realistic
approach to figure sculpture, has some of
the expressive power to be found in 17th-
century Granada sculpture.

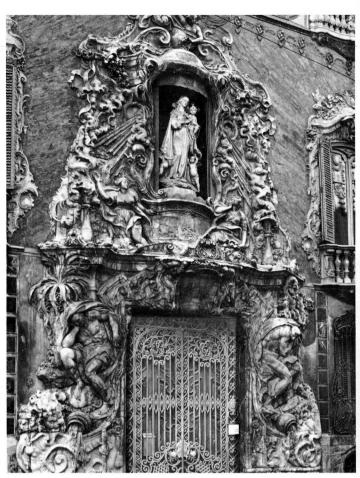

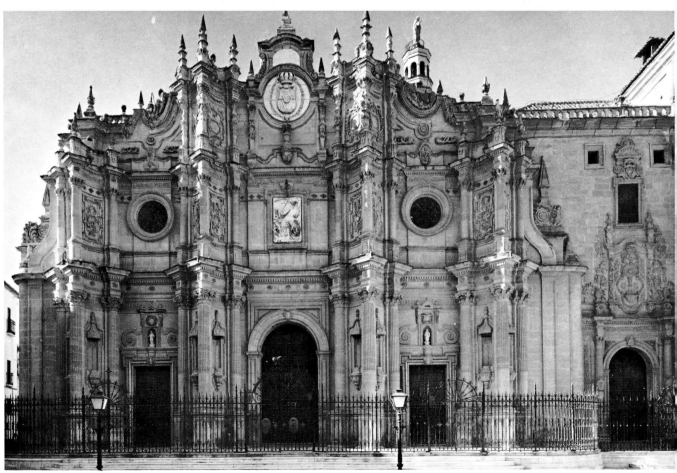

231 *left*

DOS AGUAS PALACE

1740—44
Hipolito Rovira y Brocandel 1693—1765
and Ignacio Vergara 1715—76
Valencia

Hipolito Rovira, who designed the porch,
spent a long period in Rome in his thirties,
and, when he returned with broken health,
was protected by the Marqués de Dos
Aguas. Curling smoke from two vases of
incense in the upper part of the façade,
hunched river gods, snakes, and flowing
cloth and water in the lower part
contribute to the Rococo lines of the
decoration, which was carried out in
alabaster by the sculptor Ignacio Vergara.

232 *below*

VALENCIA CATHEDRAL

1703—40
Conrad Rudolf, d. 1732

This was the first curved façade to be built
in Spain following Italian Baroque
precedents. Rudolf, a German sculptor
who had studied in Paris and Rome,
designed and began it, and was also
responsible for some of the sculptured
figures on the upper section of the façade.
The relief with angels over the door was
made in the middle of the century by
Ignacio Vergara, a Spaniard who had also
studied in Italy.

233 *top far left*

MURCIA CATHEDRAL

1741—54
Jaime Bort Miliá, d. 1754

Murcia shared with Valencia an early
contact with the French Rococo style,
which is plain to the eye in this façade— a
set of broken variations on the Corinthian
column and rounded arch, enriched with
statues, medallions, reliefs and shifting
planes. But the spread of Classical ideas
soon ended this kind of work. The
architect's nephew, Julián Sánchez Bort,
was to become a leading Neoclassical
designer in the second half of the century.

234 *bottom far left*

GUADIX CATHEDRAL

1714—20
Vincente Acero y Acebo, working 1714—38

This façade was Acero's first important
work. There are reminiscences of the
Plateresque in the frieze which runs above
the two bull's eyes and in the relief panels
on the four projecting ribs with their
clusters of Corinthian columns. The
columns themselves recall the clusters in
the nave of Granada Cathedral, which
Acero also repeated at Cádiz. But the use
of curved surfaces shows that he was also
au fait with recent developments,
particularly Conrad Rudolf's façade for
Valencia cathedral.

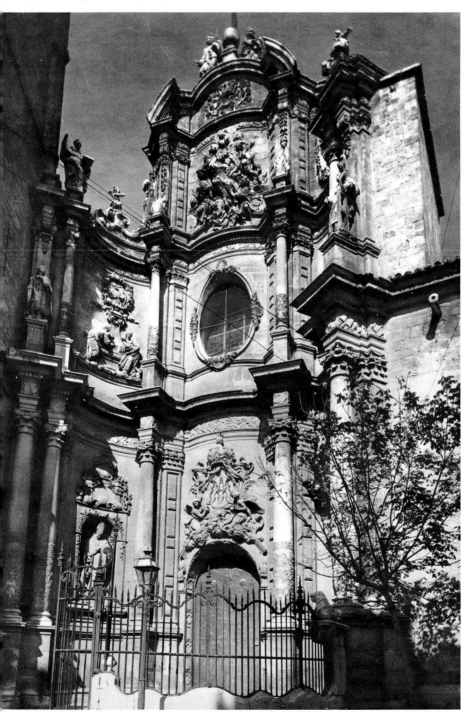

235 *right*

THE ALCALA GATE

1764–78
Francisco Sabatini 1722–97
Madrid

This gate was begun only four years after Sabatini reached Spain from Rome, as part of the scheme for improving the streets and layout of the Spanish capital. The architect tempered the austere Classicism of its basic forms by stepping forward the central arch and pilasters, and by adding curvacious variations on the Ionic capital (based on Michelangelo's Campidoglio) and white marble sculptured reliefs, trophies and figures, carved by Robert Michel and Francisco Gutiérrez.

236 *right*

CYBELE FOUNTAIN

1776
Francisco Gutiérrez 1727–82 and Robert Michel 1720–86
Madrid

Several fountains were part of the general plan to improve the appearance of Madrid in the middle of the century. Built under the overall direction of Ventura Rodríguez, the statue of the goddess Cybele and the chariot were the work of Gutiérrez, a pupil at, and later director of, the San Fernando Academy. According to Ponz, the lions were the work of the French sculptor Robert Michel.

237 *far right*

THE BURIAL OF THE SARDINE

Francisco Goya y Lucientes 1746–1828
oil on wood panel
Real Academia de San Fernando, Madrid

Goya has represented a number of characteristic elements of Carnival in this Ash Wednesday procession. The banner is a parody of those used for religious ceremonies, and some of the figures appear to be decked in mock vestments. The people wearing masks or dressed as animals, and the transvestites (one of whom carries a picador's goad) are typical of Carnival rioting, which was for some 18th-century artists a picturesque subject. Goya, however, had his own view of it, and was less concerned with pleasing his public. He depicted the more violent and rebellious aspects of the scene, emphasising them by his bold impressionistic treatment.

238 *below*

SATURN DEVOURING HIS CHILDREN

c. 1819, oil on plaster
Francisco de Goya y Lucientes 1746–1828
Prado, Madrid

This was originally painted on a wall of the ground-floor dining room of Goya's small country house just outside Madrid. Like most of the other Black Paintings (**239**) its subject is connected with age and violence; Saturn eating his children represents Time consuming the days. The manner of its painting is quite without precedent, the brushwork and distortion being of extraordinary originality and boldness.

239 *bottom left*

MEN FIGHTING WITH CLUBS

c. 1819, oil on plaster
Franciso de Goya y Lucientes 1746–1828
Prado, Madrid

The fighters' destructive violence is heightened by the tranquillity of the scene behind them, in which bulls pasture while the men appear to sink into the ground. This was painted on a wall in the first-floor room of Goya's house; on the same side there was also a scene showing the Three Fates spinning, drawing out and breaking the thread of human life.

240 *right*

THE NAKED MAJA

1796–1803
Francisco de Goya y Lucientes 1746–1828
oil on canvas
Prado, Madrid

Although there had been formal opposition to nudes in Velasquez's time, in 18th-century Spain they became increasingly common, and appeared in prints, drawings and paintings, and on palace ceilings. Goya made a number of sketches of naked or partly draped figures in his notebooks in the 1790s, and this painting was a more posed development of these bedroom studies. It may well have been stimulated by the thirty-three nude paintings from royal collections deposited in the San Fernando Academy in 1792 and 1796. Goya's *maja*, however, was not in the line of traditional Venuses, but was a compromise between them and his own unartificial intimate sketches.

For western Europe the 19th century marked the birth of middle-class civilisation, and the dominance of the new class gave rise to a great change in the nature of artistic patronage. The court and aristocratic circles were replaced by the dealer and his bourgeois client, and the post of court painter, previously so coveted, became an insignificant one. The change is well illustrated by the differing circumstances of two of Spain's greatest painters, Goya and Picasso. At the end of the 18th century Goya had found security through his appointment as court painter, while Picasso's financial success, at the beginning of the 20th century, was largely due to his adoption by the Parisian dealer Kahnweiler. In general the artist gained a new motivation from his involvement in the commercial world, and a new autonomy in his subject matter, which was no longer dictated by aristocratic patrons. However, 19th-century Spain provided an unfavourable climate for the development of a flourishing experimental art. The pace of industrialisation was slow and the development of a bourgeoisie retarded, even in Catalonia, the most advanced of the provinces. The country's political life was disrupted by a continual series of crises after 1833, and the aristocracy, faced with uncertainty and radical economic change, was nervously conservative in its outlook. The insularity and lack of patronage forced those artists who became internationally famous – Picasso, Gris and Miró – to leave Spain and further their careers abroad. But their very emergence is evidence that the Spanish scene, by the end of the 19th century, was far from sterile.

Goya appears always an isolated figure, and strangely, his influence was of little immediate importance. His successors, mere waifs in his shadow, were part of no great tradition, and displayed academic competence rather than inspiration. In the early part of the 19th century Spanish painting was permeated by a limited form of European Romanticism particularly evident in the work of Leonardo Alenza, while José de Madrazo, under the influence of the French painter David, continued the Neoclassical trends of the previous century.

The political and social problems facing Spain after 1833 made it difficult for any extensive encouragement of the visual arts. The death of Ferdinand VII left a young girl, Isabella II, as his heir, under the regency of her mother Maria Christina, and the claims of her uncle Don Carlos to the throne provide a background of instability to the next forty years. In conditions of such political uncertainty, with the constant threat of revolution, the queen and her government found themselves in straitened financial circumstances, unable to fulfil their accustomed role of artistic patronage. The great collections of the Spanish royal family which formed the basis of the Prado received few additions of importance from Isabella. Ironically, the major addition to the collection during the 19th century came, not from any conscious sense of patronage, but from the liberals' attack on the Church during the 1840s. The compulsory closure of a number of monasteries in Madrid brought first to the Trinidad Museum, and later in 1872 to the Prado, a number of important works which had previously been the property of the monasteries, including paintings by Tiepolo and Goya. But the attack also weakened another traditional source of Spanish patronage, that of the Church.

The third traditional source of patronage, the aristocracy, was both limited and marked by an adherance to strict academic standards, the main demand being for portraiture and paintings of Spanish history. The growth of public exhibitions and the spread of academic prizes, a new road to recognition and financial security for the artist, encouraged the forces of traditionalism rather than stimulating the desire for experi-

Middle-class Patrons and New Directions in Art

1900 to the present day

241

COMPOSITION

c. 1929
Joan Miró, born 1893
lithograph
Museo de Arte Moderno, Barcelona

Miró was born in Barcelona and given his first opportunities by Dalmau. After his first exhibition in 1918 he went to Paris and there became a major figure in the Surrealist movement. This painting shows his ability to translate the fantasies of the dreamworld on to paper. His constant return to Spain, except during the four years of the Spanish Civil War, is evidence of the need he feels to draw inspiration from his native land.

ment. The Academy of San Fernando in Madrid began to hold autumn art exhibitions in 1835, but although these provided a market for painters, the unadventurous taste of the organisers and patrons determined the nature of much of the art. The historical set-piece was a constant feature of such exhibitions; even a talented painter like Eduardo Rosales found his own limited acceptance by working within this convention. Rosales, trained at the San Fernando Academy, worked mainly in Italy, while exhibiting in Spain. His famous picture *Isabella the Catholic dictating her Will*, exhibited in Madrid, was purchased by the Spanish government. He survived the vicissitudes of his bohemian existence in Italy on the strength of a small pension granted by that government, while his reputation was increased in 1865 when his success in the Paris Universal Exhibition brought him the Legion of Honour from Napoleon III.

The political instability of Spain resulted in a feeling of national uncertainty and gave rise to a controversy which was reflected in art and literature. What was the nature of Spanish society and what was its relationship to European values? The extreme liberals demanded Europeanisation as the basis for political renewal; the forces of conservatism opposed it as the denial of the Spanish spirit. The tendency to artistic nationalism found expression in a new awareness of the significance of Goya. As late as 1846 the first full Goya exhibition, 'Homage to Goya', was shown in the Liceo in Madrid, and his prints and etchings were finally published in the 1860s. Consequently, in the middle of the century a fashionable Goya cult arose, which paved the way for a new romanticism. At the same time new Northern influences were beginning to appear in Spain. The arrival of Charles de Haes, a Belgian who chose to live and work in Madrid, provided an important bridgehead for the introduction of European forms and ideas. His influence encouraged the growth of realism and naturalism, and artists turned from studio painting to the depiction of open-air scenes.

One painter whose work shows in some measure both realism and romanticism was Mariano Fortuny. Born in 1838 into a prosperous family, he became fascinated with the East and with Africa. His interest in Morocco, where he travelled with the Spanish army, is reminiscent of Delacroix, and it was the Moorish influence that attracted him to Granada, where he painted brightly sunlit scenes, abandoning the gloom of the academy for the luminosity of the Spanish landscape.

The growing fashion of realism is seen in the work of Francisco Gimeno. In contrast to Fortuny, Gimeno came from peasant stock. He could only afford the most elementary training, and when he came to Madrid in 1884, he was forced to support his family by working as a house painter. He was an artist in his spare time and his subject matter was taken from his surroundings, particularly his home and family. When in the 1890s the poet Machado lamented the fate of Spain and cried that in the past men had painted courts and hunting scenes but now the artist should paint the Castilian peasant, he reflected a change already in progress. Gimeno's paintings of working-class conditions in Madrid and the later paintings of Sorolla and Mir of Spanish peasant life reflect not only the exact shift of interest demanded by the poet, but also the changing tastes and demands of a society in transition.

By the third quarter of the 19th century the influence of Paris was dominant, and painters abandoned the traditional haunts in Italy in favour of France. Thus the fashions of the Paris schools were quickly reflected. Impressionism for example made its appearance in the work of the Asturian Darío de Regoyos and Joaquín Sorolla from Valencia.

242
ISABELLA
THE CATHOLIC
DICTATING HER WILL
Eduardo Rosales 1836–73
oil on canvas
Museo de Arte Moderno, Madrid

This picture, bought by the state from a public exhibition in Madrid, represents one of the few additions to public collections made in this way in the mid-19th century. Referring to the great days of Spain under Isabella the Catholic, when Spanish unity had at last been attained, its message was clear to a country under a new Isabella, which seemed determined to destroy itself in civil war. The historical study became, in these conditions, effective propaganda.

242

246,
250

Although Sorolla studied in Rome on a municipal scholarship and in Paris as well as in Valencia, his life was spent mainly in Spain, and the subjects he chose to paint were Spanish. His prosperity, however, rested on international rather than national recognition. As early as 1884 he had made his mark at the National Exhibition in Madrid where he was awarded the second medal for the inevitable historical canvas. He returned from Paris with his own form of Impressionism – an Impressionism marked by an appreciation of light referred to in Spain as *luminismo*. Medals and prizes accumulated after 1892 in Madrid, Munich, Chicago, Venice, Berlin, and Vienna, culminating in 1900 with the Grand Prix at the Paris World Exhibition, an international recognition confirmed nationally the following year in the Madrid National Exhibition. Sorolla specialised in paintings of the life of Valencia – coastal scenes of the beaches and the fishing families. Painted in bright, luminous colours, they create an immediate impact. His best paintings, however, are of children, for whom he possessed an instinctive feeling, and the figures of his young boys are marked by a beauty of form and texture seldom surpassed. Success came to him through attracting the transatlantic market; his exhibitions in the New World brought him American patrons. In particular he gained the attention of Archer Huntingdon, the founder of the Hispanic Society in New York, who provided Sorolla with his largest commission in 1911 – the decoration of the gallery of the society's headquarters with a series of scenes of Spanish life.

The Modernists

In 1898 Spain suffered a disastrous military defeat over the last of her South American possessions, Cuba. Ironically, the loss of the last remnants of imperial greatness produced a genuine intellectual renaissance. A crisis of confidence produced a sense of inquiry into the nature of Spanish decline. The literary movement of the 'Generation of '98' in Madrid and the artistic phenomenon of 'Modernism' in Barcelona are both evidence of this. In Madrid Miguel de Unamuno and later Ortega y Gasset analysed the relationship between traditional Spanish values and the problem of Europeanisation in their search for a renewal of Spanish greatness. In Catalonia the disillusionment with the fiasco of Cuba, inflamed by the discontent of the returning troops, accelerated the denial of centralism, and separatist feeling now began to reflect Catalonia's more advanced economy. Traditionally, separatism had been conservative and Catholic; it now became anarchist and atheistic. However, both traditions in their different ways provided new ideas and attitudes, and in encouraging Catalonia's position as a bridge between Spanish and European cultures they created a fertile atmosphere for artistic experiment. The Catholic tradition produced the architecture of Gaudí: anarchism the work of the Modernists.

Modernism refers more to an environment than a style. It refers to the strange mixture of fashionable *fin de siècle* decadence and the naive commitment to new ideas that characterised intellectual circles in Barcelona at the turn of the century. The open nature of Barcelona society, led by an industrial middle class, facilitated the spread of foreign influences. The wide popularity of the English Pre-Raphaelites was combined with an enthusiasm for Art Nouveau. This, however, was a virile and highly idiosyncratic form of Art Nouveau. The elemental quality of power which Spaniards called the '*duende*' and believed to be a world force available to the artist to transform technique into inspiration, and enthusiasm for the life-affirming philosophy of Nietzsche, fused with a deep political commitment and concern about the problem of poverty in a

243
ELENA AND MARIA
ON HORSEBACK
Joaquín Sorolla
1863 – 1923
oil
Museo de Arte Moderno, Barcelona

Sorolla's feeling for his native country is illustrated in his many paintings of people in regional costume. The most extensive series of these are the sketches (now in the Museo Sorolla, Madrid) for the paintings in the Hispanic Society of New York. This picture is similar to the sketches, impressionistic in style, the draughtsmanship often crude, but the overall effect dramatic if somewhat romanticised.

developing industrial environment. Anarchism seemed to offer hope for a better future; the promise of a golden age. It was in such a spirit that Pedro Romeu founded in 1897 a new café intended as a club for intellectuals – 'Els Quatre Gats' – where the more radical of Catalan artists found a centre for discussion. Combining admiration for English painting, French styles and German philosophy with an understanding of Catalan nationalism, they produced a synthesis between European ideas and more specifically Spanish attitudes. This was Modernism. Assuming that the 19th-century philosophy of positivism, with its search for truth in the surface appearance of things, was discredited, they rejected realism and naturalism, and argued that nature was only an appearance.

245, 254, 259 At the centre of the Els Quatre Gats circle were Rusinol, Ramón Casas, Isidro Nonell, Ricardo Canals, Joaquín Mir and Joaquín Sunyer. Rusinol, less distinguished as a painter than as an imaginative critic, took a decisive lead. He lived in a world of German metaphysics and Spanish self-absorption that was a major influence on the Barcelona circle to which he belonged. His organisation from 1892 onwards of 'Art Nouveau Festivals' at Sitges allowed him a platform to spread his artistic views. He preached that art should deal with the tragic and unknown, and not surprisingly he supported the renewal of interest in El Greco, rediscovered in the late 19th century. In 1894 he organised a homage to the painter as part of the celebration at Sitges. This reawakening of interest was confirmed by the ever-conservative Prado authorities when at last in 1902 they mounted an exhibition of El Greco's work.

The painters, Casas, Sunyer and Nonell learnt their craft in France, and they returned to Spain conversant with European styles, and willing to further assimilate new ideas in Barcelona. Their association depended more on a sense of brotherhood than on stylistic similarities; they possessed no uniform artistic philosophy. The most talented of the group was Isidro Nonell, who made his reputation initially in Paris, both at the exhibitions of the 'Société des Artistes Indépendants' and under the patronage of the dealer Vollard. The largest collection of his work, however, is now in the Museum of Modern Art in Barcelona. He special-**259** ised in portraits of women from the city and suburbs of his native town, often working in dark, emotive blues which must have been of considerable influence in the development of Picasso's Blue Period.

The financial lives of the painters were precarious, although sometimes municipal commissions were available, for instance Casas painted frescoes in the Liceo Opera House. In order to earn more money they extended their activities. The new art of poster design initiated by Toulouse-Lautrec in France provided a fresh source of income as well as a new means of expression. A large proportion of Casas's work takes the form of posters. Equally the growing market for books provided work for engravers, the two main Catalan art publications, *Joventut* (*Youth*) and *Pel i Ploma* (*Fur and Feather*) gave opportunities to both artists and critics. Casas and Rusinol were constant contributors, while much of Picasso's earliest known work was published in these magazines.

244, 249, 257 Younger, and for this reason less influential in the group, was Pablo Picasso. He was born in 1881 in Málaga, but his father's work as an art teacher brought the family north to Catalonia. Consequently, the impressionable years of Picasso's life were spent in Barcelona, where he trained at the Academy and developed as an artist among the cosmopolitan influences of Els Quatre Gats. But in Barcelona Picasso always remained a member of the younger generation, never of the establishment. In 1900, perhaps convinced that Rusinol and Casas were too deeply

244
LAS MENINAS
1957
Pablo Ruiz Picasso, born 1881
Museo Picasso, Barcelona

The series of forty-four variations on the theme of Valesquez's *Las Meninas* (**179**), of which this is one, is a critique of the original and an exploration into questions of spatial relationships, as well as the culmination of a fascination for the original painting dating from when Picasso first saw it at the age of fifteen. The series was donated by the artist in May 1968 to the newly created Picasso Museum in memory of his friend the poet Jaime Sabartés, whose enthusiasm had encouraged the municipality into supporting the idea of a permanent home in Barcelona for Picasso's work.

LA MAUDRA
Ramon Casas 1866–1932, oil
Museo de Arte Moderno, Barcelona

Casas, like many of the Modernist group, was trained in Paris and
depended to a large extent on the galleries and dealers of France.
His work is well represented in Barcelona; a full-scale exhibition
in the Palacio de la Virreina in 1958, arranged by the museums of
Barcelona, evoked considerable interest in his painting. Such
co-operative ventures are part of the growing awareness of those
responsible for the Spanish public collections.

LA MAUDRA
Ramon Casas 1866–1932, oil
Museo de Arte Moderno, Barcelona

246 *below*

BOY WITH GRAPES

1898
Joaquín Sorolla 1863–1923
watercolour
Museo Sorolla, Madrid

This painting illustrates excellently the charm of Sorolla's paintings of children. The large, appealing eyes, the delicate hand to the mouth and the economy of line with which the body is sketched in create a most pleasing effect. The picture should be viewed in the company of the various oil paintings of children playing and swimming which are in the same museum – the painter's old home.

248

LA SAGRADA FAMILIA

foundation stone laid 1882
Antonio Gaudí 1852–1926
Barcelona

Promoted by Josep María Bocabella i Verdaguer, the votive Church of the Holy Family was to be built entirely on the basis of lay contributions without resort to the episcopacy. The architect Villar, originally chosen for the work, had abandoned it within a year and was replaced in 1883 by Gaudí. The massive conception of the church occupied him for the rest of his life, and after his death the project lay temporarily abandoned, until building restarted in 1954. Although little of Gaudí's vast plan has actually been built, the great Portal of the Nativity and the four completed towers with their intricate stonework and mosaic decorations give an illuminating insight into the fantastic church he had conceived.

entrenched, he went to Madrid where he started his own short-lived magazine *Art Joven* (*Young Art*). The purpose of the magazine was to preach the artistic views of Barcelona and of Modernism to the Generation of '98 in Madrid. The limited success of the mission underlines the distinct paths being followed by the provinces of Catalonia and Castile, but even more important it must have strengthened Picasso's resolve to escape Spain for Paris. He first visited Paris in 1900 and by 1904 had settled there. His subsequent career – the inception of Cubism, the designs for Diaghilev and onwards – is part of European rather than specifically Spanish art history. However his constant return to Spanish themes – his series on bullfighting is an example – demonstrates the continuing influence of his youthful experience.

Antonio Gaudí and middle-class patronage

Contemporary with the Modernists in Barcelona, but belonging to the rival club of St Luc was the architect Antonio Gaudí. Gaudí remained a convinced Catholic, and his work is a synthesis of Gothic Revivalism, which was inspired by spiritual values, and the forms and traditions of Art Nouveau. Elsewhere in Spain the fashionable style was a revival of Mudéjar, but the Gothic Revival was particularly important in Catalonia for two closely connected reasons. The traditional nationalism of the province found its expression in a return to the pattern of Gothic – the style associated in the popular imagination with the brief period of Catalan supremacy, cut short by the centralising tendencies of Castile. This romantic idea was strengthened by the association of Catalan nationalism with the Church before 1898. Gothic also represented a past golden age amidst the insecurity of change created by industrialisation.

However, this very industrialisation allowed new possibilities to individual architects, and the use of materials like wrought-iron and glazed tiles provided new textures for the designer. Gaudí in his concept of Mediterranean Gothic asserted a fresh confidence by the use of new structural techniques and materials which made possible visions inconceivable to medieval builders. Urban expansion and extensive church building programmes provided great opportunities for architects such as Doménech y Montaner, Gallissá, Font i Guma and Martorell. Gaudí, the supreme example, was fortunate enough to find patrons who were ready to accept and even encourage his experimental style. About 1882 he met Count Eusebio Güell, a wealthy textile manufacturer, who became both friend and patron. Güell was a cultured, travelled man who was evidently familiar with developments abroad, and Gaudí designed a whole string of buildings for him, including two garden-cities. Neither of these had any great success as such, and the Parc Guell in Barcelona is now a public park, but the buildings, with their rich mosaic ornamentation, remain a striking example of his theory of decoration in architecture.

Gaudí's greatest work is the Church of the Sagrada Familia. He **248** was thirty-one when he received the commission, and he worked on the building until his death in 1926. The church, although unfinished, illustrates the breadth of his imagination, and achieves the fusion of basic Gothic structure with naturalistic ornament that he constantly sought. The use of new materials and techniques, however, enabled him to abandon flying buttresses, which he termed the 'crutches' of medieval architecture.

The scale of these undertakings represents the extent of patronage provided by the *nouveau riche* industrialists, and the progressivism of Barcelona was reflected in architectural taste. However, the exciting possibilities of Catalan society between 1890 and 1910 were a dawn of

false promises. Picasso had settled in Paris by 1904. Nonell was dead by 1911. Barcelona society had provided patrons for architects and was beginning to provide a market for young painters. The emergence in the early 20th century of the dealer Dalmau as an influential figure in Barcelona's artistic life provided help for promising artists. But the attraction of Paris was still too great to keep a painter within the provincial confines of Spain. Juan Gris had left for Paris by the time he was nineteen, where he was to become a major figure in the Cubist movement. Salvador Dali and Joan Miró both started their careers in Barcelona. The patronage of Dalmau gave them their initial success, but their futures also were abroad. The part both played in the creation and development of the Surrealist movement can be to some extent traced to the influence of Catalan Modernism, Art Nouveau and the fantasies of Gaudí.

Spanish art returned to self-contemplation. The two most important artists to remain were Zuloaga and Solana, both of whom represented the anti-European tendencies always evident in Spanish society. Ignacio Zuloaga specialised in painting Spanish peasant life in a style much influenced by the revival of interest in El Greco. José Guttiérez Solana reflected the atmosphere of Madrid, but his pessimistic obsession with Spanish values lacked the determination to discover remedies for Spanish ills which was characteristic of the Generation of '98. His love of Spain was marked by a conservatism which fled from all form of change, a fear of seeing even the miseries removed.

Art languished in the '20s and '30s. The economic backwardness of the country, based on peasant farming either in the large barren estates of the south or the smaller farms of the north, kept Spain isolated from the main stream of European development. The energies of Barcelonan patronage were diverted instead into the conservation of art treasures from the past. In 1919 work began on salvaging the medieval wallpaintings left in various stages of decay in Catalan churches. Frescoes hidden behind the excesses of Baroque furnishings were brought to Barcelona and displayed in the Museum of Ancient Art.

The Civil War and after

In 1936 the Spanish Civil War broke out. The collapse of the monarchy had brought a liberal republican government to Spain, but the rebellion of General Franco, sustained by the troops of Mussolini, the diplomatic support of Hitler and the so-called neutrality of Britain, France and America turned the country again into chaos. The Exhibition of Nations in 1937 in Paris held one monument to liberal Spain. Picasso had been commissioned to work on the national stand: in the event the recent outbreak of the Civil War and the bombing of Guernica by the German air-force brought his indignation to the surface. The result was the great painting *Guernica* – Picasso's record of the inhumanity of war and the tragedy of his native land.

Artistically the tragedy of the Civil War further fragmented the tradition of Spanish painting. Painters in the post-war period seemed cut off from their own past, searching for new forms of communication. The old dichotomy still existed: Spanish painting was divided between the nationalistic obsession with native landscape and life, and a search for a more international style. The hand of censorship, perhaps because it failed to comprehend the significance of experimental art, allowed painters considerably more freedom than writers, and by 1950 the beginnings of an important abstract school were appearing. Pioneered by Antonio Tapies, the movement centred on small groups of painters in various cities from Santander to Las Palmas. The group Dau Al Set in

249

WEEPING WOMAN

1937
Pablo Ruiz Picasso, born 1881
etching and aquatint, first draft

The formation of the 'Friends of the New Arts' in the early 30s and the organisation by them of exhibitions of Picasso's work in Barcelona, Bilbao and Madrid, renewed Spanish interest in his work. In the struggle of the Civil War, Picasso's enthusiasm for the Republic was recognised by his appointment as Director of the Prado to arrange the safety of the country's art treasures. His involvement with Spanish politics was expressed in *Guernica*, commissioned for the Spanish Pavilion at the Paris International Exhibition of 1937, and in the allied series of studies and etchings on the theme of human desolation. This draft from the series *The Weeping Woman* illustrates very well Picasso's use of distorted lines to portray human emotion.

Barcelona was the first to create much interest, but the changing balance was reflected by the opening in 1954 of an all-abstract gallery, the Fernando Fe in Madrid. The creation of the gallery encouraged the development of a major group of painters in Madrid and the foundation in 1957 of a new group, El Paso. The development of abstract art by small groups of painters reflects the same tradition of artistic and intellectual co-operation that characterised the Modernists at the end of the 19th century. Similarly modern Spanish painters have found their acceptance abroad as well as at home. The opening of a museum of abstract art at La Cuenca and prizes at international competitions like the Venice Biennale and the Pittsburgh International have confirmed their success.

The '50s and '60s have been favourable to such developments. The growing market for modern art is reflected in the wide range of galleries in Madrid. The Galeria Juano Mordo, Galerie Stadler and the Galeria Seiquer are evidence of the commercial attraction. But also developments since 1950 have increased government interest. The growth of tourism has suddenly made artistic patronage by the state a good investment. State subsidies to help the expansion of the Prado and the organisation by the Ministry of Information and Tourism of exhibitions of contemporary art in the Sala del Prado are indications of this. Similarly exhibitions of modern Spanish art have toured Europe and America under state sponsorship as part of the government's political programme. Although Spain remains outside the main stream of European culture, its government cannot avoid the necessities of involvement in the international community. Graham Davies

250 *below*

COMIENDO EN LA BARCA
1898
Joaquín Sorolla 1863–1923
oil
Academia Real de San Fernando, Madrid

Sorolla's constant interest in the fishing folk of the Valencian villages is reflected in a wide range of pictures, in both Spanish and American collections. The subject matter and the bright, almost naive use of colours makes his work popular, but the style is inclined to romanticise the life of the fisherman; the hardship of poverty is smoothed away. Sorolla had a successful life, which possibly robbed him of the appreciation of tragedy that can be found in the work of his contemporary, Gimeno.

251 *right*

IRON GATE TO THE GUELL VILLA

1885 – 89
Antonio Gaudí 1852 – 1926
Barcelona

Commissioned by Count Eusebio Güell, the house was to become an important centre in Barcelona for artists and musicians. Güell's enthusiasm for music, particularly Wagner, possibly influenced the motif of the dragon used here. Certainly in other decorations by Gaudí and also in the designs of Domenech y Montaner for the Palau de la Música Catalana one finds the reiteration of Wagnerian themes. This gate, designed by Gaudí himself, is typical of his early work. The elaborate use of cast-iron and iron mesh for the dragon's wings illustrates the freedom given by new materials.

252 *above*

SOL

Pablo Serrano, born 1910
bronze
Museo de Arte Contemporáneo, Madrid

Serrano studied in Barcelona but moved to Uruguay in 1930 and remained there until 1955. In 1946 a meeting with Torres Garcia encouraged him to explore the possibilities of abstract art, and his study of post-Cubist art led to a preoccupation with questions of space and light. His work is representative of the post-war spirit of experiment found among Spanish sculptors. This statue reflects a more naturalistic interest but also demonstrates his excellent technique.

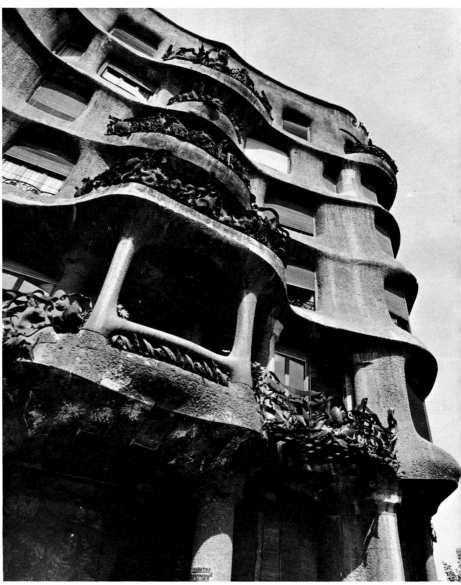

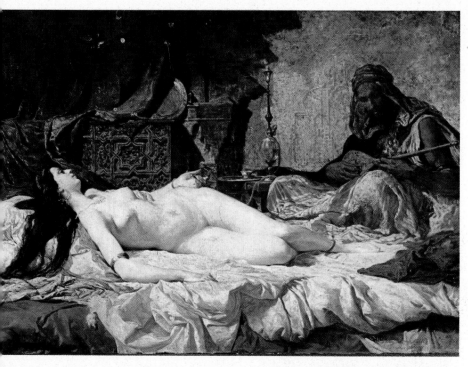

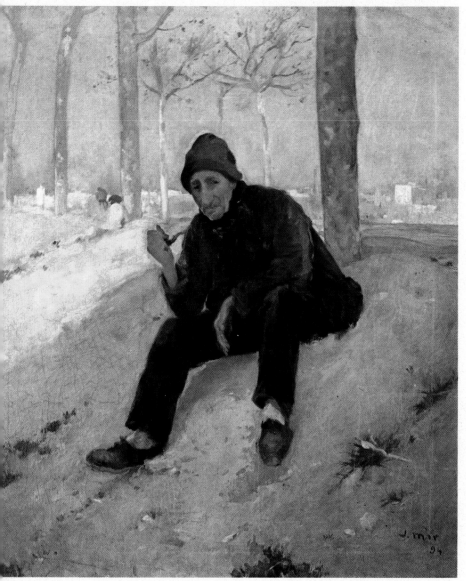

253 *left*
ODALISQUE

1861
Mariano Fortuny 1838–74
oil
Museo de Arte Moderno, Barcelona

This painting, acquired by the Friends of
the Catalan Museums, illustrates the
strong influence of the North-African
environment on Fortuny's art. Like
Delacroix, Fortuny's visit to Morocco
greatly affected his attitude to life and
changed his appreciation of the Spanish
landscape. A representative collection of
his work illustrating his new vision of
Granada is in the Museo de Arte Moderno,
Madrid.

254 *left*
SOL Y SOMBRA

1894
Joaquín Mir 1873–1941
oil
Museo de Arte Moderno, Barcelona

This study in sun and shade by Mir, a
leading figure of the Els Quatre Gats
circle, illustrates both the influence of
French styles on Spanish painting and the
interest in the Spanish working man
embodied in the Modernist movement.
Mir is not a major painter; he represents
the ranks rather than the vanguard of
Modernism. However there is an
enthusiasm for his surroundings in his
pictures which makes him worthy of
consideration.

255 *bottom centre*
THE MILA HOUSE

1905–10
Antonio Gaudí 1852–1926
Barcelona

This corner block of flats is in the Paseo de
Gracia, the main road of the new suburb
of Barcelona. Although unfinished
(Gaudí intended to place monumental
religious statuary on top of the building)
the house, with its cave-like windows and
irregular columns, is a remarkable
example of the adaptation of natural
forms to the needs of urban architecture.
The ironwork on the balconies was the
work of Josep Jujol, who was one of the
several artisan-designers with whom
Gaudí developed artistic relationships.

256 *below*

COMPOSITION

Juan Gris 1887–1927
oil
Museo de Arte Contemporáneo, Madrid

Although born in Madrid, Gris came into
contact with the Modernist tendencies of
Barcelona, and at the age of nineteen he
emigrated to France. As he went without
fulfilling his military service or obtaining
a passport, he was from that moment
excluded from Spain, and lived in Paris in
Montmartre. Patronised by Kahnweiler,
he joined with Braque and Picasso in the
Cubist movement.

257 *right*

HARLEQUIN

1917
Pablo Ruiz Picasso, born 1881
oil on canvas
Museo Picasso, Barcelona

Picasso painted this during a visit to
Barcelona as a designer with the Ballets
Russes. The theme of the harlequin, often
returned to by Picasso, was a development
from his Blue Period in which he portrayed
the underprivileged poor. The harlequins
and acrobats are outcasts, but because of
their skills they are not victims, their
talents giving their isolation from
modern urban society a dignity and
destiny.

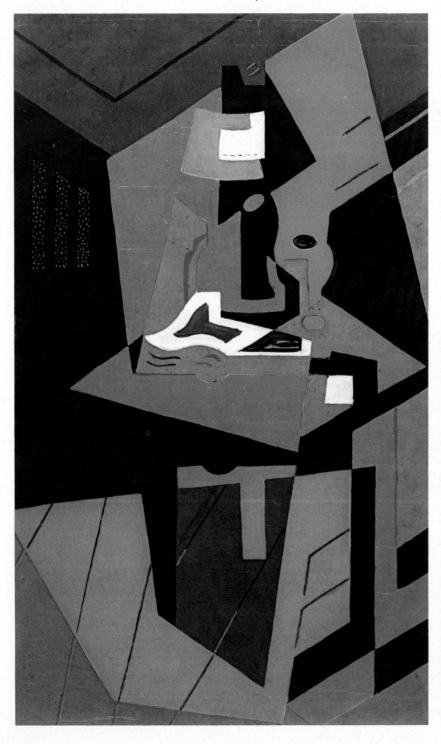

258 *bottom centre*

WOMAN WITH CHILD WEARING A TUCKER

1903
Pablo Ruiz Picasso born 1881
Museo Picasso, Barcelona

This pastel from working-class life in Barcelona combines both despair and compassion in the theme of motherhood. Picasso's Blue Period reflects in the melancholy of the colour the isolation he felt in those early years when he lived between Barcelona and Paris, an outsider in the midst of the underprivileged. The colour, however, also emphasises Picasso's strength as a draughtsman, with the sculptural figures placed dramatically against a neutral background.

259 *below*

MISERIA

1904
Isidro Nonell 1873–1911
oil
Museo de Arte Moderno, Barcelona

Nonell drew his inspiration from the poverty and emotions of the street life of the old Gothic town of Barcelona, deserted by the middle classes in favour of the new suburbs. His use of an almost monochromatic palette with a predominance of blue has been seen as an important influence on Picasso. While Nonell made his reputation in Paris, he was one of the earliest painters to work through Dalmau's Gallery in Barcelona, a fact reflected in the extensive collection of his work to be found in Barcelona.

Museums
and Monuments

An index of museums, churches, palaces and castles, listing some of the major treasures they contain, and corresponding with the places marked on the maps at the beginning and end of the book.

AGUA AMARGA, Teruel
1 **Caves** Good examples of Spanish Levantine cave art, mainly hunting scenes.
AGREDA, Soria
2 **Nuestra Señora de la Peña** Built 1193, contains Gothic panel paintings, fragments of 15th c reredos (Valencian school).
ALBACETE, Albacete
3 **San Juan Bautista** Begun early 16th c to plans of D de Siloe, continued Renaissance style. Damaged, now restored.
4 **Museo Arqueológico Provincial** Archaeological collection, particularly Iberian sculptures from Cerro de los Santos; paintings.
ALBARRACIN, Teruel
5 **Cathedral** 14th c, remodelled 1532. Contains 16th c altarpiece of San Pedro; 7 16th c Brussels tapestries; goldwork.
ALCALA DE GUADAIRA, Seville
6 **Castle** 14th c Mudéjar with remains of an earlier Almohad structure.
ALCALA DE HENARES, Madrid
7 **College of San Ildefonso** Superb Plateresque façade by Gil de Hontañón.
ALCALA LA REAL, Jaén
8 **La Mota** Arab fortress, built by the kings of Granada in the 14th c, rebuilt 16th c.
ALCANIZ, Teruel
9 **Castle** 12th c, erected by the Templars; restored 18th c; Romanesque chapel preserves 14th c mural paintings.
10 **Lonja** 14th c building with 3 fine arcades.
ALCANTARA, Cáceres
11 **Monastery of San Benito** Begun 1505 by Knights Friars of the order of Alcántara, completed 1756. Mainly in ruins, there remains fine façade with coats-of-arms; Renaissance tower.
12 **Roman Bridge** Built by Trajan in AD 106, has 6 arches each 212 yds long; triumphal arch in centre. Restored.
ALCARAZ, Albacete
13 **La Trinidad** Built 1486; 16th c tower; stellar vaulting; some 15th c sculpture.
ALCOY, Alicante
14 **Museo Arqueológico Municipal** Remains from ruins of a 4th c Iberian village.
ALCUDIA, Majorca
15 **Pollentia** Ruins of the Roman city (theatre, dwellings, necropolis).
ALICANTE, Alicante
16 **San Nicolás de Bari** Built 1616–62 by A Bernardino and M de Uceta. Capilla del Sacramento has lavish Baroque decorations by J Borja.
17 **Santa María** Gothic church with Baroque portal by Violat.
18 **Museo Arqueológico Provincial** Prehistoric, Carthaginian, Gallo-Roman exhibits.
ALMERIA, Almería
19 **Cathedral** Begun 1524 to plans of D de Siloe; fortress-like building with 4 massive towers. 2 portals and façade by J de Orea (1550–73).
20 **Santiago** Built 1553, fine Renaissance façade by J de Orea, ornamented, between Ionic columns, with shells and the cross of Santiago; above is a high relief of St James in battle.
21 **Museo Arqueológico Provincial** Prehistoric finds; Early Christian sculpture.
ALQUEZAR, Huesca
22 **Collegiate church** Built by J Segura 1525–32. Contains 16th c altarpiece over main altar and several Gothic ones; 13th c crucifix; paintings by A Cano.
ALTAMIRA, Santander
23 **Caves** Finest examples of prehistoric mural art in Europe. Polychrome paintings of bison etc.
AMPURIAS, Gerona
24 **Greek and Roman city** Remains of former include encirling walls from beginning of 5th c BC; temples from the Hellenistic period; necropolis with objects imported from Corinth, Rhodes and Chalcis. Roman city only slightly excavated, well-preserved walls (1st c BC), amphitheatre, cistern, temple.
25 **Museo Monográfico** Objects from Greek and Roman cities of Ampurias.
ARANJUEZ, Madrid
26 **Royal Palace** Principal building begun 1561 by J de Toledo and J de Herrera; construction resumed 1715–44; expanded by F Sabatini in

1772. Staircase by S Bonavia. Particularly noteworthy are the Oratorio de la Reina with paintings by F Bayeu; the Sala de Porcelana (1753–65) and a banquet hall with paintings by J Amigoni.
ARCOS DE LA FRONTERA, Cádiz
27 **San Pedro** Built on site of Moorish fortress, contains altarpiece of 1539 by F Sturm; paintings by Zurbarán and F Pacheco.
28 **Santa Maria de la Asunción** Fine façade 15th to 16th c. Contains main altarpiece by J Fernández (1586); murals from 14th c.
29 **Palace of the Dukes of Aguila** Fine façade, Mudéjar gate.
ASTORGA, León
30 **Cathedral** Originally Romanesque building, reworked 1471, completed 1693; fine Plateresque façade of pink sandstone, large portal with tympanum decorated with scenes from the New Testament. Interior: 16th c stained glass; works of art including Romanesque Virgin and Child; altarpiece carved by G Beccera (1558–62); Fernández *Immaculate Conception.*
AVILA, Avila
31 **Cathedral** Under construction 1135, continued in Gothic style, finished 14th c. Noteworthy 13th c Portada de los Apostoles. Stained glass windows from 15th and 16th c; altarpiece with sculptures by V de la Zarza (1521), paintings by P Berruguete, J de Borgona; Plateresque altars designed by V de la Zarza; stalls in *coro* designed by J Rodríguez and L Giraldo. **Museo de la Catedral;** monstrance by J de Arfe, goldwork, Castilian-Gothic panel paintings, a painting by El Greco, illuminated MSS etc.
32 **Monastery of San Tomás** Built 1482, has Gothic church with main altarpiece by P Berruguete (1494–99); tomb of Prince Juan by Fancelli.
BADAJOZ, Badajoz
33 **Cathedral** Built 1234–48, resembles fortress, but with modern façade in Renaissance style. Interior: vast Renaissance *coro* by J de Valencia; high altar in Churrigueresque style; paintings by Zurbarán, Ribera, Bocanegra etc.
BAEZA, Jaén
34 **Cathedral** Built 1567–93 by A de Vandelvira and A Barba, preserves 2 portals from earlier Gothic structure.
35 **San Andrés** Built 1500–20, Plateresque door; square tower. Large sculptured Renaissance reredos; 6 paintings on wood showing Life of Christ (school of A Fernández).
36 **Seminario de San Felipe Neri** Built *c* 1500, Isabelline façade flanked by palm-like pilasters and topped by a fine balcony.
BANDE, Orense
37 **San Coma** 7th c Visigothic church with barrel vaulting.
BARBASTRO, Huesca
38 **Cathedral** Finished by J Segura 1533, has Gothic elements. Main altarpiece begun by D Forment and finished by his pupils in 1604.
BARCELONA, Barcelona
39 **Cathedral** Begun 1258, finished 15th c. Modern principal façade; 13th c Puerta de San Ivo; Puerta de la Piedad and Puerta de Santa Eulalia 15th c. 15th c stained glass in clerestory windows; *trascoro* has marble reliefs by B Ordóñez. 14th c high altar; other notable altarpieces are by M Nadal (1454), B Martorell (*c.* 1450) and L Borrassa (14th c).
40 **La Sagrada Familia** Church of striking originality, begun 1884 to plans by Gaudí, still unfinished. Only crypt, apse and N façade complete.
41 **Santa Maria del Mar** Important Gothic church, built 1230–1370, probably work of J Fabré. Particularly noteworthy is s façade with statues of St Peter and St Paul under 2 canopies; on door bronze figures of 2 porters. Interior: fine 15th c stained glass windows by Desmames of Avignon.
42 **Museo Arqueológico** Important collection of prehistoric, Iberian, Greek, Roman and Visigothic periods.
43 **Museo de Arte de Cataluña** Priceless collection of religious paintings from 11th to 15th c including Borrassa, L Dalmau, J Huguet etc.

Romanesque frescoes from Pyrenean churches: *Pantocrator* from San Clemente, Tahull. Paintings by El Greco, Tintoretto, Velasquez.
44 **Museo de Arte Moderno** Paintings and sculpture from 19th c: Rodin *The Bronze Age;* works by M Fortuny. Outstanding contemporary Spanish artists include Picasso, Dali etc. Some foreign works.
45 **Museo de Artes Decorativas** Good collection of applied arts all periods.
46 **Museo Diocesano** Polychrome sculpture of all periods; reredoses including those by L Borrassa, the Serra brothers, J Huguet etc.
47 **Museo Federico Marés** 12th to 17th c woodcarvings; religious sculpture; unique collection of religious objects.
48 **Lonja** (exchange) Built 1392, altered 1763, large hall in Gothic style.
BELMONTE, Cuenca
49 **Castle** Built by Marquis of Villena in 1456; has crenellated wall surrounding keep; a triangular tower; chamber with Mudéjar timbering; richly sculptured windows.
BERLANGA DE DUERO, Soria
50 **San Baudilio** 11th c Mozarabic church with 12th c frescoes of hunting scenes.
BILBAO, Vizcaya
51 **Cathedral** Formerly church of Santiago, reconstructed 1404, portal designed by M Garita in 1581.
52 **Museo Arqueológico y Etnográfico** Roman inscriptions; prehistoric ceramics.
53 **Museo de Bellas Artes y de Arte Moderno** Paintings of Florentine, Italian, Dutch and Spanish schools; sculpture; modern art (19th c and 20th c Spanish paintings and sculptures).
BURGOS, Burgos
54 **Cathedral** Built after 1221 on site of earlier Romanesque church, principal architect of this stage Master Enrique, subsequent additions of several chapels modified structure. Main façade had 13th c sculpture, rose window and 2 towers with spires by J de Colonia; 13th c Puerta de la Coronería has Gothic statues; Plateresque Puerta de la Pellegería by F de Colonia. Of particular note is the Constable's Chapel by S de Colonia; *reja* by Andino; octagonal stellar vault; armorial escutcheons on walls; main altarpiece by F Vigarny and D de Siloe; in centre is the tomb of the Constable and his wife.
55 **Abbey of Miraflores** Church finished 1488 by S de Colonia contains tomb of Juan II and Isabel of Portugal and that of Infante Alfonso, both by G de Siloe who also worked on high altarpiece. Choir stalls by M Sanchez (1486); *Annunciation* by P Berruguete.
56 **Convent of Las Huelgas** Built by King Alfonso VIII and was a summer residence of the kings of Castile, converted into a Cistercian convent. Cloisters pure Romanesque style; church Gothic. Contains numerous royal tombs (13th to 15th c); Gobelins tapestries. Museum: unique collection of textiles and clothing from 12th to 14th c.
57 **Museo Arqueológico Provincial** (In Casa de Miranda 1545) Roman sculpture mainly from ancient Clunia and Lara; Visigothic and Mozarabic objects; tombs; Moorish ivories; Gothic and Renaissance sculpture and painting.
CACERES, Cáceres
58 **Cathedral** Built in Gothic style 15th to 16th c. Main altarpiece by sculptors Ferrán and Balduc (1551).
59 **Santiago** Built 1554–56 by Gil de Hontañón. Contains Plateresque *reja* by F Núñez.
60 **Museo Provincial de Bellas Artes** Iberian and Roman remains; 17th c paintings.
CADIZ, Cádiz
61 **Cathedral** Begun 1720 after plans by V Acero, finished 1838.
62 **Chapel of San Felipe de Neri** Built 1679 on elliptical plan. Contains Murillo *Immaculate Conception;* C de Torres *Eternal Father;* P Roldan, head of St John in terra-cotta.
63 **Chapel of Santa Catalina** Paintings by Murillo on high altar; wood carving by Salzillo.
64 **San Cueva** Constructed to an elliptical plan by Benjumeda at end of 18th c. Cupola painted

by Cavallini on arches decorated by Goya.

65 **Museo Arqueológico Provincial** Remains of Phoenician necropolis of Cádiz; anthropoid sarcophagus in Greco-Phoenician style; jewellery; Roman statues; vases in Greco-Italian style; Visigothic objects.

66 **Museo de Bellas Artes** Paintings by Murillo, Rubens, Jordaens, Lucas van der Leyden; Flemish triptychs of the school of Memling; a series of paintings by Zurbarán from the Cartuja of Jerez.

CALATRAVA LA NUEVA, Cuidad Real
67 **Castle** Massive 12th C building of order of Calatrava. Contains church showing Cistercian, Castilian and Mudéjar influences.

CALATAYUD, Saragossa
68 **San Pedro Mártir** Mudéjar style, fine Gothic main entrance.

69 **Santa María la Mayor** Old mosque, enlarged 1120 by Alfonso the Warrior. Plateresque entrance by E Obray and J de Talavera.

CARDONA, Barcelona
70 **Castle** Encloses Romanesque church of San Vicente built 1040 in Lombard style.

CARAVACA, Murcia
71 **Santa Cruz** Built 1617 imitation of the Escorial. Paintings, textiles etc.

CARMONA, Seville
72 **Santa María** Late Gothic, fine Moorish patio. Altarpiece by N Ortega and J B Vázquez the Elder (1559–65).

73 **Museo de la Necropolis** Objects from the huge Roman necropolis (2nd C BC–4th C) outside the town.

CARTAGENA, Murcia
74 **Cathedral** Built 13th C, now restored. In crypt, Roman column and mosaic.

75 **Museo Arqueológico Municipal** Roman sculpture, some Iberian objects.

CASTELLO DE AMPURIAS, Gerona
76 **Church** 14th C with square crenellated tower; 15th C portal of sculptured marble by Antigoni. Gothic reredos of sculptured alabaster (1485) by V Borrás.

CASTELLON DE LA PLANA, Castellón
77 **Museo Provincial de Bellas Artes** Medieval Valencian panel paintings; 14th C heraldic shields; archaeology; ceramics.

CELANOVA, Orense
78 **Monastery of San Salvador** Built 16th to 18th C. Baroque façade 1755. Church dates from 1681, has sculptured, painted and gilded reredos; Baroque *coro* with woodwork in Flamboyant Gothic style.

CERVERA, Lérida
79 **Santa María** Romanesque-Gothic style, octagonal bell-tower. Carved tombs in chapels; 13th C statue.

80 **Ayuntamiento** By F Puig 1677, enlarged 18th C; fine façades (1679), balconies supported by corbels formed of curious sculptured figures.

81 **Museo Comarcal** Gothic panel paintings

CIUDAD REAL, Ciudad Real
82 **Cathedral** Built 16th C in Gothic style, retains 12th C. W door from older building surmounted by rose window.

CIUDAD RODRIGO, Salamanca
83 **Cathedral** Begun 1145, completed 14th C, restored 1568. Fine W portal (Puerta de la Virgen) has sculptures of 13th C; Romanesque Puerta de las Amajuelas has sculptured tympanum; tower dates from 1765. Interior: foliated arches of Mudéjar influence; Capilla Mayor with stellar vaulting. Cloister showing every variation of Gothic style.

COCA, Segovia
84 **Castle** Built c. 1400 by Moorish architects for Alonso de Fonseca. Church contains tomb of Juan de Fonseca by B Ordóñez.

COGOLLUDO, Guadalajara
85 **Palacio de Medinaceli** One of the oldest Renaissance palaces in Spain (1492–95), some Gothic details.

CORDOBA, Córdoba
86 **Cathedral** (former Great Mosque) Begun by Abd-al-Rahman II (822–52) Hakam II and al-Mansur (10th C). Converted into cathedral in 13th C and altered after 1523. Various doorways of Moorish, Mudéjar and other styles; within

wall is Patio de los Naranjos; tower encloses original minaret of mosque. Interior consists of 19 aisles separated by horseshoe and semi-circular arches over columns with Roman, Visigothic and Moorish capitals; *mihrab* intricately decorated with stucco-work and mosaics.

87 **El Carmen Calzado** (monastery) 16th C church in Mudéjar style, has fine coffered ceiling and choir supported by columns of wrought iron; reredos painted by V Leal (1658).

88 **San Lorenzo** Romano-Gothic style, remodelled in 1687, with tower of 1555; main portal with 14th C porch and magnificent rose window. Fine coffered ceiling and mural paintings of 15th C.

89 **San Miguel** Built by St Ferdinand (13th C), remodelled 1749; fine Mudéjar portal.

90 **San Pablo** Romanesque Transitional style; double-arched cupola with superimposed stars inspired by Arabian models; Mudéjar ceiling of 1537; arched apses with triple nave; N portal with columns and Arab capitals.

91 **Museo Arqueológico Provincial** (In the Renaissance Palacio de Don Jerónimo Páez) Iberian, Roman, Visigothic and Moslem collections.

92 **Museo Provincial de Bellas Artes** Paintings by V Leal, Zurbarán, de Céspedes, Carreño, A Cano, Murillo, Goya; Flemish works of 15th to 16th C; sculptures by Inurria.

93 **Roman Bridge** 262 yds long, attributed to Octavius Augustus, rebuilt by the Moors and restored several times.

CORIA, Cáceres
94 **Cathedral** Gothic with Renaissance additions. Nave one of the highest in Spain; reredos by J de Gan Felix (1749); remarkable tombs by Copin and J Francés.

CORUNNA, Coruña
95 **Museo Provincial de Bellas Artes** Archaeology; ceramics of Sargadelos; paintings.

COVARRUBIAS, Burgos
96 **Museo Parroquial** Embroidered vestments; goldwork; a Flemish triptych.

CUELLAR, Segovia
97 **San Esteban** Romanesque church, brick apse with 2 blind arcades.

98 **Castle** Late 15th C, built by B de la Cueva in Gothic-Mudéjar style; transformed into a palace from 16th to 18th C.

CUENCA, Cuenca
99 **Cathedral** Built 1197–1207 by Alfonso VII. Capilla Mayor contains large altarpiece by V Rodriguez. Doors to chapter house by A Berruguete. Treasury contains 14th C Byzantine reliquary, numerous pieces of goldwork, Gothic panels by J de Borgoña and M Gomez, 2 paintings by El Greco.

100 **Museo Municipal de Arte** Painted altarpieces by J van Eyck, G David, J de Borgoña; paintings by El Greco and Caravaggio. Sculpture includes a Romanesque Calvary and pieces by J de Mena, S Carmona etc.

DAROCA, Saragossa
101 **Museo de Santissimo Sacramento** (In 16th C Collegiate Church of Santa María) Reliquary by P Moragues; altarpiece by M Bernat; panel paintings by B Bermejo; Gothic sculpture, goldwork.

EL BURGO DE OSMA, Soria
102 **Cathedral** Begun 1232 replacing early Romanesque church of 12th C. 13th C main portal has Gothic statuary derived from the Burgos group; tower constructed by J Sagarvinarga after plans by D Ondátegui 1742. Main altarpiece 1551–54 carved by J Picardo from designs of J de Juni; *reja* of Capilla Mayor and *coro* by J Francés; several Gothic-Castilian panel paintings.
Museo Biblioteca Catedralico: Beatus Apocalypse of 1086, goldwork, Hispano-Moorish textiles.

ELCHE, Alicante
103 **Santa María** Built 1673–1767, modelled on San Nicolás de Bari in Alicante.

104 **Museo Municipal** Prehistoric, Hellenistic, Iberian and Roman collections.

ESCATRON, Saragossa
105 **Abbey of Rueda del Ebro** Founded by

Alfonso II of Aragon in 1182. 13th C church; cloister with groin vaulting; small octagonal pavilion; chapter house and dormitories.

SAN LORENZO DEL ESCORIAL, Madrid
106 **The Escorial** Begun 1584 by J Bautista, completed by J de Herrera. Architectural complex consisting of church flanked by palace and cloister, preceded by a patio on which college and monastery open. Church has square basilica with dome over transept and raised choir and presbytery; vaults of nave ornamented with 8 frescoes by L Giordano. Capilla Mayor contains altarpiece with sculpture by P Leoni (1597) and paintings by F Zuccaro and P Tibaldi; bronze tombs of Carlos and Philip II by Leoni; *trascoro* has a Christ by Cellini (1562). Panteón de los Reyes contains paintings by C Coello, El Greco, Veronese, Titian, Tintoretto. In chapter room: paintings by Bosch, Rubens, Velasquez, Ribera, Veronese, Titian, El Greco, R van der Weyden and A Cano. Library with collection of illuminated MSS.

ESTANY, Barcelona
107 **Santa Maria del Estany** (abbey) Consecrated 1133, Romanesque-Gothic church of great artistic interest; contains 14th C alabaster Virgin and Child. Romanesque cloister with historiated capitals.

ESTELLA, Navarre
108 **San Miguel** One of the most interesting Romanesque churches in Spain, fine portal with sculptured tympanum; 12th C doors with iron fittings; 14th C reredos triptych painted on stucco-work, many tombs.

109 **San Pedro de la Rua** Fine Romanesque façade in Poitiers style.

110 **Palace of the Dukes of Granada** (now law courts). Remarkable Romanesque building of 12th C.

FABARA, Saragossa
111 **Roman Mausoleum** Probably late 2nd C, built in form of temple.

FIGUERAS, Gerona
112 **Castillo de San Fernando** Built 1743, pentagonal, designed by Cermeno in style of Vauban.

FRAGA, Huesca
113 **San Pedro** Romanesque, with late 15th C Gothic arch; tower of 3 storeys.

114 **Villa Fortunatus** Remains of Roman villa with mosaics of 2nd C.

FROMISTA, Palencia
115 **San Martín** Important Romanesque church, built 1035–66.

FUENTERRABIA, Guipúzcoa
116 **Santa María** Originally Gothic, rebuilt in 16th C Renaissance style.

117 **Royal Palace** Rebuilt by the Catholic Kings, finished by Charles V.

GANDIA, Valencia
118 **Palace of the Dukes of Gandia** Built 16th to 18th C. Patio has windows set with small marble columns; fine stairway with ducal coats-of-arms; magnificently decorated apartments.

GERONA, Gerona
119 **Cathedral** Gothic, begun 1316 by Henry of Narbonne on site of former 11th C building, retains Romanesque elements ('Torre de Carlomagno' and cloister with historiated capitals). 15th C S portal with statues of the Apostles (only 2 remain); Baroque façade with grand stairway, remodelled in 18th C. Aisleless nave is widest in European Gothic architecture. Capilla Mayor has 11th C Romanesque altar table, silver altarpiece by Master Bartolomeu (1320); 14th C silver canopy; 14th C stained glass windows. **Museo Catedrálico:** Tapestry of the Creation (11th C); embroidered frontals; Beatus Manuscript 975; 10th C Moorish silver casket of Córdoban workmanship; Gothic paintings; Romanesque and Gothic sculptures.

120 **San Feliú** Built 1215–1318. Octagonal tower surmounted by truncated spire; principal façade Greco-Roman in style (17th C). Contains 8 sarcophagi, 2 Roman, others of 4th C; tomb of St Narciso by J de Tournai (1328); alabaster Dead Christ (15th C).

121 **San Pedro de Galligans** Romanesque, probably 10th C; attractive doorway; cradle

vaulting; curious capitals; 12th C cloister.

122 **Arab Baths** (In former monastery of San Domingo) Rebuilt *c.* 1295 on Moslem designs.

123 **Museo Diocesano** Reredoses, goldwork, ceramics from Ampurias, modern paintings, drawings by Goya.

GORMAZ, Soria

124 **Castle** Built 965 with some additions in 13th and 14th C. Walls constructed in a Moorish manner reinforced with square towers.

GRAJAL DE CAMPOS, León

125 **Castle** First castle in Spain to be built with defences against artillery (15th C). Crenellated and flanked by round towers at each corner.

126 **Palace** Fine patio and staircase in style of Alcalá de Henares Palace.

GRANADA, Granada

127 **Cathedral** Begun in Gothic style (apse) by E de Egas, continued in Renaissance style by D Siloe, finished 1703; façade by A Cano (1667). Circular Capilla Mayor has sculpture by A Cano and marble pulpits by F Hurtado (1713). Capilla Real in florid Gothic style built by E de Egas as the pantheon to Ferdinand and Isabella, contains their tomb by Fancelli; *reja* by Master Bartolomé of Jaén; main altarpiece by F Vigarny. **Museo de la Capilla Real:** canvases by R van der Weyden; H Memling; D Bouts; Botticelli; P Berruguete.

128 **Charterhouse** Founded 1516, all that now remains is church, sacristy, cloister. Church, completed by C de Vilches in 17th C, is a fine example of Churrigueresque style with black marble portal by J Hermoso.

129 **Colegiata** 16th C Renaissance church with fine portal decorated with statues of the patron saints. Gilded reredos with carvings; statues by A Cano; paintings and sculpture by school of Granada.

130 **San Domingo** Built 1532 with superb, Gothic-ribbed nave. Contains tabernacle made of precious marble (1699); Churrigueresque reredoses; paintings and sculptures of Granada school.

131 **San Juan de los Reyes** Gothic, built by R Fernández after 1520, badly disfigured in 19th C. Has 13th C tower, a relic of Arab architecture.

132 **Santa Ana** Built 1537–63 in Renaissance style to plans by D Siloe; elegant façade and square belfry. Churrigueresque reredos; coffered ceiling; paintings by J Mora; paintings and sculpture by school of Granada.

133 **Alcazaba** Moorish fortress from 11th C, but remaining walls and towers 13th C.

134 **Alhambra** Royal residences of the Nasrid rulers. Complex is arranged round 2 large courts (Court of the Myrtles, Court of the Lions), former has porticoes on its short side and 2 fountains in centre and is connected with the Hall of the Ambassadors (occupying whole Torre de Comares) which has profuse and refined decoration. Lion Court, begun 1377, surrounded by an arcade supported by white marble columns with stalactite capitals; in centre fountain with 12 lions. Hall of the Two Sisters has roof decorated with stalactites; Hall of the Kings has vaulted roof with paintings.

135 **Casa de los Tiros** Building in Mudéjar style, dating from *c.* 1530–40.

136 **Casa del Chapiz** Built at the beginning of the 16th C, curious blend of Christian and Arab features.

137 **The Generalife** Country residence of the sultans of Granada. Made up of several distinct edifices, very simple in style; decorated in 1319 under Abu Walid. Has undergone many alterations; decoration sadly deteriorated.

138 **Palace of Charles V** Built 16th C, designed by P Machuca in Italian Renaissance style; circular courtyard. Houses **Museo Provincial de Bellas Artes:** sculpture and paintings of the Andalusian school.

LA GRANJA (San Ildefonso), Segovia

139 **Royal Palace** Begun by T Ardemans (4-towered *alcázar* design) 1721, continued A Procaccini and S Subisati. Park with French-style sculptures and fountains designed by R Carlier. Palace Chapel has painted ceilings by

Bayeu, high altar by T Ardemans. Sumptuous furnished rooms; tapestries, Flemish, French and Spanish.

GUADALAJARA, Guadalajara

140 **Santa María de la Fuente** 13th C brick Mudéjar tower, horse-shoe doorways and a portico on columns with Plateresque capitals.

141 **Palacio del Infantado** Plateresque palace begun 1461. Façade intact though interior much damaged.

GUADALUPE, Cáceres

142 **Monastery of the Hieronymites** Founded by Alfonso XI in 1340. Mudéjar with Gothic, Renaissance and Baroque elements. Gothic church (1510–14) has hammered bronze doors, Capilla Mayor has outstanding *reja* by F de Salamanca and J de Avila (1510–14); main altarpiece by G de Marlo and others; bronze baptismal font by J Francés (1402) In sacristy: Zurbarán *St Jerome* series.

GUADIX, Granada

143 **Cathedral** Influenced by that in Granada, begun by D de Siloe in 1549, completed 1796.

HUELVA, Huelva

144 **Museo Arqueológico Provincial** Prehistoric and Roman exhibits.

HUESCA, Huesca

145 **Cathedral** Originally main mosque, consecrated as cathedral in 1097, rebuilt 1497–1515 to plans by J de Olázaga, main portal has statuary of 14th C. Windows with ornate tracery by F de Valdeviesco (1516–18); alabaster main altarpiece by D Forment (1520–33); choir stalls by N de Berastegui 1587. **Museo Catedrálico:** murals from San Fructuoso de Biergo (13th C); altarpiece *Coronation of the Virgin* by the painter P Zuera (15th C); reredoses; sculpture; goldwork; Roman sarcophagus.

146 **Museo Provincial** Prehistoric and Roman collections; Early Christian mosaics; Romanesque capitals; medieval and Renaissance paintings.

IBIZA

147 **Cathedral** Built 13th C on site of a mosque, restored 18th C. Tower, apse and a few subsidiary structures are all that remain of the Gothic edifice.

148 **Museo Arqueológico** Masks, small statues, terra-cotta busts from the Carthaginian necropolis of the Puig d'es Molins, glasswork; Phoenician jars; jewellery; coins etc.

149 **Museo Etnográfico** Objects of Carthaginian origin.

ILLESCAS, Toledo

150 **Santa María de la Asunción** 13th C apse; 14th C Mudéjar tower; Plateresque portal; Gothic nave with stellar vaulting.

151 **Hospital de la Carídad** Chapel contains 5 canvases by El Greco.

ITALICA (near Santiponce), Seville

152 Ruins of Roman city of this name founded by Scipio Africanus in 206 BC. Several houses with mosaics.

JACA, Huesca

153 **Cathedral** Apparently begun 1076, of original structure preserves outside walls, main portal with fine sculpture, cloister vault of Moslem style.

154 **Citadel** Begun by Philip II in 1571, finished by Philip III.

JAEN, Jaén

155 **Cathedral** Begun end of 15th C on site of ancient mosque, continued by A de Vandelvira from 1548, finished 1691 with a façade by E L de Rojas.

156 **San Andres** Mudéjar church with fine *reja* by Master Bartolomé.

JATIVA, Valencia

157 **Hermitage of San Félix** Small Mozarabic church with Romanesque portal; Gothic interior contains 15th C Valencian painted altarpieces.

158 **Museo Municipal** (Housed in former 16th C wheat exchange) Moorish architectural elements from the Palacio de Pinohermoso; paintings 16th to 20th C.

JEREZ DE LA FRONTERA, Cádiz

159 **Charterhouse** Founded towards the end of the 15th C, in ruins from 1835–1949, now restored. Of note are main portal by A de Ribera

(1571); Gothic church with Baroque façade; Gothic cloister; Renaissance portal of refectory.

160 **San Dionisio** Built in Gothic-Moorish style during 13th C; minaret.

161 **San Miguel** Built 1482 in Gothic style, façade in 2 sections in Greco-Roman style decorated with fine *azulejos*.

162 **San Salvador** Some Gothic details from 13th C construction; completed 1750 under direction of T Cayon de la Vega. Heavily carved Churrigueresque façade; separate bell tower partly Gothic-Moorish in style. Good stained glass windows; *Christ* by J de Arcos.

163 **Alcázar** Large square 11th C building with 2 towers. Inside, chapel from the Arabian era; Arabian baths; Renaissance palace with a silk tapestry from the early 19th C.

164 **Casa del Cabildo Vieja** Former town hall, built 16th C by A de Ribera; Plateresque façade of Corinthian columns ornamented with statues and a delicately carved frieze; high portico with triple arcade. Houses **Colección Arqueológico Municipal:** Roman remains etc.

LA LAGUNA, Tenerife, Canaries

165 **Cathedral** Façade (1819) modelled on that in Pamplona. Treasury contains goldwork.

166 **La Concepción** 16th C with Mudéjar elements; Baroque choir and lecterns; fine Portuguese-style *artesonados*.

167 **Episcopal Palace** 18th C, emblazoned façade; wrought iron railings; patio.

LA OROTAVIA, Tenerife, Canaries

168 **La Concepción** By A de Llaneria 1768, Baroque façade; Neoclassic statuary designed by V Rodriguez.

LA PILETA, Málaga

169 **Caves** Prehistoric art: figures and animals mainly in black outline.

LAS PALMAS, Gran Canaria, Canaries

170 **Cathedral** 1497–1570 designed by D A Montaude, restored 1781 and 1820, Neoclassic façade of that epoch. Gothic interior is stellar-vaulted.

171 **Museo Canario** Archaeological collections

LEBENA, Santander

172 **Santa María** Mozarabic church (*c.* 930), exterior decorated with floral designs.

LEON, León

173 **Cathedral** Superb example of Gothic architecture (13th to 15th C) built under direction of Master Enrique and J Perez. w façade has 5 Gothic arches embellished with sculptures; 3 doors; San Juan de Regla with Nativity etc; Nuestra Señora de Blanca, Resurrection; San Francisco, bas-reliefs of Sleep of the Virgin. Interior: exceptional stained glass 13th to 16th C; J de Balmaseda *Calvary* (1522); 13th C tombs; altarpiece with paintings by N Francés; silver custodial of St Froilan by E de Arfe (1519).

174 **San Isidoro el Real** Romanesque, founded 11th C by Ferdinand I, enlarged 12th C, mausoleum of early Spanish kings. 2 Romanesque portals on s side; Interior: lavishly sculptured Romanesque capitals; 11th C baptismal font. Panteón de los Reyes (11th C): tombs of 11 kings, 12 queens, 21 princes; treasure includes 11th C agate chalice, 16th C processional cross.

175 **Museo Arquelógico Provincial** (In Convent of San Marcos) Roman pottery, coins etc, altar of Trajan epoch. Sculpture museum includes 11th C ivory Christ; 13th C sarcophagus; E Jordán *Praying statue of Bishop Quiñones de León;* Mozarabic cross of Peñalba.

LERIDA, Lérida

176 **Catedral Nueva** Built 1764–90, designed by P Cermeno, Neoclassic style. Façade, preceded by a double flight of steps, opens into 3 arcades and is embellished with pilasters and balustrades.

177 **Seo Antigua** (Old Cathedral) Begun 1203 under the direction of P Coma and P de Pennafreita. Gothic cloister; octagonal steeple finished by C Galtes 1416; Romanesque Puerta de los Anunciata and Puerta de los Infantes; Gothic Puerta de los Apostoles. Interior: unusual capitals on pillars, with clusters of 16 small columns, fine example of Romano-Gothic ornamentation.

178 **Ayuntiamento** (**town hall**) Built 13th C,

has fine façade. Contains a 14th c illuminated codex and an altarpiece by J Ferrer c. 1440.

179 **Castillo de Gardeny** Former command post of the Knights Templars, 12th or 13th c.

180 **Hospital de Santa María** Formerly 15th c convent, has Gothic figure of the Virgin on portal; Gothic gallery; fine stairway in Catalan style. Houses **Museo del Instituto de Estudios Ilerdenses:** archaeological collection.

181 **Museo del Seminario** Romanesque and Gothic paintings; fine library with collection of 15th c books.

LERMA, Burgos

182 **Collegiate church** Finished 1617, contains tomb of Archbishop Cristobal de Rojas with a bronze kneeling statue, planned by J de Arfe.

LOARRE, Huesca

183 **Castillo Carreres** Important Romanesque fortification, double girding walls with cylindrical towers and 2 gates. Romanesque church has good sculptured capitals.

LOGRONO, Logroño

184 **Museo de Arte** Paintings, including El Greco *St Francis*, 2 canvases by V Carducho.

LUGO, Lugo

185 **Cathedral** Begun 1129. Of note are 16th c Torre Vieja; N portal with Romanesque Christ in Majesty on tympanum; austere façade built 1769–83 from plans by J Sanchez Bort.

186 **Museo Provincial** Several collections: prehistoric; Iberian; Roman; medieval sculpture; paintings from 15th c; Galician ironwork; goldwork; ceramics from Sargadelos.

MADRID, Madrid

187 **Ermita de San Antonio de la Florida** Formerly chapel built 1792–98, now contains **Panteón Museo de Goya.** Cupola frescoes by Goya, *St Anthony preaching* and *Miracles of St Anthony.*

188 **San Francisco el Grande** Built 1776–85 by F Sabatini on site of former chapel. Huge circular building, interior Doric style with Corinthian capitals. Above altar, Goya *St Bernardino preaching.* Cloister contains works by Pacheco, Herrera, A Cano.

189 **El Pardo** Royal residence since Middle Ages; reconstructed 1604 after fire and enlarged by F Sabatini (18th c). Square plan with towers at corners and inner court. Outstanding collection of Flemish and Spanish tapestries 16th to 18th c, rich art collection. Paintings include works by Bayeu, J de Mora, F Gonzales Velasquez. Ceilings by Bayeu and Ribera. Church by F Carlier.

190 **Instituto de Valencia de Don Juan** Portraits; Goya *Dancing Majos;* Persian and Moorish carpets; medieval fabrics and church ornaments. Unique collection of ceramics.

191 **Museo Arqueológico Nacional** Prehistoric antiquities including copies of the paintings at Altamira etc. Egyptian and oriental works; Iberian art including Bronze Age jewels, La Aliseda treasure, Javea Treasure; Greek, Etruscan and Roman bronzes and ceramics; Christian art; Hispano-Moresque antiquities; medieval painting, sculpture and metalwork; earthenware and porcelain from all countries; sculpture and objets d'art from China, Japan, India, Persia.

192 **Museo de Arte Contemporáneo** Modern paintings and sculpture mainly Spanish; foreign artists represented by J Gris, Mestrovic, H Moore; small room devoted to French paintings.

193 **Museo del Duque de Alba** Paintings by Fra Angelico; Titian; Ribera; El Greco; Rembrandt; Rubens; Goya.

194 **Museo Etnológico y Antropológico** Prehistoric objects and ethnographic collections.

195 **Museo Lazaro Galdiano** Spanish and Flemish primitives; paintings by El Greco, Velazquez, Goya, Zurbarán, Cano, A Coello, Rembrandt, Hobbema, Tiepolo, Gainsborough, Constable; sculpture; ivories, enamels, jewels.

196 **Museo Municipal** Tapestry room with cartoons by Bayeu and Castillo; porcelain from the Retiro; Goya *Portrait of Charles II.* Plans for the Prado by Villanueva.

197 **Museo Nacional de Arte Moderno** Portraits by Goya; genre paintings; some foreign

works; contemporary Spanish school.

198 **Prado** Building begun 1785 by J de Villanueva, completed 1819–30. Flemish and German primitives: J Gossaert, *Virgin and Child;* G David, *Crowned Virgin;* Met de Bles, triptych *Adoration of the Three Wise Men;* R van der Weyden triptych; Q Metsys, *The Saviour;* Memling triptych; Master of Flémalle *St Barbara, St John the Baptist and Donor;* Van Eyck (?) *The Fountain of Life;* Bosch *The Creation, Adoration of the Three Wise Men;* works by Cranach. Italian school: works by Perugino; Correggio *Noli Me Tangere;* A del Sarto; Fra Angelico *Annunciation;* Mantegna *Death of the Virgin;* Bellini; Raphael *Portrait of a Cardinal, Holy Family with the Lamb;* Tintoretto *Purification of the Medianite Virgins etc;* important series of works by Titian including *Equestrian Portrait of Charles V;* Veronese *Venus and Adonis* etc. Spanish school: origins of Spanish painting represented by frescoes from Maderuelo; Sevillian, Aragonian and Catalan reredoses. Paintings by Berruguete; F Gallego; Macip; J Sanchez-Coello; Ribera; A Cano; V Leal; Murillo; Zurbarán; important series of works by Velazquez (including *Las Meninas*) and Goya. French school: works by Poussin; Claude; Watteau; Boucher *Venus's Toilet;* portraits by Rigaud; Largilliere etc. Flemish school: works by Van Eyck; series of very important works by Rubens *Adoration of the Three Wise Men, The Garden of Love;* Jordaens *Mystic Marriage of St Catherine.* Dutch and German schools: Rembrandt *Portrait of the Artist;* Dürer *Self Portrait;* works by Hobbema. Sculpture: famous Iberian statue *La Dama de Elche* (5th c BC); Greek statues. Dauphin's Treasury: gold and crystal works by French and Italian craftsmen (16th to 17th c).

199 **Museo Romántico** Paintings from 1808 to 1860; Goya room; portraits of Spanish royal family; furniture; ceramics; dressing room of Ferdinand VII with Bohemian crystals, miniatures and jewels.

200 **Museo Sorolla** Works by this artist.

201 **Royal Palace** Begun 1738 by G B Sacchetti; decorated by C Giaquinto 1735–61 and later by R Mengs and Tiepolo. Noteworthy rooms are Salon del Trono, Salon de Gasparini (1765), Sala de Porcelano (c. 1770). A magnificent collection of tapestries and paintings. Chapel (1749–57) situated in N wing is surmounted by a dome which rises above palace; vault of dome decorated by a painting of the *Blessed Trinity* by C Giaquinto; on the high altar is an *Annunciation* by Mengs. Treasury contains a reliquary with groups sculptured by P Berruguete.

MAHON, Minorca

202 **Museo de Bellas Artes** Coin collection; prehistory; archaeology; ceramics; important section of small Aztec statuettes; engravings; paintings.

MALAGA, Málaga

203 **Cathedral** Begun 1528, finished 18th c, with the intervention of D de Siloe and A de Vandelvira in the 16th c, Jose de Bada (1722) and Antonio Ramos (1755). Interior: choir stalls by P de Mena; 16th c altarpiece of Santa Barbara; altarpiece by J de Villanueva; paintings and sculptures from 16th and 17th c.

204 **Alcazaba** Old fortress going back to Roman times, reconstructed by the Arabs in the 9th c in stone and cement with square towers.

205 **Castillo de Gibralfaro** Fortress of Phoenician origin, reconstructed by King Nazari Yusuf I in the 14th c. Old mosque with naves and semicircular vaults.

206 **Museo Provincial de Bellas Artes** Paintings by El Greco; Zurbarán; A del Castillo; G Reni; modern paintings; ceramics; illuminated MSS etc.

MANACOR, Majorca

207 **Museo Arqueológico** Prehistoric collection; Early Christian art from the Basilica of San Peretó including a 5th c mosaic by Baleria.

MANRESA, Barcelona

208 **Santa María de la Seo** Present building begun 1328, fragments of original Romanesque edifice (1020) survive.

209 **Museo de la Colegiata** Several fine altar-

pieces; 12th c Romanesque crucifix; embroidered altar frontal; Borrassá *Holy Entombment.*

210 **Museo Municipal** Archaeological collection; Catalan ceramics of 12th to 14th c.

MARTORELL, Barcelona

211 **Casa-Museo Santa Cana** Archaeology; ceramics; furnishings; 19th c Catalan drawings.

212 **Museo Municipal** Iberian, Roman and prehistoric exhibits; Manresa ceramics 13th c to 15th c; some modern paintings.

MEDINACELI, Soria

213 **Triumphal Arch** Three-spanned Roman arch built in 2nd or 3rd c. The only one of its kind in Spain.

MEDINA-AZ-ZAHARA, Córdoba

214 Remains of a palace begun by Abd-al-Rahman III in 936, continued by al-Hakam II, abandoned in 1011. Complex of buildings arranged in terraces. Excavations have permitted restoration of 2 pavilions and several halls.

MEDINA DE RIOSECO, Valladolid

215 **Santa María de Mediavilla** Built 15th to 16th c on basilica plan. Octagonal Capilla Mayor with altarpiece by J de Juni and E Jordán (1585). Treasury: custodial by J de Arfe; parish cross of rock crystal and gilded silver by P Leoni.

216 **Santiago** Built 16th to 17th c. Remarkable for series of styles, Plateresque, Renaissance, Baroque. Renaissance façade designed by Gil de Hontañón.

MEDINA DEL CAMPO, Valladolid

217 **La Mota** Fortress built 1440 by Fernando Carreño for John II. Interesting example of military architecture. Now mainly in ruins.

MERIDA, Badajoz

218 **Museo** Roman remains; sculptures Mérida style; mosaics.

219 **Roman Bridge** Probably dates from 95 BC; has 60 arches formed of granite blocks.

220 **Roman Theatre** One of the most beautiful ancient monuments in Spain. Built by Agrippa in 18 BC, of particular note are the statues.

LOS MILLARES, Almeria

221 Remains of a prehistoric settlement.

MONFORTE DE LEMOS, Lugo

222 **Colegio del Cardenal** Designed by A Ruiz (1592). Church in centre finished by S de Monasterio 1608–19 contains 5 paintings by A del Sarto; 2 by El Greco; a bronze kneeling statue of the founder by Giambologna (1598).

MONTE CASTILLO, Santander

223 **Caves** A group of 4 caves (La Pasiega, El Castillo, Las Chimeneas, Las Monedas) all with paintings.

MONTERREDAMO, Orense

224 **Castle** Possibly the most important castle in Galicia, in existence by the 13th c. In addition to the fortifications and the Torre de Homenaje, it contains a hospital of the 14th c; a Gothic church and buildings of the 16th c.

MONTSERRAT, Barcelona

225 **Monastery** Founded 11th c by Abbot Oliba of Ripoll. Romanesque portal and remains of Gothic cloister preserved. Contains works by F J Ricci, Caravaggio, El Greco, P Berruguete, L Morales. 19th c church contains Romanesque statue of Black Virgin (12th c).

MORELLA, Castellón

226 **Santa María la Mayor** Gothic, built 1273–1310. Capilla Mayor magnificent Churrigueresque ensemble.

MURCIA, Murcia

227 **Cathedral** Present building begun 1394. Puerta de los Apóstoles dates from c. 1440; Puerta de las Cadenas ascribed to F Torni; tower, begun by him in 1521, continued by J Torni in 16th c; fine Baroque façade designed by J Bort Miliá.

228 **Museo Arqueológico** Iberian, Roman, Visigothic collections.

229 **Museo Diocesano** Roman sarcophagus; Gothic sculpture; altarpiece by de Modena (14th c); paintings by F Llanos (16th c); sculpture by Salzillo.

230 **Museo Provincial de Bellas Artes** Panel paintings and canvases (16t to 17th c) by the Murcian school.

231 **Museo Salzillo** Works by this sculptor.

NUEVALOS, Saragossa

232 **Abbey of Piedra** Founded by Alfonso II in 1164, on characteristic Cistercian plan; some later additions.

NUMANTIA, near Soria

233 Ancient Celtic and Iberian cities destroyed by the Romans in 133 BC.

OLITE, Navarre

234 **Santa María la Real** 13th c church with sumptuous Gothic portal of 14th c.

235 **Palace of the Kings of Navarre** Fine example of civil architecture from 12th to 15th c. In ruins, now being restored; old defensive walls well preserved.

OLIVA (LA), Navarre

236 **Oliva Monastery** Cradle of the Cistercian order in Spain, built 1164–98. Church finished 1198; 14th c Gothic cloister.

OLMEDO, Valladolid

237 **La Mejorada** (monastery) Chapel built 15th c, square in plan. Mudéjar dome; tombs decorated with Gothic-Mudéjar plasterwork.

OLOT, Gerona

238 **Museo de Bellas Artes** Archaeological collection including coins; sculptures.

239 **Museo de Arte Moderno** Works by Catalan artists including Rusinol, Amadeu, etc.

ONA, Burgos

240 **San Salvador** Abbey founded by Sancho the Great in 1011. Church (13th to 16th c) contains 15th c tombs of Castilian kings.

ORENSE, Orense

241 **Cathedral** Mainly 13th c. Pórtico del Paraíso copied from the Pórtico de la Gloria in Compostela; 13th c portals of transept are more original. Lantern over crossing attr. to J de Badajoz (1499–1505) combines Gothic and Hispano-Moresque styles.

242 **Santa María la Madre** Small church, formerly cathedral, restored 1722. Contains Byzantine figure of the Virgin; *Dolorosa* of Renaissance period; the *Christ of Santo Entierro.*

243 **Museo Arqueológico Provincial** (In 13th c former episcopal palace). Prehistoric, Roman and Visigothic collections.

ORIHUELA, Alicante

244 **Cathedral** Gothic, 14th and 15th c. Fine doorways, especially N one, in Renaissance style.

245 **Santiago** Fine doorway; late 15th c tower; Gothic nave; Renaissance choir and transepts; reredoses; statues by Salzillo.

246 **Museo Diocesano** Several fine paintings from various churches; Velasquez *Temptation of St Thomas Aquinas,* Ribera *Mary Magdalene;* chalices etc, illustrated books; fragments of 15th and 16th c altars.

247 **University** Foundation of the Bishop Loaces, begun 1552 by J Anglés, continued 17th c by A Bernardo.

OSERA, Orense

248 **Monastery** Founded by Cistercians in 1135, named 'Escorial of Galicia'. Church lantern constructed by F Martinez. 16th c chapter house has groin vaulting supported by twisted columns. 3 important 15th c cloisters.

OVIEDO, Oviedo

249 **Cathedral** Magnificent Gothic building, 1388–1528. W portal attr. to P Buyères composed of 3 arcades with richly ornamented doors; early 16th c tower one of the most beautiful in Spain. Interior: Gothic doorway with sculptures by J de Malinas (15th c); main altarpiece by Giralte and J de Balmaseda (1511–29); Capilla de San Miguel contains fine Romanesque sculpture and various important works of art.

250 **San Julián de los Prados** Founded about 830, recently restored. Blind arcades with marble columns and sculptured capitals; triumphal arch with decorated pilasters; rich painted decoration on walls and ceiling.

251 **San Miguel de Lillo** Built *c.* 848, apse rebuilt 17th c with remains of original one; portal with mullioned windows and Barbaric sculptures on side posts in imitation of Byzantine ivory work.

252 **Santa María de Naranco** Built *c.* 850 as palace or hall of justice, transformed into church between 905 and 1065; portal added end of 13th

c. Semicircular nave with interesting medallions on ceiling arches; spiral columns with sculptured capitals; crypt with cradle vaulting.

253 **Museo Arqueológico Provincial** Prehistoric objects; inscriptions; fragments of ancient buildings; 14th c tombs etc.

PALENCIA, Palencia

254 **Cathedral** Gothic Transitional style, built 1321–1516. 15th c Puerta del Obispo richly embellished with sculptures by D Hurtado de Mendoza. Many fine altarpieces and tombs; El Greco *Martyrdom of St Sebastian;* diptych by P Berruguete; objets d'art.

255 **San Pablo** Formerly church of convent founded 1217; rebuilt 15th c. Sober Renaissance façade; remarkable 16th c choir screens; superb tomb attr. to A Berruguete.

256 **Museo Arqueológico Provincial** Large Iberian and Roman collections; some tombs; 14th c altarpiece.

PALMA DE MAJORCA, Majorca

257 **Cathedral** Begun early 14th c, nave and aisles completed 1529. 14th c Puerta del Mirador richly ornamented; principal portal (1594) by M Verger; Puerta de la Almoina dates from 1498; bell tower 15th c. Gothic sculptures and altarpieces; stained-glass windows.

Museo Catedrálico Ecclesiastical ornaments; Gothic panel paintings; illuminated codices; goldwork; tapestries.

258 **Bellver Castle** Built by Jaime II at the beginning of the 14th c, curious circular form.

259 **Museo Diocesano** Balearic archaeology; Gothic sculpture; painted altarpieces.

260 **Museo Provincial** (In the 15th c *lonja* 15th and 16th c reredoses; paintings of Italian and Spanish schools; some modern paintings.

PAMPLONA, Navarre

261 **Cathedral** Largely Gothic, Neoclassical façade by V Rodriguez (1783). Contains tomb of Charles the Noble of Navarre and his wife by J Lomme of Tournai (1416); thr 14th c *Caparroso Altarpiece; Virgen de los Reyes* (14th c) in sanctuary. Doorway from transept to cloister richly sculptured on jambs and tympanum. Cloister (14th to 15th c) has much sculpture.

262 **Museo de Navarra** Prehistoric collection; Roman mosaics; Moorish and Romanesque objets d'art; Gothic murals; 16th c paintings.

PAREDES DE NAVA, Palencia

263 **Santa Eulalia** Gothic church with some modifications; fine square tower. Contains main altarpiece by E Jordán (1556), a predella with paintings by P Berruguete; Gothic and Renaissance woodcarvings and paintings; a collection of goldwork and embroideries.

PAULAR, EL, Madrid

264 **Monastery** First Carthusian monastery in Castile, founded by Henry II in 1390, built to plans of R Alfonso. Completed 1440, additions continued till 18th c.

PEDRALBES, Barcelona

265 **Convent** Founded by Doña Elisenda de Moncada in 1326. Cloister contains paintings by Bassa.

PENAFIEL, Valladolid

266 **Castle** Mainly constructed in 14th c; double defensive walls with round towers along them; *Torre de Homenaje* in centre.

267 **San Miguel and Santa María** (In the monastery of San Pablo). The former, built 1324, is one of the best examples of Mudéjar and Plateresque styles.

PENALBA, León

268 **Santiago** Mozarabic church, built 931–37. Some remains of Romanesque paintings.

PLASENCIA, Cáceres

269 **Catedral Nueva** Renaissance style on Gothic framework, incomplete. Architects J de Alava, D de Siloe, and Gil de Hontañón. Main portal finished 1558 has 4 orders of columns, superimposed and elaborately decorated.

270 **Santa María** Romanesque façade; chapter house has pyramidal spire; 14th c tower.

POBLET, Tarragona

271 **Santa María de Poblet** Cistercian abbey founded by Ramon Berenguer IV in 1150; sacked and burned in 1835; now well restored. Capilla Mayor contains altarpiece by D Forment

(1527); tombs of the kings of Catalonia and Aragon.

PONTEVEDRA

272 **Museo de Pontevedra** Important prehistoric collections from Golada, Caldas de Reyes, Foxados, Bedoya (gold jewellery); processional crosses; Sargadelos chinaware; furniture; Flemish and Spanish paintings from 16th to 18th c including Zurbarán, Lopez E Jordán, Rizi, Tolentino, Veronese etc.

PRIEGO DE CORDOBA, Córdoba

273 **Castle of the Medinaceli** of Moorish epoch with later additions.

RAMALES, Santander

274 **Covalanas Caves** Interesting prehistoric paintings.

REMIGIA, Castellón

275 **Caves** Fine examples of Spanish Levantine cave art. Hunting and domestic scenes.

REUS, Tarragona

276 **Museo Municipal Prim-Rull** Iberian and Roman objects discovered in region; remains of tombs of 15th to 17th c; sculpture on wood; reredoses; goldwork; local ceramics 15th to 16th c; paintings by Fortuny.

RIPOLL, Gerona

277 **Monastery of Santa María** Founded 589 by King Reccared; re-established 888 by Wilfred; construction continued till 16th c. Badly damaged 1835, since restored. Church has Romanesque square tower; 12th c portal with sculptures including biblical scenes. Romanesque cloister has 2 storeys with 252 columns, purple bloodstone and granite; capitals decorated with biblical and mythological scenes.

RONCESVALLES, Navarre

278 **Abbey** Founded 12th c. Early Gothic church of French influence, contains Gothic tombs of the kings of Navarre.

RONDA, Málaga

279 **Cathedral** 16th to 17th c, built over an old mosque, from which there remains minaret and *mihrab* with stucco-work arch.

280 **Arab baths** 3 rooms with vaults of semicircular shape.

281 **Casa del Rey Moro** Originally 11th c, restored. Collection of works of art and antique furniture. Terraced garden in Arab style.

282 **Minaret** Tower of the destroyed church of San Sebastian. Decorated with horseshoe-shaped windows, arcades, glazed bricks.

RONDA LA VIEJA (near Ronda), Málaga

283 Important Roman ruins: theatre with Doric doors and arcades; semi-circular circus.

SADABA, Saragossa

284 **Clarina** Ruins of Roman city, mausoleum of Atilios (2nd c); baths; 2nd c aqueduct.

SAGUNTO, Valencia

285 **Museo Arqueológico** Prehistoric objects; fragments of Iberian and Roman sculpture; mosaics; ceramics; glassware etc.

286 **Roman Remains** Theatre 2nd c BC with later additions; Early Christian circus; necropolis.

SAHAGUN, León

287 **San Lorenzo** Mudéjar, built 13th c. Altarpiece by G Doncel and J de Anglés (1545).

288 **San Tirso** Built 12th c of brick. Nave and 2 aisles covered by a wooden roof; Mudéjar apses and tower.

SALAMANCA, Salamanca

289 **Catedral Nueva** Begun 1513 under direction of Gil de Hontañón; completed 1733. 3 portals of façade richly decorated in Plateresque style; on N portal relief of Christ's entry into Jerusalem. Interior: Flemish stained glass windows (1556); Virgin and Child by L de Morales; choir stalls by J de Lara and A Carnicero 1725–33; Baroque *trascoro* with St John and St Anne in polychrome wood by J de Juni.

290 **Catedral Vieja** Begun 12th c, completed 14th c. Transept with lantern tower (Torre del Gallo) on sculptured pendentives at crossing; fine capitals; vault of presbytery with paintings by N Florentino; series of 13th and 14th c tombs. 12th c cloister has several fine tombs and a *Pietà* by J de Juni. **Museo Diocesano**; paintings by the Gallegos, P. Bello, J de Flandes; sculpture; 12th c Hispano-Moresque textiles.

291 **Augustinas Recoletas** (convent) Church

built in 1636 in Italian style by Fontana. Huge cupola dates from 1681. Paintings by Ribera and 17th c Italian artists; 17th c Italian sculptures; a lapis-lazuli tabernacle; large collection of relics and ornaments; remarkable examples of 17th and 18th c religious art.

292 **Clerecía** (seminary) Built by the Jesuits 1617–1755. Large church with 2 towers, work of G Mora. Main altar with 4 twisted columns and in centre, a reredos of polychrome wood.

293 **Colegio del Arzobispo** Sumptuous building begun 1527 by Philip II. Façade, patio and church by D de Siloe and J de Alava; contains altarpiece by A Berruguete.

294 **El Espíritu Santo** Built 1541, Renaissance decoration. Superb sculptured reredos dated 1649; 16th and 17th c sculptures; Gothic woodwork.

295 **Escueles Menores** (convent) Built 1533 with 2 Plateresque portals. Renaissance and Baroque patio; hall with Mudéjar and Renaissance ceiling; statues of the Virgin and Saints by P de Borgoña in library; statues of the Virgin and Saints by P de Borgoña; *Adoration and Annunciation* painted on wood by J de Borgoña.

296 **San Esteban** Built 1524–1610 in Gothic style after plans of J de Alava; Plateresque façade embellished with sculptures. Fresco by Palomino; main altar 1693 by J Churriguera with a painting by C Coello.

297 **Casa de la Salina** (Fonseca Palace) Built *c.* 1519, attr. to Gil de Hontañón; fine façade; vestibule and patio with balconies supported by huge consoles formed of curious figures.

298 **Casa de las Muertas** Built beginning of 16th c, excellent example of Plateresque style.

SANGUESA, Navarre

299 **Santa María la Real** Built 12th to 13th c, sculptured portal by various Romanesque masters.

SAN JUAN DE LA PENA (near Jaca), Huesca

300 **Monastery** Built 11th to 12th c in Cluniac style. Church with one nave built partly in the rocks. 3 Byzantine arcades on sculptured capitals; Romanesque frescoes; Romanesque sacristy contains pantheon of the first kings of Aragon.

SAN MIGUEL DE ESCALADA, León

301 **Monastery** Fine Mozarabic building founded by the monks of Córdoba in 913.

SAN MILLAN DE COGOLLA, Logroño

302 **Abbey** Founded 537, rebuilt 16th c. Church (1504–40) contains paintings by F J Ricci (*c.* 1653); *rejas;* carved lecterns; Baroque *trascoro;* the 16th c sacristy with Baroque decoration; ivory reliquary casket of San Millán.

SAN PEDRO DE LA NAVE

303 **Church** Interesting Visigothic building of 7th c.

SAN PEDRO DE RODA, Gerona

304 **Mónastery and Church** Of monastery, only walls, 2 towers and church remain. Church is principal monument of Catalan Romanesque before Lombard influence.

SAN SEBASTIAN, Guipúzcoa

305 **Museo Municipal de San Telmo** Archaeology; Basque ethnography; paintings 14th to 20th c (El Greco *Christ*); sculpture; furniture; faience.

SAN SALVADOR DE LEYRE, Aragon

306 **Monastery and Church** Romanesque church of 11th c; sculptures reflect the style of Jaca; crypt dating from 11th c has enormous capitals from an earlier structure of the 9th c.

SANTA CREUS, Tarragona

307 **Abbey** Founded 1169, follows general plan of Cistercian order. Church (12th to 13th c) contains many fine tombs. Cloister decorated with Flamboyant Gothic tracery.

SANTA CRUZ DE TENERIFE, Canaries

308 **Museo Municipal** Archaeology, paintings.

SANTANDER, Santander

309 **Cathedral** Gothic, modified 16th and 18th c.

310 **Museo Municipal de Pinturas** Paintings mainly 17th and 18th c Spanish school.

SANTIAGO DE COMPOSTELA, Coruña

311 **Cathedral** One of the oldest and most interesting in Spain, dates from 12th c. Restored in 17th and 18th c. Main façade by F Casas y Novoa in Churrigueresque style (1750); N façade by V Rodriguez (1757); Portico Real de la Quintaña by J Peña de Toro; clock tower begun 14th c, finished by D de Andrade (1676–80); Puerta de las Platerias 11th to 12th c, decorated with fine Romanesque sculptures on tympanum, jambs and high frieze; Portico de la Gloria masterpiece of Romanesque art by Master Mateo. Interior; many Romanesque capitals and some sculptures remain; altarpieces, goldwork etc.

312 **San Martín** Façade by M Lopez (1590), 3 sections embellished with 15 statues and surmounted by a pediment with a bas-relief of St Martin sharing his cloak.

313 **Hospital Real** Founded by the Catholic Kings, has fine sculptured portal and many statues, work of E de Egas (1501–11); façade rebuilt 1678. Principal chapel architectural gem dating from time of Isabella with *rejas* by Guillén (1556).

314 **Museo Arqueológico** Medieval sculpture, sacrophagi, tombstones; marble columns from the destroyed part of the Pórtico de la Gloria; finest collection of tapestry in Spain. Library: collection of MSS and very old books.

315 **Rajoy Palace** Begun 1766 by G de Quinones, completed by C Lemaur in Neoclassical style. Fine rooms with portraits etc.

SANTIPONCE, Seville

316 **San Isidoro del Campo** Monastery built 14th c. 2 Gothic churches of unequal height joined by an arch. One has main altarpiece of wood (1613–19) by J M Montañés. Other church has Mudéjar portals.

SANTO DOMINGO DE LA CALZADA, Logroño

317 **Cathedral** Begun *c.* 1158, still has original Romanesque apse. Baroque tower and s portal; main altarpiece by D Forment (1537).

SANTO DOMINGO DE SILOS, Burgos

318 **Abbey** Only Romanesque cloister remains: fine sculptures on columns and 8 bas-reliefs on piers at corners. **Museo del Monasterio**; prehistoric and Roman exhibits, the 11th c Mozarabic Chalice of St Domingo, a copper Romanesque frontal, goldwork.

SARAGOSSA, Saragossa

319 **Cathedral** Built 1119–1550 on site of former mosque. Greco-Roman façade of late 17th c dominated by an octagonal tower; on N–E side interesting exterior decorations of brick and *azulejos* in Mudéjar style; Renaissance portal; some Romanesque windows remain. Important main altarpiece begun by P Johan (1431), finished by H de Suabia (1467); *trascoro* (one of the masterpieces of Spanish Renaissance) by A de Bruselas (1557) and Tudelilla, embellished with statues and high reliefs; Capilla de San Miguel contains altarpiece by M de Ancheta (16th c) and tomb of Archbishop de Luna by P Moragues (1382); Capilla de San Augustin has altarpiece by G Morlanes the Younger and G Joly.

320 **Aula Dei** (monastery) Carthusian, founded in 1564, perfectly restored. In cloister, paintings *Life of St Bruno* by A Martínez; in church, frescoes by Goya.

321 **Nuestra Señora del Pilar** Begun 1681 to plans by Herrera and Rodriguez. Vast Baroque edifice with 10 cupolas faced with coloured *azulejos;* big central dome; towers at each of the 4 corners. Lavish Capilla de la Virgen del Pilar is by V Rodriguez; main altarpiece by D Forment; *coro* by E de Obray and N Lobato (1544); frescoes by A Gonzalez Velázquez, Bayeu, Goya.

322 **San Ildefonso** Built 1661 by D Zapata, has longest nave in region with richly decorated arches; contains tombs and reredoses.

323 **Audienca** Built 1551, former palace of the Counts of Luna. Façade flanked by 2 towers; door with 2 huge caryatids by the French sculptor G de Brimbez; fine patio with green and blue *azulejos;* rooms with fine ceilings.

324 **Castillo de la Aljaferia** Palace built 864, enlarged from 1030–81, and again in the 14th c and 15th c. Rooms with interesting ceilings; royal staircase in florid Gothic style. Small 11th c mosque contains attractive decorations and a remarkable cupola.

325 **Museo Diocesano** Flemish and French tapestries; sketches by Goya and Francisco and R Bayeu for mural decorations; paintings, statues; furniture; illuminated MSS.

326 **Museo Provincial de Bellas Artes** Archaeological collection; Roman objects; mosaics and inscriptions; exhibits from excavations at Sena. Moslem collection: capitals and fragments of architecture from Aljafería. Medieval, Renaissance, 17th c paintings and sculpture.

327 **Palacio de la Maestranza** Built 1537–47 in pure Aragonese style. Fine cornice; tall gallery with blind arcades; unusual stairway surmounted by a Mudéjar cupola; magnificent ceilings.

SEGORBE, Castellón

328 **Cathedral** 15th to 16th c, remodelled 18th c. Contains altarpieces by P Serra, J Baco, Jacomart, J Rexach and the so-called Master of Segorbe (15th c); paintings by V Macip; relief attr. to D da Settignano; tombs; goldwork.

SEGOVIA, Segovia

329 **Cathedral** Designed by Gil de Hontañón, begun 1525, finished 17th c. Latest example of Gothic style in Spain. Interior: stellar vaulting, stained glass windows (16th–17th c); main altarpiece designed by F Sabatini (1722); *trascoro* designed by V Rodriguez (1784); paintings by F Camillo; an altarpiece by J de Juni (1571), Gothic *rejas.* **Museo y Archivo de la Catedral**; Paintings by Ribera, L de Morales, 13th c sculptures; Brussels tapestries; MSS.

330 **Church of the Santa Cruz Monastery** Rebuilt end of 15th c. Rich Gothic-Plateresque portal with sculptures of the J Guas school.

331 **Vera Cruz** Romanesque church built 1246, formerly belonged to the Templars, restored about 1830.

332 **Alcázar** Originally built by King Alfonso VI, several times rebuilt and enlarged. Castle with towers and high gables, in centre of which stands an enormous rectangular keep built by Juan II.

333 **Aqueduct** Probably dates from the time of Trajan, has 128 arches, about ½ a mile long and 94 ft at maximum height.

334 **Museo Provincial de Bellas Artes** Archaeological collection; Castilian panel painting; 17th c canvases.

SEO DE URGEL, Lérida

335 **Cathedral** Dedicated to St Odo, built by St Armengol, finished together with fine cloister 1175 by masons from Lombardy. Pillaged and devastated in 1936, now offers only beautiful proportions of nave and apses, and some curious ornaments on capitals.

336 **Episcopal Palace** Built at different epochs. Graceful patio with arcades; façade surmounted with battlements and a square tower.

SEVILLE, Seville

337 **Cathedral** Begun 1401, erected on site of the mosque, hence its plan and its great size (nave and 4 aisles with side aisles). 9 portals, some with terra-cotta sculptures by L Mercadente (1453) and P Millán (*c.* 1500). Stained glass windows date from 16th to 19th c. *Coro* has a screen by F de Salamanca; Gothic-Mudéjar choir-stalls by N Sanchez and P Dancart; Capilla Mayor has *reja* by F de Salamanca and a carved altarpiece begun by P Dancart in 1482. Paintings by Murillo, J Valdés Leal, L de Vargas, Montañés, Pacheco, Zurbarán, L Tristán; notable tombs (Fancelli); embroideries 16th to 19th c.

338 **Convent of Santa Paula** Founded 1475, has Gothic portal with terra-cotta decorations (16th c) by F Nicoloso. Church: sculpture by A Cano and M Montañés.

339 **Sagrario** Begun 1618 by Zumárraga, completed 1662 by Iglesias. Altarpiece with sculpture by P Roldán.

340 **Alcázar** Preserves some elements from Almohade epoch (defensive outer walls and towers, Puerta del León), but is mainly a Mudéjar palace (1364–66) from time of Pedro the Cruel.

341 Ayuntamiento Built *c.* 1527 from plans by D de Riaño, restored 1891. s wing a masterpiece of Plateresque style.

342 Casa de Pilatos Built in Moorish style with mixture of Renaissance and Flamboyant Gothic in decoration.

343 Casa del Duque de Alba Founded by the Pinedae family in the 15th c, enlarged by the Ribera family, ornamentation 16th c. Magnificent patio in Moorish and Plateresque style dating in part from the 15th c; Gothic chapel with *azulejos*; rooms with stuccoed arches and panelled ceilings.

344 Casa Lonja Built 1583–98 by J de Minjares to plans by J de Herrera, in classic Renaissance style.

345 Giralda Tower Once minaret of old mosque, built at end of 12th c.

346 Museo Arqueológico Provincial Prehistoric collection; large group of Roman mosaics and statuary from Italica; Greek sculpture; funerary stones; pottery; jewellery.

347 Museo Provincial de Bellas Artes Paintings of the Sevillian school; works by Herrera the Younger, Zurbarán, Ribera, P de Mena; statue by Torrigiani; primitives; modern paintings; tapestry from a sketch by Murillo (only example from the factory at Seville); objets d'art.

SIGUENZA, Gudalajara
348 Cathedral Begun *c.* 1150 by French artists in Poitevin-Romanesque style, continued Cistercian style, finished 14th c. Interior: sculptured altarpiece by G de Merlo; *coro* has stalls with Gothic tracery and Baroque screen; Plateresque *reja* (1515) with Mudéjar decoration; paintings by J de Perreda; Castilian sculptures and panel paintings. **Museo Diocesano**; 12th c Hispano-Moresque textiles, Gothic religious images, 17th c tapestries, gold and silverwork.

SOLSONA, Lérida
349 Cathedral Gothic with Baroque portal.

350 Museo Arqueológico Prehistoric exhibits; Romanesque and Gothic paintings; sculpture; goldwork.

SORIA, Soria
351 San Pedro Commissioned from J Martínez Mucio in 1551, finished 1573, modelled on collegiate church at Berlanga de Duero. Main altarpiece by F del Rio (1578). Romanesque cloister.

352 Santo Domingo Important Romanesque building of 13th c, altered in 16th c though only the apse and transept were affected. Along the tympanum and capitals and round the rose window are nearly 250 statuettes depicting scenes from the Old and New Testament.

353 Palace of the Counts of Gomara Renaissance building (1592) with imposing façade.

354 Museo Celtibérico Prehistoric and Roman remains.

355 Museo Numantino Exhibits from the excavations at Numantia; a collection of about 900 vases with polychrome decoration; votive offerings; jewellery.

TAHULL, Lérida
356 Santa María and Santa Clemente Consecrated 1123, each church has nave with flanking aisles, 3 apses, and free-standing bell tower. The frescoes from these churches are now in the Museo de Arte de Cataluña, Barcelona.

TARAZONA, Saragossa
357 Cathedral Built 1235, Mudéjar lantern tower at crossing constructed by J Botero (1519) Choir stalls from 1464; altarpieces, tombs.

TARIFA, Cádiz
358 Roman remains Sections of the wall (1st c BC) with 2 gates; 3 identical small temples, a colonnaded street; Roman houses.

TARRAGONA, Tarragona
359 Cathedral Excellent example of the various phases of Gothic art, built 1171–1331 on site of a former mosque, retains imposing Romanesque apse resembling a fortress; bell tower with Romanesque base is unfinished; main portal has sculptures by Master Bartolomeu; w façade begun 1278 is also unfinished.

360 Acropolis Surrounded by megalithic walls, probably built during first Roman occupation,

remains of 6 gates, 3 of which are still in use. Contained Temple of Augustus built AD 15, of which a few architectural elements remain.

361 Amphitheatre and circus Both are preserved in part.

362 Aqueduct Roman, built under Trajan, restored 18th c.

363 Arch of Bara Built early 2nd c AD. Fine proportions, only decoration 2 fluted pilasters.

364 Museo Arqueológico Provincial Pre-Roman, Roman and Spanish Roman archaeology, capitals, tiles etc; Roman sculpture; Phoenician and Iberian coins; jewellery; Hispano-Moresque ceramics; medieval sculpture; 16th c paintings.

365 Museo Diocesano 14th and 15th c reredoses, sculptures and paintings; liturgical gold and silverwork; tapestries; coin collection; 13th and 14th c wood-carvings; ironwork, *azulejos*.

366 Museo Molas Roman antiquities; medieval ceramics; Greek, Roman and Spanish coins.

367 Romano-Christian Necropolis Funeral urns, tombstones, sarcophagi, mosaics, the remains of a basilica, 2 fine crypts. **Museo Paleocristiano** (in situ) houses the most important finds from the necropolis.

TARRASA, Barcelona
368 San Miguel Of Visigothic origin, enlarged 10th c; crypt contains 12th c murals.

369 San Pedro Romanesque, 12th c vaulted nave, traces of 10th c murals remain.

370 Santa María Romanesque, with 9th c apse, 12th c nave, contains painted stone altarpiece (10th c) and Romanesque murals (12th c).

TERUEL, Teruel
371 Cathedral Mudéjar tower (1257); apse constructed 1335 by Moslems; transept has Mudéjar lantern *c.* 1538 by M de Montalban; nave roofed by painted *arteonados* (14th c).

372 San Pedro Mudéjar tower and apse. Contains 16th c main altarpiece by G Joly.

TOLEDO, Toledo
373 Cathedral Purest French-Gothic, begun 1227 and continued with important additions up to 18th c. Stained glass 14th c to 18th c by P Bonifacio, J de Cuesta and others. In ambulatory is the *Transparente* by N Tomé; fine altarpieces and tombs; frescoes by Giordano; paintings by El Greco, Goya, Bellini, Bassano, Van Dyck etc.

374 San Juan de los Reyes Once part of monastery erected 1476 by the Catholic kings, architect J Guas. Most remarkable part of building is richly decorated chevet; N-W façade begun 1533 by Covarrubias in imitation of Gothic style; interior completely restored in recent years; pillars covered with arabesques and curiously ribbed vault; stone balconies carved in open-work design bearing initials of Ferdinand and Isabella. Cloister is one of the finest examples of florid Gothic in Spain.

375 Santiago del Arabel Good example of Toledan Mudéjar church of 13th c.

376 Alcázar Originally fortress erected by Alfonso V; embellished by Alfonso VIII who gave it its present quadrilateral form with 4 square corner towers. Now mainly in ruins.

377 Casa del Greco (museum) Contains 20 canvases by El Greco who was said to have lived here. Paintings by Herrera the elder, Zurbarán, Valdés Leal, Pacheco and others.

378 Hospital of San Juan Bautista Built 1541–99 by Bustamante, huge quadrangular edifice; church contains tomb by A Berruguete; on high altar, reredos designed and painted by El Greco. Apartments contain period furniture and decorations; paintings including C Coello, Caravaggio, Salvator Rosa, El Greco.

379 Museo Parroquial Religious ornaments of 15th to 18th c; paintings by El Greco; incunabula; illuminated MSS; Brussels tapestries; goldsmiths work including a custodial by J de Arfe.

380 Puerta del Sol Masterpiece of Moorish architecture, erected by the Knights Hospitallers at the beginning of the 14th c.

381 Santa Cruz Hospital Built 1514–44 by E de Egas. Badly damaged 1936, since restored. One of the finest examples of Renaissance architecture in Spain. **Museo Provincial:**

Roman mosaics, prehistoric, Iberian, Visigoth and Arab objects; sculpture by P Berruguete, Pereyra etc; paintings by Bassano, Ribera, Murillo etc.

TORDESILLAS, Valladolid
382 Santa Clara (convent) Former palace built by Alfonso XI *c.* 1350. Notable example of Mudéjar style; stone and polychrome ceramic façade.

TORTOSA, Tarragona
383 Cathedral Present edifice begun 1347 under direction of B Dalguayre, finished 18th c. Baroque façade; Moorish tower.

384 San Luis (convent) Founded by Charles IV in 1544. Graceful Renaissance façade by J Anglés.

385 Museo Archivo Municipal Iberian, Roman, Arab and medieval antiquities; ceramics from Alcora and Manises; paintings, sculpture.

386 Santa María le Mayor Begun 1160, richly sculptured 13th c w portal; N portal late Romanesque.

TUDELA, Navarre
387 Cathedral 13th c building, retains some elements of a 9th c mosque. Noteworthy Judgment Portal *c.* 1200.

TUY, Pontevedra
388 Cathedral Fortress-like appearance, exterior walls, transept and chancel constructed at the beginning of the 13th c, remodelled towards end of 15th c, main portal with Gothic sculptures and decoration completed before 1287.

UBEDA, Jaén
389 El Salvador Designed by D de Siloe, executed 1540 by A de Vandelvira; altarpiece by A Berruguete.

390 Santa María de los Reales Alcázares Mainly 13th c; fine façade (1615–46); Gothic cloister; *rejas* by Master Bartolomeu.

391 Hospital of Santiago Built 1567–75 in style of the Escorial by A de Vandelvira.

392 Palace of the Ortegas Elegant but severe façade; 17th c Classical door.

393 Palace of Vazquez de Molina Built by A de Vandelvira, Classical façade in style of Bramante.

UNCASTILLO, Saragossa
394 Santa María Romanesque, has 14th c fortified tower; cloister by J Larrandi 1557.

VALENCIA, Valencia
395 Cathedral Begun 1262, finished before 1376. s portal Romanesque, derived from that of the cathedral of Lérida; Gothic N portal richly ornamented with statues and surmounted by a rose window; concave main portal in Baroque style by C Rudolph (1703). Over crossing. octagonal lantern tower (14th c) with windows. Main altarpiece painted by F Yáñez de la Almedina and F Llanos; alabaster reliefs by G Florentino; Gothic paintings; canvases by V Masip, J de Juanes, Goya.

396 San Esteban 15th c, interior magnificently decorated in Churrigueresque style by J B Perez.

397 San Juan del Hospital Founded by the Knights of Malta, built *c.* 1300. Reredos by J E Bonet; paintings.

398 Santo Domingo Interior Neoclassical style (1772–81) decorated by A Gilobert, paintings by V Salvador Gomez, frescoes by J Vergara; highly ornamented main altar with reredos painted by Zarineña (1588).

399 Colegio de Patriarca Palace in Roman style, built 1586–94 by A del Rey. Contains 16th c statue of the Virgin attr. to G Fernández; paintings by El Greco, J Macip, Morales, Ribalta, Ribera, Murillo, Zurbarán.

400 Lonja de la Seda (silk exchange) Large building in Flamboyant Gothic style by P Compte 1483–98, since restored.

401 Museo de Bellas Artes One of the largest museums in Spain, contains some 2,000 paintings especially Valencian school; a room devoted to paintings and drawings by Goya.

402 Museo González Martí (In Palace of the Marqués de Dos Aguas with 18th c façade and Baroque entrance) National collection of ceramics of all periods, including 4 plates by Picasso; glassware; furniture; carpets.

403 Museo Prehistórico Richest collection of

Iberian ceramics in Spain.

VALLADOLID, Valladolid

404 **Cathedral** Designed by J de Herrera *c.* 1585, resumed by Churriguera and later by V Rodriguez but never finished. Choir stalls and a reredos both by J de Juni; sacristy contains a masterpiece by J de Arfe, a monstrance over 6 ft high depicting Adam and Eve (1590).

405 **Nuestra Señora de las Angustias** Built 1597–1604 to designs by pupils of Herrera. Contains reredos by C Velázquez sculptured by Brother de Rincon and painted by T de Prado; the celebrated *Virgin de los Cuchillos* by J de Juni; *St John* and *Mary Magdalen* by G Fernández.

406 **Santa Ana** (convent) Built 1870 by R Sabatini. Paintings by Goya, Bayeu; sculptures by G Fernández.

407 **Santa Catalina** (convent) 16th C patio; *Christ* by G Fernández; *Christ* by J de Juni; fine coffering; Renaissance doors.

408 **Santa María la Antigua** Founded 1095, though much of it dates from 14th C. Romanesque tower ranked as the most beautiful in Spain.

409 **Colegio de San Gregorio** Gothic with modifications by J Guas. Particularly interesting façade with heraldic ornament.

410 **Colegio Mayor de Santa Cruz** Built 1487–91 by E de Egas in Plateresque style with marked Gothic influence. Library: valuable MSS (Beatus Manuscript of Valcavado).

411 **Museo Arqueológico** Iberian, Roman and Visigothic art; Spanish primitives and 16th C paintings; frescoes from Peñafiel; polychrome sculpture; *azulejos*; ceramics; ironwork; processional crosses; tapestries.

412 **Museo Nacional de Escultura** Finest examples of polychrome sculpture. Sculptures by A Berruguete for Convent of San Benito el Real, notably main reredos; G Fernández *St Theresa, Christ, St Bruno, Pietà;* Pedro de Mena *Magdalene;* A Alvarez *San Marcos reredos;* S Carmona *Christ.* Paintings: works by Pereda, B González, D Valentin Diaz; Rubens, Zurbarán, Ribera, Martínez, A Perella, Murillo, E Jordán.

VERUELA, Saragossa

413 **Abbey** One of the most remarkable in Spain, built by Cistercians from 11th to 12th C. Crenellated defensive walls with round towers and gates and armorial bearings of Cardinal-Infante D Fernando de Aragon (16th C).

VICH, Barcelona

414 **Cathedral** Founded 1038 on site of earlier church; enlarged from 12th C to 15th C; rebuilt in Classical style by J Morato from 1780 to 1803. Burnt 1936, since restored. 11th C crypt with rounded arches; murals by J M Sert (d. 1945); 12th C cloister.

415 **Museo Arqueológico Artistice Episcopal** Paintings on wood, particularly Romanesque altar fronts; embroidery; medieval goldwork; MSS; panels of the *Reredos of the Clarisses* by L Borrassa; 14th C English cope.

VILLALCAZAR DE SIRGA, Palencia

416 **Santa María la Blanca** Gothic, built 13th C. Side portal with 2 sculptured doors. Fine tomb of the Infante Don Felipe (d. 1274) and his wife; some painted Gothic altarpieces.

VILLAGARCIA DE CAMPOS, Valladolid

417 **Collegiate church** Founded 1527 constructed by J de la Vega after designs by Gil de Hontañón. Altarpiece with reliefs in alabaster (1579–82).

VILLANUEVA DE CANEDO, Salamanca

418 **Fonseca Palace** 15th to 16th C, mixture of Gothic, Mudéjar and Renaissance styles; built on square plan with towers at corners.

VILLANUEVA Y GELTRU, Barcelona

419 **Castle and Museum** Castle 12th C, remodelled in 14th and 15th C, additional storey built 17th C. Museum: paintings including works by El Greco, J-B Mayno, Carreño, Escalante etc.

420 **Museo Balaguer** Egyptian and Roman antiquities; ceramics; sculpture and paintings; coins; oriental art.

VITORIA, Alava

421 **Cathedral Vieja** Built 14th to 15th C, has richly sculptured Gothic portal. Gothic and Renaissance tombs and many examples of goldwork.

422 **Museo Provincial** Prehistoric and Roman exhibits; panel paintings 15th to 16th C; paintings by J Ribera and A Cano.

YUSTE, Cáceres

423 **San Jeronimo de Yuste** (monastery) Founded beginning of 15th C, 2 patios preserved, one Gothic, one Plateresque.

ZAFRA, Badajoz

424 **Alcázar** Considered one of the most beautiful in Estremadura; rebuilt 1437 by L S de Figueroa, part modernised in 16th C.

ZAMORA, Zamora

425 **Cathedral** Romanesque building of remarkably pure lines, built 1151–74. 17th C N façade with portal in imitation of Roman arch; outstanding portal on S side (Puerta del Obispo). Several fine altarpieces, carved stalls, etc. **Museo Catedrálico:** sculptures by B Ordóñez; monstrance in Plateresque style by J de Arfe and Master Claudio (1515); Flemish tapestries 16th to 17th C; MSS; paintings include F Gallego *Pentecost.*

426 **Museo Provincial de Bellas Artes** Roman steles; Visigothic objects; medieval and Renaissance statuary; paintings 16th to 20th C.

Acknowledgements

All the photographs other than those listed below were provided by Scala, Florence.
Numbers in heavy type refer to colour illustrations.

Anderson-Giraudon 99, 134; Archives Photographiques, Paris 92; Biblioteca Nacional, Madrid 221; J. Allan Cash, London 236; Courtauld Institute, London 158, 163, 249; Hamlyn Group Picture Library 248; Hirmer Fotoarchiv 31, 32, 33, 36, 37, 38, 41, 42, **45**, 58; M. Holford, London 166, **261**; Mansell-Anderson 165, 167, 178, 191; MAS, Barcelona 4, 22, 23, 24, 28, **30**, **55**, 59, **65**, **69**, **70**, 73, 74, 75, 76, 87, 88, 90, 91, 94, 107, 109, 110, 111, 117, 121, 133, 135, 136, 143, 145, 146, 149, 156, 160, 161, 162, 164, 175, 176, 177, 184, 186, 187, 199, 206, 209, 211, 220, 232, 235, 242; M. Moreno, Seville 148; Museo Arqueológico, Barcelona 5; Museo Arqueológico Nacional, Madrid 52, 57, 222; Museo Nacional del Prado, Madrid 144, 157, 159, 174, 192; Mary Orr, London **71**; U. Pfistermeister, Artelshofen introduction, 118; H. Roger-Viollet, Paris 86; J. Roubier, Paris 62, 63, 89, 93, 97, 119, 202; Bradley Smith, New York **frontispiece**; Yan, Toulouse 35, 53, 54, 56, 95, 137; Yan-Zodiaque 60.

Index

The numbers in heavy type refer to illustrations and those in italics to the Museums and Monuments index.

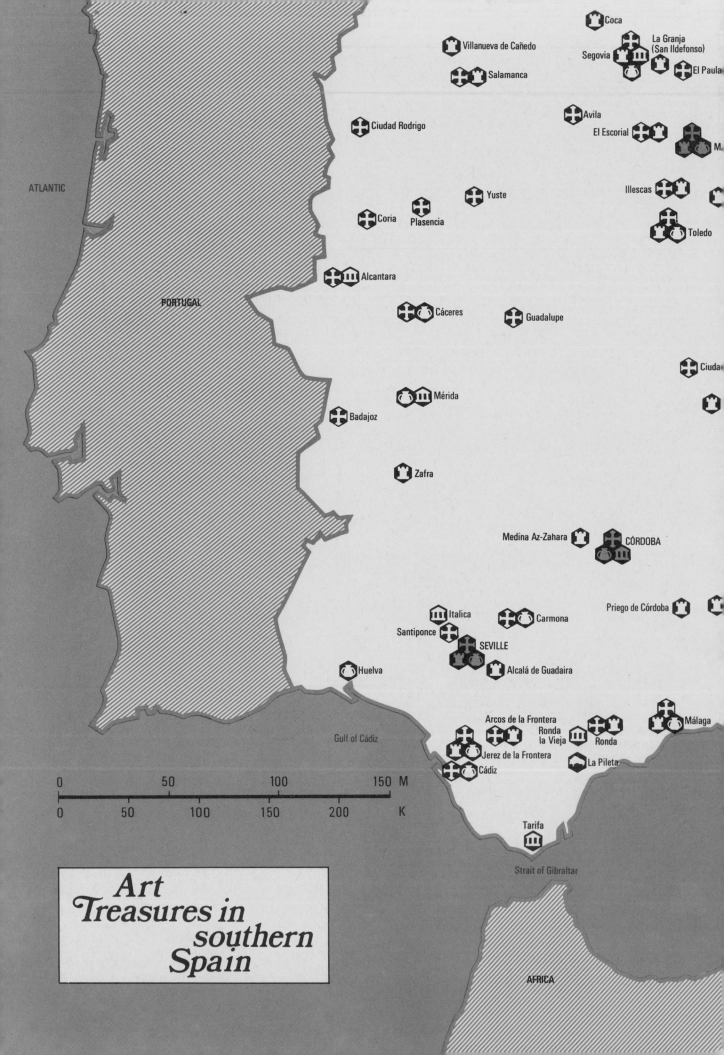

ATLANTIC

PORTUGAL

Coca

Villanueva de Cañedo

La Granja
(San Ildefonso)

Segovia

El Paula

Salamanca

Avila

El Escorial

M.

Ciudad Rodrigo

Illescas

Yuste

Coria

Plasencia

Toledo

Alcantara

Cáceres

Guadalupe

Ciuda

Mérida

Badajoz

Zafra

Medina Az-Zahara

CÓRDOBA

Priego de Córdoba

Italica

Santiponce

Carmona

SEVILLE

Alcalá de Guadaira

Huelva

Gulf of Cádiz

Arcos de la Frontera

Ronda
la Vieja

Ronda

Málaga

Jerez de la Frontera

La Pileta

Cádiz

0 50 100 150 M

0 50 100 150 200 K

Tarifa

Strait of Gibraltar

*Art
Treasures in
southern
Spain*

AFRICA